CINEMATIC APPEALS

Film and Culture
John Belton, Editor

FILM AND CULTURE

A series of Columbia University Press

EDITED BY JOHN BELTON

For the list of titles in this series, see page 331.

CINEMATIC APPEALS

The Experience of
New Movie Technologies

Ariel Rogers

Columbia University Press New York

Columbia University Press
Publishers Since 1893
New York Chichester, West Sussex
cup.columbia.edu
Copyright © 2013 Columbia University Press
All rights reserved
Library of Congress Cataloging-in-Publication Data

Rogers, Ariel.
　　Cinematic appeals : the experience of new movie technologies / Ariel Rogers.
　　　　pages cm. — (Film and culture)
　　Includes bibliographical references and index.
　　ISBN 978-0-231-15916-6 (cloth : alk. paper) — ISBN 978-0-231-15917-3 (pbk. :
alk paper) — ISBN 978-0-231-53578-6 (ebook)
　　1. Motion picture audiences. 2. Technology in motion pictures. 3. Cinema-
tography—Technological innovations. 4. Digital cinematography.　　I. Title.

PN1995.9.A8R64　2013
302.23'43—dc23　　　　　　　　　　　　　　　　　2013008591

∞

Cover design by Julia Kushirsky.

References to websites (URLs) were accurate at the time of writing.
Neither the author nor Columbia University Press is responsible
for URLs that may have expired or changed since the manuscript
was prepared.

Chapter 1, "'Smothered in Baked Alaska': The Anxious Appeal of Widescreen
Cinema," was first published in *Cinema Journal* 51.3 (Spring 2012): 74–96. Copyright
© 2012 by the University of Texas Press. All rights reserved.

FOR ANTHONY AND SENYA

CONTENTS

LIST OF ILLUSTRATIONS

ACKNOWLEDGMENTS

This book would not have been possible without a great deal of support. The project began at the University of Chicago, where Tom Gunning consistently modeled how one can be both an inspired thinker and an inspiring teacher. His intellectual generosity has been unflagging and has fueled this work, both at the dissertation stage and since. James Lastra has offered generous, expert guidance from the very beginning of this project, consistently helping me see ways to think more deeply about my material. Miriam Hansen's wide-ranging suggestions far exceeded anything I could have hoped for, and have, together with her own scholarly example, guided my work on this book at every level. I hope it does justice to her memory.

John Belton has been extremely giving of his expertise and time throughout his shepherding of this project. Without his superb, careful work on movie technologies—not to mention his advice and support—this book would not exist. I am grateful for a Mellon postdoctoral fellowship at Colby College, which provided me time to revise the manuscript. I would particularly like to thank Steve Wurtzler for creating a supportive and congenial environment for both writing and

teaching, and for offering comments on parts of the manuscript. I also owe very special thanks to Sarah Keller, Theresa Scandiffio, Caitlin McGrath, Josh Yumibe, Julie Turnock, Katharina Loew, and Tricia Har, all of whom offered thoughtful and detailed suggestions on chapters as well as other kinds of guidance and emotional support.

This project was developed at Austin College, Colby College, and the University of Southern Maine; I would like to thank my colleagues and students at all of these institutions. For professional help and moral support I am especially indebted to Elizabeth Banks, Sherry Berard, Brett Boessen, Wendy Chapkis, Patrick Duffey, Amanda Huffer, Matthew Killmeier, Lynn Kuzma, Rebecca Lockridge, David Pierson, Winifred Tate, Stephanie Towns, John Turner, and Kate Wininger.

I have had the opportunity to present research from this book in several different contexts, benefiting in particular from questions posed and comments made by Stefan Andriopoulos, Carol Armstrong, Francesca Coppa, Noam Elcott, Jane Gaines, Andrew Johnston, Peter Lev, Diane Lewis, Janine Marchessault, Inga Pollmann, Catherine Russell, Marc Steinberg, and Haidee Wasson. For various kinds of help and advice I would also like to thank Peter Decherney, Marshall Deutelbaum, Doron Galili, Oliver Gaycken, Martin Hart, Matt Lutthans, Daniel Morgan, Pauline Piechota, David Strohmaier, Buddy Weiss, Edward Yeterian, and Caveh Zahedi.

For assistance with research I am grateful to Charles Silver at the Museum of Modern Art, Joan Miller at the Wesleyan Cinema Archives, Mark Quigley at the UCLA Film and Television Archive, Tara Craig and Susan Hamson at the Columbia University Rare Book and Manuscript Library, and the staff in the Theatre Division at the New York Public Library for the Performing Arts. Thanks, as well, to Ron Barrett, Rob Hummel, Mirko Ilić, Marc Rosenthal, and Mark Wasyl for their generosity with their illustrations.

Earlier versions of sections of this book have previously been published as "'Smothered in Baked Alaska': The Anxious Appeal of Widescreen Cinema," *Cinema Journal* 51, no. 3 (Spring 2012): 74–96; and "'You Don't So Much Watch It as Download It': Conceptualizations of Digital Spectatorship," *Film History* 24, no. 2 (2012): 221–34. I am grateful to the University of Texas Press and Indiana University Press for permission to republish this material.

It has been a pleasure to work with Jennifer Crewe at Columbia University Press. I would also like to thank Kathryn Schell and Anastasia Graf for their patience throughout this process, Roy Thomas for steering it to completion, and Joe Abbott for his expert and detailed work on the manuscript.

Most of all, I would like to thank my family for their love and support. My parents, Susan and Rodney Rogers, have always encouraged me in my work and persisted in reminding me to enjoy life along the way. My brother, Michael, provided valuable input into this manuscript and has constantly inspired me with his brilliance and integrity. My husband, Anthony, and son, Senya, have made sure that each day I have worked on this book has included moments of sheer joy. Anthony has supported this project in most every way imaginable, including offering careful suggestions on several drafts and tireless encouragement.

CINEMATIC APPEALS

INTRODUCTION
MOVING MACHINES

If CinemaScope does nothing else it will force us back into the moving
picture business—I mean moving pictures that *move*.
—Darryl Zanuck (March 1953)[1]

Darryl Zanuck's professed interest in harnessing the new widescreen
format to make "moving pictures that *move*" may seem ironic since early
CinemaScope films were notoriously static.[2] But widescreen, together
with stereoscopic 3D, did move viewers in 1953—not only away from
their television sets and into the movie theater but also to what were
widely heralded as new forms of cinematic experience. Almost fifty
years later another technological development, the increasing incor-
poration of digital tools in production, postproduction, distribution,
and exhibition, again reputedly transformed viewers' mode of engage-
ment with movies, an apparent evolution that has persisted well into
the twenty-first century with, among other changes, the proliferation
of smaller and smaller screens outside the theater and of digital 3D
screens within it. Examining how the experience of cinema has been
formulated in conjunction with these technological transformations,
this book posits such instances of upheaval as particularly useful
matrices through which to consider the relationship between movie
spectator and cinematic spectacle. Not only has the introduction of
these technologies provoked filmmakers to reevaluate their resources

for appealing to viewers, but it has also compelled commentators both within and outside the industry to articulate what they believe cinema can and should do for, with, and to viewers, voicing ideas about cinema's pleasures and dangers that resonate in important ways with historically specific interests and concerns. Considering these instances of technological change with relation to ideas about cinematic experience thus not only provides insight into pivotal periods in cinema history but also illuminates specific ways in which conceptualizations of cinema's affective address—its means for moving viewers—have transformed with its contexts.

This book locates cinematic experience in the interplay among the movie on the screen, the viewer confronting it, and the social and material configurations that inflect how this encounter is understood and felt. Thus conceived, cinematic experience is, obviously, not a straightforward object of study. Arising at a unique time and place—the nonrepeatable coming together of a specific movie, viewer, and context—it does not adhere to historical documents or movies as artifacts. Neither viewers' reflections on cinematic experience nor movies' textual modes of representation or address exhaust the complexity of that experience. Taken together, however, movies and the discourses surrounding their creation and reception can give us a sense of the issues informing how cinematic experience is framed within a given context, allowing us to glean the specific attitudes and assumptions that inflect cinema's affective functioning in that context. This book takes up such a project by examining how the concepts used to describe and evaluate cinematic experience, such as realism and embodiment, were mobilized in conjunction with the coming of widescreen and stereoscopic 3D in the 1950s, the emergence of digital cinema in the 1990s and early 2000s, and the diffusion of digital 3D since 2005. Although it is not possible to fully account for the conditions of experience at these junctures, paying attention to shifts in the ways such concepts have been deployed to account for the novel forms of spectatorship purportedly offered by these technologies, I argue, deepens our understanding of how movies have moved—and continue to move—their viewers.

This book is thus less a history of spectatorial experience itself than a history of the discursive and affective frameworks within which that experience was formulated at these moments of technological change. Such frameworks are not taken to *define* cinematic experience at these

junctures so much as to give it shape, to inform the parameters within which it has emerged. Although every viewer's encounter with cinema is unique to the individual, cultural, and physical context in which it occurs—and thus cannot be fully anticipated by examining these frameworks—such an exploration sheds light on the shared beliefs and habits informing the contours of this encounter, if in diverse ways, at particular times and places. In focusing on the discursive and affective frameworks subtending the emergence of widescreen, 3D, and digital formats, I claim neither that cinematic experience can be reduced to these frameworks nor that it is only the frameworks that have changed, while some fundamental core of cinematic experience has somehow remained stable. Rather, I propose that examining transformations in these frameworks offers a useful and concrete way of parsing subtle (and not so subtle) transformations in a form of cinematic experience that, although not entirely delimited by these frameworks, can be approached through them.

Specifically, I suggest that we can assess how cinematic experience has been framed by examining cinema's appeals—the ways in which public discourses (including discourses of publicity and criticism) and modes of presentation (including film style and forms of exhibition) conspire to formulate cinema's draw for viewers. I approach this notion of appeal by asking questions such as What terms does publicity employ in the attempt to attract viewers? What do executives and technicians claim successful films offer their audiences? How do critics describe how cinema can and should move people? And how do the films and their platforms function together to address viewers? While certain claims make perennial appearances—such as claims about the capacity of new technologies to enhance cinematic realism—such questions encourage exploring how the terms according to which these claims are made change along with ideas about how people can and should interact with the world and with each other. For instance, while the claims to realism made regarding widescreen tend to highlight perceptual verisimilitude and bodily effects, those mobilized with relation to digital cinema often envisage a form of intersubjectivity based not on bodily contact but on what is portrayed as an ephemeral flow of information or affect.

This approach presents such ideas not as ontological statements about the technologies themselves—such as the ubiquitous claim that

digital technology devalues or obscures materiality and, specifically, the human body—but as culturally rooted tensions through which we can detect diverse hopes and concerns about cinema's role in life. Although I focus specifically on ideas about the experience of cinema, these ideas are, ultimately, bound up with contemporary perspectives on what it means to be human within these contexts.[3] In mapping shifts in conceptualizations of cinema's appeals, this project thus offers a glimpse into the ways in which the terms used to describe human-ness at these moments have taken on different inflections as well. In particular, these discourses display shifting ideas about (and attitudes toward) the body and the experience of embodiment. Far from simply affirming cinema's bodily address in one context and marginalizing it in another, they show how cinema's changing forms of production, presentation, representation, and address reflect and provoke reevalu-ations of bodies' boundaries, constitution, and functions.[4]

Addressing how cinema appeals to viewers within specific contexts, especially during periods of upheaval such as those accompanying major technological changes, also requires considering the films and modes of presentation that conspire to materially structure view-ers' encounters with cinema. Thus, in addition to examining how discourses of publicity and criticism portray the ways in which tech-nological changes in production, distribution, and exhibition impact spectatorship, I also explore how the films themselves manifest and anticipate these changes. Acknowledging the importance of film style to cinema's address does not necessitate viewing it as the only (or even the chief) contributor to that address. However, not only is film style a fruitful site for examining filmmakers' conceptualizations of what cin-ema can and should do within a given context, but it is also an integral component of the architecture within which take shape viewers' indi-vidual and collective experiences of, with, and diverging from cinema.[5]

Like much contemporary scholarship on cinema, this project, at its base, represents a response to the psychoanalytic-semiotic theory that dominated film studies in the 1970s and 1980s.[6] In particular, by view-ing spectatorship through the lens of technology, it both invokes and differentiates itself from the "apparatus theory" elaborated by theo-rists such as Jean-Louis Baudry and Jean-Louis Comolli.[7] Guided by Althusserian-Lacanian thought, that tradition conceived spectator-ship in terms of the subject positions constituted by the cinematic

apparatus and film text. Since the 1980s, this view of spectatorship has been criticized—on both theoretical and historical grounds—for eliding important differences among viewers, viewing contexts, and films.[8] Furthermore, the unified idea of the cinematic apparatus that apparatus theory took for granted (which entailed projection onto a screen for immobile viewers in a darkened theater) was, by the late 1970s, already being challenged by new configurations of distribution and exhibition facilitated by cable, satellite, and video.[9] This destabilization of the apparatus (or, perhaps more accurately, of confidence about its coherence) has only intensified with the widespread adoption of digital technologies in production, postproduction, distribution, and exhibition, provoking many scholars to suggest concomitant changes in the definition, boundaries, experience, and politics of cinema— and others (often in response to assertions of a radical break) to elucidate a long-standing heterogeneity in cinematic practice, fluidity in cinema's relationships with other media, and diversity in its material forms that have been insufficiently acknowledged in apparatus theory and beyond.[10] My work on ideas about the experience of widescreen, 3D, and digital technologies is deeply indebted to these responses to apparatus theory, offering another indication that neither cinema nor its address is always or everywhere the same. At the same time, this project is fueled by certain ideas from apparatus theory.

One important legacy from apparatus theory is its insistence that an understanding of movie technology entail a conceptualization of that technology's spectatorial address. Baudry puts particular emphasis on this connection, framing it as a central polemic in his 1975 essay on "the apparatus." Invoking previous work on cinema as "a simulation apparatus"—work that, he contends, looked only at the moving image itself without considering the spectator—he argues that, "in order to explain the cinema effect, it is necessary to consider it from the viewpoint of the apparatus that it constitutes, [an] apparatus which in its totality includes the subject."[11] This translation uses the English word *apparatus* for the French *dispositif*, eliding Baudry's distinction between the *dispositif*—which refers specifically to the viewing context and suggests the more abstract sense of apparatus as device, arrangement, or tendency—and the *appareil de base* (the basic apparatus), which entails production and conveys the more literal sense of apparatus as machine.[12] Through this concept of

dispositif, Baudry thus emphasizes that cinema's material organization (the apparatus constituted by elements such as the filmstrip, camera, lenses, projector, screen, and theater design) produces a "subject effect" marked by a certain psychic, political, and physical arrangement. (In Baudry's formulation the physical dimension, like the apparatus itself, is characterized by occlusion; however, the positioning of viewers' bodies—immobile, in front of the projector—is nevertheless important to the *dispositif* he describes.)[13]

Although Baudry's description of this *dispositif* in terms of the "impression of reality" that cinema purportedly supplies (which he traces to Plato's allegory of the cave and analogizes, in psychoanalytic terms, to a dream state) is, ultimately, both reductive (historically) and overly restrictive (in terms of spectators' agency), the idea that movie technologies and their modes of deployment encourage certain kinds of viewing arrangements or tendencies need not be, especially if we emphasize the diachronic and synchronic plurality of cinema's *dispositifs*.[14] As Frank Kessler has argued, "At different moments in history, a medium can produce a specific and (temporarily) dominating configuration of technology, text, and spectatorship. An analysis of these configurations could thus serve as a heuristic tool for the study of how the function and functioning of media undergo historical changes."[15] In focusing on the concept of cinematic experience, and guided by scholarship that has responded to apparatus theory by emphasizing the embodied uniqueness of that experience, I want to acknowledge the individual dimensions of spectatorship elided by the idea of such dominating configurations. Accommodating that acknowledgment, however, this book attempts something quite like the project Kessler describes as a historically attuned exploration of media's (in this case, cinema's) *dispositifs*, conceiving spectatorship at the juncture of technology, text, and context. Insofar as I approach these *dispositifs* through analysis of discursive and material formations understood as a set of conditions or field subtending spectatorship, my analysis also draws significantly on the notion of archaeology elucidated by Michel Foucault.[16]

Perhaps somewhat polemically, then, the concept of cinematic experience this book elaborates invokes apparatus theory by emphasizing the importance of dominant political and affective regimes to the experience of cinema even as it departs from apparatus theory's psychoanalytic assumptions, emphasizing the historical diversity of

these regimes and asserting that they do not so much define cinematic experience as frame it. My decision to rely heavily on historical materials produced within the realm of dominant culture, in particular, may appear to disregard some of the lessons taught by recent scholarship on spectatorship. Certainly, many of the documents I examine—from technical manuals to fan magazines—are rooted in promotional rhetoric and, as such, attest less to how actual audiences experienced the movie technologies than to how the culture industry presented those experiences. But while the dominant discourses I describe do not exhaust the possibilities for cinematic experience, I do believe they remain crucial to our understanding of that experience insofar as they enable us to grapple with the powerful epistemological and affective frameworks in conversation with which (indeed, often in terms of which) individual—and even oppositional—encounters with cinema have been diversely conceived.[17]

In addition to emphasizing the spectatorial arrangement encouraged by film technology, apparatus theory also made a significant intervention in film historiography, offering a poststructuralist indictment of the teleological, "idealist" approaches that had purportedly portrayed film history as a causally related, linear, and autonomous sequence of developments.[18] Calling instead for a "materialist history" of cinema—and citing Julia Kristeva's call for a *stratified history*; that is, a history characterized by discontinuous temporality, which is recursive, dialectical, and not reducible to a single meaning, but rather is made up of types of *signifying practices* whose plural series has neither origin nor end"—Comolli has argued that the history of techniques such as deep focus and close framing "cannot be constructed without bringing into play a system of determinations which *are not exclusively technical*."[19] Notwithstanding Comolli's own reduction of the nontechnical "system of determinations" influencing cinema to a purported persistent demand for illusionism, much can still be gained from exploring what he identifies as the "complex relationships which link the field and history of the cinema to other fields and other histories."[20] Indeed, insofar as a focus on film experience addresses the social forces shaping spectatorial engagement with films and film technology (without suggesting, with apparatus theory, that these can be neatly summed up by Marxist or psychoanalytic theory), it demands such a view. Therefore, my project follows

the lead of historians of film technology such as John Belton and James Lastra, who, while rightly wary of Comolli's particular methodology and conclusions (and while not, especially in Belton's case, affording the concept of experience the central role I do), have nevertheless approached film technology through such "complex relationships."[21] Through a shared emphasis on cinema's cultural resonances and a concomitant openness to discontinuity (which extends, pace apparatus theory, to the apparatus itself), this project also reverberates with several other contemporary film and media historical programs, including Rick Altman's concept of "crisis historiography," André Gaudreault's notion of the "cultural series," and the set of approaches associated with "media archaeology."[22]

One important corollary to this view of technology's relationship with extracinematic discourses is a suspicion of technological determinism, of which Comolli himself has, despite his attempt to counter "technicist" film history, been accused.[23] Such determinism is perhaps most notoriously evident in Marshall McLuhan's 1964 *Understanding Media*, famous for its pithy formulation, "the medium is the message," as well as in the branch of media archaeology associated with Friedrich Kittler's adaptation of McLuhan.[24] Raymond Williams, for instance, has argued that McLuhan's theory of communications "is significant mainly as an example of an ideological representation of technology as a cause" and advised, "What has to be seen, by contrast, is the radically different position in which technology . . . is at once an intention and an effect of a particular social order."[25] My project also seeks to avoid technological determinism—not by denying technology any agency at all, however, but by conceiving it in a fluid and reciprocal relationship with the cultures that produce and use it.

In the past few decades scholars have employed the concept of cinematic experience as a means for suggesting those dimensions of spectatorship that elude the subject-position approach proffered by psychoanalytic-semiotic film theory. Influentially, this concept has been mobilized in theoretically oriented scholarship countering ideas about a disembodied, technologically and textually circumscribed subject with the argument that the experience of cinema is, fundamentally, a bodily experience—one that is unique and irreducible to the operations of the apparatus or film text. Baudry had associated cinema's ideological constitution of its subject with the illusion of

freedom from the body, and he explicitly attributed the subversion of that effect—as when a film's apparent coherence is ruptured through revelation of the discontinuity subtending it—to the spectator's recognition not only of the technical apparatus but also of "the body," both of which, Baudry claimed, the spectator "had *forgotten*."[26] Subsequent accounts of the spectatorial body drawing on Foucault, notably Linda Williams's *Hard Core: Power, Pleasure, and the "Frenzy of the Visible"* (1989)—and, within art history, Jonathan Crary's *Techniques of the Observer: On Vision and Modernity in the Nineteenth Century* (1990)—not only reasserted the centrality of the body to spectatorship but also reversed Baudry's assessment of the body's subversive function, showing how, in Williams's words, "pleasures of the body . . . are produced within configurations of power that put pleasures to particular use."[27] In a way, more recent work on spectatorial embodiment that purports to offer a radical challenge to apparatus theory by returning to theorizations of the body by Maurice Merleau-Ponty or Henri Bergson, often by way of Gilles Deleuze, also constitutes something of a return to Baudry's position insofar as it again associates the body with discontinuity and subversion—albeit with a significant shift in focus away from ideological critique and toward an exploration of the progressive potential associated with an emphasis on, and address to, the body. The challenge to apparatus theory posed by that work is also somewhat mitigated by its tendency to describe cinema's potentially subversive appeal to embodiment with reference not to the classical Hollywood cinema often targeted by apparatus theory but to its "others," including the avant-garde, international art cinema, and "low" genres, including horror.[28]

This more recent work on spectatorial embodiment, however, replaces the abstract concept of "the body" emphasized in the Foucauldian model with a focus on embodiment as an emergent, lived experience.[29] Pioneering this tradition, for instance, Vivian Sobchack draws on Merleau-Ponty to argue that film experience is rooted in the human body's status as simultaneously "visual and visible . . . both sense-making and sensible."[30] Contending that the film, too, has a body— one that, like the viewer's, is both perceptive and expressive—she proposes that we understand our encounter with movies as the meeting of two bodies, both simultaneously subject and object. Guided by Gilles Deleuze and Félix Guattari, Steven Shaviro contends that the

body's sensuality and materiality mark the place where meanings break down.[31] By encouraging the viewer to enter into a tactile, mimetic relationship with the screen image, Shaviro claims, cinema invites a form of alterity experienced as abjection.[32] Drawing on both theoretical traditions (and more clearly underscoring the resonances between Deleuzian ideas about emergence and Sobchack's phenomenology), Laura U. Marks emphasizes the political possibilities of the experience of otherness offered by cinema's bodily address, both contending that cinema's appeal to the senses can invite an eroticism based in mutuality rather than mastery and arguing that the evocation of senses such as touch, smell, and taste by intercultural artists represents "the very foundation of acts of cultural reclamation and redefinition."[33]

The concept of cinematic experience that I elaborate in the chapters to follow benefits greatly from this work on embodied spectatorship, especially its attunement to the ways in which spectatorial experience is bound up with technologies and its tendency to portray embodiment as a lived process. However, while my focus on cinema's appeals during specific periods of technological change is not incommensurate with these accounts of spectatorial embodiment (and while I have found that they resonate in useful ways with the discourses I have examined, as is made explicit in the chapters to follow), I think that an approach that pays close attention to the historical forces structuring cinematic experience encourages grappling with the heterogeneity and variability of that experience in a way that these theoretically rooted accounts of embodiment do not. Such an approach foregrounds the imbrication of abstract concepts of the body and the lived experience of embodiment, emphasizing both the sociohistorical frameworks circumscribing cinematic experience and the capacity of embodied viewers to negotiate and challenge these frameworks in unique ways.[34] Perhaps most urgently, it calls attention to the fact that conceptualizations of the body—and, with them, the contours of embodiment as well—are historically contingent and subject to change.

Another approach to film experience formulated in response to apparatus theory's concept of spectatorship as subject positioning emerged from historical work on "early cinema" and its relation to industrial capitalist modernity.[35] Influentially, in elucidating the concept of the "cinema of attractions" that he introduced with André Gaudreault, Tom Gunning distinguishes early cinema's address from

that of post-1906 narrative cinema: he argues that, until 1906–7, cinema tended to call attention to the act of display, confronting viewers directly and appealing to their curiosity rather than inviting the type of absorption that psychoanalytic-semiotic theorists, looking to classical Hollywood, had claimed was inherent to spectatorship.[36] Gunning and others—including, prominently, Miriam Hansen—have drawn on ideas about the experience of industrial modernity elaborated by cultural critics including Siegfried Kracauer and Walter Benjamin (who, in turn, drew on commentators including Charles Baudelaire and Georg Simmel) in order to underscore the historical specificity of this "exhibitionist" address, arguing that early cinema, far from immersing viewers in illusion, invited them to rehearse the forms of shock and fragmentation that had pervaded daily life by the first decades of the twentieth century.[37] This book was inspired, in part, by the apparent appositeness of such a historically and technologically rooted concept of film experience to the recent proliferation of digital movie technologies. Not only has the spread of digital media brought with it a concomitant shift in day-to-day experience, as has been widely observed, but cinema's high-profile deployment of digital tools has once again seemed to bind it to such changes, raising questions about whether and how its address has transformed with the new modes of production, distribution, and exhibition.

Especially salient for my project is the idea, modeled in the work of Kracauer and Benjamin, that cinematic experience is not limited to what the film spectacle itself conveys but entails individual and cultural dimensions including memory and imagination. Kracauer and Benjamin understood experience to be both embodied and historically contingent, encompassing unconscious and habitual, as well as conscious, forms of knowledge and perception.[38] In Hansen's words, they conceived experience "as that which mediates individual perception with social meaning, conscious with unconscious processes, loss of self with self-reflexivity; experience as the capacity to see connections and relations (Zusammenhang); experience as the matrix of conflicting temporalities, of memory and hope, including the historical loss of these dimensions."[39]

This concept of experience also informs Oskar Negt and Alexander Kluge's later conceptualization of the public sphere as a "general social horizon of experience in which everything that is actually or

ostensibly relevant for all members of society is integrated."[40] Hansen has identified this view of the public sphere, in particular, as a useful guide for thinking about spectatorship since it acknowledges the uniqueness of individual experience while not "missing out on the more systematic parameters of subjectivity that structure, enable, and refract our personal engagement with the film."[41] Such a view of spectatorship accounts for the diversity of film experience often asserted in response to apparatus theory's totalizing view of spectatorship while remaining mindful of apparatus theory's lessons about the ways in which this experience remains imbricated with—if not entirely dictated by—social, economic, and political regimes.[42]

Influential for this project is the fact that this concept of experience is bound not only to particular historical contexts but also, more specifically (and particularly as elaborated by Benjamin), to the technologies that have arisen within them. Far from neutral means to ends, such technologies are understood to contribute to—and make manifest—the physical and epistemological texture of experience in these contexts.[43] Benjamin argued in the 1930s that the then relatively new medium of film not only grew out of the context of industrial modernity but also offered viewers a particularly relevant means for engaging with the forms of shock and distraction that had come to mark urban-industrial life.[44] In "The Work of Art in the Age of Its Technological Reproducibility," for instance, he claimed that film's function is to "train human beings in the apperceptions and reactions needed to deal with a vast apparatus whose role in their lives is expanding almost daily."[45] Furthermore, he contended that this perceptual and kinesthetic accommodation to the changing apparatus of modernity simultaneously reflected the dangers of the contemporary moment and, by the same token, offered the only means for overcoming them. Thus, while his "Work of Art" essay is famous for its warning that this technological organization of experience could be put in the service of fascism, this threat, for Benjamin, was integrally linked to the progressive possibilities offered by the creative and collective innervation of technology.[46] While Benjamin's ideas about cinema in the 1930s are not simply transplantable onto more recent periods in cinema history, the dialectical nature of his thinking about the political implications of technologically mediated experience remains a useful guide, especially in a contemporary context dominated by competing and

often hyperbolic proclamations about the new technologies' dangers and possibilities.[47]

Additionally, whether or not we grant objections to the idea that culturally rooted "modes of perception" bear a causal relationship with film style, Benjamin's emphasis on cinema's historically rooted organization of sensory experience remains instructive for understanding spectatorship.[48] He conceives this organization through an expanded concept of aesthetics as *aisthesis*, considering not only the stylistic properties of films but also cinema's sensual address and activation of experience.[49] Such a consideration, as Hansen suggests, remains particularly relevant in a contemporary context marked by the continuing reconfiguration of our mediated environment and, with it, what Benjamin calls "the *physis* that is being organized for [the collective body] in technology" with the interpenetration of "body space" and "image space."[50] Without falling prey to the technological determinism of which Benjamin, too, has been accused; without suggesting that ideas about the experience of modernity provide the only, or even the most important, explanation of film style; and without simply imposing culturally rooted ideas about shock or distraction upon different historical contexts, contemporary scholarship can continue to profit from paying close attention to the ways in which historically rooted material and social configurations encourage specific modes of cinematic experience that are bound up with technologies' political uses and proclivities—without assuming (as does apparatus theory) that this imbrication forecloses alternative approaches or appropriations.[51]

Although Gunning, Hansen, and others have suggested that contemporary cinema resonates with the "cinema of attractions" model— and although I acknowledge certain echoes as well—my project does not aim to trace the legacy of early cinema and its context to more recent periods.[52] Rather, it gains from scholarship on early cinema (and, through it, Kracauer's and Benjamin's ideas about cinema and experience) an approach to the history of cinema through a concept of spectatorial experience that attempts to account for the complex, historically rooted, and fluid relationships among texts, technologies, viewers, and contexts. It thereby falls in line with other contemporary media historical work that has taken that scholarship as a model (with caution against the form of teleology that, as Thomas Elsaesser claims, can be inadvertently reinscribed in *"longue durée*

accounts around 'multi-medial,' 'immersive,' 'panoramic,' or 'haptic' media experiences"), undertaking what he describes as a form of media archaeology that aims to reassess the parameters that "regulate how a spectator is addressed as both (imaginary) subject and physical, embodied presence in a determinate space."[53] I approach such a project by looking closely at how public discourses have reframed the constellation of social, political, economic, and material forces structuring cinematic experience during specific periods of technological upheaval—how conceptualizations of cinema's appeals convey shifts in cinema's *dispositifs* at these junctures. In doing so, I seek to elucidate specific ways in which the concepts central to scholarly as well as nonacademic formulations of that experience (not only the concepts of realism and embodiment but also related ideas such as spectacle and immersion), far from simply taking on greater or lesser relevance at different points in cinema history, themselves adopt historically contingent and variable meanings and functions.

Such an approach is particularly useful for addressing cinema's continuing confrontation with so-called new media.[54] Within cinema studies, scholarly debates on this matter have revolved around whether the changes accompanying (but not entirely delimited by) the increasing dominance of digital technologies have resulted in a radical break separating what was traditionally known as cinema from what often still goes by that name—and how these changes might compel us to reevaluate film history.[55] The concept of convergence plays an important role in these debates, especially since it can be seen to threaten the continued relevance of cinema as an institution and, with it, cinema studies as a discipline. I do think that the experience of cinema has been transformed with the introduction of digital technologies and that the contemporary fluidity among media plays a significant role in this change; however, an unequivocal embrace of the concept of convergence risks downplaying the deep and complex relationships cinema has long borne with other media, as well as the significant role the institution of cinema continues to play in the contemporary media landscape.[56] It also risks obscuring the material specificity of each encounter with media—a specificity that demands as much consideration now as ever, with the current situation marked equally by the proliferation of devices (with, for example, cinema, television, video games, and the Internet all capable of being experienced

through various kinds of screens) as by movement among them.[57] Insofar as it emphasizes the juncture of cinema's material and social formations, a dynamic concept of cinematic experience encourages considering the ways in which the *dispositifs* fostered by cinema can change with its contexts while simultaneously calling attention to the physical and conceptual arrangements that continue to frame certain configurations as cinematic.

Many of the issues I've mapped out here surrounding the concept of cinematic experience and its relationship to technology are worked out further in the chapters of this book. I devote two chapters each to the coming of widescreen cinema in the early to mid-1950s and the emergence of digital cinema in the late 1990s and early 2000s. Chapters 1 and 3 examine marketing materials, industry records, technical manuals, trade journals, and popular periodicals to explore how filmmakers and critics formulated the new technology's appeals. Chapters 2 and 4 look closely at particular films in order to elucidate the ways in which the use of the new technologies in production and exhibition conspired with textual modes of representation and address to convey and nuance those appeals. My concluding chapter considers how the forms of experience associated with the stereoscopic 3D systems introduced in the 1950s and 2000s were conceptualized and elicited at these different historical junctures—and in dialogue with the widescreen and digital formats discussed in the previous chapters. Although all of these technologies have moved across national borders in important ways, I have chosen, in the interest of specificity and space, to focus my research predominantly on discourses surrounding filmmaking and viewing in the United States (although I also consider the international art cinema, particularly the Danish Dogma 95 movement, which had a significant impact on conceptualizations of digital cinema in the United States).[58]

Chapter 1, "'Smothered in Baked Alaska': The Anxious Appeal of Widescreen Cinema," argues that widescreen cinema appealed to viewers by inviting them into close, mimetic contact with the film spectacle, including the spectacle of technologically transformed bodies. I probe the notion of "audience participation" at the heart of contemporary conceptions of widescreen experience, tying the allure of this experience to the feeling of sensual immersion it offered. Tracing a tendency within widescreen discourse to describe the format's novel

appeal through reference to Marilyn Monroe, I argue that the plea-
sures promised by widescreen were linked simultaneously to its capac-
ity to immerse viewers and to its emphasis on display. The resultant
oscillation between investment in and knowledge about the onscreen
illusion rendered widescreen spectatorship both thrilling and fright-
ening, providing viewers firsthand experience of the kind of power-
ful new technology that was transforming life outside the theater for
both better and worse.

Shifting focus to aesthetic concerns, chapter 2, "*East of Eden* in
CinemaScope: Intimacy Writ Large," examines the ways in which Elia
Kazan's version of *East of Eden* (1955) both draws on and transgresses
the widescreen norms established by early Cinerama and Cinema-
Scope films such as *This Is Cinerama* (Merian C. Cooper, 1952) and *The
Robe* (Henry Koster, 1953). I argue that Kazan's most striking depar-
tures from these norms—including his use of canted angles and close
framing—offered viewers a destabilizing experience of the body, both
rendering screen bodies at an unprecedented scale and calling atten-
tion to viewers' own physical situation in the theater. Furthermore, I
tie this presentation of the body to James Dean's performance (which
was associated, rightly or wrongly, with the Method technique), sug-
gesting that Dean's appearance on the gigantic screen, like Monroe's,
invited viewers to experience the ways in which new technologies ren-
dered the human body simultaneously massive and vulnerable.

In chapter 3, "Digital Cinema's Heterogeneous Appeal: Debates on
Embodiment, Intersubjectivity, and Immediacy," I begin my consid-
eration of digital cinema by examining the industrial and critical dis-
courses surrounding cinema's increasing dominance by digital tech-
nologies in the late 1990s and early 2000s. I consider discourses on
Hollywood cinema (particularly its use of digital visual effects) together
with discussions of independent cinema (especially its deployment of
digital cinematography), both underscoring a significant heteroge-
neity in ideas about the digital and, at the same time, highlighting
concerns that cut across industries and institutions. While it follows
the lead of media theorists in identifying certain key tropes mark-
ing the spectatorial transformation digital cinema was reputed to
provoke (including the ideas about disembodiment and intersubjec-
tivity associated with what has been called the "Information Age"),
this chapter's focus on the historical discourses on digital cinema

allows us to view these tropes not as static pronouncements (about, for instance, the waning of reality or the decline of bodily experience) to be either upheld or overturned but rather as concerns—including concerns about the relationship between self and world and about the status of the body—that the proliferation of digital technologies compelled users and critics to work through in disparate ways.

Chapter 4, "Awe and Aggression: The Experience of Erasure in *The Phantom Menace* and *The Celebration*," examines the address of these two very different instances of digital cinema. The pervasive and intricate use of CGI for which *Star Wars: Episode I—The Phantom Menace* (George Lucas, 1999) was hailed as a digital cinema watershed, I argue, not only invited the sense of awe that scholars of digital visual effects have described in terms of the technological sublime but also addressed contemporary concerns with the boundaries of human life, inviting viewers to marvel at its devaluation. While *The Phantom Menace*'s use of CGI allows for the proliferation of detail, *The Celebration*'s (*Festen*, Thomas Vinterberg, 1998) use of consumer-grade digital video cameras produces a low-resolution aesthetic, especially in long shots and low-light situations. Director Thomas Vinterberg harnesses the video image's tendency to break down under such conditions in order to evoke an unsettling feeling in his audience. Not only do these images do violence to the figures portrayed onscreen, blurring their bodily boundaries and, toward the end of the film, threatening to disintegrate them altogether, but they also inflict violence upon the viewer, forcing him or her to struggle to discern the images themselves. Considering *The Phantom Menace* and *The Celebration* together underscores a pervasive (although diversely conceived) concern with addressing how the experience of spatiality and embodiment has been reconfigured in conjunction with new technologies in cinema and beyond.

Finally, chapter 5, "Points of Convergence: Conceptualizing the Appeal of 3D Cinema Then and Now," examines the ways in which the appeal of stereoscopic 3D was formulated in conjunction with its periods of popularity in the 1950s and since 2005. In deploying this comparative framework, I offer an indication of how the approach to cinema's appeals modeled throughout the book can address the contemporary cinematic landscape, which has, since the rise of digital cinema around the turn of the millennium, been marked by a proliferation of screens of various kinds. The recent reemergence of 3D offers a

particularly useful lens through which to reconsider the claims made in the previous chapters, since it appears in many ways to simply repackage digitally a format that was often conflated with widescreen in the 1950s. In particular, since both widescreen and stereoscopic 3D were, at that time, widely conceived as formats that aggressively addressed viewers' bodies, the recent popularity of digital 3D might be seen as either a contradiction or simply an antidote to the concerns about disembodiment that have been voiced in conjunction with the concept of digital cinema. However, looking closely at the discourses surrounding the introduction of 3D during these two periods, as well as at prominent film examples from each—Jack Arnold's *Creature from the Black Lagoon* (1954) and James Cameron's *Avatar* (2009)—I argue that the bodily address of 3D was formulated quite differently at these junctures. In many ways the appeal of digital 3D is aligned more closely with the address I attribute to digital cinema in chapters 3 and 4 than with the appeal of 1950s stereoscopic 3D, which draws on the concept of audience participation I discuss in relationship to widescreen in chapters 1 and 2.

Writing in the 1920s, Benjamin asserted that "people whom nothing moves or touches any longer are taught to cry again by films."[59] I argue that cinema's affective force has continued to be bound up with the contemporaneity of its address—its capacity to engage historically rooted and shifting concerns and habits. Specifically, the discourses surrounding the introduction of these technologies show how the frameworks within which cinema's address is formulated have changed along with its contexts. In examining the terms through which the experience of cinema is conceptualized in conjunction with new technologies at these pivotal junctures in cinema history, this book seeks to provide insight into cinema's protean power to continue to move us.

"SMOTHERED IN BAKED ALASKA"

The Anxious Appeal
of Widescreen Cinema

The big question, "How does Marilyn Monroe look stretched across a broad screen?" is easily answered. If you insist on sitting in the front row, you would probably feel as though you were being smothered in baked Alaska.
—Otis L. Guernsey Jr.[1]

In the face of a severe decline in film attendance, widescreen cinema lured viewers in 1950s America by promising a thrilling new experience that set it apart from both traditional moviegoing and the phenomenon of television. Beginning with the debut of Cinerama in 1952 and continuing with the introduction of CinemaScope and numerous similar systems in subsequent years, industry executives and critics described the novel experience widescreen offered with reference to the idea of "audience participation."[2] While this notion of audience participation appears frequently in the advertisements and film reviews surrounding the introduction of widescreen processes and is widely acknowledged in scholarship on the format, the concept of participation itself has not been thoroughly interrogated. How did public discourse present the notion of participation as a new form of cinematic experience? And what was its appeal—what pleasures did it offer moviegoers—at this particular historical juncture?

This chapter addresses these questions by examining how the Hollywood film industry and critical establishment conceptualized and promoted the experience of widescreen at the time of its popularization.

Specifically, it shows how discourses of publicity, criticism, and film-making conveyed the appeal of—and concern about—the bigger, broader screens via the prospect of close, tactile contact with over-whelming images, including massively inflated images of stars such as Marilyn Monroe. Widescreen, these discourses suggest, offered moviegoers an experience that was both empowering and overpow-ering, at once rendering the body on a gigantic scale and threaten-ing to smother it. Scholarship on the format has shown widescreen's affinity for seemingly contradictory concepts, particularly its appar-ent capacity to enhance the realism and the spectacular nature of the cinematic image, as well as the activity and passivity of the spectator.[3] An exploration of widescreen's appeals does not resolve these tensions but rather shows how they converge around historically inflected ideas about the human body, both in the theater and on the screen.

The move to widescreen can be viewed as the Hollywood studio sys-tem's swan song—a drive to maintain its hegemony despite the 1948 antitrust Paramount Decision, which divested production and dis-tribution companies of their theater chains, and in the face of broad social and economic changes in postwar America, including the rise of television.[4] This period also ushered in significant industrial and institutional changes, including Hollywood's diversification into tele-vision and a limitation on the diversity of cinematic output in favor of expensive, large-scale spectacles (which frame widescreen, as John Belton, Sheldon Hall, and Steve Neale contend, as "a model for the Spielberg and Lucas films of the 1970s and later").[5] As *Time* magazine put it, Hollywood responded to television's usurpation of "the bread & butter public" by encouraging "a taste for steak and caviar—i.e., fewer and bigger pictures."[6]

Insofar as widescreen asserted Hollywood's power by making the cinematic spectacle bigger, more awe-inspiring, and more homoge-neous, even as the studios negotiated their own involvement with television, the format offers a particularly overt instantiation of the mass culture that was of widespread interest at the time. Such interest burgeoned within the academy in the wake of Clement Greenberg's polemics against kitsch and Theodor Adorno and Max Horkheimer's indictment of the culture industry, which, despite their differences, share a suspicion of commercial cultural products including movies as homogeneous, formulaic, and deceptive, addressing the masses in

a way that eschews critical thought.[7] Outside academe there was also concern about the duplicity of the mass media, particularly with what one news story called the "veritable fad" in advertising to draw on the social sciences (notably psychology and sociology) to influence consumer choices.[8] That concern existed concurrently with fears about communist techniques for conditioning and propaganda, extending to Hollywood with the House Committee on Un-American Activities (HUAC) hearings, which had resumed in 1951, and the ongoing Hollywood blacklist.[9] Hollywood's offer of massive, overpowering spectacles, in short, emerged in a context deeply interested in—and concerned about—the ways in which the mass media could manipulate the American public.[10]

While I do not argue that such manipulation defines or delimits spectatorship of widescreen cinema, I do want to highlight the ways in which such ideas emerge in contemporaneous evaluations of the format—and especially its effects on the body. This is a particularly important point given that the bodily address attributed to the format can seem to epitomize the type of embodied spectatorship that recent film theory has described as facilitating viewers' ability to elude control. While not contradicting that possibility, the discourses examined here offer insight into the specific inflections marking the concept— and framing the experience—of cinematic embodiment at this particular historical juncture. Portraying widescreen's impact on the body as both a thrill and a threat, these discourses depict the affective charge (either positive or negative) of the new form of spectatorship in terms of the format's purported capacity to provide a bodily encounter with powerful technological, economic, social, and political forces.[11]

This period of technological innovation offers a useful comparison to the more recent transition to digital cinema insofar as it seems, in some ways, to provide a sharp contrast. In particular, widescreen's presentation as a massive, overpowering spectacle with an assertive bodily address may seem to offer a counterpoint to the dispersed and disembodied address that has been attributed to electronic and digital media.[12] As is indicated, however, by recent scholarly explorations of topoi and practices such as immersion and multiple-screen display, which suggest significant resonances between 1950s widescreen cinema and contemporary media, the modes of address offered by cinema during these periods of technological change cannot simply be

opposed to one another.[13] Rather, an archaeology of both instances of upheaval shows how concepts such as immersion and, relatedly, embodiment are not simply activated or deactivated in such contexts but take on specific shades of meaning in conjunction with them. The mapping of cinematic embodiment carried out in this chapter and the next will, ultimately, help to put into relief the ways in which such embodiment has been not simply devalued but reconfigured in conjunction with the ascent of digital cinema.

WIDESCREEN CINEMA

. . . plunges you into a startling new world.
—*This Is Cinerama* souvenir program

The term *widescreen* generally refers to films with aspect ratios significantly greater than the pre-1953 Academy standard of 1.37:1 (usually reaching at least 1.66:1); however, the format encompasses numerous systems, which entail different film gauges, aspect ratios, sound systems, and screens.[14] There had been experiments with wide-film formats in both North America and Europe since the 1890s and a particular consolidation of interest in the 1920s—when, for instance, Abel Gance made *Napoléon* (1927) in his three-camera Polyvision system—with a concerted effort by Hollywood to agree on a wide-film standard in 1930–31 (when Sergei Eisenstein made his famous speech urging Hollywood to adopt a "dynamic square" format).[15] Widescreen, however, was not successfully innovated and diffused until the 1950s. As is well known, the studios faced a major crisis at that time, with movie attendance having declined precipitously, from ninety million per week in 1948 to sixty million per week in 1950.[16] Although television was widely identified as the culprit, John Belton has shown that wider cultural shifts both threatened traditional moviegoing and framed widescreen (as well as stereoscopic 3D, which was popularized concurrently) as a viable solution.[17] Not only did the new systems offer a sensory plenitude (with size, scope, color, apparent depth, and stereophonic sound) that television did not, but they also reframed moviegoing as the kind of active recreation (such as travel and outdoor sports) then in vogue.[18] Widescreen films' portrayal as large-scale events to be experienced presented the act of moviegoing as an

activity to be anticipated and remembered, like a visit to Niagara Falls or the Grand Canyon.[19]

The 1950s widescreen "revolution" was incited by the opening on September 30, 1952, of *This Is Cinerama*—a film that displayed the eponymous Cinerama system developed by Fred Waller, who had created similar systems for the 1939 World's Fair and for a "flexible gunnery trainer" for the U.S. military in World War II.[20] The Cinerama camera captured a quasi-panoramic view by using three lenses to expose three strips of 35mm negative simultaneously. Each frame on the filmstrips covered an area one and a half times larger than was standard, extending six perforations high rather than four. In the exhibition context three projectors projected these images, at a rate of twenty-six frames per second, onto a broad, deeply curved, louvered screen. While the camera aspect ratio was 2.59:1, the aspect ratio of the screen image varied with different installations and could reach approximately 2.77:1.[21] A seven-track stereophonic sound system included five speakers spaced behind the screen, with additional speakers placed on each side and in the rear of the theater to create surround sound (fig. 1.1). Because the cost of theater conversion for Cinerama was so high—requiring the installation of two projection booths, the removal of seats, and the employment of additional personnel—its releases were very limited. Only twenty-two theaters had been equipped for the system by 1959.[22]

Independently produced, *This Is Cinerama* was a critical and box-office success, but the studios sought a means to capitalize on the audience appeal of widescreen without such a limitation on exhibition venues. (The studios pursued widescreen in conjunction with stereoscopic 3D, the fad that was launched with the November 1952 release of Arch Oboler's *Bwana Devil*; while widescreen itself was not, despite marketing claims, actually three dimensional, it had the advantage, as CinemaScope publicity emphasized, of doing away with the much-maligned glasses.)[23] One early means for achieving widescreen images without costly theater conversion was simply to use a wide-angle projection lens to magnify films made in Academy ratio to fit wider screens (with aspect ratios of between 1.66:1 and 1.85:1), cropping the top and bottom of the image—an approach Belton calls "ersatz widescreen."[24] Paramount recommended that *Shane* (George Stevens) be exhibited this way as early as April 1953.[25] This exhibition method, however, was

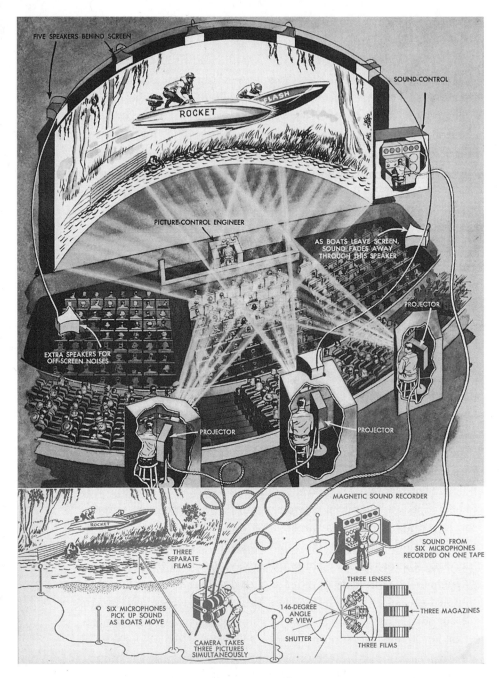

FIGURE 1.1 A diagram included in souvenir programs for *This Is Cinerama* shows how the Cinerama system works in production and exhibition. (Cinerama Corp., 1952)

not ideal, eliciting rancor from viewers miffed at the resultant decapitations and amputations.[26]

It was Twentieth Century–Fox's CinemaScope, introduced with *The Robe* in September 1953 after months of fanfare, that disseminated the wide screen widely. By 1957, four out of five theaters in the United States were equipped for the system.[27] CinemaScope used an anamorphic lens—invented almost thirty years earlier by French scientist Henri Chrétien and adapted by Bausch & Lomb—to compress a wide field of vision onto a single strip of 35mm film.[28] The image was then uncompressed using a compensating projection lens and projected at an aspect ratio of 2.55:1 (fig. 1.2).[29] Like Cinerama, the system included stereophonic sound, although at the urging of struggling theater owners, Fox eventually gave up its insistence that all theaters showing CinemaScope convert to this costly sound system. Similarly, Fox initially insisted that installations of the system use a curved screen (it had developed a special "Miracle Mirror" screen as part of the Cinema-Scope package), although it eventually relented on this requirement as well.[30]

Although CinemaScope dominated the market in the subsequent few years, numerous competing processes were developed during this time. These included, most prominently, VistaVision (Paramount) and Todd-AO (Michael Todd and American Optical Company), both of which, like Cinerama, offered an expanded area of exposure on the camera negative and thus increased image clarity. VistaVision, first used for *White Christmas* (Michael Curtiz), which opened in October 1954, fitted this expanded area on standard 35mm film by exposing the wide image horizontally across two frames of the filmstrip. Presented as a system that would facilitate big-screen exhibition through height as well as width (and thus addressing the difficulties faced by theaters that were too narrow to display CinemaScope adequately), VistaVision accommodated aspect ratios ranging from 1.66:1 to 2:1, with a recommended ratio of 1.85:1.[31] Todd-AO, introduced with the premiere of *Oklahoma!* (Fred Zinnemann) in October 1955, used 65mm camera film and 70mm projection prints, boasted a frame rate of thirty frames per second, and provided an aspect ratio of 2:1 (VistaVision, by contrast, reduced its image for projection, utilizing conventional 35mm release prints).[32] Fox eventually opted for a wider-gauge negative as well, converting to 55mm stock (reduced, like VistaVision, to 35mm for

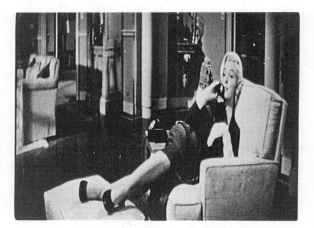

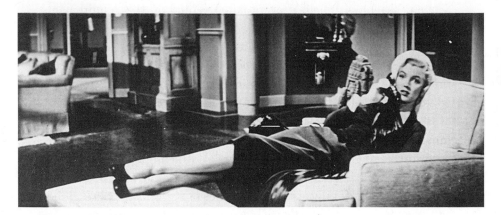

FIGURE 1.2 Using the reclining figure of Marilyn Monroe, CinemaScope publicity stills demonstrate the way in which the anamorphic lens compresses the image onto 35mm film and show how the uncompressed image appears when projected. (Twentieth Century–Fox, 1953 / Photofest)

projection) with CinemaScope 55, first used with *Carousel* (Henry King), which opened in February 1956.[33]

As I discuss in the pages to follow, the different components constituting these systems—including the shape, size, and positioning of the screens and the use of stereophonic sound—were presented as offering viewers a heightened sense of immersion in the cinematic spectacle. Alexander Leydenfrost's widely circulated publicity image depicting an audience experiencing the opening scene of *This Is Cinerama* conveys such immersion by omitting the edges of the imaged movie screen, making it appear as though the pictured audience occupies the space of the diegesis (fig. 1.3). Widescreen shared with stereoscopic 3D this pretense to transgressing the boundary separating image from theater space, although as William Paul elucidates, the sense of immersion offered by widescreen has been distinguished from what he calls the "emergence" effect produced by 3D insofar as the former was reputed to pull the audience into the represented space and the latter to thrust the represented objects out into the theater space.[34] I discuss the dialogue between these concepts and formats in greater detail in chapter 5. Here I explore the ways in which public discourses on widescreen portrayed the appeal of immersion for viewers.

AUDIENCE PARTICIPATION

Gone is the viewer's sense of eavesdropping on activities that are, after all, going on in another room. In CinemaScope, the illusion of the other room outflanks the beholder in his theater seat and overwhelms him with a frontal attack of enormous images and sounds.
—*Time*[35]

Publicity and advertising for Cinerama and CinemaScope almost universally utilized the idea of audience participation to communicate the appeal of the new systems. Publicity photographs for *This Is Cinerama*, for instance, superimposed images of supposed audience members over images from the film, implying that they felt as though they were waterskiing along with Floridian bathing beauties or riding the roller coaster featured in the film (fig. 1.4).[36] Advertising for CinemaScope explicitly stated that the process "[made] the audience participants in the action."[37] As John Belton argues, this idea of audience

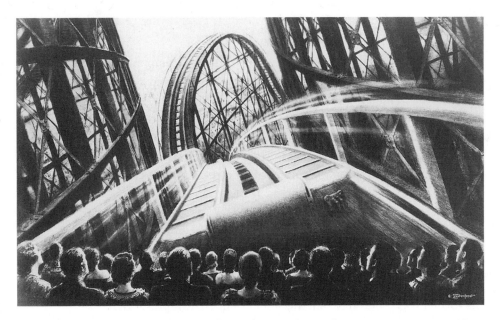

FIGURE 1.3 A publicity image by Alexander Leydenfrost depicts the immersive experience of *This Is Cinerama*. (Cinerama Corp., c. 1952)

participation emerged as part of a broader change in attitudes toward leisure in post–World War II America, when potential audiences were believed, increasingly, to favor "active recreation" over "passive entertainment."[38] And as William Paul elaborates, the notion of audience participation also linked the new systems with contemporary theater, both marking an attempt to legitimate film and evoking movements in avant-garde theater aimed at "bringing audiences away from their inactive state as compliant observers."[39] As I explain below, however, the immersive experience promised by widescreen was also often presented as an overpowering one.[40]

Ideas about widescreen's capacity to elicit audience participation were rooted in a number of different features of the systems, each of which, it was claimed, made the viewer's perceptual experience of cinema more lifelike and thus offered the sensation of immersion. The term *widescreen*, of course, refers to the new screen shape offered by the systems. The makers of Cinerama and CinemaScope claimed that they chose to employ a wider frame to approximate more closely a human field of vision encompassing 165-degree horizontal and 60-degree

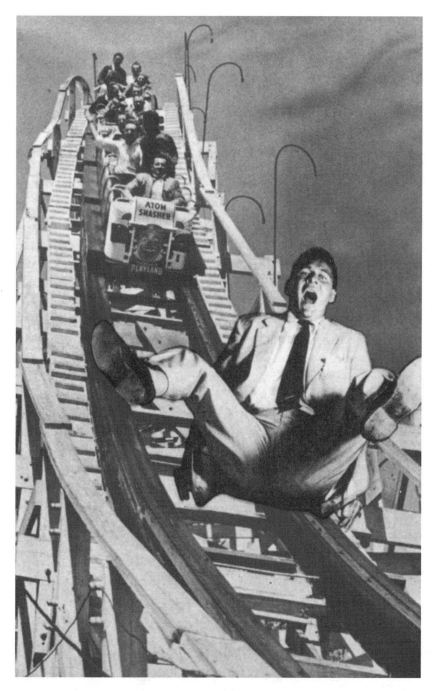

FIGURE 1.4 Publicity stills for *This Is Cinerama* superimpose supposed audience members over images from the film. (Cinerama Corp., c. 1952 / Photofest)

vertical angles.[41] This closer approximation purportedly aided the feeling of immersion by stimulating the viewer's peripheral vision, which was reputed to provide the illusion of depth. In fact, early discussions of Cinerama and CinemaScope frequently referred to these processes as three dimensional, conflating them with the concurrent fad for stereoscopic 3D. And they suggested that this wider scope ushered the viewer into the screen image.[42]

Despite claims by the makers of Cinerama and CinemaScope that the new aspect ratios conformed more precisely to human vision, it was the sheer magnitude of the screens that constituted much of the systems' appeal (not to mention their ability to stimulate peripheral vision). In the theaters converted for these systems, the wider shape played a practical role in the service of size, enabling screens to expand dramatically in the one direction that auditoriums with limited vertical sight lines allowed.[43] The Cinerama screen at the Broadway Theater in New York, where This Is Cinerama debuted, measured approximately 64 feet by 23 feet, offering an image touted by the press as six times larger than that accommodated by traditional movie screens (which, before 1953, averaged 18–20 feet wide and 13.5–15 feet high).[44] The CinemaScope screen at the Roxy Theater in New York, where that system's debut feature, The Robe, premiered, reportedly stretched to 65 feet by 25 feet.[45] The size of the new screens contributed to the idea that the widescreen viewing experience approximated real-life vision by making it difficult to perceive the entire image at once and thus requiring viewers to move their heads to see different sections of the screen.[46] It was claimed that this new scale elicited a feeling of immersion by downplaying the viewer's awareness of the limits of the frame and, as a result, obscuring the barrier between viewer and spectacle.[47]

The immersive effect of Cinerama and CinemaScope was also frequently attributed to the (initial, in the case of CinemaScope) curvature of their screens—which allowed them to gesture toward encircling the audience—as well as the use of stereophonic sound.[48] Both of these elements contributed to the sensation that, as in the world outside the theater, action surrounded the viewer, further justifying the assertion by film critics and publicists for Cinerama and CinemaScope that the new technologies engulfed audience members and pulled them into the film.[49] Additionally, the way in which the new screens

were installed in exhibition spaces was reputed to enhance this feeling of immersion. Theater owners were instructed to move the new screen in front of the eye-catching prosceniums of yesteryear, allowing it to extend from wall to wall at the front of the theater.[50] Like the overwhelming size of the image, this obscuring of the proscenium downplayed the limits of the frame and, it was claimed, made the viewer feel enveloped in the space pictured onscreen.[51]

The sensation evoked by this new experience of cinematic immersion was often communicated through reference to the sense of touch (in the case of CinemaScope) and the feeling of motion (with Cinerama). This referencing of bodily sensations is commensurate with a long tradition in which immersive media—including, notably, the nineteenth-century panorama (a lineage acknowledged in the name *Cinerama*)—have addressed viewers polysensorily, inviting what Alison Griffiths describes as "visceral reactions and embodied modes of spectating."[52] For instance, the review of *How to Marry a Millionaire* (Jean Negulesco, 1953) cited above not only provides an indication of the significant role Marilyn Monroe played in the promotion and critical reception of CinemaScope but also demonstrates the way in which the visual experience of widescreen—how Monroe looked in the format—was described in terms of tactility (and even taste): the sensation of being smothered in a decadent dessert.[53] It also highlights the sense of anxiety underlying discussions of this sensual address, with the prospect of close contact with the enormous spectacle presented not only as a new form of cinematic pleasure but also as something that could be suffocating.

The images generated around these widescreen systems also depicted the new experience of participation in terms of bodily sensations. The Cinerama publicity photographs mentioned earlier not only show the portrayed viewers as immersed in the spectacle but also emphasize the sensation of movement the system was reputed to elicit, conveying the viewers' own sensation of kinesis through their flailing legs (as in Figure 1.4) or waving arms (as in a similar publicity still depicting the film's Cypress Gardens waterskiing sequence).[54] The cover of *Time* magazine's June 8, 1953, issue—which featured a story on the new movie technologies that conflated widescreen and stereoscopic 3D as novelties supplying the illusion of depth—demonstrates the way in which the sense of spatial immersion promised by these

systems was also presented as something that evoked an experience of tactile contact (fig. 1.5).[55] The onscreen image of a giant, curvaceous woman is pictured extending beyond the proscenium and into the space of the theater, with one of her hands appearing as if it is about to caress the face of an eager moviegoer. At the same time, the illustration depicts two audience members reaching toward the movie image, as if about to touch it. Thus, the promise of a cinematic experience that erased the boundaries between image and theater space was conveyed as one that provided tactile as well as visual pleasures.

The promise of tactile pleasures is also demonstrated by the compulsion felt by more than one commentator to invoke the futuristic form of spectatorship described in Aldous Huxley's 1932 novel *Brave New World*, implying that widescreen represented a step in the direction of the "feelie."[56] The *Salem (OR) Statesman*, for example, asked, "Next, 'feelies?' If these could be developed the motion picture industry certainly would make itself felt as a threat to TV. What video set could possible [*sic*] arouse the audience response to a Marilyn Monroe 'feelie?'"[57] In a "forecast" of cinema's future after the 3D revolution, *Variety* predicted: "The feelies at last were a reality. No longer would you merely have Marilyn Monroe in your lap and breathe her intoxicating perfume. . . . You would now be able to intimately caress her."[58] Such references to *Brave New World*'s dystopian future further suggest that widescreen's promise of new sensual (and sexual) pleasures provoked anxieties as well.[59]

Scholarly accounts of immersion often associate immersive experience with the concept of presence.[60] While the discourses surrounding the emergence of Cinerama and CinemaScope appealed to this concept as well, they often presented widescreen's promise of immersion through reference to the related but conceptually distinct idea that the systems could provoke and control viewers' bodily mechanisms. Although these systems had, as we have seen, purportedly been designed to mimic viewers' visual and aural experience of the world outside the theater (with a broader angle of vision and surround sound), references to widescreen's capacity not only to mirror but also to govern the human perceptual apparatus were relatively widespread. *Motion Picture Herald*, for instance, claimed that the size of the Cinerama image "[commanded] the senses completely," and Earl Sponable, the Fox engineer responsible for shepherding the development of CinemaScope, suggested that the magnitude of the CinemaScope

FIGURE 1.5 Titled *3-D Movies*, this illustration by Boris Artzybasheff appeared on the cover of the June 8, 1953, issue of *Time* magazine. (Courtesy of the Syracuse University Art Collection)

screen "[realized] the purpose of visual domination."[61] *Motion Picture Herald* painted a particularly illustrative picture of the resulting experience: "When one has looked daily for many years at a little picture of moving images looming distantly out of surrounding blackness, it is pretty devastating to have that world of the screen spread out vastly and move in on you, so dominating and intimate that you are scarcely outside it. Sometimes, if the material so wills, you are in it."[62] By claiming that the format subjected the viewer to the "will" of the film—and thus implying that widescreen technology suspended the viewer's own will—such a response portrays the form of immersion offered by widescreen as a form of control.

The idea that widescreen subjected viewers to an overpowering experience was central to the format's appeal. The promotional rhetoric surrounding the technology emphasized widescreen's capacity to act upon its audience. Cinerama publicist Lynn Farnol explains, "The appeal adopted by the advertising agency . . . and the company's publicity representatives was a simple one: what Cinerama does to you!"[63] A souvenir program for *This Is Cinerama* illustrates this strategy, exclaiming, "Everything that happens on the curved Cinerama screen *is happening to you*."[64] While this conception of widescreen spectatorship as an experience of submission was described by detractors—noteworthy among them, *New York Times* critic Bosley Crowther—as an assault, even Crowther acknowledged that this assault could be "satisfying" and even "intoxicating."[65] The appeal of such an assault lay in the way in which the tactile and kinesthetic feelings evoked by the format were conceived as a thrill. Numerous reviews surrounding *This Is Cinerama*'s debut compared the excitement evoked by the system with that offered by the type of roller-coaster ride that opens the film.[66] And, contrary to Fox's advertising campaign, which attempted to endow CinemaScope—over and against Cinerama—with what William Paul calls "an aura of class," some critics (for instance, those at *Sight and Sound* in the United Kingdom) decried the destruction of aesthetic distance that they associated with widescreen's bodily address, claiming that the new format returned cinema to the fairground.[67]

Furthermore, it was suggested that, as in a roller-coaster ride, the feelings evoked by the new experience were so powerful that they elicited psychosomatic responses.[68] Discussions of *This Is Cinerama* not only contended that the viewer could feel the motion pictured onscreen via the roller coaster and plane but also reported that

audiences screamed, gasped, applauded, and even turned away in response.[69] Lowell Thomas, the radio personality with a financial stake and a role as narrator in *This Is Cinerama*, reported that "drugstores close to the New York theater at which *Cinerama* is playing now have a large supply of Dramamine and other remedies for air-sickness."[70] *Life* magazine went so far as to claim that audience members "sometimes faint[ed]" during the roller-coaster sequence.[71] What Cinerama promised to do to its audience, in other words, was subject it to feelings of immersion so encompassing as to produce the types of physiological response that accompany real-life danger and adventure. The form of audience participation offered by widescreen was thus presented as a chance for viewers to thrill at the new technology's power not only to command their senses but also to take over their bodily controls.

Of course, it does not take a twenty-first-century perspective to recognize the dangers lurking within these pleasures. *Time* magazine's June 8, 1953, cover story on the new "3-D" film technologies suggests the ideological implications of their capacity to act on the audience. The story claims that Cinerama "ran over the customers like a colossal vacuum cleaner, sucking them up into whatever it was doing. When the screen went for a roller-coaster ride, the whole theater seemed to heave and be dragged, screaming, after it." The story further contends that, with the advent of CinemaScope, "it may be that the villainous old eagle [Hollywood] . . . can still regain his grip on the wide-eyed public, and flap away in screaming triumph, as of old, with the innocent and apparently contented victim dangling from his claws."[72] Ultimately, the article takes issue with the quality of Hollywood product rather than with the systems themselves. This discussion clearly reflects, however, the worry that widescreen's bodily address (and its association with the diminishment of critical distance) would render audiences susceptible to control from above. Thus, while widescreen's ability, in the words of playwright and screenwriter Robert E. Sherwood, to "submit the audience to any experience we want to give them, and what is more, condition them for that experience," may have been a thrilling prospect, it was also considered "almost frightening."[73]

At the same time that these discourses conceived audience participation as an experience of submission to the widescreen apparatus, they also suggested that immersion entailed the merging of the viewer's perceptual apparatus with that of the camera. Whereas in a traditional cinematic arrangement the film image was an object within

the viewer's field of vision (which also encompassed elements of theater space, including the proscenium), the new systems, as we have seen, strove to fill—and indeed constitute—that field of vision. Particularly with *This Is Cinerama*, the potential to align one's eye with the new camera was presented, in the film's voice-over narration and promotional materials, as well as in commentary on its debut, as an enhancement to human vision, the opportunity to see the world in a new, technologically improved way. The film's souvenir program proclaimed, "With Cinerama you actually perceive more than you would if you were on the scene, strange as that may seem. More sensations pour in, with greater vividness, from both sides of your field of vision. This is the new technique for seeing the world of reality as well as the world of make-believe through new eyes."[74] Likewise, *Motion Picture Herald* stated, "The special aptitude of Cinerama for scenic material, notably natural scenery where it can use its unique width and depth of focus, provided many a moment when the eyes were given to see as they could never otherwise behold such beauty."[75] And *Variety* reported that the "process gave onlookers [a] better cosmic view of the Rockies, Venice, Vienna and other global points than if actually visited."[76]

Anxious commentators, however, highlighted how widescreen diverged from perceptual norms. Claiming that Cinerama was "unnatural and exhausting to the human eye," Bosley Crowther informed his readers, "Someone has said that it gives you 'the vision of a three-eyed bird, which provides a most novel experience—but it's uncomfortable to be a three-eyed bird for long.'"[77] *Time* magazine argued that the CinemaScope screen was "curiously oppressive for eyes trained to the simpler demands of 'flat' . . . films."[78] More satirical observers imagined the ways the new screens might transform the human perceptual apparatus. One article on CinemaScope declared that "the next generation of movie-goers will have to develop wide-angle eyes and swivel necks."[79] *Life* magazine offered a cartoon that juxtaposed the picture of a man with oblong eyes wearing letterbox-shaped glasses, captioned "glasses for the wide screen," and the image of a man with tall, skinny eyes wearing tall, skinny glasses, captioned "in case there is a tall screen" (fig. 1.6).[80] Such thinking seems odd since, as we have seen, widescreen was developed

GLASSES FOR THE WIDE SCREEN

IN CASE THERE IS A TALL SCREEN

FIGURE 1.6 Ward Kimball's *Life* magazine cartoon suggests that the new technol- ·
ogy challenged perceptual norms. (*Life* magazine, Nov. 9, 1953)

on the understanding that humans already have swivel necks and
letterbox-shaped vision. However, in making the seemingly cir-
cular suggestion that widescreen—which had been conceived to
conform to human perception—was challenging perceptual norms,
these comments indicate that the new technology raised questions
about the potential plasticity of perception. In claiming to align the
viewer's vision with that of the camera, widescreen offered the expe-
rience of an alternative regime of vision, blurring the boundaries
between human and machine vision and, in doing so, promising (or
threatening) to stretch the limits of human perceptual experience.[81]

The final section of this chapter explores the implications of these
ideas for contemporary debates on spectatorship. First, however, it
is useful to elaborate on the anxious appeal attributed to the format
by looking closely at the discourses surrounding a single film, *How to
Marry a Millionaire*, and, in particular, its most heralded asset, Marilyn
Monroe. Fox's second CinemaScope release, *How to Marry a Million-
aire* was employed extensively in the studio's promotion of the system.
Replacing *The Robe*'s (and *This Is Cinerama*'s) emphasis on spectacu-
lar vistas with the widescreen presentation of a trio of female stars
(including Lauren Bacall and Betty Grable, as well as Monroe), it com-
pelled commentators to focus not only on the bodies in the audience
of widescreen films but on those displayed within the new frames as

well. As is exemplified by the come-hither finger gesture that posters and advertisements for the film portrayed the stars making, Fox framed CinemaScope's offer of close, tactile contact with the screen spectacle as a promise of intimate communion with female bodies including, most notably, Monroe's (fig. 1.7).

MARILYN MONROE IN CINEMASCOPE

One thing is proved beyond question about the nature of CinemaScope with its second and milder demonstration in *How to Marry a Millionaire*. The giant panel screen is without equal as a surface on which to display the casually recumbent figure of the temptatious Marilyn Monroe. Thirty-odd feet of the blond charmer stretched out on a forty-foot chaise longue, purring stereophonic sweet nothings into a three-foot telephone, is an eye-filling sight which suits completely the modern-day taste for size, and, to that extent, anyhow, warrants this gigantic way of showing films.

—Bosley Crowther[82]

As discussion of CinemaScope infiltrated the trade and popular press, Monroe's figure was employed consistently to encapsulate the appeal of the new technology.[83] Monroe rose to the height of her celebrity in 1953, when she headlined the Academy-ratio films *Niagara* (Henry Hathaway) and *Gentlemen Prefer Blondes* (Howard Hawks), as well as *How to Marry a Millionaire*, and when she appeared in the first edition of *Playboy*.[84] In this year *Variety* deemed her "the continuing No. 1 space-grabber," and U.S. distributors first voted her the top female box-office star.[85] Although Fox released *The Robe* to much fanfare in September, it consistently employed Monroe and her role in *How to Marry a Millionaire* (released in November) to publicize CinemaScope. For its industry demonstrations of the new process, the studio shot a special CinemaScope version of the "Diamonds Are a Girl's Best Friend" number from *Gentlemen Prefer Blondes*.[86] Fox offered the press stills of Monroe in *How to Marry a Millionaire* to illustrate how CinemaScope's anamorphic lenses worked.[87] On CinemaScope's first anniversary the studio had Monroe pose, cutting a birthday cake, for publicity photographs (fig. 1.8).[88] While this decision certainly underscores the studio's marketing savvy, as it utilized one of its major assets (Monroe) to sell another (CinemaScope), it also provides insight into one of the

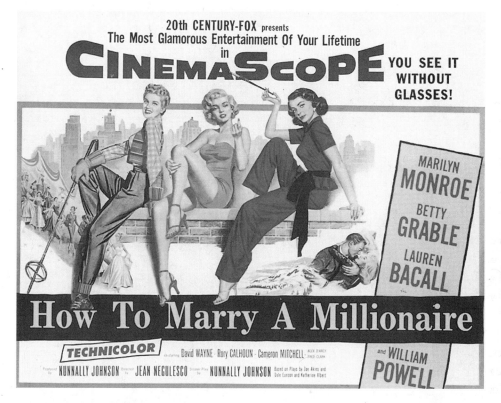

FIGURE 1.7 A poster for *How to Marry a Millionaire* suggests that the film offers intimate contact with its female stars. (Twentieth Century–Fox, 1953)

most aggressively advertised types of screen spectacle within which widescreen promised to immerse its viewers.

This Is Cinerama and *The Robe* famously employed the new screen dimensions to present quasi-panoramic landscapes. However, publicity for *How to Marry a Millionaire* portrayed the appeal of that film's use of widescreen not only in relation to the kind of spectacular scenery emphasized with the earlier films but also, much more forcefully, via a different kind of spectacle, namely the bodies of its three female stars. As the film's director, Jean Negulesco, explained, *How to Marry a Millionaire* "had its own type of breath-taking scenery, in Betty Grable, Lauren Bacall and Marilyn Monroe."[89] Publicity photographs emphasized the expanded view of such scenery made possible by Cinema-Scope by comparing a still from the film with an image cropped to suggest the comparatively limited view offered by the "old standard

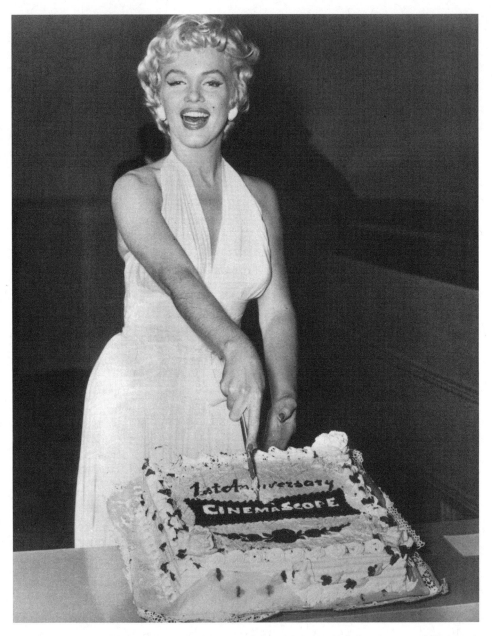

FIGURE 1.8 In a publicity photograph Marilyn Monroe celebrates CinemaScope's one-year anniversary. (Twentieth Century–Fox, c. 1954 / Photofest)

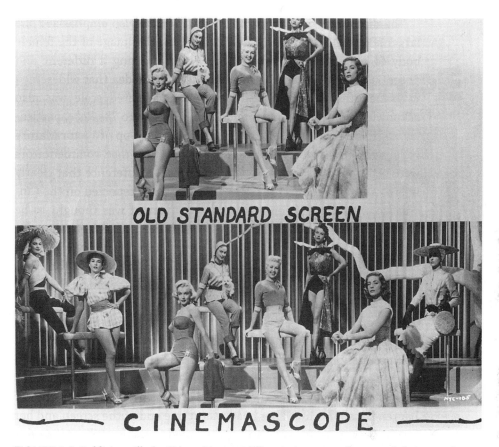

FIGURE 1.9 Publicity stills for *How to Marry a Millionaire* juxtapose the expanded vista made possible by CinemaScope with the comparatively limited view offered by the "old standard screen." (Twentieth Century–Fox, c. 1953 / Photofest)

screen" (fig. 1.9). These photographs indicate the broad frame's capacity to accommodate a greater quantity of displayed bodies, conveying what Kathrina Glitre identifies as the "sense of excess and abundance" through which she links widescreen cinema with contemporaneous consumerist culture.[90] *This Is Cinerama*, it should be noted, also emphasizes the spectacle of the female body imbricated with spectacular landscape in its extended Florida segment, which, in the words of one reviewer, features "cuties attired in modified antebellum crinolines . . . strewn about the gorgeous Cypress Gardens like so many Easter eggs."[91]

Advertisements for *How to Marry a Millionaire* utilized Monroe's voluptuous body to convey the idea that widescreen offered the illusion of depth, positioning the scantily clad star—showing off her derriere in a cheesecake pose—in front of a wide and curved screen (fig. 1.10). This form of presentation echoes the way in which concurrent marketing for stereoscopic 3D indicated that technology's emergence effect by picturing objects breaking imaged screen frames, as is exemplified in the posters for *House of Wax* (André de Toth, 1953) (fig. 1.11). De Toth's film, which was released several months before *How to Marry a Millionaire*, shows off the emergence effects made possible by stereoscopic 3D not only in its famous paddle-ball sequence but also in a narratively extraneous performance by female can-can dancers.[99] Through a similar compositional strategy, the *How to Marry a Millionaire* advertisement implies that CinemaScope provided a three-dimensional—and thus more suitable—view of Monroe's shapely body (the ad enhances this effect by allowing Monroe's body to break the frame of not only the portrayed screen but the image of the movie theater as well). The format's happy communion with the star, in short, was

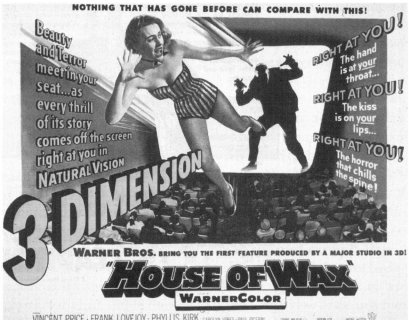

FIGURE 1.11 A poster for *House of Wax* emphasizes the emergence effects made possible by stereoscopic 3D. (Warner Bros., 1953/Photofest)

widely constituted and validated in publicity for and reporting about the format—from Bausch & Lomb advertising its CinemaScope lenses via a not-too-subtle comparison with Monroe's breasts to a *Variety* reporter repeatedly confirming that "Miss Monroe looks even better on widescreen" (fig. 1.12).[100]

In addition to this alignment between the volume of Monroe's body and the sense of depth reputedly supplied by CinemaScope, captions of stills from *How to Marry a Millionaire* emphasized the way in which the new screens would further expand the size of her body (the already-extreme proportions of which inspired her designation as "the girl with the horizontal walk").[101] And while at least one observer joked that the new format would do her justice only if it pictured her lying down, Fox consistently maximized the size of the star's image in its CinemaScope films by featuring her in a reclining position (fig. 1.13).[102] Monroe's next film after *How to Marry a Millionaire*, Otto Preminger's *River of No Return* (1954), uses her character's cold, wet clothing as a premise to display her prone body being vigorously massaged by Robert Mitchum (fig. 1.14)—a scenario that was closely reiterated the next year with Jane Russell and Clark Gable in Raoul Walsh's *The Tall Men* (1955) in a scene that would garner its own Bausch & Lomb lens ad (fig. 1.15). By *There's No Business Like Show Business* (Walter Lang, 1954), the staging of a musical number ("Lazy") revolves around the anticipation that the prominently featured chaise will provide the opportunity for a full-body shot in which Monroe's figure will extend the length of the oblong frame—an anticipation that is satisfied in full only at the very end of the number, when the camera moves in as she is stretching out on the chaise; up to that point Monroe is pictured lying on the chaise only in long shot, while closer shots picture her standing, sitting, or curled up on the chaise (fig. 1.16). That such a moment acted, by the time of the film's release in December 1954, as something of an inside joke attests to the lasting impact of Monroe's "casually recumbent" image from *How to Marry a Millionaire*.[103]

The popular press heralded such gigantic presentation of the human body as an opportunity for fans to scrutinize the figures of their favorite stars. *Time* magazine claimed that *How to Marry a Millionaire* was "devoted to a close inspection of three famous girls," and *Photoplay* suggested that with "3-D" (here conflating stereoscopic and widescreen processes), "some of the most valuable of all the equipment in Hollywood—

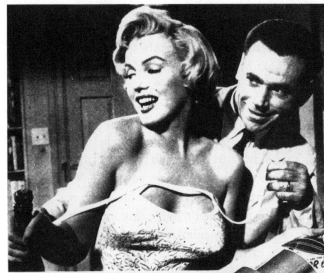

Scene from "The Seven Year Itch," 20th Century-Fox CinemaScope Production.

Gross more every week with your

Bausch & Lomb
Super Cinephor
Projection Lenses

PERFECT-PICTURE PAIR

Count on Marilyn to bring them in ... and count on your B&L Perfect-Picture Pair to bring them *back,* week after week, to enjoy today's clearest, brightest full-screen views. Complete line for all projectors ... for theatres and drive-ins ... for Wide Screen, CinemaScope, SuperScope.

Bausch & Lomb
CinemaScope
Projection Lenses

SEE THE BIG DIFFERENCE ON YOUR OWN SCREEN IN FREE DEMONSTRATION

Write today for demonstration, and for Catalog E-123. Bausch & Lomb Optical Co., 67944 St. Paul St., Rochester 2, New York.

ACADEMY HONORARY AWARD FOR OPTICAL SERVICE TO THE INDUSTRY

BAUSCH & LOMB
SINCE 1853

FIGURE 1.13 A scene from *How to Marry a Millionaire* showcases Monroe's reclining body. (Twentieth Century–Fox, 1953)

FIGURE 1.14 In *River of No Return* Monroe is once again displayed in a prone position. (Twentieth Century–Fox, 1954)

the appealing curves of the film stars—has been coming in for extra close and extra careful scrutiny."[104] Such discussions proposed that, by lending a sense of depth as well as size, widescreen (and stereoscopic 3D) revealed the flaws in actors' appearances that remained hidden in traditional films.[105] Thus, *Photoplay* cited an MGM costume designer, who explained that "3-D is super-realistic" and that "overweight girls cannot rely on girdles to look trim."[106] Bosley Crowther noted that the larger screens revealed excessive makeup and the use of toupees.[107]

At the same time, these discourses presented the potential for intimate contact with the massive bodies on the screen as a pleasure in and of itself, as the promise of being "smothered in baked Alaska"

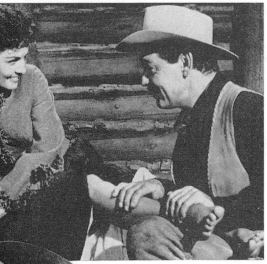

FIGURE 1.15 An ad (c. 1955) for *Bausch & Lomb* lenses features Jane Russell with Clark Gable in *The Tall Men* as another example of a female star who is best seen in CinemaScope.

Clark Gable and Jane Russell in "The Tall Men, 20th Century-Fox CinemaScope production.

APPEAL
that brings 'em back!
PERFECT-PICTURE
PAIR

Bausch & Lomb
Super Cinephor
Projection Lenses

It's how well they *see* that determines how much they'll enjoy the movies you show ... how often they'll come back to *your* theatre. Insure repeat patronage with today's clearest, brightest full-screen views. Don't take chances. Insist on the B&L Perfect-Picture Pair. Complete line for all projectors ... for theatres and drive-ins ... for Wide Screen, CinemaScope, SuperScope.

Bausch & Lomb
CinemaScope
Projection Lenses

**SEE THE BIG DIFFERENCE!
... FREE DEMONSTRATION!**

Write today for demonstration. and for informative Catalogs E-123 and E-141. Bausch & Lomb Optical Co., 72046 St. Paul St. Rochester 2, N. Y. (In Canada General Theatre Supply Toronto)

Academy Honorary Award for optical service to the industry

BAUSCH & LOMB

SINCE 1853

A.M.I
A.S.

FIGURE 1.16 In *There's No Business Like Show Business* the staging of a musical number performed by Marilyn Monroe, Donald O'Connor, and Mitzi Gaynor revolves around the anticipation that Monroe will lie down on a chaise. (Twentieth Century–Fox, 1954)

attests. Even *Photoplay*, addressing an implied heterosexual female readership, articulated the appeal of the format through the idea of proximity to Monroe: "CinemaScope's wide, wide screen is going to show you an awful lot of Marilyn, while its curve brings you closer to hers."[108] For heterosexual female viewers the appeal of immersion in the massive image of Monroe might usefully be understood in the context of contemporary fan discourse, which encouraged female fans to mimic celebrities by learning their beauty secrets and emulating their wardrobes. *Photoplay* magazine, for instance, offered its readers ways to emulate their favorite stars, listing the locations where fans could buy "Photoplay star fashions."[109] One such section proclaimed, "You are the image of a star," and suggested, "Find your image in the mirrored reflections of the bevy of beauties on these pages. . . . Then do yourself a big favor and treat yourself to the correct star styles your image wears."[110] An advertisement asked, "What puts the *M-M-M* in Monroe?" and proclaimed, "You can learn Marilyn's Beauty Secrets in the October *Photoplay*."[111] Such promises suggest that the magazine appealed to its female readers by providing means for adopting the glamour of their favorite stars. Widescreen's purported ability to pull the viewer into the image can be viewed as offering to enhance this process of mimesis by further blurring the boundaries between star and fan.[112]

At the same time that widescreen—and Monroe as its mascot—invited its viewers into intimate contact with the film image, it also appealed to viewers by offering knowledge about this image. *Photoplay*'s gossip-column coverage of the *How to Marry a Millionaire* premiere demonstrates the way in which Monroe's appeal shifted between the allure of a glamorous illusion and the recognition of its illusoriness. The column stresses the glamour of the event and of Monroe in particular, claiming, "The most glittery wingding was the opening of 'How to Marry a Millionaire.' And if ever a gal could call an event her very own, it was Marilyn Monroe that night!" However, it also places a strong emphasis on the work behind that glamour. Its discussion of Monroe's presentation—"The studio had M.M. really done up for her big night. She was poured into a strapless white lace over nude crepe that clung to her"—stresses the studio's active role in styling the star to such an extent that it renders Monroe herself the passive object of action. Monroe becomes not a glamorous figure in and of herself but a plastic substance to be pressed into a glamorous mold. Even when the article attributes action to the star—"Marilyn had asked the studio make-up department for platinum polish on her nails, 'I want to be all platinum and white tonight.' *She was!*"—it is to describe how the studio worked to render her image.[113] Thus, the article presents the reader not only with a glossy picture of glamour but also with knowledge about the construction of that picture. In doing so, it illustrates Richard Dyer's point that a star's image entails an acknowledgment of its manufacture.[114] What is interesting about this emphasis on knowledge is that—far from undermining Monroe's glamorous appeal—it enhances her status as an ideal object of mimesis. Framing Monroe as the kind of "assimilable" star that Edgar Morin contends became more prominent after 1930 (a star that is not only more mortal than her divine predecessors but also therefore "nearer" and "more intimate" with her fans), the *Photoplay* article makes her glamour appear attainable by suggesting that it is not inherent to Monroe but, rather, something fans could adopt themselves if only they, too, could employ the studio's powerful machinery.[115]

Similarly, CinemaScope both presented an enlarged platform on which to portray Monroe's glamorous image and emphasized the mechanism supporting that image. *How to Marry a Millionaire*'s powder-room scene illustrates this duality. Prominent in the mise-en-scène is the type of folded, full-length mirror found in dressing rooms and capable of

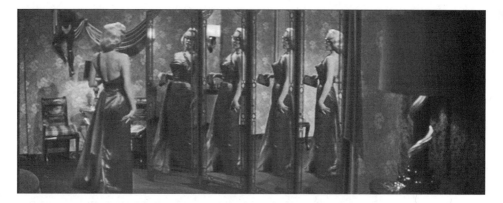

FIGURE 1.17 In *How to Marry a Millionaire* a powder-room mirror echoes the promise made by CinemaScope itself in providing a multidimensional view of Monroe's body. (Twentieth Century–Fox, 1953)

creating a reflected *mise en abîme*. The scene begins with Grable admiring herself in the mirror and ends with Monroe doing the same (fig. 1.17). The result is a shot of each woman that shows iterations of her full figure spanning the wide screen. In this scene Monroe wears a brightly colored, body-hugging gown that dominates the viewer's attention and emphasizes the star's "to-be-looked-at-ness." Multiplied five times (thanks to the mirror) and extending across the screen, this massive and repeated image can be read as a command to its female spectator, urging her to conform to this model of glamorous white femininity. However, insofar as widescreen provides a large-enough platform for such a command to be not only written on high but also reiterated in a single shot, the new technology also denaturalizes this message and makes its ideology explicit. The mirror further reflects this oscillation by at once providing the audience a better, multidimensional view of Monroe's body and serving as visual evidence that such a view relies on material props—thus acting as an onscreen reminder of the work done by the widescreen apparatus itself.[116] Like the gossip-column coverage of the film's premiere, then, this onscreen manifestation of the technology emphasizes both the star's glamour and its means of construction, offering an enhanced view of Monroe's body while simultaneously identifying this possibility as a technological feat.

Gaylyn Studlar has employed the concept of fetishism to describe the way fan magazines in the 1920s offered fans both a sense of

intimacy with stars and a level of awareness about the star system.[117] While the magazines' treatment of Monroe in the 1950s certainly has strong roots in this tradition, her image—and the widescreen systems it advertised—foregrounded the act of display in a way that sits uneasily with the concept of disavowal.[118] CinemaScope treatment of Monroe self-consciously calls attention to her star persona, as when *How to Marry a Millionaire* references the "Diamonds Are a Girl's Best Friend" number from *Gentlemen Prefer Blondes* and when Tom Ewell's character in *The Seven Year Itch* (Billy Wilder, 1955) jokes that the "blonde in the kitchen" may be Marilyn Monroe. Cinematic pleasure, at such moments, arises not from a fetishistic belief in the screen fictions but from knowledge about their intertexts and contexts.

Similarly, the discourses on widescreen tended not to disavow its spectacular appeal but instead to present the format's realism as spectacle, inviting film audiences to thrill at the power of the apparatus.[119] This emphasis on display recalls Tom Gunning's description of early cinema, which, he argues, elicited a sense of incredulity in its audiences.[120] Like the early film screenings Gunning discusses, which astonished viewers by launching still images into motion, early widescreen films emphasized the incredible nature of the technology by beginning with a standard-sized screen before widening the image to one of the new, supposedly more lifelike, aspect ratios.[121] The first four Cinerama films—*This Is Cinerama, Cinerama Holiday* (Robert L. Bendick and Philippe De Lacy, 1955), *Seven Wonders of the World* (Tay Garnett et al., 1956), and *Search for Paradise* (Otto Lang, 1957)—each began with an Academy-ratio prologue before the curtains parted to expose the full width of the Cinerama screen, a sudden revelation that one reviewer of *Cinerama Holiday* called "awesome and moving."[122] *The Robe*, too, was preceded by an Academy-ratio "newsreel" on the history of the motion pictures leading up to the development of Cinema-Scope, before what a reporter described as "the big moment, as *The Robe* was offered in evidence [of CinemaScope's status as the culmination of that history] and as a gauntlet thrown in challenge to competition from all other dramatic mediums."[123] The Todd-AO extravaganza *Around the World in 80 Days* (Michael Anderson, 1956) also began at Academy ratio—featuring an abbreviated version of Georges Méliès's *Le voyage dans la lune* (*A Trip to the Moon*, 1902)—before expanding the screen's width (and height as well).[124]

The emphasis on the display of CinemaScope can also be seen in the theatrical trailer for *How to Marry a Millionaire*, which utilizes images of Monroe and her fellow stars to bolster this effect.[125] Presented in Academy ratio and black and white, the trailer does not provide the audience even a peek at the technological innovation it advertises. Indeed, the trailer does not offer any moving images at all.[126] It begins with text over a shot of satin curtains, with transitions ushering in shots of . . . more curtains. When the trailer finally presents images of the stars that constitute, along with the new process itself, the film's major attraction, they are images of framed publicity stills and magazine covers. The diegetic frames here underscore not only the immobility of these stills but also their remove from the audience. If CinemaScope promised to bring the audience closer to these stars by presenting a massive, lifelike spectacle, *How to Marry a Millionaire*'s trailer suggests that traditional cinema operated at a remove from the viewer through an anemic form of realism. By withholding moving footage, color, and, most importantly (even if necessarily), any glimpse of the wide screen itself, the trailer builds suspense in anticipation of the moment of revelation when this promise will be fulfilled.

This emphasis on display frames Monroe's confluence with Cinema-Scope as much more than a happy accident. Both the star and the format simultaneously promised a pleasurable form of intimacy and called attention to the mechanism enabling it. As with Gunning's discussion of early cinema, the display of this technology must be understood in relation to a specific historical juncture in which other powerful new technologies were transforming the texture of human experience. While Gunning details the way in which the astonishment elicited by early cinema allowed its audience to rehearse the form of shock that marked the experience of industrial modernity, in the 1950s—at a time when scientific experimentation presented the potential to both eradicate disease and wreak mass destruction—widescreen offered viewers a medium through which to play out Cold War–era hopes and anxieties about technology's possibilities and dangers. Both the United States and the Soviet Union, for instance, employed Cinerama (adapted by the latter as Kinopanorama) as an instrument of propaganda; the systems functioned not only as powerful means for circulating grandiose depictions of these countries internationally but also as what Belton describes as "an index of technological prowess" themselves.[127]

Fox also framed CinemaScope as a powerful, cutting-edge technology, the result of the studio's "unending experimentation" and "unceasing search for entertainment progress."[128] When Paramount turned VistaVision to the subject of military aviation in *Strategic Air Command* (Anthony Mann, 1955), Bosley Crowther suggested that the powerful military technology it depicted was particularly appropriate for the format, noting that the "huge intercontinental bombers" featured in the film "look great on the giant screen." He also complained, however, that close-ups rendered June Allyson "as large and imposing in the eyes of the audience as a full-length view of a B-36."[129] Nicholas Ray's aptly titled CinemaScope feature *Bigger Than Life* (1956) consistently and explicitly associates the format's scale with the powerful effects of scientific "progress," in this case aligning the massive screen with the grotesque megalomania resulting from schoolteacher Ed Avery's (James Mason) ill-fated experiment with the "wonder drug," cortisone.[130] When Avery exclaims that he feels "ten feet tall" (a line of dialogue that references the *New Yorker* article on which the film was based), the film cuts to a low-angle medium shot that makes Mason's figure loom large in the CinemaScope frame.[131] As the family friend Wally (Walter Matthau) exclaims, "Big shot; he even looks bigger."

While the inflated image of Monroe similarly promised viewers firsthand experience of a new, technologically mediated sense of scale, it also addressed changing attitudes toward sex at a moment marked by the appearance—all in 1953—of the Kinsey report on women, the first issue of *Playboy*, and adult-themed films such as *The Moon Is Blue* (Otto Preminger) and *From Here to Eternity* (Fred Zinnemann).[132] Monroe's image itself was not exactly subversive; as Richard Dyer argues, she offered her audience the pleasures of a new openness about sexuality while rendering it nonthreatening. And for her female fans her unabashed sexuality suggested the possibility of female sexual fulfillment without sacrificing desirability to men.[133] A front-page *Variety* report from February of that year on the trend "toward 'mature' themes and frank, realistic circumstances" associates Monroe (and her shapely and soon-to-be "CinemaScoped" *Blondes* costar Jane Russell) with racy fare while asserting the fundamental safety of these portrayals: "Now . . . some importantly-placed film men admit they're injecting spice for the purpose of jazzing up their pix. 'But we're not trying to get away with anything,' one said. 'We've found the way to get

across an interesting idea involving Marilyn Monroe or Jane Russell, but without being boldly indecent about it.'"[134] The widescreen presentation of Monroe's body should also be placed against this background. In a report on Cinerama the January 1953 issue of *Vogue* indicated that "showmen" were worried that the new format itself would render love scenes "vulgar or erotic," a concern that put a particularly topical spin on the more widely articulated fear that massive images of the human body could seem grotesque or inhuman.[135]

As we have seen, some commentators voiced concern that the enormous new screens would render the image of the male body strange—or even, in Bosley Crowther's words, "slightly horrifying."[136] *Look* magazine projected these worries onto the female figures in *How to Marry a Millionaire* as well. Referring to the debate over whether widescreen would "make present stars take on unfamiliar proportions," and affirming that "Monroe, Grable and Bacall loom larger than life but are still pleasing," the magazine not only emphasized the way in which widescreen altered the images of these stars but also highlighted the fear that this transformation could make them disagreeable.[137] Such concern that widescreen rendered images of the body unpleasant and even horrifying suggests the extent to which contact with the new screen spectacle was conceived as an experience of alterity. In this context the inflated image of Monroe, although not "boldly indecent," should be understood as simultaneously reassuring and defamiliarizing.

THE PLEASURES OF CONTACT

I lean forward on my elbows, becoming as horizontal as the spectacle, and
out of my larval state emerge as a little god because here I am, no longer
under the image but in front of it, in the middle of it, separated from it
by this ideal distance, necessary to creation, which is no longer that of the
glance but of the arm's reach.
—Roland Barthes[138]

Widescreen cinema offers a useful test case for film theory since it seems to fit into diverse and, in some ways, incommensurate frameworks, from the "myth of total cinema" to the "cinema of attractions," from 1970s apparatus theory to recent phenomenological film theory. We find in the discourses promoting and evaluating the format debates

surrounding whether the new technology rendered the cinematic spectacle more or less lifelike and—in dialogue with that issue— whether it heightened viewers' activity or submitted them more forcefully to spectacle. The public discourses, of course, display as much of a lack of consensus on these issues as do the scholarly ones; however, despite (indeed, through) these disagreements, they nevertheless offer a useful contribution to scholarly debates by providing a view into the terms according to which concepts such as cinematic realism and spectatorial activity were framed vis-à-vis a specific movie technology at a specific historical juncture. As Roland Barthes's response to CinemaScope illustrates, the format activated a particular constellation of ideas about viewers' bodily relationship to the spectacle and its implications for their (actual or apparent) agency.

The form of "total cinema" offered by American widescreen films such as *The Robe* and *How to Marry a Millionaire* seems closer to the illusionism decried by apparatus theory than to André Bazin's ideas about realism: far from offering viewers the kind of encounter with an elusive reality championed by Bazin (and despite the fact that Bazin himself saw in the format the theoretical potential to bring film "even nearer to its profound vocation, which is to show before it expresses, or, more accurately, to express through the evidence of the real"), such films offered viewers the position, in Barthes's words, of a "little god" beholding vistas and bodies loaded with predetermined meaning (including ideologically framed conceptions of religion and glamour).[139] At the same time, as scholars of widescreen have long pointed out, the format departs dramatically from the ideas put forth by apparatus theory insofar as it simultaneously called attention to its mode of presentation, functioning not only as an instance of illusionism but also, equally, as a form of spectacle.[140] My exploration of widescreen's appeals likewise highlights the difficulty of conceiving the experience offered by the format via the frameworks put forth by apparatus theory insofar as it shows how the promotion and critical reception of widescreen emphasized the act of display and, in particular, associated the format with an assertively bodily address. Furthermore, although Marilyn Monroe's association with the format seems to bolster some of the key claims made by feminist theorists working in the psychoanalytic-semiotic tradition, including Laura Mulvey and Mary Ann Doane, the discourses surrounding her appearance in CinemaScope

also emphasized the workings of the apparatus more forcefully than that tradition allows.[141]

Indeed, the discourses on widescreen seem to identify the format as a particularly good model for certain approaches to spectatorship posited in response to apparatus theory's claims about the ideological positioning of a disembodied subject. The discussions of Cinema-Scope, in particular, share with the phenomenological and Deleuzian accounts of spectatorial embodiment that have become prominent in cinema studies the conviction that the experience of cinema can, in an important and somewhat counterintuitive way, be a tactile one. Theorists working in this tradition, such as Vivian Sobchack, Steven Shaviro, and Laura Marks, have described the bodily encounter between viewer and film through ideas such as mutuality and contagion, framing the experience of cinema as a destabilizing and potentially progressive experience of alterity.[142] The discourses on audience participation of the 1950s, as we have seen, also presented the experience of widescreen as one that blurred the boundaries between viewer and image, self and other, promising to put the viewer into intimate contact with Otherness. Additionally, the idea that the format's appeal lay in its promise to act on and even overpower its viewers seems to align the experience it offered with Shaviro's and Studlar's arguments that film spectatorship can be not only passive but also masochistic, as William Paul has also contended.[143] My argument that the massive and engulfing image of the female figure emblematized widescreen's appeal further seems to support the format's association with a masochistic aesthetic, which—in Studlar's extension of Deleuze's formulation—revolves around the desire to return to a state of merger with a powerful mother.[144]

The discourses on widescreen, however, also caution against applying these models too rigidly. There is, first of all, a significant difference between Marlene Dietrich (on whose films Studlar bases her formulation of the masochistic aesthetic) and Marilyn Monroe, who did not reflect the same sort of authoritative presence or fluid relationship to gender as did the earlier star. More important, while this tradition tends to frame the bodily and masochistic experience of cinema as empowering or subversive, it is difficult in good faith to conceive the use of Monroe's image or the idea of audience participation it advertised exclusively or even predominantly in these terms. While the

star's appearance in and on behalf of CinemaScope emphasized the act of display—and while she did burlesque femininity and challenge norms for the display of female sexuality—her figure simultaneously, and rather vigorously, reinforced dominant conceptions of race, class, and gender.[145] Moreover, the bodily address associated with audience participation—while presented as a spectacular effect of the technology—was nevertheless often portrayed as something that, far from allowing viewers to escape the hold of dominant culture, would either align them with its power or submit them to it.

In this sense the discourses on widescreen also rehearse concerns elaborated decades earlier vis-à-vis the cinematic medium itself. The idea that Cinerama offered viewers a technologically enhanced view of the world evokes Dziga Vertov's concept of the kino-eye; however, whereas Vertov considered machine vision a means for "the communist decoding of the world" in the service of social change, Cinerama's presentation of front-seat and aerial views and CinemaScope's display of famous scenery of various stripes seem more closely aligned with what Alison Griffiths describes as nineteenth-century panoramas' offer of "vicarious identification with the players of history and a privileged vantage point on some of nature's most prized beauty."[146]

Through their emphasis on viewers' conformity to a powerful apparatus, the discussions of widescreen seem to offer a particularly fitting instantiation of ideas about spectatorship developed by thinkers grappling with the experience of industrial capitalist modernity, especially Walter Benjamin.[147] Describing the experience of modernity as one marked by the collapse of "body space" and "image space," Benjamin contended that the masses accommodated their own perceptual apparatus to the machinery of modern life (including the cinema) in part through their unconscious, bodily encounter with it. He conceptualized this bodily encounter through the idea of mimesis—understood not only as representation but as bodily mimicry, as when children emulate the people and things around them—which undergirds his ideas about how human experience (including the organization of perception and bodily habits) is transformed within a technologically altered environment.[148]

Theodor Adorno and Max Horkheimer conceptualized the address of the culture industry through a similar concept of mimesis, decrying "the compulsive imitation by consumers of cultural commodities

which, at the same time, they recognize as false."[149] While Benjamin likewise considered such mimesis dangerous insofar as it destroyed traditional forms of experience and threatened to anesthetize the masses to their own manipulation, he contended that it simultaneously offered them the means for conceptualizing an alternative future by allowing them to internalize—and begin to alter the boundaries of—the status quo. Thus, he explained that "revolutions are . . . innervations on the part of the new, historically unique collective which has its organs in the new technology."[150] Although Benjamin did not live to comment on the postwar American culture that produced widescreen, the ideas he articulated in Europe in the 1920s and 1930s help us to make sense of the ways in which conceptualizations of widescreen's bodily address are framed in terms of the thrill and threat of close contact with—indeed, mimesis to—an overpowering new technology controlled by economically and politically powerful entities. In particular, it frames widescreen's promise of a tactile experience of and with this powerful apparatus—which projected not only contemporary hopes and fears about scientific progress but also attendant ideologies of nation, sex, and gender—as an opportunity for its mass audience to redefine itself accordingly, for better or for worse.

It must be emphasized that Benjamin's ideas cannot fully address the specificities of widescreen's context such as the changing attitudes toward sex that inflect the appeal of Monroe's appearance in the format. They serve here not as an ultimate explanation of widescreen spectatorship but rather as a point of entry into the complex tensions underlying conceptualizations of cinema's appeals at this particular juncture. The discourses on widescreen emphasized the ways in which the format enabled its viewers to experience the allure and danger of powerful social, economic, political, and technological forces firsthand. The body's encounter with technology was central to the excitement and unease attributed to that experience, facilitating intimate contact with such forces and, through that contact, an experience of alterity—the incorporation of a new, defamiliarizing mode of perceptual experience and the encounter with bodies altered beyond previous standards of propriety. Although there has been a tendency in recent work on spectatorial embodiment—including work drawing on Benjamin's ideas about embodied experience—to emphasize the subversiveness of that experience, the discourses examined here depict it

as neither fully supportive of the status quo (insofar as it challenged naturalized modes of perception and representational norms) nor capable of being divorced from the power of mass culture (insofar as it solicited both submission to and identification with the "players of history" and their ideologies).[151] Widescreen, in short, offered viewers a bodily experience of participation that both promised to align them with a powerful apparatus and threatened to submit them to it, simultaneously inviting conformity to overwhelming images and imagery and framing such conformity as a source of anxiety.

EAST OF EDEN IN CINEMASCOPE
Intimacy Writ Large

The evidence is that intimacy is going to be hard to sustain on the large screen. Magnification seems to make everything a spectacle.
—Bosley Crowther on CinemaScope[1]

I think I've treated CinemaScope a little differently in this picture. . . . I don't think you'll have the feeling of that big screen.
—Elia Kazan on *East of Eden*[2]

Warner Bros. persuaded Elia Kazan to shoot *East of Eden* in Cinema-Scope. During production of the film the director claimed to be unenthusiastic about the system and predicted that it would not last long.[3] Even years later, he maintained that *East of Eden*'s intimate content did not lend itself to the format and justified the choice by explaining that "that was the rule in those days. Nearly all the big pictures had to be shot in CinemaScope."[4] Rather than accept the new filmmaking norms minted by early CinemaScope features such as *The Robe* and *How to Marry a Millionaire* along with the format, however, Kazan—fresh from the success of *On the Waterfront* (1954)—attempted to counteract "the feeling of that big screen" by trying "to shoot most of the picture just as I would for the conventional screen."[5] The result was a film that broke the CinemaScope mold. As Andrew Sarris wrote in his 1955 review, "The old canards about the static, non-cinematic qualities of Cinemascope will have to be revised."[6]

The established "static" widescreen norms, which emphasized mise-en-scène and unobtrusive camerawork, in many ways prevented the new, massive screens from threatening previous models of

spectatorship.[7] While *East of Eden* makes heavy use of this mise-en-scène aesthetic as well, at certain key points its style recalls pre-widescreen filmmaking, particularly in its use of sharply canted camera angles and close framing.[8] Far from activating a previous mode of address, this reversion (whether intentionally or not on Kazan's part) invited viewers into a new relationship with the screen image, including offering a changed relationship with the human figures onscreen. Not coincidentally, *East of Eden* also represented the first major film role for James Dean, whose performance drew as much critical attention, both positive and negative, as did Kazan's deployment of the wide format. I argue here that the effect of this performance is indissociable from the massive scale of its platform. This confluence would, of course, be repeated in Dean's next film, iconic for its implementation of both the actor and the format, Nicholas Ray's *Rebel Without a Cause* (1955).

This chapter builds on the previous one by providing an in-depth discussion of the ways in which the massive new scale of the wide screens conspired with film style to reframe the cinematic experience of the human body. William Paul has demonstrated the close relationship between scale and film style in widescreen cinema. Comparing widescreen and Academy-ratio versions of *The Big Trail* (Raoul Walsh, 1930), he argues that stylistic choices such as close camera distances, centered framing, and shallow focus are linked to theater and screen design, and he contends that Twentieth Century–Fox's late 1920s and early 1930s 70mm "Grandeur" widescreen system—with its large, undistorted images—was treated as rendering such devices unnecessary. While that assumption was widely echoed in the 1950s as well, the move to widescreen did not, as *East of Eden* and *Rebel Without a Cause* evidence, do away with close framing. Although Paul associates the continued use of close-ups in 1950s widescreen filmmaking with the ascension of the classical Hollywood style in the previous decades, his observation that "CinemaScope and most other wide screen processes of the fifties produced big heads that were simply much bigger than early practitioners of the Hollywood classical style would have dreamed possible—or possibly even desirable" suggests the extent to which the scale of the wider screens altered, rather than simply maintained, the function and address of this device, at least during the transitional period in the mid-1950s when the portrayal of the body at that scale had not been normalized.[9]

As I show in what follows, *East of Eden* both harnesses and transgresses the widescreen norms forged by *This Is Cinerama* and the first CinemaScope releases. While critics have often noted the film's use of canted angles, I focus in particular on the implications of Kazan's decision to flout the general rule—explicitly advocated by Warner Bros.—that the CinemaScope camera be placed at least six feet from actors.[10] The resultant close framing, while recalling classical filmmaking, paradoxically transformed widescreen's address. By inflating the human image to an unprecedented scale on the new screens, such close framing not only exaggerated the sense of proximity and intimacy the close-up had come to convey in the classical system but also reintroduced the destabilizing effect close framing exerted on cinema's first audiences, inviting allegations of monstrosity.[11] Further, Dean's performance is usefully understood in conjunction with this new level of magnification, conspiring with it to offer viewers a new experience of—and with—the human body.

WIDESCREEN FILMMAKING

In CinemaScope closeups, the actors are so big that an
average adult could stand erect in Victor Mature's ear.
—*Time* on *The Robe*[12]

As discussed in the previous chapter, the new aspect ratios, image sizes, screen curvature, and sound systems popularized with Cinerama and CinemaScope were reputed to offer audiences a novel experience of immersion in the cinematic spectacle, with Cinerama promoted as producing not only the experience of ersatz travel but also the thrilling, visceral feeling of vicarious motion. Key to *This Is Cinerama*'s filmmaking and promotion was the Cinerama camera's placement at the front of a host of moving vehicles, from the roller coaster with which it famously begins to an airplane and motorboat. Marketing for the film contended that this moving perspective took the place of conventional characters, with souvenir programs identifying the Cinerama camera itself as "a new kind of hero."[13] Although the sense of audience participation promised by the film was routinely attributed to Cinerama's capability to replicate the conditions of perception more accurately, that effect also relied heavily on this moving camera, which rendered

its objects in continual motion. In this regard *This Is Cinerama* recalls early cinema's phantom rides, which, Tom Gunning explains, evoked a give-and-take between the senses of "presence and absence, sensation and distance."[14] As Gunning argues, the experience offered by these early "panoramic views" was a ghostly one, with the locomotives themselves unseen yet the effects of their motion producing physiological effects. Similarly, *This Is Cinerama*'s moving point of view—in this case often soaring through the air—feels simultaneously transcendent and sensational, evoking psychosomatic responses while simultaneously offering a sense of mastery.

While *This Is Cinerama* falls in line in many ways with the idea of a "cinema of attractions," CinemaScope's relation to spectacle is more ambiguous. Fox's marketing personnel were well aware that the technology's novelty constituted a large part of its appeal. Its advertising campaign identified the CinemaScope process itself as a starring attraction, with one advertisement, for instance, featuring a dressing-room door reading "CinemaScope" in place of the name of an actor.[15] A pamphlet created for technical personnel suggested that one of the benefits of the screen's new shape was that it was "sufficiently different from past product so that it is noticeable to the audience rather than merely going part way in this regard."[16] At the same time, as John Belton claims, CinemaScope retained "a strong identification with the narrative tradition in which Hollywood remained steadfastly rooted." Fox attempted to prevent spectacle from overwhelming narrative by using CinemaScope for historical films, "which functioned to naturalize pictorial spectacle." Indeed, Belton contends that Fox sought to distance CinemaScope from Cinerama's lowbrow association with the amusement park by reframing the sense of "audience participation" elicited by its own widescreen format in terms of the legitimate theater.[17] Here (and despite the critical discourse describing CinemaScope's tactile address), participation is presented in terms of intellectual involvement rather than physical thrills. Thus, for instance, cinematographer Leon Shamroy (*The Robe*) claims that the "great value of this new approach to films is that it invites the audience to joint [*sic*] in telling the story," since "the watcher may study any part of the huge vista in front of him that he chooses."[18] And *American Cinematographer* explains that "C-pix will be like stage plays where the spectator visualizes closeups and medium

shots when he focuses his individual attention on the principal player or some specific bit of action."[19]

Many narrative widescreen films produced in the mid-1950s evidence this oscillation between offering a sensational bodily address and attempting to mitigate the potentially destabilizing effect of the format's magnitude. These films often include sequences that recall *This Is Cinerama* by aligning the viewer's perspective with that of the moving widescreen camera. *How to Marry a Millionaire*, for example, includes footage of an airplane landing, shot from the nose of the plane; *20,000 Leagues Under the Sea* (Richard Fleischer, 1954) motivates such movement with a racing submarine; *River of No Return* employs a raft amid rapids; and *Around the World in 80 Days* utilizes a host of vehicles, including a hot-air balloon and an elephant, as well as a series of trains and boats. In a pamphlet entitled "CinemaScope Techniques," prominent CinemaScope cinematographer Charles G. Clarke identifies such "views taken straight ahead from moving vehicles," together with low camera heights, as particularly capable of "[creating] audience stimulation that lends excitement and enjoyment to the production," and, he urges, "They should be used whenever logically possible."[20]

In contrast to this emphasis on a thrilling use of camera movement, however, Fox simultaneously suggested that CinemaScope's oblong frame approximated the theater stage, enabling filmmakers to *avoid* such cinematic techniques as camera movement and editing and to focus on mise-en-scène instead.[21] Thus, in memos to his production staff, written upon seeing rushes from *The Robe* and *How to Marry a Millionaire*, Fox production head Darryl Zanuck advised the makers of these films to move the actors rather than the camera.[22] Contending that the magnitude of the CinemaScope screen rendered close-ups unnecessary, he also favored sizable camera distances, which permitted interaction among multiple characters. In a memo on *The Robe*, for instance, he explained, "The greatest kick I get is when one person talks across the room to another person and when both of them are in the scene and near enough to be seen without getting a head close-up." Thus, he urged his personnel to spread out the actors in order to fill the screen—a tactic that, he suggested, "[put] on film an effect that we cannot get on the old 35 mm."[23] CinemaScope's capacity to encompass more clearly legible profilmic information within a single shot was also reputed to reduce the need for cuts and numerous

camera angles, motivating the repeated contention that shooting in CinemaScope saved both time and expense.[24] Finally, as both Zanuck and Clarke enthused, the new process allowed directors to stage action in width as well as depth.[25]

Filmmakers and executives associated with Fox claimed that the benefits of this approach included increased freedom for actors and directors, the ability to show cause and effect within a single shot, and the capacity to include more reactions from secondary characters.[26] They also proclaimed it particularly suited to stereophonic sound, an integral part of CinemaScope's attraction and an element that Zanuck believed provided "at least 25 per cent" of the system's three-dimensional effect. Zanuck claimed that spreading actors out across the wide frame enhanced stereophonic sound's appeal, suggesting that the "full value of stereophonic sound comes from the *distance* between two people who are talking. If one person is planted at one end of the set and the other person is on the other side of the set then the sound has a [sic] opportunity to add to the illusion of depth."[27] Additionally *Robe* cinematographer Shamroy argued that stereophonic sound functioned to direct the viewer's attention and thus further mitigated the need for camera movement.[28]

As David Bordwell has shown, this approach to CinemaScope stylistics—emphasizing a relatively static camera, limited close-ups, longer takes, and what he calls "spacious horizontality"—was intimately bound up with particularities of the early CinemaScope lenses, including their uneven squeeze ratios, focusing difficulties, and limited depth of field. As a result of the uneven squeeze ratios (ultimately rectified by the introduction of Panavision lenses in 1958), figures appeared thinner at the edges of the frame and stouter at the center—a problem that was most pronounced at close camera distances, producing a phenomenon termed the "CinemaScope mumps."[29] Additionally, each of the first three CinemaScope films—*The Robe, How to Marry a Millionaire,* and *Beneath the 12-Mile Reef* (Robert Webb, 1953)—was shot with only one 50mm lens and a separate anamorphic attachment.[30] Because the lens and attachment needed to be focused separately, sharp focus was difficult to achieve; indeed, Zanuck complained of extensive focus problems in *The Robe.*[31] As Bordwell argues, this difficulty with focus contributed to the static blocking in that film, while parallax problems exacerbating the difficulty of camera movement

further contributed to the "lumbering" quality of early CinemaScope films.[32] Moreover, Zanuck observed that distortion increased with sharpness, so that *How to Marry a Millionaire* and *Beneath the 12-Mile Reef*, while sharper than *The Robe*, also had more problems with distortion.[33] Another major problem was early CinemaScope's limited depth of field, which has been attributed to the initial restriction to 50mm lenses, as well as the slow color film stock on which Fox initially insisted.[34] As Bordwell elucidates, moving the camera relatively far back from the foreground plane enhanced depth of field, a fact that contributed to what he identifies as "perhaps the most striking invention—or perhaps we should say rediscovery—facilitated by Scope: a kind of return to the 1910s, when filmmakers exploited the rich possibilities of midrange foregrounds and remarkably remote background planes."[35]

Scholarship on widescreen aesthetics has focused in large part on the shift in emphasis away from camerawork and editing and toward mise-en-scène. Early detractors, such as Rudolf Arnheim and the critics at *Sight and Sound* in the United Kingdom contended that widescreen undermined cinema's potential to function as what Richard Kohler called an "interpretive art."[36] These critics suggested that a small frame was necessary to create what Arnheim termed the "meaningfully organized image."[37] The *Sight and Sound* critics contrasted the experience of aesthetic distance facilitated by the small frame with widescreen's address, which Kohler described in terms of physicality and distraction and his colleague Walter Lassally associated with the fairground.[38] In his 1930 speech addressed to the American Academy of Motion Picture Arts and Sciences on the issue of wide screens, Sergei Eisenstein, focusing on screen shape rather than size, offered an exception to the idea that widescreen shifted attention away from the frame. Emphasizing the formal implications of horizontal as well as vertical frames, he argued for a "dynamic square," which would allow the two spatial orientations to come into dialectical conflict.[39]

In contrast with Arnheim's and Kohler's disparagement of what they took to be a shift of focus away from the frame, André Bazin and his followers considered widescreen's emphasis on mise-en-scène a step in the direction of cinematic realism. Bazin claimed that the new format helped to hasten "the shedding of all artifice extrinsic to the image's content itself," and he proclaimed, in particular, that

widescreen, "even better than depth of field . . . has come ultimately to destroy montage as the major element of cinematic discourse." He admitted, however, that the optical defects evident in *The Robe* "dealt a harsh blow to [his] theoretical enthusiasm."[40]

The critics at *Cahiers du cinéma* and, later, *Movie* in the United Kingdom also embraced widescreen's emphasis on mise-en-scène as encouraging a realist aesthetic.[41] Thus, Eric Rohmer lauded the sense of spatial continuity with which widescreen endowed filmmaking, and Jacques Rivette argued that staging in width allowed filmmakers to reveal connections among characters without imposing upon them the variations in scale that result from what he called "distorted perspective."[42] Writing in *Movie*, V. F. Perkins influentially described a scene in *River of No Return*—the film that has easily garnered the most attention in scholarly debates about how (and whether) widescreen transformed film style—when Kay's (Marilyn Monroe) suitcase falls out of her raft (fig. 2.1): "Kay's gradual loss of the physical tokens of her way of life has great symbolic significance. But Preminger is not over-impressed. The bundle simply floats away offscreen while Harry brings Kay ashore. It would be wrong to describe this as understatement. The symbolism is in the event, not in the visual pattern, so the director presents the action clearly and leaves interpretation to the viewer."[43] In his seminal essay on widescreen, "CinemaScope: Before and After," Charles Barr not only echoes this contention that widescreen filmmaking allows for complex, subtle images that encourage viewers to interpret for themselves; he also suggests that widescreen's physical address contributes to the format's realism, enhancing the viewer's empathy for characters.[44]

Bordwell has argued against what he takes to be the suggestion that this emphasis on mise-en-scène subverted a classical filmmaking style. Although the raft sequence in *River of No Return* avoids editing, he observes, it uses other classical tools, including dialogue, sound cues, framing, and camera movement, to focus the viewer's attention. Additionally, while he acknowledges that average shot length did increase somewhat at first with the popularization of widescreen, he argues that "the classical system fairly quickly restabilized itself." Thus, Bordwell identifies Hollywood widescreen filmmaking as "a new set of stylistic devices brought into line with the classical schemata."[45]

FIGURE 2.1 In *River of No Return* Kay's belongings float away down the river. (Twentieth Century–Fox, 1954)

John Belton contends that the tendency to position figures across the breadth of the new frame (advocated, as we have seen, by Zanuck himself) encouraged a sense of audience participation by compelling the viewer to "shift his or her center of attention from one area of the widescreen frame to another within shots or from shot to shot," scanning the width of the image as well as its depth. Belton, too, uses *River of No Return* as a privileged example, offering a still of Robert Mitchum's character, at the left edge of the frame, watching Monroe perform a musical number at frame right.[46] Additionally, noting the way in which CinemaScope composition "often depends upon the set's ability to be photographed simultaneously as both a plausible setting and a geometrically patterned flatness," Marshall Deutelbaum argues that filmmakers working in anamorphic formats composed shots according to a quartered grid system, which endowed a sense of uniformity to diverse shots and thus eased the potentially jarring effect of editing the wide image.[47]

My own contribution to the debates on *River of No Return*'s implications for an understanding of widescreen's address is to emphasize the important role Monroe's figure played in this address. Paying attention to the star compels us to acknowledge that widescreen intersected with film style in diverse ways, not only encouraging modulations in film style but also affecting the function and address of staid devices.

In addition to facilitating the long-shot approach that has hitherto attracted the vast majority of scholarly attention, the introduction of a large, wide frame also significantly transformed the presentation of human bodies at particular camera distances. The new screen dimensions altered the proportions of the human figure as displayed in long shot, medium shot, and close-up, offering viewers an encounter with the imaged body that was reputed to be close, tactile, and enveloping. This shift of emphasis calls attention not to the type of large landscape shots and busy interiors usually highlighted but to shots devoted to displaying the body, such as *River of No Return*'s full-body shot of Monroe, relieved of her wet clothing, being massaged by Mitchum. It is worth noting that, in addition to his beloved group shots, Zanuck also favored such framings. Upon viewing the rushes of *How to Marry a Millionaire*, he identified "the full figure shot of Bacall on the bed and the big closeup filling the screen of Monroe" as "unique examples of the new medium."[48]

Widescreen enabled filmmakers to maintain the figure size previously associated with close-ups while increasing the amount of bodily information (for instance, Monroe's and Bacall's legs as well as their heads) capable of being presented at a large scale within a single shot. Leon Shamroy explains, "With CinemaScope it is quite possible to show five full-length figures simultaneously, with the face of each just, [*sic*] as large and intimate as now seen on a conventional screen when only one player is given a full closeup."[49] Similarly, Jacques Rivette claims that the essential point about CinemaScope is "the fact that visual range is not extended at the expense of closeness."[50] Although contemporary commentators thus emphasized the new capacity to portray *more profilmic material at a comparable scale* to the old close-up, an examination of *East of Eden* raises a question: What happens when the CinemaScope camera reverts to previous approaches to close framing, presenting a *comparable amount of profilmic material at a dramatically increased scale*? While Kazan's use of close framing supports Bordwell's point that widescreen filmmaking ultimately accommodated the classical Hollywood style, it also compels us to consider how the big screen transformed the address of this classical device—as well as that of other elements of film style including staging, camera movement, and performance.

EAST OF EDEN IN CINEMASCOPE

I'm also kind of enjoying Cinemascope. It's a problem, a new one,
and I think I'm getting something unusual out of it.
—Elia Kazan during production of *East of Eden*[51]

Despite Kazan's suggestion that his use of CinemaScope in *East of Eden* was "unusual," much of the movie reflects the mise-en-scène aesthetic advocated by Zanuck and highlighted in scholarship on widescreen. Throughout the body of the film the most striking departure from the new norm is Kazan's emphasis on shot composition, including bilaterally symmetrical frames, as well as sharply canted ones—both of which broke with the usual approach to widescreen cinematography, which, as Barry Salt has observed, emphasized conventionally balanced compositions.[52] Referring to the canted compositions, which also entail unusual depth of field, Bordwell contends that "Kazan seemed to be trying to become the Orson Welles of Scope."[53] Notably, Kazan's approach to filmmaking shifts at the film's emotional conclusion, which replaces such attention-grabbing long shots with close framing and shot/reverse shot editing. However, with screens so large that, as Belton puts it, there was, "for all intents and purposes, no sense of any borders at the edges of the frame," Wellesian composition and close framing offered viewers a different relationship to the cinematic spectacle than they did with earlier screens.[54] Bosley Crowther, for one, proclaimed that the film's "pictorial stylization" was "new and audacious in CinemaScope."[55]

Scholarship dealing with *East of Eden*'s themes has focused on the relationship between Cal Trask (James Dean) and his father, Adam (Raymond Massey), with relation to Oedipal issues, taken to be reflective of (1) social and cultural changes in 1950s America, including the rising interest in juvenile delinquency, the questioning of authority, and postwar struggles with masculinity; (2) Kazan's own biography, which entails rebellion against a domineering father; and (3) a rechanneling of Kazan's political energies in the wake of his House Committee on Un-American Activities (HUAC) testimony.[56] Discussions of the film's style have overwhelmingly highlighted its canted compositions, which are most often viewed as excessive stylistic flourishes.

The *Movie* critics, in particular, opposed such self-conscious use of "rhetoric," with Jim Hillier citing the canted compositions as "unnecessary and aesthetically disruptive" and Robin Wood claiming that these "stylistic aberrations" contribute to the film's grotesqueness.[57] Even Kazan's biographer, Richard Schickel, contends that Kazan's use of canted framing in *East of Eden* is "uncommonly pretentious by his usual standards."[58] Another point of entry into the film is through James Dean, whose performance as Cal is understood not only to lay the groundwork for Dean's star persona but also (rightly or wrongly) to exemplify the Method acting associated with the Actors Studio, which was cofounded by Kazan, Robert Lewis, and Cheryl Crawford and run by Lee Strasberg.[59] Exploring *East of Eden* with an eye to its exhibition in CinemaScope shows how staging, framing, camera movement, and performance conspired with the scale of the new screens to address viewers in a way that could be viewed as simultaneously disconcerting and affecting.

As we have seen, the mise-en-scène aesthetic generally considered appropriate for the format favors unobtrusive camerawork and minimal editing to realize the dramatic potential opened up by the increased sense of space offered by the wide screen, especially at sizable camera distances. Kazan harnesses the format's wider view this way to underscore Cal's alienation from his father and brother.[60] The new aspect ratio allows the director to position Dean repeatedly in the background and on one side of the frame while other actors occupy the foreground on the other. For example, when the film introduces Cal's brother, Aron (Richard Davalos), and his intended, Abra (Julie Harris), the happy couple walks along the road in the middle foreground while Dean traipses behind them, moving through trees in the background, back and forth between the extreme right and left edges of the frame. When the film introduces Adam, discussing his new investment in the left foreground—in a scene that, as Kazan's notated script indicates, dramatizes Cal's "history of rejection and the anger that builds up from it"—Cal, again, lurks in the right background (fig. 2.2).[61] While it is certainly possible to juxtapose characters in such a way in Academy-ratio films, widescreen eliminates the need to reduce their screen size in order to achieve this effect. When Dean moves into the background in these shots, the large screen allows his facial expressions and body language to remain legible, illustrating Rivette's point about

FIGURE 2.2 In *East of Eden* the CinemaScope frame emphasizes Cal's alienation from his father. (Warner Bros., 1955)

the ability to retain closeness despite the extension of visual range. (Dean tends to move in and out from behind elements in the mise-en-scène—here, trees and a post—emphasizing this new legibility by periodically withholding it.) Moreover, the new aspect ratio allows for an increased sense of distance between the left and right edges of the frame, enhancing Kazan's ability to literalize the gulf between Dean and his family members within the shot. As Lisa Dombrowski notes, regarding a later scene, Kazan's CinemaScope composition "dramatically illustrates the gulf that separates father and son in a more overt manner than would be possible with the smaller Academy frame."[62]

While *East of Eden* thus reflects the general belief that widescreen enhanced the capacity to use space, rather than cinematography or editing, in Cynthia Contreras's words, "to suggest relationships," the new spatiality offered by widescreen was not restricted to the portrayed image.[63] In addition to providing a purportedly more verisimilar depiction of space onscreen, widescreen transformed the experience of theatrical space as well, with the new image size and aspect ratio, together with the screen's placement in front of the proscenium (and, initially with CinemaScope, its curvature), reputed to blur the boundaries between image and theater space. By offering an experience of immersion in the cinematic spectacle, in other words, widescreen rendered screen space as the viewer's environment. In this sense widescreen echoed other immersive media such as the nineteenth-century panorama, which, as Tom Gunning argues, "functioned as an

environmental, rather than simply a representational, form, creating a new space as much as it represented one."[64]

This transformation in the viewer's experience of spatiality has important implications for the effect of staging. We can appreciate the significance of this change by comparing the effect of a shot in *East of Eden*, which situates Cal and Adam at opposite edges of the dining room table (fig. 2.3), with the famous sequence in the Academy-ratio *Citizen Kane* (Orson Welles, 1941) that positions Kane (Welles) and his first wife, Emily (Ruth Warrick), in a similar way (fig. 2.4). Whereas the visible Academy-ratio frame underscores the ontological distinction between the space of the diegesis and that of the auditorium, the widescreen frame, which lies outside the viewer's central field of vision, presents an image that seems to constitute the viewer's own physical space. So, whereas Welles positions Kane and his wife on opposite sides of the frame, Kazan—thanks to CinemaScope—positions Cal and his father on opposite ends of the theater. Thus, whereas this use of blocking in *Kane* functions mainly to communicate information (the viewer learns that the Kane marriage has dissolved), the scene in *East of Eden* also affects the viewer's physical environment. The distance between Cal and Adam is not only depicted by the film but experienced physically by the viewer, the two characters now occupying different enough spaces in the movie theater (assuming a large CinemaScope installation) that the viewer must move his or her head in order to look from one to the other.

Such a physical address was the very thing the *Sight and Sound* critics decried as inimical to aesthetic distance. These examples from *East of Eden*, however, indicate that widescreen's bodily address was not limited to the sensational thrill rides offered by *This Is Cinerama* and punctuating early CinemaScope releases. They suggest that CinemaScope's bodily address could affect the experience of narrative as well, increasing the viewer's experience of empathy—allowing him or her to feel *with* rather than simply *for* the situation and people depicted onscreen.[65] Charles Barr outlines such a view of widescreen's capacity to elicit empathy. Claiming that the shots from the nose of the airplane that conveys the servicemen home in the Academy-ratio film *The Best Years of Our Lives* (William Wyler, 1946) give us "direct insight into their sensations and through this into 'what it is like' generally for them," he contends that "Scope automatically gives images like

FIGURE 2.3 A large CinemaScope installation positions Cal and his father not only at opposite ends of the frame in this shot but at opposite ends of the theater. (Warner Bros., 1955)

FIGURE 2.4 A scene from *Citizen Kane* represents the emotional distance between husband and wife. (RKO, 1941)

this more 'weight.'"[66] With the dining room scene from *East of Eden*, for instance, the new experience of spatiality provided by widescreen offers the viewer a visceral experience of the distance between father and son, as well as intellectual knowledge about it.[67]

Acknowledging this bodily address permits us to view Kazan's more self-conscious stylistic choices—including his use of camera movement and canted composition—in continuity with his more conventional deployment of mise-en-scène. As does the staging described above, Kazan's use of camera movement in *East of Eden* invites the audience to share physically in Cal's unease. For instance, Kazan mounts the camera on a train to picture Cal as he writhes on top of one of its cars, allowing the visceral feeling of motion provided by the moving widescreen camera to enhance the disquieting experience of the boy's discovery that his mother is the town madam. At the climax of the film, after Cal has not only told Aron that their mother is alive but brought him to her brothel to meet her, Kazan cants the camera back and forth as Cal, on a swing, informs their father of his misdeed—one of the moments often singled out as an unnecessary rhetorical flourish (fig. 2.5). Rather than simply calling attention to itself, however, the motion of the widescreen camera here, too, conspires with the narrative to produce a very physical queasiness in the audience.

Kazan's deployment of sharp camera angles produces such an effect as well. Because the image now immerses the viewer, acting as his or her environment, severely skewed lines not only express psychological states but allow the viewer to experience them. Kazan uses such canted angles in two key scenes conveying Cal's emotional turmoil. In the first Cal discovers that the story Adam has always told him and Aron about their mother's death is a lie. Although the scene is introduced with an assertively symmetrical composition, Kazan cuts to canted angles when trouble erupts between father and son. In the second scene Adam rejects the monetary gift Cal has worked hard to present to him, considering Cal's attempt at benevolence an act of callous gain from the suffering of others. Again, the straight lines of the family home are presented at sharply canted angles as Cal registers his failure (fig. 2.6). In both of these scenes CinemaScope allows the off-kilter compositions to surround the viewer, urging him or her to experience viscerally the disquieting feeling presented onscreen.

FIGURE 2.5 In *East of Eden* the camera cants back and forth as Cal swings forward and back. (Warner Bros., 1955)

FIGURE 2.6 CinemaScope allows the off-kilter compositions in *East of Eden* to constitute the viewer's own environment. (Warner Bros., 1955)

While the canted compositions are certainly the film's most atten-tion-grabbing departure from CinemaScope norms, its use of close framing also underscores widescreen's new, potentially destabilizing mode of address. It was the decision to ignore Warner Bros.' sugges-tion that he keep the camera a sizable distance from the actors that Kazan has identified as a highlight of the production.[68] Asked years later about the difficulties CinemaScope presented, he quoted George Stevens's quip, "They finally found a way to photograph a snake," and

explained, "So we all knew the problems. But I'll never forget the day I kept pushing the camera in."[69] This approach to camera distance manifests itself in two notable ways. In the first place Kazan frequently positions objects and actors in the close foreground in order to create internal frames, which, he claims, ease transitions from shot to shot (fig. 2.7). He contends that this technique "was often copied by other directors," and he cites it as evidence that he "did break a little ground."[70] Additionally, he sometimes photographs his actors from a distance significantly closer than was the widescreen norm at the time. Admitting that the shots in which he and cinematographer Ted McCord pushed the camera closer than six feet displayed some distortion, becoming "curved at the sides," he explains, "Sometimes I moved the camera very close and used the distortion to help the drama."[71] Such shots are most extreme—with the framing approximating that of traditional, Academy-ratio close-ups—in the climactic confrontation among Abra, Cal, and Adam.

While earlier widescreen films included scattered close-ups, they tended to be few and far between. In addition to the distortion present in CinemaScope close-ups and the (related) fact that the new systems were heralded as particularly suited to large landscapes and spectacular fare, such close-ups, as we have seen, also ruptured norms governing the scale of imaged bodies. However, despite what *Movie* writers Stuart Byron and Martin L. Rubin identify as the film's overall paucity of close-ups—and despite Kazan's stated interest in the graphic nature of Dean's body—the climactic scene in the film presents a sustained succession of such close views and even employs conventional shot/reverse shot editing.[72] As Adam lies paralyzed from a stroke, Abra urges him to show Cal that he loves him. Here, the camera does not move, the composition is unremarkable, and the actors are not blocked across the wide screen. Rather, this segment alternates between centered close-ups and medium close-ups of Abra and Adam (figs. 2.8 and 2.9). Next, Cal approaches his father. Adam now acts on Abra's advice, demonstrating his affection for Cal by asking for his help. Kazan presents this final exchange in a two-shot, yoking together close-up visages of father and son (fig. 2.10). This climactic sequence thus represents a significant break from the long-shot/long-take aesthetic prescribed for widescreen filmmaking.

FIGURE 2.7 In *East of Eden* Elia Kazan positions objects and actors in the close foreground to create internal frames. (Warner Bros., 1955)

FIGURE 2.8 Abra, in a close-up, confronts Adam in *East of Eden*. (Warner Bros., 1955)

FIGURE 2.9 Adam contemplates his relationship to Cal in a medium close-up. (Warner Bros., 1955)

FIGURE 2.10 This climactic sequence from *East of Eden* represents a significant break from the long-shot / long-take aesthetic prescribed for widescreen filmmaking. (Warner Bros., 1955)

Widescreen's reputed incommensurability with close framing was tied to its supposed inappropriateness for what were often called "intimate" movies. An early *American Cinematographer* article on Cinema-Scope voiced received opinion in stating that "CinemaScope is ideally suited to spectacle films in which most of the action can be played against huge outdoor panoramic vistas."[73] Indeed, shortly after securing ownership of the French lens system that Fox would adapt and market as CinemaScope, Zanuck wrote a letter to studio president Spyros Skouras insisting that the system's "main value lies . . . in the production of large scale spectacles and big outdoor films." Admitting that "in time we may find a way to use it effectively for intimate dramas and comedies," he nevertheless maintains that "at the present time, intimate stories . . . would mean nothing on this system."[74] After announcing that Fox would make all of its coming films in CinemaScope, Zanuck urged his staff to halt any work on "intimate comedies or small scale, domestic stories" in order to devote exclusive attention to the kind of spectacular fare purportedly suited to the new system.[75] It was for this reason that, Zanuck claims, he withdrew his support for *On the Waterfront* after working to develop the project with Kazan and screenwriter Budd Schulberg.[76] Although Zanuck ultimately changed his mind about widescreen's aptness for intimate films, admitting that "one of our most successful CinemaScope pictures [*Three Coins in the Fountain* (Jean Negulesco, 1954)] is based on an intimate story," even that film largely forgoes close-ups in favor of the established long-shot aesthetic.[77]

We can thus read Kazan's suggestion that *East of Eden* would not give viewers "the feeling of that big screen" as a response to the widespread belief that such big screens were only appropriate to large-scale spectacles. Indeed, Martin Scorsese has noted that *East of Eden* showed that "CinemaScope could suit an intimate family drama as well as vast frescoes."[78] And Kazan referenced *East of Eden* in describing how "tiny" a story was his earlier film *A Tree Grows in Brooklyn* (1945): "In the same way as *East of Eden* is the scale of Julie Harris' face and the little flicker in her eyes, so *A Tree*, too, is an intimate, interior story. The outside has to be there, but what is important is that I get the light in that little girl's eyes, the expression on her face, the feeling in her soul."[79] Thus, Kazan not only emphasized the intimacy and small scale of *East of Eden* (as well as the Academy-ratio *A Tree Grows in Brooklyn*) but also described it specifically with reference to the scale of the heroine's face and even the expression in her eyes. Given that alignment between the intimacy of the material and the scale of the face, it is not surprising that *East of Eden* employs the close framing that had been associated with such intimate material before the popularization of CinemaScope.

As much as the scale of the close-up asserted the potential intimacy of the CinemaScope film, however, so did the scale of the CinemaScope frame transform the effect of such an intimate shot. The exact size of portrayed figures, of course, varied with CinemaScope installations. While CinemaScope screen widths reached sixty-five feet at premiere theaters such as the Roxy in New York, as of 1956 American screens reportedly averaged about a thirty-foot width in medium-sized theaters.[80] It is perhaps this variation (and perhaps also exaggeration on Shamroy's part) that accounts for the difference between Shamroy's suggestion that the new screens could display five full figures with heads at a scale comparable to a close-up single on the old screens and Charles G. Clarke's more modest claim that the figure size in a CinemaScope *two-shot* was bigger than that in a traditional close-up.[81] While the amount of magnification offered by CinemaScope was variable, however, the increase in scale it offered was widely agreed to be significant.

The size of widescreen close-ups, in particular, was often portrayed as disturbing, with commentators using terms such as *unfamiliar* and even *horrifying* to describe the widescreen spectacle of larger-than-life bodies, as we saw in chapter 1.[82] Nicholas Ray integrates

this off-putting address into his filmmaking in *Bigger Than Life*, using close-ups not so much to guide attention or communicate charac-ters' emotions—as tends to be the case in classical filmmaking—as to portray Ed Avery's (James Mason) drug-induced monstrosity.[83] For instance, a massive close-up of Mason's clenched hand just after the opening credits provide the first indication that Avery is experienc-ing the health problems that will propel his ill-fated experiment with cortisone. The scene where Avery meets with the parents of his stu-dents—an incident that displays the extent of his transformation, as he ridicules his young charges—culminates with an extreme close-up of the star's countenance, conveying Avery's newfound grotesque-ness through its inhuman scale (fig. 2.11). Thus, while the film's title simultaneously describes Avery's cortisone-induced megalomania and the CinemaScope format itself, it is such massive close-ups that epito-mize the potential to render life bigger than ever before—and express anxiety about the implications of such a development.[84]

Despite Kazan's stated interest in their distortion, the close-ups culminating *East of Eden* do not convey monstrosity (although the film has been described as an influence on Ray, who screened it as he was preparing *Rebel Without a Cause*).[85] Far from mitigating "the feel-ing of that big screen," however, such shots actually emphasized its novelty and threat. With close-ups rendering actors, in Crowther's words, "large and imposing," widescreen transformed the experience of cinematic intimacy.[86] Although the new screen dimensions were generally understood to make viewers feel closer to the figures pre-sented onscreen, they also rendered those figures strange. Worrying about the gigantism of close-ups in its review of *The Robe*, *Newsweek* contended, "Until the wide-screen filmmakers find ways of combining wide-screen virtues with the more intimate values, they are often likely to find that they have an embarrassing monstrosity on their hands." Such monstrosity could encompass not only bodily proportions but also bodily movements. Indeed, *Newsweek's* further suggestion that "nobody wants to see a nuance as big as the side of a house" sheds light on the critical reception of the performances in *East of Eden*, especially that of James Dean.[87]

Although Kazan would later disparage Dean as having "no technique to speak of," during production of *East of Eden* the director described his crew's widespread respect for the young actor as "the big surprise

FIGURE 2.11 *Bigger Than Life* conveys a schoolteacher's drug-induced monstrosity with an extreme close-up. (Twentieth Century–Fox, 1956)

of the whole experience."[88] He wrote in a letter to his wife: "Jimmy is inventive and true. You're going to be surprised with him, I think. Amazingly he takes to movies like it was *his* medium. Like he owned it. None of the others do. Not Julie, not Jo, not even Ray Massey who's made a million. This kid acts for movies. He is like Jim Cagney or Spencer Tracy, except twenty three. He'll be a big star."[89] *Time* magazine's review of the film proclaimed Dean "unquestionably the biggest news Hollywood has made in 1955," and *Look*'s review announced, "This movie introduces a new star, James Dean."[90] The actor, of course, went on to become a 1950s icon after his untimely death on September 30, 1955, earning posthumous Academy Award nominations two years in a row, for his work in *East of Eden* and *Giant* (George Stevens, 1956), and quickly coming to be seen as what Nicholas Ray described as a symbol of "the aspirations and doubts of his generation."[91]

Despite Dean's ultimate validation, critical reception of his performance in *East of Eden* was mixed (and discussions of his acting often dominated reviews of the film). Critics frequently drew comparisons with Marlon Brando, whom Kazan briefly considered for the part and whom Dean is reputed to have idolized, with Crowther quipping, "That [Dean] follows the style of Mr. Brando is . . . disconcerting in the extreme."[92] Reviewers' discomfort with Dean's performance and the parallels with Brando had much to do with the actors' shared association with a "Method"performance style that emphasized physicality to an extent that overturned previous screen acting norms. For

instance, Andrew Sarris explains in his *East of Eden* review, "The many stylized mannerisms and movements that replace cogent dialogue are part of the Kazan-Strassberg [sic], Actor's Lab, East of Hollywood trend in motion pictures," and, he contends, "The acting is shaped to fit this style. It would be almost irrelevant to complain about the diction or vocal quality of James Dean. Kazan has called upon him for a physical performance of rare intensity and Dean has delivered in a role that completely lacks distinctive dialogue."[93]

Founded by Kazan, Robert Lewis, and Cheryl Crawford in 1947 and run by Strasberg beginning in 1951, the Actors Studio had its roots in the Group Theatre over which Strasberg presided in the 1930s.[94] Members of the Group—including Strasberg, Stella Adler (who was Brando's teacher and who had major differences with Strasberg), and Harold Clurman—were influenced by the work and teaching of the Moscow Art Theatre, which came to New York in 1923.[95] It was through Strasberg, in the context of the Group Theatre, that Kazan encountered the work of Constantin Stanislavsky and his protégés, including Yevgeny Vakhtangov and Vsevolod Meyerhold. Kazan explains that those with roots in the Group and eventually associated with the Method had "the same basic emphasis, which is fundamental: Experience on the stage must be actual, not suggested by external imitation; the actor must be going through what the character he's playing is going through; the emotion must be real, not pretended; it must be happening, not indicated."[96] There were differences among the practitioners, however, and Kazan criticizes Strasberg, in particular, for his emphasis on interiority. Kazan himself advocated an approach to directing that emphasized behavior, explaining that it was important to "[turn] your emotional resources on and off, this way and that, while at the same time directing the cunning of your body to the most telling external behavior."[97] This focus on behavior sheds light on Kazan's interest in Dean, whose body Kazan thought "was very graphic; it was almost writhing in pain sometimes. He was very twisted, almost like a cripple or a spastic of some kind. He couldn't do anything straight. He even walked like a crab, as if he was cringing all the time."[98] While Kazan has claimed that Dean had natural talent, he also complained of the actor's lack of training, contending that Dean would "either get the scene right immediately, without any detailed direction—that was ninety-five percent of the

time—or he couldn't get it at all," at which point Kazan would have to resort to giving him Chianti, a technique Kazan "used on occasion to supersede Stanislavski."[99]

Dean's intense physicality, described in the press as both awkward and exaggerated, was a major point of criticism in reviews of *East of Eden*.[100] The *New Yorker*'s review described Dean's acting as "unpredictable": "Sometimes he jumps up and down like a kangaroo, sometimes he giggles like a lunatic, and sometimes he is surly and offended," and added condescendingly, "He's a hard man to decipher."[101] Crowther, in particular, found this performance style overblown. He complained of all of the acting in *East of Eden*: "the demonstrations of [the characters'] torment are perceptibly stylized and grotesque." He went on to suggest that this was especially "true of James Dean in the role of the confused and cranky Cal. The young actor, who is here doing his first big screen stint, is a mass of histrionic gingerbread."[102] While Dean's performance style—whether attributable to the Method or the Chianti—certainly goes a long way in explaining this response, we must acknowledge the way in which the new, massive screens conspired with the actor's physicality in endowing this performance (and the others in the film) its purported grotesquerie. As Susan Stewart argues in her discussion of the figure of the gigantic, what she deems its "grotesque realism" is achieved through "microscopic description," which "both enlarges its object and 'makes it strange.'"[103] In the case of *East of Eden*'s presentation in CinemaScope—as Crowther himself anticipates in the quote heading this chapter—physical nuance, writ large, becomes grand gesture.

Despite claims that the physicality of Dean's acting rendered his performance stylized, the actor, like the Method itself, was also viewed as unusually authentic. Kazan and Ray both described Dean in terms of nakedness. Ray claimed that Dean "shied away from social conventions, from manners, because they suggested disguise. He wanted his self to be naked." Kazan distinguished him from Brando by explaining that Dean was "considerably more introverted, more drawn, more naked."[104] This naked persona projected the idea of an inner truth resonant with the contemporaneous popular interest in psychoanalysis.[105] It also offered an apt subject for the massive screen, which promised viewers deeper truths via the prospect of penetrating stars' veneers. In this sense Dean's persona resonates with Monroe's, which, as

Richard Dyer has argued, appealed to fans by evoking a sense of natural sexuality—even though she, as we have seen, simultaneously and paradoxically conveyed constructedness as well.[106] Both of these stars, magnified on the large screen, also tend famously to project a sense of vulnerability.[107] In this regard the portrayal of these icons further illustrates the tension between widescreen's evocation of a sense of power and its suggestion of human fragility.

With both Dean and Monroe, this suggestion of authenticity and vulnerability occurred not despite the actor's physicality but rather through it. As Leo Braudy contends, Method acting, too, posits the body as a means to access a truth understood to lie beyond language. (Indeed, we should not forget Monroe's mid-1950s involvement with the Actors Studio as well, even though it has been framed as a response to, rather than an influence on, the roles she played in films like *How to Marry a Millionaire*.)[108] Together with other 1950s countercultural phenomena such as beatniks, Method acting, Braudy argues, "helped establish an art based on the armature of the body. It was a text of the anti-text, a return to flesh and feeling, the magnification of a vulnerability that denied traditional forms along with their more detached commitment to order."[109] Although Braudy is not referring to the type of magnification offered by CinemaScope per se, the widespread interest in—and concern about—the implications of widescreen's treatment of the human body underscores the format's resonance with this discourse on bodily authenticity.

BODIES WRIT LARGE

And yet, as we say, they all move you.
—Bosley Crowther on the characters in *East of Eden*[110]

This examination of *East of Eden* suggests the extent to which Cinema-Scope's dramatically increased size inflected its mode of address. In particular, it indicates specific ways in which the new form of presentation simultaneously offered viewers a bodily encounter with the cinematic spectacle and altered how that spectacle could portray imaged bodies. This focus on a transformed cinematic experience of and with the human body recommends (at least) two ways of viewing the format's address.

The first and more obvious, especially given the 1950s context, is based in psychoanalysis and considers bodily display as the breaking-through of repression. The discourses on widescreen seem to support such a reading in their frequent reference to the way in which the format enhanced the viewer's capacity to scrutinize the actor's image for hidden truths. This psychoanalytic reading highlights the format's resonance with melodrama, which has often been described in these terms.[111] Indeed, the vogue for widescreen overlapped significantly with the flowering of the 1950s family melodrama, within which *East of Eden* has been grouped.[112] The above discussion of the widescreen close-up—viewed simultaneously as stylized and authentic, something that emphasizes the body's capacity to indicate truths beyond the realm of language—frames this device as a particularly apt vehicle for melodrama, which, in Peter Brooks's formulation, similarly attempts to convey moral and psychic truths through an aesthetic of "excess" that he likens to hysteria.[113] For Brooks melodrama moves viewers by rendering the everyday strange enough to allow it to be read as a sign of such occulted truths. While Brooks posits theatrical techniques such as tableau and stylized gesture as means to such revelation, my discussion of *East of Eden* has indicated that magnification on the large screens could operate in this way as well. This connection thus suggests one way in which the disorienting effect of Kazan's departure from widescreen norms—and in particular, his use of close framing— achieves an affective impact. Indeed, even Crowther, who criticized the film's characters as superficial, admitted that they nevertheless moved their audience—"whether to be compassionate or wroth."[114]

Method acting, with its interest in using the body to convey a sense of authenticity, has also been associated with psychoanalysis. Richard Dyer identifies the development of this performance style as an index of "how far psychoanalytic ideas, however garbled, had got under the skin of popular culture."[115] Christine Gledhill employs this connection to argue that Method technique, although purportedly a vehicle for realism, "drew realism towards melodramatic concerns." The Method's emphasis on physicality as a means for expressing the unconscious and emotion, conceived as "the essence of the personal self," she explains, marks "a return to the primal and ineffable gesture that underpins melodramatic acting for the access it offers to hidden moral drives and desires. Like the melodramatic persona, the Method actor

embodies conflicts, if not in terms of public rhetoric, then through an equally codifiable set of personal mannerisms, nervous ticks, inarticulate mumblings, and so on." The widescreen format would appear particularly apt for the display of this embodiment. Indeed, if, as Gledhill argues, the "intimate relations with the actor's body afforded by cinematography" in general compensate for the difficulties filmmaking presents for performers, CinemaScope, as we have seen, enhances such bodily intimacy.[116]

Although psychoanalysis provides a powerful model for understanding Dean's widescreen performance in *East of Eden*, it must be viewed in conversation with another, less popularly recognized but perhaps equally influential, means for understanding the function and effect of gesture: the concept of biomechanics developed in Soviet theater by Vsevolod Meyerhold. Although Strasberg's Method is well known to have roots in Stanislavsky's "System," Strasberg was particularly inspired by Stanislavsky's estranged student Meyerhold, whom Strasberg deemed "the greatest director of all times."[117] Describing his own tutelage to Strasberg, Kazan recounts, "Lee was especially enthused over the work of Meyerhold, and he described to us, in scene-by-scene detail, the master's productions of *Camille* and *The Inspector General*. . . . I was fascinated."[118] Although Kazan took issue with Strasberg, his criticism revolves around Strasberg's inability to emulate Meyerhold; while "Lee was a deeply introspective man and restrained in his physical expression" with "no facility for stage movement," Kazan contended, "the man he'd chosen for his ideal and his inspiration, V. E. Meyerhold, was his opposite. No choreographer was ever bolder." Indeed, Kazan claims that Meyerhold "was a director whose work I'd studied and admired"—repeatedly quoting him as saying that "words are decorations on the hem of the skirt of action"— and Kazan suggests that the director's execution by the Soviet government "fed my anger at the Party."[119]

Recognizing Meyerhold's importance for Kazan underscores the fact that the latter's emphasis on physicality need not be understood exclusively according to the concept of expression with which Method acting is often associated. Influenced by the "objective psychology" that had become prominent in America and Russia in the early twentieth century—including William James's thinking on the physiological root of emotions and Ivan Pavlov's work on conditioned reflexes—

Meyerhold believed that actors arouse emotions reflexively through the proper placement and movement of the body.[120] This approach was described by one of his assistants: "The art of the actor is manifested in movements, which by means of 'will,' convey a brilliance, a vividness, and a facility for infecting the spectator."[121] Although Strasberg maintained a strong interest in interiority, we can view Meyerhold's continued (if mutated) influence in Strasberg's suggestion regarding the Actors Studio that "contrary to popular belief, our work is really Pavlovian, the conditioned reflex theory, rather than Freudian."[122]

Meyerhold's idea of affective engagement through physical mimesis was taken up and applied to cinema by his pupil, Sergei Eisenstein, as well as by Walter Benjamin.[123] Miriam Hansen has suggested the aptness of this view of spectatorial address for the mass medium: "The recourse to neuro-physiological, mechanistic, and reflex psychology may not be as sophisticated as the insights of psychoanalysis; yet it may have been more in tune with new, technically mediated forms of aesthetic experience, predicated on mass production, unprecedented circulation and mobility, and collective, public reception."[124]

In chapter 1, I argued that the discourses surrounding the emergence of widescreen in the 1950s instantiated in some ways the observations that Benjamin made about cinematic experience in the 1920s and 1930s insofar as the format further collapsed the distinction between body and image space and invited viewers into close, mimetic contact with the new spectacle. This discussion of *East of Eden*, particularly as it brings together CinemaScope, close framing, and Method acting, further supports the idea that the sense of proximity widescreen offered did not simply enhance viewers' capacity to read actors' bodies as signs but also invited them into tactile contact with these bodies, offering the opportunity to inhabit the motions—and emotions—portrayed onscreen.

While this form of experience may be read as reactionary, especially insofar as it encouraged viewers to conform to the capitalist, patriarchal, and white supremacist ideologies rampant in Hollywood widescreen films of the era, I would contend, following Dyer's argument about stars generally and about Monroe in particular, that Monroe's and Dean's figures, although certainly not subversive (even Dean's rebellious adolescents ultimately seek social approval), nevertheless activated contemporary concerns about humanness, particularly

relating to received ideas about gender and sexuality.[125] In magnifying these figures to overwhelming proportions, the CinemaScope screen—and the new approaches to and experiences of close framing it made possible—offered viewers a particularly intimate encounter with these conflicts and thus encouraged them to conform to the ideologies they projected while simultaneously offering a potentially productive experience of alterity.

Ultimately, I do not want to suggest that a mimetic concept of spectatorial engagement is more appropriate to widescreen than is the more entrenched psychoanalytic framework so much as to highlight what the two approaches share—namely, a faith that the body plays a central role in experience. While each has been posited as a means for describing cinematic experience broadly, their particular relevance to widescreen and the context of 1950s America is crucial to their validity as explanatory models. As chapters 3 and 4 will elucidate, very different formulations of affectivity arose alongside digital cinema almost fifty years later. While we find with widescreen pervasive tensions regarding bodies' relationships with the new technologies (and the social, economic, and political forces with which those technologies are linked), conceptions of digital cinema's bodily address are fraught in a very different way.

DIGITAL CINEMA'S HETEROGENEOUS APPEAL

Debates on Embodiment, Intersubjectivity, and Immediacy

You don't so much watch it as download it, and it crashes your brain.
—Matt Zoller Seitz on *The Matrix*[1]

The increasing ubiquity of electronic and digital technologies has been a major concern in cinema studies over the past two decades. In the broader field of media studies the legacy is longer. However we view the relationship between these disciplines, one thing they share is a profound lack of consensus about these technologies.[2] Within cinema studies, arguments have ranged from the claim that digital—and sometimes electronic—technologies radically alter cinema's ontological relationship with the world to the contention that these technologies do not fundamentally transform the experience cinema offers at all.[3] Recently, prominent scholars have also drawn attention to the ways in which cinema's increased digitization compels us to reevaluate assumptions about cinema's historical status as medium, apparatus, and institution.[4] On one hand, the new prevalence, both within and around cinema, of information technologies—what sociologist Manuel Castells identifies as the "converging set of technologies in micro-electronics, computing (machines and software), telecommunications/broadcasting, and opto-electronics," as well as genetic engineering, which align cinema with a brave new economic and social

order marked by globalization, convergence, and simulation—has been taken to significantly transform the industry and institution, as well as the ontology of cinema.[5] On the other hand, productive work has been done to problematize the claim that cinema (and cinema studies) has therefore been fundamentally destabilized, showing how transnational flows, intermedial relationships, and institutional and material heterogeneity have long endowed the definitions and functions of cinema with a certain synchronic and diachronic porousness.[6] Within media studies evaluations of information technologies and their implications run the gamut from utopian celebrations of enhanced connectivity and freedom to dystopian claims about human beings' increased isolation and subjection to new forms of control.[7]

One of the ways an exploration of digital cinema's appeals contributes to the scholarly discourse is by underscoring a heterogeneity in conceptualizations and evaluations of the digital that many theorizations, in the push to define the contours of a new cultural or ontological regime, do not sufficiently acknowledge. This heterogeneity is integrally linked to the diversity of digital technology's applications in cinema—including digital previsualization, cinematography, sound, nonlinear editing, visual effects, projection, and distribution through the Internet—which have been evaluated according to diverse industrial and aesthetic traditions. To do justice to the complexity of the perceived transformation in spectatorship associated with the coming of digital cinema, I contend, we must parse the various, overlapping, and often competing discourses that these applications have inspired. This approach mediates debates about whether the new technologies radically alter cinema, showing how digital cinema has been treated as much more than a move from continuous to discrete forms of inscription, extending to entail significant yet diverse changes in practice.

This heterogeneity does not foreclose the possibility of making claims about this recent instance of technological change. On the contrary, this chapter shows how even otherwise divergent discourses on digital cinema frame their evaluations of that cinema's implications for spectatorship according to certain shared, historically contingent criteria. Specifically, whether the millennial discourses on digital cinema celebrated the utopian potentials of the new technology or warned of its dangers, they often rooted their claims in ideas about

transmission—ideas about flows of information or affect and their blockages. In this respect the argument I make here follows the lead of work in media studies, which has emphasized the importance of such flows within the contemporary social, economic, and technological landscape, as well as for earlier, related developments including the elaboration of cybernetics in the 1940s and discourses on electricity since the nineteenth century.[8] Norbert Wiener described the conceptual shift distinguishing the cybernetic systems he was instrumental in developing during World War II from the machines of the "first industrial revolution" in terms that echo the way in which the discourses on digital cinema diverge from the earlier discourses on widescreen. Whereas the older machines were governed by the concepts of energy and power, Wiener claimed, "The machine appears now, not as a source of power, but as a source of control and communication. We communicate with the machine and the machine communicates with us. Machines communicate with one another."[9] Although this statement coincided historically with the height of the widescreen "revolution," this concept of communication did not play a significant role in concurrent discussions of widescreen technology. By the end of the 1990s, however, public discourses evaluated digital movie technologies and the "films" employing them according to claims about the facilitation or obstruction of communication.[10]

In conceptualizing cinema's appeals in these terms, the discourses on digital cinema raise related issues central to debates about information technologies in media studies. In particular, nonacademic commentators on the coming of digital cinema articulated, as have "new media" scholars, a conviction that digital technologies were changing the experience of immediacy, the shape of intersubjectivity, and the relationship between sensual experience and the body. At the same time, and again as with the scholarly discourses, evaluations of this change diverged sharply. Far from attempting to resolve these debates—whether to show that digital technologies have or have not attenuated cinema's truth value, detracted from its collective dimensions, or diminished the body's role in spectatorial experience—a focus on cinema's appeals identifies these tensions themselves as valuable indications of the concerns according to which the experience offered by cinema was depicted and evaluated in conjunction with this recent instance of technological change.

This focus contributes to debates on digital technology within cinema studies by reframing questions about cinema's continued truth value and viewers' continued bodily engagement in cinematic experience to elucidate the shifting ways in which ideas about cinematic authenticity and embodiment themselves have been conceptualized. That the conceptualization elucidated here is significantly inflected by cinema's intermedial context in the late 1990s may seem to support ideas about convergence—the notion that, as various media adopted a common base in code, they would merge both theoretically (as in arguments about the dissolution of the concept of the medium) and practically (as in the corporate race to capitalize on the new fluidity among media).[11] Indeed, descriptions of the new form of experience digital cinema could or would offer often reflect contemporary ideas about digital technology generally—especially ideas about the immateriality and transmissibility of information—which seem to have more to do with the experience of personal computers than with any material changes the rise of digital technologies were bringing about within cinema itself. The struggles described in the pages to follow over how to understand digital technology's implications for movie spectatorship thus provide a glimpse into broader ideas about how human experience was changing along with an increasingly digitally mediated environment around the turn of the millennium. At the same time, ideas about cinema (including its economic, social, and material configurations) remain vital in the discourses examined here, and comparison with the emergence of widescreen makes it possible to map the ways in which the conceptualization of digital spectatorship articulated in the late 1990s and early 2000s not only reflected the cultural pervasion of information technologies broadly but also contributed to a reevaluation of the appeal of cinema itself.

THE EMERGENCE OF DIGITAL CINEMA

The coming of digital cinema differed from the transition to widescreen in a number of ways. Unlike the earlier instance of innovation, the emergence of digital cinema was both diffuse and gradual. Converting to widescreen entailed adopting a number of different elements, from new camera equipment to new sound systems, screens, and projectors or projection lenses. Although exhibitors might have

been able to do without the stereophonic sound systems and curved screens, converting to widescreen for the most part meant adopting the whole package all at once.[12] Exhibitors needed a three-projector Cinerama setup, for example, to show a movie shot with Cinerama's three-lens camera. "Digital cinema," in contrast, is not a system. It is a label that came to be used to refer to movies incorporating digital technology at some point in their making, distribution, or exhibition, although this point varies from film to film.

Moreover, the process by which digital technology permeated cinema was quite slow, influencing visual effects, sound, and editing years before digital cameras and exhibition platforms were widely used, creating a period of hybridity that prompted some to analogize movie technology to a sandwich with digital filling surrounded by analog bread.[13] Analog computers were used to create moving images as early as 1957 (most famously by John Whitney Sr.), with digital computers deployed for this purpose in the 1960s.[14] Director Michael Crichton digitally manipulated filmed images with *Westworld* (1973). In 1977 both *Star Wars* (George Lucas) and *Close Encounters of the Third Kind* (Steven Spielberg) displayed extensive use of computer-assisted motion control. Digital animation and image synthesis gained prominence throughout the 1980s and early 1990s, culminating in films such as *The Abyss* (James Cameron, 1989), *Terminator 2: Judgment Day* (James Cameron, 1991), *Jurassic Park* (Steven Spielberg, 1993), *Forrest Gump* (Robert Zemeckis, 1994), and *Toy Story* (John Lasseter, 1995). Digital sound was introduced in 1990. And digital editing systems began replacing mechanical systems in the late 1980s, pervading the industry by 1995.[15]

Despite these earlier developments, it was in the late 1990s that the concept of digital cinema became a powerful force in the industrial and popular media, and in 1999 and 2000 outlets ranging from *Variety* to the *New York Times*, *Newsweek*, and *USA Today* offered a barrage of articles musing about how significantly cinema was changing.[16] It was during this period that the prospect of a completely digital cinematic "sandwich" became tangible.[17] The viability of digital cinematography was demonstrated when two digitally shot features from Denmark, *The Celebration* (*Festen*) and *The Idiots* (*Idioterne*, Lars von Trier), gained recognition at the 1998 Cannes Film Festival.[18] Often citing such films as an inspiration, several American independent

companies devoted to digital production were formed the following year.[19] Additionally, new possibilities for digital distribution and exhibition, from the digital video disc (DVD) to digital projection and web streaming, were popularized during this period. DVD was introduced in 1997.[20] Websites including IFilm.net and Atomfilms.com made news in 1999, the same year the release of *Star Wars: Episode 1—The Phantom Menace*, as was widely publicized, included four screens with digital projection.[21] In this period Hollywood also began utilizing digital intermediates (DI) in feature filmmaking, first partially with *Pleasantville* (Gary Ross, 1998) and first entirely with *O Brother Where Art Thou?* (Joel and Ethan Coen, 2000).[22] While the term *digital cinema* was often employed to refer specifically to digital projection, the term also bore a broader significance, encapsulating the potential for a cinema dominated by digital technology.[23]

Discussions of digital cinema in this period reflect two different trends. On one hand, there was a steady interest in big-budget digital visual effects with films like *Titanic* (James Cameron, 1997), *The Matrix* (Larry and Andy Wachowski, 1999), and the first two *Star Wars* "prequels," *Star Wars: Episode 1—The Phantom Menace* and *Star Wars: Episode II—Attack of the Clones* (George Lucas, 2002). At the same time, there was a surge of interest in ultra–low budget filmmaking made possible by the introduction and popularization of high-quality but inexpensive digital cameras and editing software. This independent digital cinema movement gained widespread recognition in 1998, with the success of *The Celebration*, in particular, at Cannes; the attention given to the Dogma 95 movement it inaugurated; and the publicity surrounding digitally shot American independents, including *The Cruise* (Bennett Miller) and *The Last Broadcast* (Stefan Avalos and Lance Weiler). That recognition continued into 1999, when *The Blair Witch Project* (Daniel Myrick and Eduardo Sánchez), which was shot on film and analog video, caused a sensation with its unprecedented use of Internet marketing.[24]

The concept of digital cinema was thus popularized as digital technology began to play a prominent role across the different components of production, postproduction, distribution, and exhibition, although for the majority of even those films associated with digital cinema during this period, it did not pervade all of these stages at once. While there was a good deal of attention paid to digital *effects* in the early

1990s and a strong scholarly interest in electronic and digital media in the preceding decades, it was with the emergence of the independent digital movement, when digital technology was widely treated as a dominant across the different stages of the filmmaking process, that the idea (if not, immediately, the actuality) of an integrated digital *cinema* took hold.[25] This chapter focuses on that period, beginning in 1997, the year *The Celebration* was produced, and extending to 2002, when *Attack of the Clones'* highly publicized reliance on digital cameras presented the prospect of an integrated digital cinema on a massive scale.[26]

As the juxtaposition of Danish art film *The Celebration* and Hollywood blockbuster *Attack of the Clones* makes clear, the discourses on digital cinema, emphasizing heterogeneous industrial contexts and cinematic institutions, also display disparate—and often conflicting—aesthetic interests and values. Whereas discussions of digital visual effects continued to participate in the long-standing tug-of-war between spectacle and realism in cinema, discussions of independent cinema often viewed digital technology (referring, in this case, not to effects but to the minimal production apparatus made possible by digital cameras) as a means for enhancing forms of intimacy and immediacy long posited in opposition to studio filmmaking.[27] Considering discussions of Hollywood effects cinema together with discourses on independent digital cinema not only complicates the attempt to associate digital technology with cut-and-dried attitudes toward cinematic authenticity and spectatorial experience; it also underscores shared concerns, including concerns about digital technology's implications for the experience of intersubjectivity, the idea of authorship, and the potential for an unmediated relationship with the world, as I elaborate below.

Another significant difference from widescreen is that digital cinema's conceptual boundaries are quite difficult to delineate—a difficulty that is exacerbated by our lack of historical distance. While the line separating widescreen from Academy-ratio cinema is easily drawn, the hybridity and heterogeneity discussed above complicate the attempt to differentiate digital from analog cinema. Additionally, although the concept of discrete coding theoretically distinguishes the digital from the analog, many theorists posit analog video as an intermediate step between film and digital cinema, raising the question of whether the important disjuncture might be between mechanical and electronic technologies rather than between analog and digital ones.[28]

Moreover, as Philip Rosen has pointed out, discussions of digital cinema have often been based not on a description of the present, hybrid condition of the technology but on a forecast of a supposedly digitally pure future.[29] Whereas commentators on the coming of widescreen in the 1950s referred to systems that already existed in more or less complete form, those discussing the emergence of digital cinema in the late 1990s envisioned a potential configuration that was still coming into existence. One of the benefits of approaching digital cinema by way of its appeal is that the futurity of the concept is not so much a problem as a point of interest. For the purpose of the present discussion digital cinema's status as a forecast underscores its identity as a concept and emphasizes the fact that this instance of cinematic change was as much epistemological and experiential as it was technological. In this sense the messiness of the digital moment is instructive for approaching seemingly more clear-cut instances of technological change, like the coming of widescreen, insofar as it calls our attention to the diversity of definitions, attitudes, and experiences that precede and are often eclipsed by the emergence of consensus.

A final key distinction between the emergence of digital cinema and the coming of widescreen is that, even during the peak years of 1998 to 2000, when digital cinema received a great deal of attention in the press, it was not presented or discussed as providing the type of revolutionary new cinematic experience that widescreen was reputed to offer. This is perhaps due in part to the heterogeneity discussed above and probably also in part because, relatedly, no one corporation held a vested interest in marketing the overarching concept of "digital cinema" itself. More fundamentally, digital technology did not drastically transform cinema's theatrical presentation in the way the coming of sync sound, color, or widescreen did—a fact that has led John Belton to deem the emergence of digital cinema a "false revolution." As Belton observes, those earlier innovations provoked periods in which the viewers' attention was focused on the filmic apparatus itself.[30] The result has been moments in which the spectacle of new cinematic possibilities—from moving images themselves, to Technicolor extravaganzas, to Cinerama's thrill rides—have complicated the idea that the cinematic apparatus occludes its mechanism in the service of illusion. By contrast, digital cinema did not, in this period, introduce a radically new perceptual dimension or alter the shape, size, or positioning

of the screen.[31] Indeed, Belton argues that the studios' more recent resurrection of 3D as a consummate digital technology represents an attempt to endow digital cinema with such spectacular appeal even though stereoscopic spectacles themselves are far from novel.[32]

The forays into digital cinematography and projection that took place in the late 1990s and early 2000s were presented by industry executives and critics alike as advancements in the efficiency of filmmaking that, if done well, would be invisible to theatrical audiences. Discussions of digital cameras and projectors often focused on whether the new equipment successfully replicated the look and experience of film.[33] And new tools—such as an After Effects plug-in called "CineLook," which was marketed to independent filmmakers—were designed to make digital video appear more like film (with CineLook reintroducing the dust, hair, dirt, scratches, and stains that, in other contexts, digital enthusiasts lauded the new technology for eliminating) (fig. 3.1). Despite the fact that *The Celebration* and *The Cruise* marked significant early experiments with digital cinematography, their advertisements did not even mention that technology (figs. 3.2 and 3.3).

This diffuseness, heterogeneity, and relatively unspectacular presentation should not be taken as mitigations of the significance of the emergent concept of digital cinema but rather as important elements of this instance of technological change. Digital technologies' uneven infiltration into the different layers and varieties of the cinematic sandwich in the late 1990s and early 2000s prompted a reconsideration in public and scholarly discourse of the relationship between cinema's material forms and its forms of address—the boundaries, constitution, and effects of what was once (rightly or wrongly) more confidently described as a unified cinematic apparatus.[34] In her wide-ranging history of windows and screens Anne Friedberg points to one of the ways this constitution was challenged, allowing that "perhaps, as films like *ExistenZ*, *The Matrix*, and *Strange Days* predict, the screen may dissolve; images and data will be 'uploaded' directly, bypassing the eye and the optics of vision."[35] Such a prediction attests to the perceived prospect that a digitally transformed cinema might forfeit both its material forms (including its screens) and its bodily address (including its mediation by the eye), reconfiguring cinema as yet another type of information to be transmitted. At the same time—and, paradoxically,

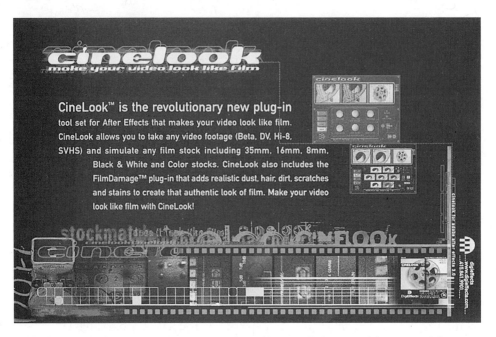

FIGURE 3.1 An advertisement for an After Effects plug-in called CineLook boasts its ability to make digital video appear like film. (*Res* magazine, Fall 1997)

accompanying not a disappearance of screens but a profusion of them—they grapple with just what it would mean for cinema to surmount this materiality.[36]

THE SPECTATORIAL FUTURE: TRANSMISSION, IMPLOSION, AND (DIS)EMBODIMENT

New York Press critic Matt Zoller Seitz's comment, with which I opened this chapter, analogizing spectatorship of *The Matrix* to importing data into a computer, was not meant to be taken literally; Seitz had not actually downloaded the film into his brain, nor is it likely that he believed people would or could do so. Such rhetoric sheds light, however, on the kind of lens through which cinema was being viewed at the end of the twentieth century. Seitz's comment, like Friedberg's, reflects a broader tendency in millennial musings on digital cinema to imagine that it could, in the imminent future, reconfigure spectatorship as a transfer of information into consciousness. In

FIGURE 3.2 An advertisement for *The Celebration* (October Films, 1998) avoids any mention of its digital cinematography. (*Time Out New York*, Oct. 22–29, 1998)

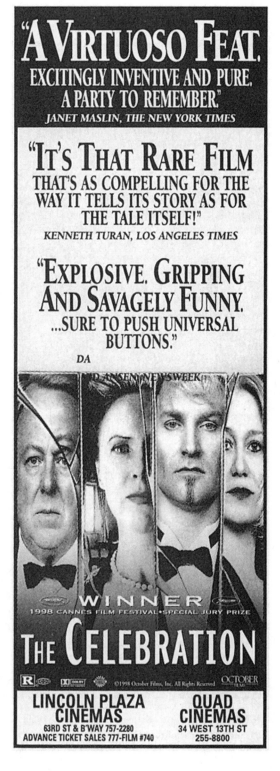

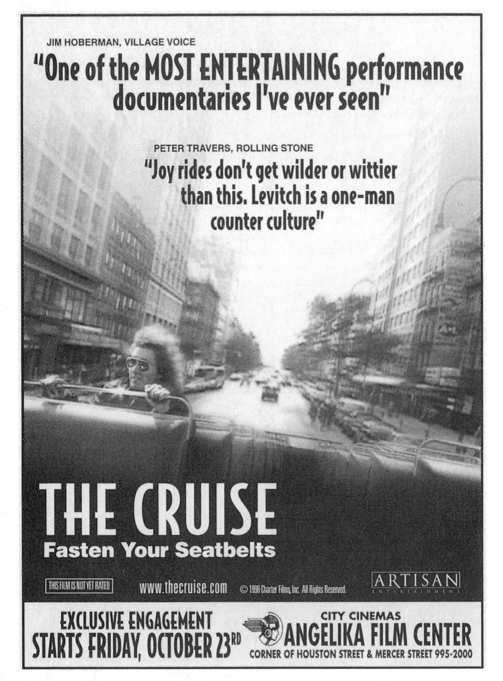

FIGURE 3.3 An advertisement for *The Cruise* (Charter Films, 1998) also eschews any acknowledgment of its use of digital video. (*Time Out New York*, Oct. 22–29, 1998)

1997, for instance, visual effects artist Douglas Trumbull declared, "We're not that far from being able to plant images, memories, and emotional states directly into the brain."[37] In 2002 Steven Spielberg forecast, "Someday the entire motion picture may take place inside the mind."[38] Whether or not such proclamations accurately predicted the cinematic future, they show how concerns central to concurrent debates about information technologies both within and outside the academy inflected the very parameters according to which spectatorship was conceived and evaluated.[39]

The futuristic depictions of spectatorship described in this section show how key concepts from more general discourses on information technologies—the concepts of transmission, implosion, and disembodiment—come into play in discussions of digital cinema. Each of the sections to follow focuses on one of these concepts and shows how it emerges in discussions of digital cinematic practice. In all of these cases we find divergent evaluations of the new technologies, as well as a strikingly consistent set of criteria framing them. As in the hyperbolic debates about information technologies of the 1980s and 1990s, prognoses for an increasingly digital cinema range from dystopian accounts of isolation and immobility to utopian visions of enhanced connectivity and fluidity of identity. At the same time, even the conflicting accounts often base their ideas about this instance of upheaval on the shared assumption that the prevalence of information technologies was affecting cinema's bodily address and its implications for intersubjective exchange. Ultimately, the resultant view of cinematic immediacy has implications for our understanding of cinema's continuing appeal to authenticity.

An illustration by Ron Barrett, which accompanied a 1999 New York Times article by Walter Murch entitled "A Digital Cinema of the Mind? Could Be," exemplifies how the future of digital spectatorship was imagined via ideas about the transmission of information (fig. 3.4). Captioned "Going to the movies in The World of Tomorrow," the image pictures the spectator of tomorrow as a giant head topped with the marquee, "Brainplex." Above the head, the mise-en-scène of science fiction—flying space gadgets made out of household appliances—mingles with particles labeled "incoming digits," which sprinkle into the satellite dish that emerges from its crown. A short arrow extends from the figure's eye to the place where its brain should be, which is

occupied instead by images from familiar movie genres. The insinuation here is that digital cinema could represent a step toward the most direct process of filmmaking and spectatorship possible, where digitization (the "incoming digit" particles) marks the only intermediary step between profilmic material (a toaster-and-umbrella satellite) and mental images (including the picture of a rocket ship). Like Friedberg, Seitz, Trumbull, and Spielberg, Barrett thus imagines spectatorship as a transfer of data into the mind—although, in this case, the caption "Going to the movies in The World of Tomorrow," with its reference to the 1939 World's Fair and its outdated vision of the future, frames the illustration as a satire of the more earnest predictions.[40]

This view frames spectatorial transmission in terms of a contemporary, popular understanding of information and consciousness as homologous, interchangeable, and immaterial. Such a view was put forth, for instance, by Ray Kurzweil, whose best-selling book of 1999 forecasted that "well before the twenty-first century is completed, people will port their entire mind file to the new thinking technology," and this idea can be seen in popular portrayals of computer technology entering or even taking the place of the human brain.[41] Such portrayals are prominent in Time magazine's June 2000 issue on "The Future of Technology," which featured a cover image showing a disc drive entering a human head and, in its interior, the illustration of a disembodied head whose brain has been replaced by circuitry (fig. 3.5).[42] In conceiving digital spectatorship according to such ideas, observers imagined that the new cinematic experience could also bypass bodily mediation. For instance, Barrett's spectator of the future, represented by only its head and foot, has no body. The movie images are housed inside the head, and the eye-arrow and label "incoming digits" project a movement inward, toward the "brain." Although we see the eye and mouth, these organs seem oddly unnecessary to the experience depicted, evoking the sensual experiences of sight and taste we associate with the movies yet themselves superfluous to a situation where images are beamed into the head via satellite, and snacks are housed and delivered internally.

Quoted in Wired magazine, Spielberg similarly identifies the future experience of digital cinema as "the most internal experience anyone can have."[43] The image Wired utilized to illustrate this prediction reduces the spectator's bodily presence to the faint image of a brain,

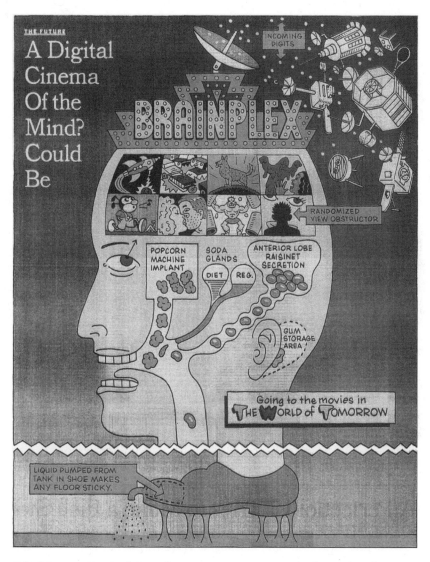

FIGURE 3.4 A *New York Times* illustration imagines spectatorship of digital cinema as a transfer of data into the mind. (Illustration by Ron Barrett, 1999; courtesy of the artist)

FIGURE 3.5 A *Time* magazine illustration suggests a homology between computer circuitry and the human brain. (Illustration by Marc Rosenthal, 2000; courtesy of the artist)

inside which is projected a large still of Humphrey Bogart and Ingrid Bergman in *Casablanca* (Michael Curtiz, 1942) (fig. 3.6). As in the "Brainplex," the disembodied, internal spectatorship of the future is presented as isolating, with the spectatorial mind portrayed as alone and decontextualized. Such depictions echo the theoretical tendency to associate information technologies with the idea of implosion, distinguishing the supposed mental inwardness of the "Information Age" from the emphasis on bodily extension attributed to the "Space Age."[44] This sense of isolation is also at the center of the article that accompanies Barrett's illustration, wherein Walter Murch worries that digital technologies' capacity for consolidation would eliminate the communal nature of both filmmaking and spectatorship.[45]

Science fiction films also envisioned the spectatorial future as one marked by the transfer of information among minds and computers. We see this explicitly in *Conceiving Ada* (1997), the debut feature film

FIGURE 3.6 *Wired* magazine portrays the future of spectatorship as disembodied and internal. (Illustration by Mark Wasyl, 2002, courtesy of the artist; still frame from *Casablanca* [Warner Bros., 1942])

of artist and new media pioneer Lynn Hershman Leeson—a film that made groundbreaking use of digital tools by combining, in real time, digitally composited backgrounds with live-action footage shot in Digital Betacam (eventually transferred to 35mm) against a bluescreen.[46] In the movie a computer scientist named Emmy (Francesca Faridany) develops a program that allows her to communicate with the long-dead computer language pioneer Ada Lovelace (Tilda Swinton). When Emmy finally makes contact with Ada, she explains to her, "I seem to be able to see through your eyes . . . through your memories." The film thus imagines that Ada's experience (her vision and memories) can be divorced from her body, encoded, and imported directly into Emmy's consciousness (fig. 3.7). In doing so, *Conceiving Ada*—like science fiction ruminations about digital technologies from William Gibson's 1984 novel *Neuromancer* to *The Matrix*—severs consciousness from embodiment, equating it with the purported immateriality of information and emphasizing its transmissibility. In contradistinction to the sense of isolation conveyed by the "Brainplex" and *Wired* illustrations, however,

FIGURE 3.7 In *Conceiving Ada* Emmy develops a computer program that allows her to communicate with long-dead computer pioneer Ada Lovelace. (Fox Lorber, 1997)

this depiction of connection among women in different eras echoes the hope, articulated by media theorists from Marshall McLuhan to Henry Jenkins, that information technologies would put people into closer contact with one another by facilitating the flow of information.[47]

Taken together, these technofuturist depictions of digital spectatorship reflect prominent theoretical claims about electronic and digital media, particularly the contention that contemporary mediated life is marked by a sense of inwardness wherein the body has become increasingly peripheral to experience.[48] However, these depictions also echo some of the rifts marking academic discourse. Most overtly, they illustrate competing, hyperbolic claims about information technologies' implications for intersubjectivity, as mentioned above. They also mediate ongoing debates about the continued relevance of materiality and embodiment in new media.[49] As N. Katherine Hayles has detailed, the idea that information is immaterial arises from the way Claude Shannon and Norbert Wiener influentially formulated the concept abstractly in terms of probabilities. Linking this concept of information with the emergence of an understanding of human

consciousness as something that is also immaterial (and thus plausibly transmissible), Hayles offers a strong argument that this view of information was not inevitable and is both inaccurate and frightening.[50] This deemphasis on materiality could be seen as a progressive move, allowing humans to transcend the bodily markers of race and gender that have led to so much discrimination (an attitude *Conceiving Ada* reflects by portraying the titular character's rebirth in the computer age as a liberation from the oppression she experienced in the past).[51] However, the drive to conceive knowledge and experience as disembodied, as Hayles insinuates (and the "Brainplex" and *Wired* illustrations model), also threatens to resurrect the universal human subject, shifting attention away from power discrepancies unlikely to evacuate the world of living bodies so quickly.[52]

These representations of digital spectatorship show how conceptualizations of spectatorial embodiment itself were being challenged and redefined. While presenting consciousness as immaterial and transmissible, *Conceiving Ada* also emphasizes the necessity of a material "agent" for such transmission. Emmy decides to use her own pregnant body as such an agent, and the narrative culminates with the revelation that she has infused her fetus with Ada's information thanks to a "DNA memory chip." The film concludes with the reincarnation of what Emmy identifies as Ada's memory, voice, and spirit in the child. Although the film's science fiction is clearly more fiction than science, this thematization of pregnancy shows how even a utopian imagining of the fluid transmission of knowledge from one era to another (and from digitally captured consciousness to viewer/user) does not so much dispense with the body as grapple with its changing role in such an interaction. This emphasis on pregnancy as the means to produce a new conduit for a "disembodied" transmission of consciousness finds striking reiteration in *Being John Malkovich* (Spike Jonze, 1999) despite its more low-tech premise (fig. 3.8).

While Barrett's illustration implies that, with digital cinema, the human body will no longer be central to the experience of moviegoing, the sensual dimensions of that experience remain a key concern. Insofar as the drawing renders the eye and mouth peripheral to the experience depicted, it seems to support Friedrich Kittler's contention that, with digitization, "sound and image, voice and text are reduced to surface effects."[53] Rather than discounting sensual

FIGURE 3.8 In *Being John Malkovich* office workers discover a portal into the actor's mind. (USA Films, 1999 / Photofest)

experience as what Kittler terms "eyewash," however, the illustration centers on imagining how sensual experience might be reconfigured in this spectatorial future. Detailing new means for delivering the sights, tastes, and forms of tactility associated with the movies (the latter evoked via a foot mired in goo, labeled "liquid pumped from tank in shoe makes any floor sticky"), the drawing focuses on conceptualizing how the sensual dimensions of that experience might be evoked internally rather than externally. In other words, while (reflecting theories of the "posthuman" and anticipated by cybernetics a half century earlier) the body's role as an interface between inside and outside has been called into question, it is not so much to discount the sensual experiences associated with it as to imagine the new technologies' implications for this association.[54]

This tension is particularly evident in the arrow leading from eye to mental images, which at once suggests the irrelevance of the eye for the new form of cinematic sight and vigorously marks the internal movies as visible—as available, in other words, to the sense of sight rather than remaining in the abstract form of "incoming digits." The *Wired* illustration displays this tension as well. Here, too, arrows linking eye and mental image portray spectatorship as a fully internal process, although, in this case, the arrows point *from mind to eye*. This reversal of direction asserts even more aggressively that the cinematic image originates within the mind and has not been apprehended by the eye—even as the presence of the eye and arrows proclaim the continued visibility of that image.

It is telling to compare these futuristic depictions of digital spectatorship with the 1953 *Time* magazine cover illustration discussed in chapter 1 and reproduced on the cover of this book. That image portrays the experience of widescreen and stereoscopic 3D by depicting a giant movie screen with a giant female figure reaching out beyond the proscenium and toward the pictured viewers who, in turn, extend their arms toward the screen. The illustration centers on the sensual pleasures that these technologies reputedly offered viewers, and it conveys these pleasures through depictions of the viewers' bodies. The fact that the audience members wear glasses not only acknowledges the material arrangement for stereoscopic viewing but also underscores the role vision itself plays in achieving the form of experience depicted. And the attention given to the hands of both onscreen diva

and moviegoers—whose fingers are poised to caress one another—highlights the tactile pleasures on offer. By contrast, the depictions of digital spectatorship neither take sensual experience for granted as a pleasure in and of itself nor associate it unproblematically with the material body; rather, they focus on imagining how it might be reconfigured internally.

Additionally, in the *Time* illustration the pictured starlet dominates the image in terms of both her size and her positioning above the audience. She is separated from the audience members by what the drawing suggests is a bridgeable distance. Contact is possible between the body of the viewer and the body onscreen, but each must go outside itself to achieve it. In the "Brainplex" and *Wired* illustrations, by contrast, the spectator's head or brain dominates the picture, with the portrayed movie images housed within it (indeed, the "Brainplex" illustration portrays multiple movie images internal to the figure's head).[55] If widescreen was depicted as immersing the viewer in its spectacle, these more recent illustrations portray spectatorship of digital cinema as a situation where the spectacle is immersed in the viewer. In doing so, they echo Paul Virilio's claim about digital media's implications for architecture: "in the end, people are not so much *in* the architecture; it is more the architecture of the electronic system which invades them, which is *in* them." Following Virilio, we can understand this movement inward as the catalyst for what he calls an "inertia that radically alters our relationship to the world."[56] While the viewers' hands in the *Time* cover suggest an outward motion—a movement into an external Otherness—the eye-arrows in the "Brainplex" and *Wired* illustrations, like the relationship between the two women in *Conceiving Ada*, project a movement inward that is markedly reminiscent of Sean Cubitt's warning that the form of alterity offered by digital media should be understood as a sense of multiplicity *within the self* commensurate with "the loss of a certain human contact."[57]

TRANSMISSION: MEDIATION AND IMMEDIACY

As the foregoing makes clear, the view that spectatorship functioned as a form of transmission had important implications for ideas about cinema's potential to facilitate intersubjective exchange. Some depictions of this type of experience (like Hershman Leeson's film) imagined

that digital technologies might put people into more intimate contact with others by allowing a more direct, unmediated form of connection—the ability to see through another's eyes or, as with depictions of virtual reality in *Brainstorm* (Douglas Trumbull, 1983) and *Strange Days* (Kathryn Bigelow, 1995), even experience the sensation of another's death. Other portrayals (like the "Brainplex" and *Wired* illustrations) presented the competing suspicion that the turn inward could be isolating. Despite these divergent attitudes toward digital technologies, the shared conviction that these technologies could transform people's interaction with others is notable. More quotidian accounts by practitioners and critics of the ways the new movie technologies were purportedly transforming the relationships among the people involved in cinema—on the screen, behind the camera (or computer), and in the audience—also portrayed cinema's appeal according to an ideal of fluid transmission, whether to argue that the new tools would impede communication or facilitate it.

Discussions of Hollywood's emerging and potential capacity to create lifelike digital characters tended to worry that computer-generated "synthespians" (or "cyberstars")—and the bluescreen work required to integrate them with live action—would evoke a sense of detachment, insinuating that live actors were more connected with one another and with the audience.[58] In his review of *The Phantom Menace*, *New Yorker* critic Anthony Lane wrote of the infamous digital creation Jar Jar Binks: "Like many of his fellow bit players, Jar Jar was added separately, by computer, so if Liam Neeson and Ewan McGregor look straight through him you can hardly blame them."[59] Actor Hayden Christensen, too, identified bluescreen as a potential impediment to interaction, explaining that "you have to be aware of things other than your fellow actors"—suggesting that the apparatus required to employ CGI could interrupt the dynamic among live actors as well.[60]

New York Times critic Dave Kehr extended the worry about detachment to the relationship between spectator and screen, imagining software that would be able to create a perfect model of actor Tom Hanks and contending that even this ideal CG specimen would not achieve what he described as the appeal of live-action cinema, the "the ineffable energy that passes between an actor on the screen and a viewer in a movie theater."[61] While much of the response to *The Phantom Menace*, in particular, quibbled with the subtle aesthetic faults of bluescreen

work, Kehr—grappling with the prospect of a computer-generated actor perceptually indistinguishable from a live one—based his evaluation of the hypothetical digital creation's inferiority on the claim that viewers enjoy a metaphysical connection with live actors. In an interview on the prospect of digitally created characters, actor Maximilian Schell resorted to a similar strategy: "There are always technological innovations, but finally what's exciting is the human soul."[62]

The idea that a new form of mediation had disrupted an interhuman connection associated with an older medium was not new to digital cinema. Theater producer and playwright David Belasco's (relatively belated) 1908 reaction to the coming of cinema was quite similar to Schell's and Kehr's responses to CGI. Belasco claimed that with the "mechanically produced illusion . . . there would be wholly wanting that indescribable bond of sympathy between the actor and his audience."[63] While Schell's, Kehr's, and Belasco's claims may all be understood as reactionary responses to changing forms of technological mediation—and particularly, in the case of Schell and Kehr, to the dissolving boundary between human and computer—the difference between Kehr's and Belasco's phrasing is meaningful. Whereas the earlier commentator used the physical metaphor of a bond to describe the ideal of interhuman connection he associated with theater, the more recent critic's evocation of an "ineffable energy that passes between" actor and viewer in live-action cinema reverberates with contemporary conceptions of the fluidity and immateriality of what Marshall McLuhan called the "spiritual form of information" and idealizes cinematic intersubjectivity in those terms.[64]

The illustration accompanying Kehr's article portrays the relationship between *filmmaker* and character along these lines as well, depicting the artist's presence via glowing green, circuit-filled hands, from which shoot what look like lasers at the frightened-looking cast of characters from *The Wizard of Oz* (Victor Fleming, 1939) (fig. 3.9). Evoking Michelangelo's portrayal of the creation of Adam, the illustration thus reconceives CGI as a form of divine animation and depicts the relationship between creator and character as an immaterial, even spiritual, flow of energy. The inhuman green glow of the hands, however, and the wary look on the characters' faces as they are digitized portray this new form of contact—in contradistinction to the

FIGURE 3.9 A *New York Times* illustration confronts the prospect of digital actors. (Illustration by Mirko Ilić, 2001; courtesy of the artist)

energy that Kehr contends flows between the human participants in cinema—as menacing.

Discourses on independent cinema also emphasized the idea of a direct connection between filmmaker/viewer and film subject, in this case often praising the digital technology for enhancing the connection. In this context commentary on digital technology did not revolve around visual effects but focused on the new possibilities opened up by digital cameras, which were cheaper and smaller, permitted more pared-down crews, and allowed much longer takes than film cameras. The idea was that, in contrast to celluloid filmmaking, where larger crews and equipment were understood to interfere with the connection between filmmaker and subject, the digital apparatus intruded less and thus facilitated a sense of connection referenced through terms like *intimacy* and *immediacy*. Independent filmmaker Kate Davis, for example, elaborated on the advantages of digital technology: "The huge benefits are the ease and the intimacy. On . . . *Southern Comfort* [2001] it was very important to be in a one-to-one situation with the people in the film, to be able to strip it down to just myself as the crew with these people. . . . It was very intense stuff and I don't think it would have had the immediacy if I'd had to deal with switching stock magazines."[65] Discussing Agnès Varda's *The Gleaners and I* (*Les glaneurs et la glaneuse*, 2000), *indieWIRE* reporter Anthony Kaufman agreed: "The intimacy with which Varda captures her subjects was undoubtedly aided by her use of the small digital equipment."[66] Whereas the discourse on CGI contended that digital technology mediated excessively, this independent discourse suggested that the new technology allowed filmmakers to surmount what was viewed as traditional cinema's excessive mediation. Thus director Samira Makhmalbaf claimed that the "digital revolution" would "once again [allow] the centrality of the human aspect of cinema [to] overcome the intermediary function of its instruments."[67]

One way of approaching this alternating view of the new technology as either more opaque or more transparent than the older technology is via the notion of remediation elaborated by Jay David Bolter and Richard Grusin.[68] Bolter and Grusin argue that the history of art, since at least the Renaissance, has been one in which the desire for immediacy has oscillated with hypermediacy, or a focus on mediation. The term *remediation* names the process by which new media define

themselves with reference to older media, often claiming to offer a less mediated connection with reality while simultaneously foregrounding this very capacity. While the idea of remediation provides a useful framework for understanding competing claims about the mediation and immediacy of digital cinema, however, the concept of remediation itself demands historicization.

Bolter and Grusin offer a broad and inclusive definition of *immediacy* as the experience of what is *felt* to be reality—something that is culturally determined and can be defined as either unmediated referentiality or the authenticity of experience itself (they give rock music and rock videos as examples). But their discussion of the process of remediation seems to recast long-standing debates about realism in terms of the notion of mediation without carefully treating the difference between the two concepts or examining the significance of this renaming. For instance, they write, "Bazin concluded that 'photography and the cinema . . . are discoveries that satisfy, once and for all in its very essence, our obsession with *realism*,' yet he was certainly wrong. These two visual technologies did not satisfy our culture's desire for *immediacy*. Computer graphics has become the latest expression of that desire."[69] While realism and immediacy are closely related concepts, this conflation masks the importance of the shift from talking about realism to talking about immediacy, as well as the different inflections such concepts take in different contexts.[70] Indeed, delimiting the specific contours of the contemporary interest in immediacy is crucial to understanding what was new about the discourses on digital cinema (of which Bolter and Grusin's book, published in 1999, is a part). The form of immediacy promised by digital cinema was framed significantly differently from the types of realism offered by previous instances of technological change such as the coming of widescreen. As the technofuturist depictions of digital spectatorship exemplify, conceptualizations of immediacy in the context of digital cinema often presented this idea in terms of the direct transfer of information—a transfer whose immediacy was portrayed as freedom from the mediation of bodies (human and otherwise). And, as the discourses on synthespians and independent digital production indicate, evaluations of digital technologies' effect on cinematic immediacy often rested on claims about intersubjectivity, whether to argue that these technologies would undermine or enhance it.[71]

We can see such hopes and concerns about digital technology's implications for intersubjectivity played out in two important early examples of independent digital cinema, which display a striking reiteration of subject matter. The first of these is the well-known *Blair Witch Project*, which, despite its analog format, is often cited as an exemplar of the digital cinema movement because of its innovative website.[72] As J. P. Telotte observes, the film's website served as far more than an advertisement; it was an integral part of the filmmaking project itself. Telotte argues that the new type of cinema embodied by the project, which incorporated both film and website, echoes the notion of hypertext, "which consists of a series of documents connected to one another by links; that is, it is a text of many fragments but no whole, no master text."[73] Thus, although the project communicated a sense of "lostness" in part through the film—which records three filmmaking students' increasing disorientation in the woods and ultimately posits itself as the last trace of their lives and deaths—this sense of lostness was also part and parcel of the Internet experience that initiated many viewers' encounters with the work (fig. 3.10).

While *The Blair Witch Project* received widespread attention from the filmmaking community and the public at large, a lesser-known example of early digital filmmaking presented a strikingly similar premise. Stefan Avalos and Lance Weiler's *The Last Broadcast*—which also unfolds through "recovered" video footage from a filmmaking expedition-turned-deadly and featured the tagline, "What really happened that night in the woods?"—was shot on a "prosumer" digital camcorder and edited using Adobe Premiere for a reported total cost of $900. Avalos attributed the film's aesthetic strategy to the limitations presented by such a budget: "We didn't try and fight with this technology," he explained; "we used it for what it could do, making sure we didn't try and emulate the production value of a big budget film."[74] But while the two films' resorting to video-within-a-film (or video) can be understood as a strategy for justifying amateur-looking filmmaking, their shared concern with using video as a means of contact with the dead—a way to allow murder victims to tell the stories of their deaths—exemplifies the interest in transmission I have been tracing throughout the discourse on digital cinema more broadly.

This fantasy of contact with the dead—displayed in *Conceiving Ada* as well—positions these experiments with digital technology within

FIGURE 3.10 The website for *The Blair Witch Project* invites viewers to piece together the details of the "filmmakers'" murders. (www.blairwitch.com/aftermath.html, c. 1998; accessed Jan. 21, 2013)

a long tradition in which new media have been conceived as mediums in the spiritual sense, with claims to novel forms of immediacy evoking the idea of otherworldly communication. As Jeffrey Sconce argues, electric media since the telegraph have often been associated with such supernatural contact. Not only do these media reconfigure ideas about liveness and immediacy, but they participate in a broader cultural discourse on electricity, often evoking "a series of interrelated metaphors of 'flow,' suggesting analogies between electricity, consciousness, and information that enable fantastic forms of electronic transmutation, substitution, and exchange."[75] Still photography and cinema have, of course, also been taken to suggest an idea of ghostly presence.[76]

What is notable about these examples of independent digital cinema is that they conceive such contact not as an encounter with an external Other but rather as the incorporation of another's viewpoint. With *Conceiving Ada* this emerges in the premise that Emmy literally accesses Ada's consciousness with the ability to see through the earlier woman's eyes and memories. With the two horror films this form of incorporation is rooted in the thematization of video technology (and certainly both films' thematization of video owed much to the digital cameras that were major news, especially within the independent film

industry, at the time of their making and release). *The Last Broadcast*'s narrative arc is rooted in the discovery and restoration of damaged videotape containing an image of the elusive killer (fig. 3.11). *Blair Witch*'s larger project—film plus website—also appeals to viewers/users by inviting them to piece together the stories of the murdered students from video and audio fragments. Both movies build suspense around whether and when we might share the amateur cinematographers' perspective as they confront their murderers and, ultimately, their deaths.

While this storytelling strategy was certainly not unprecedented, these examples are significant insofar as they illustrate a certain attitude toward video. Drawing on the handheld style of home movies, the films use video to achieve a first-person aesthetic that aligns viewer and diegetic "filmmaker." Alexander Galloway identifies such "subjective shots"—which are distinct from point-of-view shots insofar as the former "mean to show the exact physiological or emotional qualities of what a character would see"—as a relative rarity in cinema. He claims that such shots, which have become central to popular "first-person shooter" video games, are particularly successful when applied to the portrayal of "computerized, cybernetic, or machine vision" in films like *The Terminator* (James Cameron, 1984), *RoboCop* (Paul Verhoeven, 1987), and *Predator* (John McTiernan, 1987)—and I would add the significant example of *Westworld*—which thus "mark one aspect of the aesthetic transition from cinema to digital media and hence video gaming."[77]

Galloway contends that such shots—whose cinematic precedents range from experiments with camera-mediated subjectivity such as *The Last Laugh* (*Der letzte Mann*, F. W. Murnau, 1924) and *Lady in the Lake* (Robert Montgomery, 1947) to horror films like *The Silence of the Lambs* (Jonathan Demme, 1991)—function primarily to "effect a sense of alienation, otherness, detachment, or fear." Indeed, he explicitly associates *The Blair Witch Project* (as well as other films germane to this discussion, including *Strange Days* and *Being John Malkovich*) with these effects.[78] But while this shared perspective certainly contributes to the sense of disorientation *The Blair Witch Project* evokes as Galloway contends, it is also significant that this film, like *The Last Broadcast*, utilizes the first-person perspective associated with video cameras as a means for sharing the victims' knowledge. As do *Strange Days* and *Brainstorm* vis-à-vis virtual reality and as does *Conceiving*

FIGURE 3.11 *The Last Broadcast* also involves the reconstruction of footage from a fateful, video-taped trip to the woods. (Wavelength Releasing, 1998)

Ada vis-à-vis computer technology, *The Blair Witch Project* and *The Last Broadcast* approach video as a tool for accessing the consciousness of another (deceased) person.

While thus sharing, to some extent, *Conceiving Ada*'s enthusiastic attitude toward this form of contact, the horror films also express anxiety about its ramifications. *The Last Broadcast* derives a good measure of its suspense from the anonymity of digital communication. The film purports to be a documentary about two cable-access producers who decide to jumpstart their show by taking audience suggestions via the Internet. And it is the untraceable nature of the ultimately deadly suggestion that they investigate the "Jersey Devil"—an anonymity underscored by the electronic voice intoning the typed message—that lends the narrative its eeriness. At the same time that the movie, like

Blair Witch and *Conceiving Ada*, suggests that video promised a form of communication across a spatiotemporal divide, then, it also reflects the technophobic concerns evident in the "Brainplex" illustration and discussions of synthespians: concerns that new forms of technological mediation made users uncertain about with whom—or with what—they were communicating (indeed, whether what they were doing was communicating at all).[79] Was the cable-access show's "caller" an innocent fan, a crazed killer, the Jersey Devil itself? *The Last Broadcast* suggested that, with digital technology, one could not know.[80]

IMPLOSION: CONVERGENCE, CONTROL, AND AUTHORSHIP

Convergence tends to be conceptualized as a new fluidity among media on technological, economic, and social levels, uniting disparate media through a common base in numerical code and promoting movement among media through the contemporary structure of media ownership and spectatorial practice.[81] However, practitioners and executives within the film industry also saw digital technology as something that was unifying the filmmaking process itself and, in doing so, enhancing filmmakers' control over their works. This consolidation echoes the inward movement charted by theorists of electronic and digital media insofar as it promised to diminish the need for a heterogeneous filmmaking apparatus, rendering the previously disparate elements involved in filmmaking (live action, effects, sound) in the single, shared form of digital information, which was capable of being manipulated by a solitary, creative force. Echoing the scholarly debates, evaluations of this transformation within the film industry diverged dramatically yet, as with the discourses on digital spectatorship, shared the premise that the new technology had transformed the potential for intersubjective communication, for better or worse. Thus, on the one hand, the notion of fluid transmission emerges again as an ideal according to which numerous commentators considered the implications of this instance of technological change, some arguing that digital tools facilitated the circulation of information and others worrying that they rendered moviemaking and spectatorship solitary pursuits. On the other hand, there was a marked diversity in conceptualizations of digital cinema's perceived successes and failures

at achieving this ideal of unimpeded communication. The new level of control with which digital technology was believed to endow filmmakers was viewed, alternately, as the death of communal creation and the means for artistic freedom, as a tool for industrial hegemony and an aid in democratizing the medium, as a way for anyone to become an auteur and a threat to the existence of the audience.

As Walter Murch explained, working with film was "so heterogeneous, with so many technologies woven together in a complex and expensive fabric, that it [was] almost by definition impossible for a single person to control." By contrast, digital technology endowed the disparate elements of filmmaking with a "mathematical commonality; thus they [came] under easier control by a single person." Murch observed this consolidation of power in the area of sound mixing, where he claimed that the boundary between sound editing and mixing had—at the time of his writing in May 1999—already begun to blur. And he suggested that it was about to happen with the integration of editing and visual effects.[82] Furthermore, there was a widespread and more radical suggestion in industry discourse that digital technology was dissolving the borders among production, postproduction, and distribution. In an article entitled "Post, Prod'n Merging," *Daily Variety* reported, "Post-production . . . once was considered a completely separate discipline from production and distribution. When the computer entered the film- and video-editing processes, that separation diminished."[83] Hollywood producer Todd Moyer claimed that "visual effects have to be considered as part of production and not as an afterthought."[84] And Nick DeMartino, director of strategic planning for the American Film Institute, explained, "When you are dealing with the digital domain, the whole thing is producing software—production and post-production are not clearly defined, writing code is all post-production."[85] We can thus extrapolate that not only were the different stages of postproduction becoming easier for one person to control, as Murch suggested, but the entire filmmaking process (including production and distribution) was conceived as capable of coming under this type of control.

Indeed, digital technology was believed to have important implications for the filmmaker's status as author. While Murch and others mourned the loss of the internal tension they believed arose out of communal creation, the potential for making movies in the image of

one person's vision was also celebrated as something that enhanced cinema's capacity for artistic expression.[86] George Lucas, for example, contended that, with *The Phantom Menace*, he "finally reached a point with the technology where it could create a fantasy world closer to what [his] imagination saw."[87] Comparing the transition from film to digital cinema to the move from frescoes to oil painting, he claimed, "Digital technology makes cinema a more painterly medium," explaining, "Technology . . . gives the artist more freedom."[88] Matt Zoller Seitz agreed, contending that *The Phantom Menace* is "clearly the product of one man's vision; despite its $120 million budget, 133-minute running time and army of behind-the-scenes technicians, it has a peculiar but welcome handmade quality."[89]

One way the new technology was reputed to facilitate filmmakers' control over their projects was through digital previsualization tools. Traditionally, filmmakers have used storyboards and conceptual designs to envision how yet-to-be-filmed sequences would look. As *American Cinematographer* reported in 1998, however, the new potential for digital previsualization enabled filmmakers to see how camera movements and effects would look before any shooting took place. Digital "previs" allowed effects artists to build electronic, three-dimensional models of sets and simulate camera movement through virtual space, even picturing the effects of different lenses. And it enabled directors to cut the resultant animations like a movie, putting sequences together before filming. Not only did this process cut down on the need for costly experimentation during production, but filmmakers and technical personnel viewed it as a means to unify a production under a single creative vision, shattering the wall that traditionally existed between production design and effects departments. Director Steve M. Katz explained, "The whole idea is that you can build the set based on plans in the computer, light it in the computer, include simplified digital versions of the actors, and unify all the different departments with this one little box."[90] The animations produced were believed to leave less room for differing interpretations among creative personnel than traditional storyboards. Warner Bros. effects supervisor Jeffrey Okun described the way in which traditional storyboards encouraged debate: "As the project came closer to actually having film roll and the departments began to staff up, all of those differing ideas went into flux. That's where the digital animatics finally

settled all the arguments."[91] Thus, it was suggested that the technology endowed the director (and/or production designer) with broad and precise control over the look of the film.

Another way digital technology promised to consolidate control in the hands of a director, blurring the boundaries among previously distinct phases in the filmmaking process, was that digital projection obviated the need for a definitive cut of a film—and thus muddied a clear-cut transition from editing to distribution. Thus, even as prints of *Attack of the Clones* were being made, George Lucas changed more than seventy shots for the digitally projected version of the movie, including adding "a more affectionate exchange" to its ending.[92] In a 2002 article entitled "Will H'w'd Freak at Endless Tweaks?" *Variety* featured the illustration of a movie screen reading, "Stand-by as we re-edit," and predicted, "Thanks to Hollywood's imminent adoption of digital cinema, Lucas is the first of many filmmakers who are expected to take advantage of the ability to perfect their projects not just days, hours or minutes before their pics bow, but also well after they hit theater screens."[93] The new flexibility with which digital projection endowed filmmakers echoed the exhibition and filmmaking practices of early cinema, when (at the turn of the twentieth century) exhibitors, as Charles Musser has shown, exercised creative control of film programs, and when—before and in opposition to the development of the continuity script in the early 1910s—filmmakers were able to define their projects as they shot, as Janet Staiger has shown.[94] While the possibility for endless reediting reintroduced with digital projection once again promised to allow filmmakers to tailor their product to specific audiences and endow filmmaking with an artisanal quality that seemed to contrast with studio production, it also extended the controlling reach of moguls like Lucas.[95]

Although this consolidation of control over the filmmaking process may thus be viewed as a means for bolstering the homogeneity of Hollywood product—rendering it, in Murch's words, "a solitary monolithic vision"—it was widely discussed at the time as an opportunity for democratizing cinema.[96] While digital technology increased the control already exercised by the privileged Hollywood few, it also extended moviemaking potential to those who could not previously afford it. As the *New York Times* reported in January 1999, "The flip side of the digital revolution, one that is just starting to make

its presence felt, is the democratizing effect that cheaper and easier-to-use technology is having on control over the moving image."[97] In this sense the analogy between filmmakers and painters takes on a different meaning, suggesting that digital technology liberated moviemaking from the dependence on financing it once had. Proclaiming that "the digital camera is the death of Hollywood production," director Samira Makhmalbaf explained in a talk at the 2000 Cannes Film Festival: "Three moves of external control have historically stifled the creative process for a film-make [sic]: political, financial, and technological. Today with the digital revolution, the camera will bypass all such controls and be placed squarely at the disposal of the artist. The genuine birth of the author cinema is yet to be celebrated after the invention of the 'camera-pen,' for we will then be at the dawn of a whole new history in our profession. As film making becomes as inexpensive as writing, the centrality of capital in [the] creative process will be radically diminished."[98]

Makhmalbaf was not alone in evoking Alexandre Astruc's conception of the caméra-stylo. New York Times critic A. O. Scott reported, "At a recent documentary festival, everyone I spoke to seemed to come up with the same analogy: the camera has become less like a printing press and more like a pencil, something you can grab hold of when the mood strikes, and use to transform your impressions into art."[99] The hope here was that the new technology—with its ease of use and low price tag—was making it possible for virtually anyone to become an auteur.

Tempering such enthusiasm was the simultaneous worry that more widely accessible technology would produce an onslaught of content—and thus obstruct extant channels of communication. With everyone rendered a filmmaker, commentators worried, would movies still find audiences? Describing the way in which digital video was "democratizing filmmaking, creating a nation of do-it-yourself auteurs," Newsweek wondered, "with so many people making movies, will anyone be left to watch them?" Time magazine predicted that "in a few more years, everyone will be so busy making movies, there won't be any audience left to watch them." And Makhmalbaf asked, "Would an astronomical increase . . . in the number of auteurs not result in the death of the very idea of the auteur?"[100] Indeed, many feared a profusion of subpar cinema. Newsweek claimed, "There is, to be sure, something scary about

the sheer volume of movies the new technology is unleashing," and identified the caveat by the American Film Institute's Nick DeMartino that "access to tools doesn't guarantee talent" as an understatement. *USA Today* predicted, "The new video-laden world may be even more replete with garbage." The *New York Times* concurred: "The emergence of desktop video means that people will be able to flood the world and clog the Internet with digital video"—thus likening the digital "revolution" more to an overflowing toilet than to an artistic renaissance and making the concern with unobstructed flow explicit.[101]

These debates about digital cinema's implications for authorship and spectatorship betray a shared sense that digital technology was transforming cinema's role as a mode of communication and support the claim that the form of participation facilitated by the new technologies significantly changed the relationship between filmakers and audiences. The suggestion that digital technology was rendering cinema more democratic, enabling viewers to become filmmakers, echoes Henry Jenkins's hope that the new participatory culture has facilitated intersubjective exchange in the form of what he calls, drawing on Pierre Lévy, "knowledge communities."[102] At the same time, worries about the continued existence of an audience for widely available and democratically produced product reflect the fear that the inwardness encouraged by new media would diminish the potential for inter-human contact.

(DIS)EMBODIMENT: THE ADDRESS OF THE DIGITAL IMAGE

Although much of the discourse on the emergence of digital cinema conceived this instance of technological change via its implications for the moviemaking process rather than for the cinematic image itself, aesthetic changes did receive some attention, particularly in conjunction with computer-generated imagery, digital cinematography, and digital projection. Certain shared tropes again traverse these discussions—here they relate to digital cinema's capacity for detail and what was claimed to be its more uniform image—although, again, commentators draw different conclusions about these transformations in different contexts. Although these discussions disagree, in particular, about digital technology's ramifications for cinema's affective appeal,

we can glimpse, in the excitement and disappointment expressed over the look and feel of the new format, a persistent interest in reevaluating the contours and implications of cinema's sensual address.

Computer-generated imagery's aesthetic tended to be described as both presenting a heightened attention to detail and rendering the cinematic image increasingly uniform. Discussions of *The Phantom Menace* often identified the denseness of its computer-generated images as a key to the appeal of both the film and the technology it utilized. The *Newark Star-Ledger* explained that the film "showcases the vast improvements in software designed . . . to simulate fabric, hair and skin, to animate facial expressions and to create landscapes and skylines richer and more detailed than any backdrop or scale model." *Newsday* observed that "all the trappings, from the architectural landscapes of the exotic interplanetary locales to the facial tics of the least-consequential extra-terrestrial, are handled with admirable devotion to detail." As *USA Today* put it, "The Force is in the details."[103]

Reference to this new level of detail often supported claims about CGI's reputed "photorealism"—its capacity to create fantastic images that mimicked the look of photochemically based photography and thus purportedly assimilated its aura of authenticity.[104] Matt Zoller Seitz, for example, predicted that "in the very near future, it will be possible to render just about anything with imaging software and make it seem so *dense and plausible* that even devoted tech-heads won't be able to identify the result as a special-effect," implying that denseness and plausibility are integrally intertwined.[105] Similarly, Dave Kehr observed that the synthetic human figures in *Final Fantasy: The Spirits Within* (Hironobu Sakaguchi and Motonori Sakakibara, 2001) were rendered in "eerily naturalistic detail—down to skin pores and split ends."[106]

The reputed realism of this new level of detail was not limited to visual verisimilitude. Seitz, in particular, tended to associate digital technology's capacity for detail with an enhanced sense of tactility. In his review of *The Matrix* he suggested that the film's "computer-animated dreamscapes" were "intricately detailed, almost tactile" (fig. 3.12). And in his discussion of *The Phantom Menace* he explained that "the new digitized action-adventure blockbusters . . . deploy state-of-the-art computer technology to achieve complex, tactile images."[107] This acknowledgment of CGI's multisensory address aligns the

FIGURE 3.12 In its representation of the "real world" *The Matrix* displays a detailed aesthetic facilitated by CGI. (Warner Bros., 1999)

format's illusionism with the discourses on widescreen—as well as with the forms of immersive experience offered by other digital media such as virtual reality.[108] The parallel with widescreen extends to the pervasive sense, evidenced by Kehr's use of the term *eerie* to describe *Final Fantasy*'s naturalism, that the new form of realism presented by the format went so far as to render the image uncanny—a concept also prevalent in discussions of high-definition cinematography, which was often said to allow the viewer, in the words of filmmaker and cinematographer Dyanna Taylor, to "almost see too much."[109]

A second aesthetic change associated with CGI entailed what was portrayed as the digital image's increased uniformity. Computer-based postproduction was believed to unify the image aesthetically by more efficiently hiding the seams evident in traditional effects work.[110] Like CGI's capacity for detail, this increased uniformity was believed to enhance the photographic realism for which numerous commentators lauded digital cinema—and was thus often believed to heighten the power of visual effects. Discussing his work on the visual effects in *Batman and Robin* (Joel Schumacher, 1997), for instance, John Dykstra explained that the production integrated computer-generated work with live action and miniature shots. Claiming that "it's getting to the point where the seams are hard to see," he concluded, "I think we did a pretty good job of flummoxing people as to what's CG, what's miniature

and what's live action."[111] The insinuation here was that computer-generated imagery integrated so well with live action that filmmakers could present increasingly outlandish stunts as real, thus increasing the sense of danger movies conveyed (Dykstra referred to *Batman and Robin*'s rooftop car chase across the New York City skyline, which simulated an eighty-foot leap from one structure to another).

Whereas CGI's capacity for detail compelled Seitz to argue consistently that the new technology enhanced the tactility of the cinematic image—and although much of the discourse on mainstream digital cinema also suggested that the digital tools heightened visual effects' power to elicit bodily thrills—there was a concurrent, and insistent, feeling that the very uniformity believed to endow digital visual effects with their realism simultaneously drained cinema of its excitement. *Times Literary Supplement* critic Eric Korn, for instance, claimed vis-à-vis the digital effects in *The Phantom Menace* that "a certain wearied, wearying sameness develops out of the seamless interweave of the human and the virtual actors."[112] In his review of *The Matrix*, *Newsday* critic John Anderson explained that "we've had our perception questioned so many times we're immune to any illusion of peril. Or, for that matter, any illusion at all. Ergo, it's a small step outside the movie entirely." Anderson was referring to the different layers of "reality" in *The Matrix*, but the sentiment extended to the real-world digital technology the film both utilized and thematized. He asked rhetorically, "If state-of-the-art, computer-driven special effects allow moviemakers to produce just about anything, is there anything left to get excited about? Has Hollywood's almost routine resorting to blue screens and morphing driven any residual magic out of the movies?"[113] The other side of the coin in which the seamless interweave of live and computer-generated stunts were thought to endow the latter with an increased sense of danger, in other words, was that the very possibility of this conflation was felt to elicit a new sense of ennui.

Discussions of digital cinematography and projection also emphasized the increased uniformity of the digital image, although, in this context, that uniformity was associated with material changes as cinema dispensed with film and the mechanical apparatus associated with it, rather than with the issues of representation at the core of the discourses on CGI. The new sense of uniformity was attributed, in part, to digital video's stable pixel grid, which was believed to render

images captured on digital cameras and/or shown with digital projectors more homogeneous and static than images rooted in film, with its perpetually changing grain pattern. In an article for the *New York Times*, cinematographer John Bailey explained: "The silver halide crystals embedded in the film emulsion, the surface that contains the pictorial record, are random and continuous. There is no definite pattern to the crystal array, called grain." He described this grain as "ever shifting." By contrast, with digital video, "pixels are not random or shifting. Their position is fixed. A good analogy for the pixel array is an image made of mosaic tiles."[114]

Additionally—and often in the same breath as the claim that digital projectors duplicated the look of film—advocates contended that the images these projectors produced were better insofar as they eliminated irregularities attributed to film and created a new sense of constancy by eliminating the flicker and jitter associated with mechanical projection.[115] For instance, Walter Murch contended that digitally projected images would be "astonishing" to see since they would be as "clear or clearer than 35-millimeter film, with none of the scratches, dirt or jitter that infect even the most pristine of 35-millimeter prints."[116] Mike Levi, president of Digital Projection, explained that not only did digitally preserved film avoid dirt and wear and tear, but digital projection was superior to mechanical because "it has a very continuous feel and is very accurate."[117] *New York Times* journalist Rob Sabin reported in a comparison of high-definition and mechanical projection that the digital version eliminated flicker and presented less grain than the film screening.[118]

Writing on early film spectatorship in Russia, Yuri Tsivian claims that the new movie technology addressed a "medium-sensitive" viewer who did not look past irregularities in the celluloid medium like scratches and "fogging" but read them as part of the spectacle.[119] Robert Spadoni argues that the coming of sound provoked a return to medium sensitivity, with viewers integrating the material circumstances of the new sound systems into their reception experience—with the spatial disjuncture between actors' imaged mouths and the sound sources projecting their voices, for instance, rendering the actors' screen presence uncanny.[120] Conversely, the commentary on digital projection suggested that the introduction of this technology would heighten sensitivity not primarily to the new format but to the

old one. Commentators presented digital cinema as the transparent format, framing film projection as an impediment to direct experience. In that sense this discourse does exemplify Bolter and Grusin's concept of remediation, emphasizing digital projection's "astonishing" capacity to appear less overtly mediated than film projection—and framing such apparent freedom from mediation as the ideal according to which both formats should be evaluated.[121]

Tempering enthusiasm about the increased transparency made possible by digital technology, other commentators blamed the uniformity associated with digital cinematography and projection for a degradation of spectatorship, suggesting that this uniformity produced psychoperceptual changes in the cinematic experience.[122] Posing the question, "Does the static pixel array of digital video render images whose quality is fundamentally different from those created by the ever shifting, random movement of film grain?" Bailey further wondered, "Is the dreamlike state of suspension that we associate with film inherent in its photochemical architecture?"[123] Similarly, Roger Ebert, according to a September 1999 *Variety* story, "was telling anyone in Cannes who would listen that, although there is only sketchy science to back him up, film and electronic images reach different parts of the brain and therefore affect human beings in different ways. Very roughly speaking, film creates an alpha state of reverie due to its imperceptible flickering, therefore creating a more emotional and intense reaction. Television, by contrast, creates a beta state that is constant and more hypnotic."[124]

Reporter Todd McCarthy extrapolated: "The hidden danger to the industry, therefore, is that, while digital projection will soon look just as rich and sharp and beautiful as 35mm film, its emotional and imaginative impact over the long term will not be the same," and he suggested that this "could be the end of movies as we know them."[125] Such references to digital video's pixel grid and digital projection's elimination of flicker identified traditional cinema's appeal with the effect of its perceived and literal movement (the movement of film's grains and the movement of the projector's shutter) and suggested that digital technology's apparent lack of movement (the uniformity of its pixels and the constancy of its light) detracted from its capacity to move viewers.[126]

In emphasizing the transparency of digital technology, these discourses may seem to align digital cinema, as Oliver Grau does virtual

reality, with the immersive experience attributed to widescreen, particularly insofar as they frame the new technology as an enhancement to cinema's illusionism. The discourses on digital cinema's aesthetics, however, do not unanimously equate the technologically mediated image with the experience of immersion or transparency. In contrast with those claims that digital technology heightened cinema's photorealism, conversations about the cinematography used in independent digital cinema often cited the low resolution of the image attained with inexpensive, consumer-grade cameras, its opacity or *lack* of detail, as a crucial factor in its affective impact. Director Thomas Vinterberg, for instance, conceived the affective power of *The Celebration* through this aesthetic. "Looking at that picture, seeing all the grains, I felt, 'Wow, how depressing,'" he explained, "And that was inspiring."[127] The film's director of photography, Anthony Dod Mantle, also associated the breakdown of the image with affective impact. Describing his work on *Julien Donkey-Boy* (Harmony Korine, 1999), he explained, "I felt that this image too, as an electronic image, had to be broken down and destroyed so that a new kind of organic emotional message could appear on the screen" (fig. 3.13).[128] Although this conversation was also invested in the concept of realism, realism in this context referred not to perceptual verisimilitude but to what was understood as a lack of artifice—a form of immediacy concerned with preventing excessive mediation by the apparatus, even if this mediation would result in more legible or transparent images.[129]

Like the increased detail associated with the computer-generated imagery of *The Phantom Menace*, this *decrease* in image detail was also associated with a heightened sense of tactility. *Guardian* critic Jonathan Romney, for instance, wrote of *The Celebration*, "Rather than offer the pretence of a transparent window on reality, *Festen* places a dense filter between us and its world. Everything is seen through the tactile gauze of the electronic image. The picture shifts, shimmers and melts; in the night interiors, the picture thickens like dark grainy soup."[130] Seitz's references to the tactility of effects cinema had attested to the new image's verisimilitude. In reference to *The Phantom Menace*, he explained, "Despite the unending parade of digital vistas and creatures . . . there weren't many moments during this long film where I questioned the tactile reality of the setting."[131] By contrast, Romney evoked the concept of tactility to describe the density of the "filter"

FIGURE 3.13 *Julien Donkey-Boy* explores the emotional power of degraded, low-resolution digital video. (Fine Line Features, 1999)

The Celebration's digital image placed between viewer and imaged world. Tactility here thus operated as part of his description of the film's aesthetic of opacity; he suggested that the low-resolution tactility of the digital image *impeded* the illusion of an unmediated flow of information from imaged world to viewer.

Although Romney invokes the idea of critical distance, suggesting that *The Celebration*'s aesthetic "one minute [pulls] us into the immediacy of the action, the next [nudges] us out again, making us squint to see what's happening," his description of this sense of being "out" of the action is not opposed to affective involvement.[132] The idea that the movie's grainy images compel the viewer to squint to decipher the action suggests that the movie's aesthetic of opacity produces tangible physical effects bound up with emotional engagement. This bodily response is quite different from that offered by the effects films and their heightened illusionism. Rather than immerse viewers, eliciting bodily effects linked to the sense of presence in a fantastic world, this affective drive to decipher the image is reminiscent of Laura U. Marks's discussion, following Aloïs Riegl, of haptic cinema, those videos and films that do not so much present an illusion of depth as call attention to the surface of the image. As opposed to images that offer

a sense of visual distance and mastery, haptic images, for Marks, elicit an experience of tactile proximity and mutuality, rendering cinema "an object with which we interact rather than an illusion into which we enter." Explaining that "haptic visuality requires the viewer to work to constitute the image," she identifies video's low level of detail and contrast ratio as means for eliciting this experience.[133]

Discussions of the aesthetic of low-resolution digital cinematography thus had in common with conversations about CGI an idea that the new technology transformed cinema's sensual address; however, evaluations of this transformation diverged significantly. While references to the tactility of digital effects attested to the power of that cinema's illusionism—suggesting that the CG image was so convincing that, as was argued with widescreen, it *felt* real—the evocation of tactility vis-à-vis independent cinema attested to a type of experiential immediacy. Whereas the sensual address described in the discussion of CGI was, in an important way, severed from the viewer's embodied materiality (and it is this disjunction that worried so many critics of digital media), the sensual address of the low-resolution digital images attested, instead, to a continued investment in the idea that cinema could provide viewers with an authentic experience, returning them to their bodily presence in the world.

AUTHENTICITY

The most familiar argument about digital technologies within cinema studies is that they have moved cinema away from reality and realism.[134] Because digital technology has been understood to transform cinema's material base so profoundly, it has reinvigorated interest in the question of medium specificity engaged by classical film theorists in the first half of the twentieth century, compelling some "new media" theorists to claim a radical break between film and digital cinema centering on their relative authenticity. This line of reasoning has tended to attribute analog cinema's status as a truthful document to its base in photochemical processes, which, it is suggested—often with reference to André Bazin and the notion of indexicality that Peter Wollen associated with him—permit an ontological link between film image and world.[135] By contrast, digital technology's root in numerical code—which, as D. N. Rodowick puts it, does not *transcribe*

information from the world but *converts* or *calculates* it—is under-stood to sever this link.[136] Lev Manovich emphasizes this disjuncture when he proclaims that, with its embrace of digital technology, cinema "is no longer an indexical media technology but, rather, a subgenre of painting."[137]

In addition to this ontological argument, discussions of digital technology's implications for cinema's truth claims have also focused on the aesthetic qualities of the digital image. Although it has always been possible—through techniques such as composite printing and double exposure—to manipulate film to create fantastic images, digital technology has been understood to significantly increase the ease and efficiency of the process. Because their base in numerical code endows digital images with what Philip Rosen terms "practically infinite manipulability," filmmakers working in the new format can tinker with their footage without incurring the quality loss that afflicts analog media.[138] And because algorithms can be written that simulate minutiae like the movement of hair, digital technology has allowed animation to approximate "photorealism."[139] As a result, digital filmmakers have been able to create imaginary worlds that simulate our perception of photochemically based photography to a degree that was not possible when cinema was bound exclusively to film. Accordingly, digital technology has been thought to make it easier for the cinematic image to appear as the trace of a profilmic event even when it is not one. As media theorist and artist Timothy Binkley argues, "Every picture may tell a story, but the veracity of its tale is no longer attested by its photographic mien."[140]

Against those who cite digital cinema's mode of inscription and aesthetic possibilities as evidence that the new format attenuates or even falsifies cinema's connection with the world, many have argued that digital cinema does not represent such a radical break from analog. This argument has often entailed debunking an easy distinction between analog and digital cinema based on the idea of indexicality as material trace, whether by offering a more nuanced reading of the concept of indexicality (as associated with Bazin or described by Charles Saunders Peirce) or by showing how cinema's claim to authenticity (even as described by Bazin) has long been rooted in elements other than just indexicality.[141] Expanding a consideration of digital cinema beyond its material base, scholars such as Thomas Elsaesser,

Tom Gunning, and Dudley Andrew have shown how cinema's mode of address, aesthetic forms, and institutional frameworks can, even with digital technologies, continue to claim authenticity.[142]

This book follows the lead of scholars arguing against a radical break insofar as juxtaposing the discourses on widescreen, 3D, and digital cinema underscores continuities and modulations, as well as distinctions among different periods of upheaval in cinema history, and emphasizes the range of factors that inflect cinema's appeals in a given context. Furthermore, the heterogeneous discourses on digital cinema examined here suggest that limiting our understanding of digital cinema to one element such as numerical code or computer generation must be recognized as a polemical move; the concept of digital cinema that emerged in the late 1990s reflected a broad array of (actual or imminent) changes in practice across a spectrum of industrial and aesthetic traditions. The pressing question in this context is not whether digital technologies diminished cinema's claims to authenticity (as we have seen, answers to this question varied from an emphatic yes to an equally assured no) but, rather, how such authenticity was conceived in conjunction with that technology. Indeed, the discourses on digital cinema show how the concept of cinematic authenticity took on historically specific inflections in conjunction with information technologies.

Bazin and his fellow postwar realist Siegfried Kracauer, for all of their differences, shared a common investment in the ambiguity of reality and a common faith that cinema presents the unique potential to put people into contact with an intractable world, both social and material.[143] In recent work on Bazin and Kracauer, Dudley Andrew and Miriam Hansen have shifted focus away from the question of cinema's materiality that might seem to threaten these theorists' relevance for a contemporary context dominated by the digital, emphasizing instead Bazin's and Kracauer's investment in aesthetic approaches centered on the experience of encounter—conceptions of cinema that new technologies do not necessarily foreclose.[144] At the same time, for better or worse, the discourses on digital cinema modify how such an encounter is conceptualized. In particular, ideas about an unknowable yet approachable material world have receded in these discourses. This recession does not suggest that digital technologies diminish the possibility or advantages of the kind of cinema Bazin and Kracauer

envisioned. Nor does it necessarily imply a lack of investment within public discourses in authenticity, indeterminacy, or the possibility of engagement with alterity. What it does indicate is that, in the context within which the concept of digital cinema emerged, such terms took on different shades of meaning.

In a context in which sensual experience was not necessarily believed to correspond faithfully to a bodily encounter with the world (a perception of disconnection epitomized by virtual reality but carried over into conceptualizations of digital cinema, as in the "Brainplex" and *Wired* illustrations), authentic experience was not, within the discourses on digital cinema, by and large conceived phenomenologically. Much of the concern articulated in these discourses revolves around a notion of intersubjectivity conceived not as a bodily encounter with Otherness but according to a concept of transmission for which success is evaluated with reference to the ideal of an unimpeded flow of information or affect. This emphasis on transmission is evident in Dave Kehr's assertion that cinema should entail an ineffable transfer of energy between actors and viewers, in the fear that the proliferation of inexpensive digital technologies would impede extant channels of communication between authors and audiences, and in the hope that digital technologies would promote a more fluid form of knowledge sharing, as exemplified by *Conceiving Ada*, *The Blair Witch Project*, and *The Last Broadcast*. The idea that cinema should facilitate a form of contact with alterity thus remained a factor in evaluations of digital cinema's appeal (and the prospect that the new technologies diminished this potential was a cause for concern, especially in evaluations of digital visual effects). What changed, as much of the commentary on independent digital cinema attests, was that the experience of immediacy was conceptualized not as a bodily encounter with an inscrutable world but with reference to a different kind of mutuality modeled on ideas about transmission.

Rather than understand this new situation as one in which the body was no longer important, I want to suggest that what changed was that the body was no longer taken for granted as a unified site for experience; it became a problem. We saw a continued interest in bodily experience in the diverse attempts to portray the sensual dimensions of digital spectatorship and the tactility of the digital image. As the divergent evaluations of that tactility show, however, the relationship

between perceptual experience and bodily materiality had become unmoored, with the sensual experience of the digital image associated, alternately, with a detachment from the material world and a return to it. Thus, here, too, the discourses on digital cinema do not suggest the waning of reality or even a loss of investment in bodily experience. Rather, they posit concerns about the changing relationship between self and other, perception and world, as crucial terms in the continued, if often fraught, conviction that cinema holds the potential to offer viewers an experience of immediacy commensurate with that term's shifting significance.

Considering this recent instance of upheaval in light of the coming of widescreen permits us to appreciate the significance of this transformation. In the 1950s the discourses on widescreen emphasized the massiveness of the new apparatus and the images it produced, encouraging viewers to thrill at the opportunity to submit to the overwhelming experience it offered. In the late 1990s and early 2000s the concept of digital cinema emerged as information technologies were imagined, rightly or wrongly, to be at the brink of unifying the previously heterogeneous elements of our lives (work and play, telephone and television, all in one box) and connecting dispersed people and nations into a global network—forms of unification and connection that destabilized traditional relationships to space and problematized the body's role in experience. Public discourses framed digital cinema's appeals according to these terms, valuing free-flowing information and affect and questioning whether the new technologies would facilitate or obstruct communication. The discourses on digital cinema, in short, voiced new worries, bound to a context dominated by information technologies, surrounding the changed shape of human interaction.

AWE AND AGGRESSION

The Experience of Erasure in
The Phantom Menace and *The Celebration*

Lucas and his Industrial Light Magicians have created the most varied, extravagant panoply of other worlds maybe ever attempted in the cinema. As Obi-Wan (Ewan McGregor) and Qui-Gon (Liam Neeson) traverse the galaxy, one's proper response to each destination—an undersea civilization, planet Naboo, space capital Coruscant—is bug-eyed awe.
—Armond White on *The Phantom Menace*[1]

There is . . . a huge aggression in the film.
—Thomas Vinterberg on *The Celebration*[2]

As we saw in chapter 3, the concept of digital cinema that gained prominence in the late 1990s encompassed a wide variety of applications of digital technologies in the processes of production, postproduction, distribution, and exhibition. This chapter considers the aesthetic transformations accompanying this technological shift, focusing on two films widely identified as watersheds for digital cinema: George Lucas's *Star Wars: Episode I—The Phantom Menace* and Thomas Vinterberg's *The Celebration* (*Festen*). These movies represent very different cinematic industries and institutions—the former epitomizing the tradition of the high-concept Hollywood blockbuster that the original *Star Wars* had been influential in inaugurating two decades prior, the latter exemplifying an international art cinema often considered in opposition to Hollywood. The movies also employ digital technology in very different ways, the former relying heavily on computer-generated imagery and the latter on digital cinematography. Neither of these films was the first to employ these tools. *The Phantom Menace* arose in the wake of CGI landmarks such as *The Abyss*, *Terminator 2: Judgment Day*, and *Jurassic Park*, all of which Lucas's visual effects

company, Industrial Light and Magic (ILM), had been instrumental in creating. *The Celebration* shared the limelight at the 1998 Cannes Film Festival with another digitally shot Danish film, *The Idiots* (*Idioterne*), and it appeared in U.S. theaters the same month as digitally shot American independents *The Last Broadcast* and *The Cruise*. However, *The Phantom Menace* and *The Celebration* were widely taken to exemplify the new aesthetic possibilities associated with the concept of digital cinema that was being heralded around the turn of the millennium.[3] Juxtaposing these films demonstrates the heterogeneity of that concept. At the same time, this juxtaposition underscores surprising resonances cutting across otherwise divergent approaches to digital cinema. Specifically, both *The Phantom Menace* and *The Celebration* use digital technology in a way that transforms the relationship between figure and ground. While the films' affective and political effects are quite distinct, this common emphasis shows one way in which contemporary concerns about embodiment and enworldedness manifested themselves on the screen.

This discussion of film style enters into conversation with scholarly work on how electronic and digital technologies inflect cinema's *dispositifs*. That work has often focused on new modes of distribution and exhibition, from the proliferation of cable, satellite, and home video since the late 1970s to the rise of DVD, web streaming, and increasingly small and mobile screens since the late 1990s. As has been widely noted, these changes challenge long-held assumptions about the constitution, boundaries, and experience of cinema, emphasizing nontheatrical (home or mobile) viewing and accompanying broad changes in cinema's industrial organization, intermedial relationships, and geopolitical dynamics. In doing so, they raise questions about how factors including the new viewing contexts, modes of delivery, electronic base, screen scale, transmediality, and potential for interactivity might impact cinema's temporality, spatiality, and appeal to the body, as well as the epistemological and political frameworks within which it operates.[4]

This book is committed to such a project as well, and it has explored how the experience of cinema is inflected by different modes of exhibition in particular. As I argued in chapters 1 and 2, appreciating the specificity of widescreen's address must entail acknowledging the size of the screens introduced in the 1950s. Even—and especially—when

widescreen films utilized the stylistic devices normalized in the preceding decades, such as the close-up, these new screens endowed such devices with a novel address. In chapter 5 I will explore one of the ways in which exhibition has transformed with digital technologies: the move to digital 3D since 2005 (a move that both hearkens back to the 1950s, when widescreen was introduced in dialogue with stereoscopic 3D, and responds to the new pervasion of small screens in the 2000s). Thomas Elsaesser offers a useful model for such a project when he advocates reassessing cinema, including digital cinema, through a concept of diegesis or "world-making" that considers, among other things, the relation of screen space to auditorium space. As he argues, close attention to films—specifically in relation to their particular historical "'diegetic' ground"—is important for such a project.[5] As the case of widescreen makes clear, style and exhibition platforms function in tandem to produce the forms of spatiality and bodily engagement offered by cinema in a given historical and physical context.

It is in that spirit that this chapter examines the style of *The Phantom Menace* and *The Celebration*. This is not to discount the role changes in distribution and exhibition (and the broader industrial, institutional, and technological forces with which they are bound) play in the films' address to viewers. Indeed, building on industrial practices that the original *Star Wars* had been instrumental in demonstrating viable (particularly cross-promotion, a strategy that has been facilitated by the studios' incorporation into global multimedia conglomerates), *The Phantom Menace*'s release both contributed to and benefited from what Henry Jenkins describes as an ascendant "convergence culture."[6] Marked by the increasing fluidity among media around the turn of the millennium—and linked not only to technological changes but to industrial and social shifts as well—this culture, Jenkins argues, not only further bolstered the hegemony of the entertainment industry but also encouraged viewers/users to move smoothly across media and platforms. Thus, while the culture of convergence facilitated "a period of heightened corporate scrutiny and expanding control" by media companies including Lucasfilm, as Jenkins contends, the very pervasiveness of the *Star Wars* franchise across areas including the Internet, computer games, and a barrage of consumer products has also facilitated a form of participation by fans "that includes many unauthorized and unanticipated ways of relating to media content."[7]

As much as *Star Wars* exemplifies the kind of synergistic franchise that proliferates products and media to be consumed in the home, however, the films' marketing simultaneously prized the theatrical experience, emphasizing what has been recognized as blockbusters' function as "events."[8] Lucasfilm's 1997 remastering of the original trilogy, for instance, was groundbreaking not simply for its use of digital effects but also for its widely touted theatrical release. As Michele Pierson explains, the trailer for that release

> began with a shot of a television set showing scenes from the original *Star Wars* film. A voice-over explained that "for an entire generation, people have experienced *Star Wars* the only way it's been possible—on the TV screen. But if you've only seen it this way, you haven't seen it at all." Then, as a blast from a rebel X-wing fighter burst through the television screen, the image on the TV reformed to fill the entire cinema screen. "Finally," the voice-over continued, "the motion picture event the way it was meant to be experienced": on the big screen and "with newly enhanced visual effects and a few new surprises."[9]

Similarly, in 1999, the novel form of exhibition most enthusiastically associated with *The Phantom Menace* was not related to home screens but to digital projection in theaters. Theatrical projection is also anticipated in the film's emphasis on the kind of large vistas that, as Geoff King notes, "work at their best on the big screen."[10] The 2012 rerelease of *The Phantom Menace* in digital 3D reiterated this interest in theatrical projection (and duplicated the marketing strategy used in the 1997 trailer). As is indicated by *The Celebration*'s debut at the Cannes Film Festival and by Dogma 95's insistence on a distribution format of Academy 35mm, theatrical projection was emphasized as a primary mode of exhibition for Vinterberg's film as well.[11]

Treating these movies as theatrical projections, then—and bracketing, though not discounting, the ways in which other forms of distribution and exhibition could conspire with the approaches to style elucidated here to inflect their forms of address—this chapter follows the lead of public discourse on these films by focusing on their use of digital tools in production (and postproduction), namely CGI and digital cinematography. As discussed in chapter 3, these tools

were reputed to alter cinema's bodily address, either by heightening the experience of immersion or by offering tactile engagement with a transformed cinematic object. Here I explore in more detail the ways in which the digital cinematic images themselves contribute to those encounters, particularly through the forms of spatiality they project. Computer-generated and -synthesized images are often marked by their modularity and density, presenting space, as Lev Manovich argues, as both navigable and mediumless.[12] *The Phantom Menace* displays such density, particularly through its awe-inspiring CG vistas, which are filled with moving elements and, ultimately, bodies.[13] While *The Phantom Menace* emphasizes navigation through exotic locales, the space offered for such exploration is rendered awe-inspiring through such constitution by synthetic bodies. By contrast, *The Celebration*'s digital cinematography presents not a dense space but a disintegrated one, the film's low resolution and eventual pervasion by video noise threatening to dissolve the portrayed bodies into nothingness. Along with the material transformations altering the physical contours of cinema at the time, such portrayals of bodies' relation to space contributed to the forms of spatiality and embodied experience the films offered viewers as well, presenting an alternately thrilling or disturbing encounter with bodies under erasure.

THE PHANTOM MENACE

Nobody making films today alludes to Riefenstahl.

—Susan Sontag, February 1975[14]

Released in the United States and Canada on May 19, 1999—twenty-two years after the original installment of the *Star Wars* series, almost to the day—*The Phantom Menace* represented the culmination of George Lucas's drive to render his fantasy galaxy with the significant technological developments that arose in the intervening decades. Although Lucas had not directed a movie since that 1977 blockbuster, he had been instrumental in driving these developments, with his company, Lucasfilm, pioneering, among other things, digital nonlinear editing and CGI technologies.[15] Lucas had previously employed CGI to enhance the visual effects in the original *Star Wars* trilogy for

its 1997 rerelease.[16] With *The Phantom Menace*, however, CGI pervaded a film like never before. As *New York Press* critic Matt Zoller Seitz observed, "Other film has used computer-generated imagery, but never with such boldness and scope."[17] Whereas big films typically had around 250 effects shots and huge films could have 400 to 500—for instance, 1997's CGI blockbuster *Titanic* reportedly contained about 500 effects shots and 1999's other big effects film, *The Matrix*, 413—Lucas claimed that 2,000 of *The Phantom Menace*'s 2,200 shots entailed digital manipulation.[18] By relying so heavily on computer-generated creatures, spaceships, and landscapes, as *American Cinematographer* put it, the film "proved the viability of the 'digital backlot.'"[19]

Fueling the attention devoted to *The Phantom Menace* and its use of CGI was, of course, its status as a long-awaited expansion of the wildly popular *Star Wars* universe. The original *Star Wars* trilogy netted about a $1.5 billion in ticket sales.[20] In 1997, after Lucas repackaged the trilogy as digitally remastered Special Edition videotapes and DVDs, which themselves sold twenty million copies, Fox rereleased the films theatrically, grossing another $250 million.[21] With this history of mind-boggling commercial success—and the fervent fan culture accompanying it—to say that *The Phantom Menace* was highly anticipated is a dramatic understatement. About thirty intrepid fans reportedly stood in a shifting line for six weeks to ensure they would be the first to see *The Phantom Menace* at Mann's Chinese Theater in Hollywood.[22] Two weeks before the film's release, the *New York Times* observed that "there are so many 'Star Wars' sites on the Web that the creator of one site . . . felt compelled to list his favorite 100."[23] Around the same time, the *New Yorker* printed a cartoon of an otherwise blasé-looking man sitting at a bar with a beer and cigarette, the caption reading, "Forgive me, Eddie, if I'm unable to contain the occasional squeal of anticipatory glee over the new 'Star Wars' movie."[24]

The film invited so many promotional tie-ins that the *Hollywood Reporter* identified it as "the first film that will make money even if nobody buys a ticket to see it."[25] Distributor Twentieth Century–Fox insisted that it did not need to spend exorbitantly on advertising, since newspapers, magazines, and television, eager to capitalize on the fervor, offered plenty of free coverage. While the opening of *Titanic* reportedly cost Fox about $30 million, the studio claimed to have spent only about $15 million on *The Phantom Menace* as of the

week after its release.[26] Nevertheless, as the *New York Press* put it in its opening-day review, "There are probably dead people who are tired of hearing about this movie."[27] The film broke box-office records in its first twenty-four hours, netting what was then the "biggest single-day take in film history," with a one-day gross of $28.5 million, beating the previous record set in 1997 by *The Lost World: Jurassic Park* (Steven Spielberg). Despite a barrage of bad reviews, rumors of disappointment in the theater, and initial concern—when *The Phantom Menace* lost its edge over *The Lost World*'s box-office records by day five of its release—that it had "turned into . . . just another successful movie," it went on for several years to rank second, after *Titanic*, in all-time domestic and worldwide box-office grosses.[28]

At the time of the film's debut the prospect of increasingly lifelike computer-generated and -animated characters was of widespread interest.[29] And it was what *New York Times* critic Janet Maslin called *The Phantom Menace*'s "crazily lifelike space beings"—including central characters Jar Jar Binks and Watto—that dominated much discussion of the film's use of CGI.[30] However, the film's innovative deployment of CGI was not limited to its "photorealistic" aliens. Many of its memorable uses of computer-generated imagery are landscapes. Indeed, reviews of the film often enthused about its treatment of setting, as well as its facility with other life forms, citing the complexity and detail of its landscapes and skylines.[31] A close look at this depiction of setting suggests that CGI's role in the film's landscapes has important implications for our understanding of how digital technology influenced its address to viewers. CGI enabled Lucas to create landscapes not only vast and dense but teeming with (synthetic) life.

One of the main foci in scholarly discussions of CGI has been the issue of realism, specifically photorealism, with *The Phantom Menace* epitomizing what Michele Pierson calls a "simulationist aesthetic" marked by "the phenomenological simulation of photographic or cinematographic reality and the representational simulation of objects in the natural world."[32] While the resultant capacity, in Warren Buckland's words, "to combine seamlessly the actual with the possible" has received a great deal of attention, some scholars (including Pierson and Julie Turnock) have emphasized the fact that this seamlessness is a historically rooted, and thus not inevitable, style.[33] A second focus in scholarly discussions of visual effects, including CGI, has been on

the way they can offer a sense of astonishment, awe, and wonder, inviting contemplation and even the experience of the sublime.[34] Such concepts often function to validate films using visual effects, showing how such films function as more than mere means of escapism. The *Star Wars* films have sometimes been posited as counterexamples in such arguments. Pierson argues, for example, that *The Phantom Menace*'s simulationist aesthetic forecloses the sense of amazement, admiration, and intellectual curiosity that she associates with the techno-futurism of the films from the early 1990s that used CGI to create "a hyperreal, electronic aesthetic" aimed at making itself visible.[35] Similarly, Scott Bukatman distinguishes the sublimity of Douglas Trumbull's effects work in films such as *Close Encounters of the Third Kind* and *2001: A Space Odyssey* (Stanley Kubrick, 1968) from John Dykstra's effects work in the original *Star Wars*, which, he suggests, does not invite contemplation but, instead, is "all hyperkinesis and participatory action."[36]

Focusing specifically on the intricately detailed landscapes punctuating *The Phantom Menace* (rather than the CG characters Pierson emphasizes or the kinesis Bukatman finds in the original film), I argue that those spectacles did look quite special at the time of the film's release, eliciting something like the sense of wonder (not simply "dumb enjoyment" but also an appreciation of craft) that Pierson contends eludes the film. I also contend that these landscapes invited the contemplation of infinity that Bukatman and Sean Cubitt have associated with the technological sublime of cinematic effects, falling in line with what Bukatman identifies as the latter's tendency to emphasize the exhilaration of mastery over anxiety or terror.[37] Moreover, *The Phantom Menace* changes its strategy for eliciting awe as it progresses. While the bulk of the film focuses its application of CGI to landscape on the establishing shots that introduce the new environments punctuating the Jedis' quest to defend Queen Amidala (Natalie Portman) and, ultimately, the democracy of the galaxy, Lucas trumps this strategy in the climactic Gungan-droid battle and concluding procession by rendering diverse forms of life (organic and machine) *as* landscape, producing images that dramatically increase the detail and movement contributing to the sublimity of the earlier landscapes.

In treating life as landscape, Lucas not only confirms suspicions about his lack of concern with human characters but also expands on

his long-held interest in emulating Leni Riefenstahl's notorious Nazi propaganda film, *Triumph of the Will* (*Triumph des Willens*, 1935).[38] Although the use of such mass displays of life to evoke aesthetic pleasure and awe recalls Siegfried Kracauer's and Walter Benjamin's concerns about the political implications of mass culture and its forms of spectacle in the 1920s and 1930s, *The Phantom Menace* harnesses such imagery to address (and assuage) contemporary anxieties about the status of embodied life at the turn of the millennium.[39] This evocation of awe at *The Phantom Menace*'s treatment of life as landscape will, ultimately, offer a useful juxtaposition with *The Celebration*'s form of address. Although Vinterberg's film also uses digital technology to blur the boundaries between figure and ground, it provokes a discomfort whose violence is not balanced by an exhilarating sense of mastery—and whose threat is viscerally felt.

Before I begin my analysis, a few clarifications are necessary. Despite references to *The Phantom Menace* as a watershed for digital cinema, the vast majority of its principal photography was done on film: only five shots in the movie were taken with a digital camera.[40] Lucas claims to have wanted to shoot *The Phantom Menace* digitally, but the particular camera package he desired (a high-definition camera that could shoot at the same frame rate as film, twenty-four frames per second, with progressive-scan rather than interlaced images, and with improved lenses) was not yet ready.[41] He would use this package to shoot the next installment of the "prequel" trilogy, *Star Wars: Episode II—Attack of the Clones*.[42] Although most shots in *The Phantom Menace* involved some digital manipulation, its visual effects included both CGI and traditional miniature work, and its locations entailed a combination of virtual and actual sets. While the city-planet of Coruscant was largely created digitally, for instance, the Naboo city of Theed entailed an extensive miniature set built on the ILM backlot. Additionally, while the creatures Jar Jar Binks and Watto were created digitally, the robot C-3PO was a puppet (with digital technology, in this case, employed to erase the puppeteer from the finished image), and the droid R2-D2, in a number of scenes, was, as in the original trilogy, inhabited by the actor Kenny Baker.[43] Moreover, although Lucas used *The Phantom Menace* to test digital projection in four theaters, the great majority of the movie's audiences saw it projected on film.[44] While some uses of CGI are easily identifiable (for instance, in creatures like Watto and Jar Jar), it is

often difficult, especially when analyzing settings, to discern computer-generated from photographed elements. This difficulty was, indeed, a point of pride for the film's creators.[45] I use secondary sources to verify the production strategies used for particular shots; however, the specific modes of construction are ultimately less important to this discussion than the overall aesthetic strategy applied to a film making such notable, extensive use of CGI.

Lev Manovich contends that digital media have transformed the relationship between narratives and worlds, with computer games, in particular, equating narrative and time with movement through three-dimensional (although aggregate and ultimately disjunctive) space. He quotes Robyn Miller, codesigner of the landmark computer game *Myst* (Cyan, 1993): "We are creating environments to just wander around inside of. People have been calling it a game for lack of anything better, and we've called it a game at times. But that's not what it really is; it's a world." Manovich emphasizes the way in which computer technology facilitates navigation through such virtual space and claims that the concept of navigable space has influenced digital-age cinema as well, citing the "fly-through sequence" in the original *Star Wars* as an exemplar of this new emphasis.[46] *The Phantom Menace* continues this interest with the centerpiece pod-race sequence in particular. Not only does this sequence recall the "participatory" tradition of widescreen cinema—its resonance with *Ben-Hur* (William Wyler, 1959) has been noted, and I would add its widescreen predecessor *This Is Cinerama*—but it also echoes contemporary immersive media, including computer games.[47] Indeed, the first of four video games associated with the film, *Star Wars Episode I: Racer* (LucasArts, 1999), released two days before *The Phantom Menace*, was based on this sequence.[48]

Although *The Phantom Menace* thus displays the emphasis on navigation already present in the original *Star Wars*, for this film (and the other two "prequels," *Attack of the Clones* and 2005's *Star Wars: Episode III—Revenge of the Sith*, as well as, to a lesser extent, the 1997 Special Editions), Lucas employed CGI to lavish greater attention on the exotic worlds to be explored. The original trilogy did not emphasize settings so much as fantastic creatures and machines; with *The Phantom Menace* and its updated technology, settings evoke as much excitement as aliens do. For instance, *American Cinematographer* claimed, "No aspect of *The Phantom Menace* is more spectacular than the diverse

environments used as backdrops for the film's operatic drama," and Janet Maslin concluded her review of *The Phantom Menace* by writing of Lucas: "There's no better tour guide for a trip to other worlds. Bon voyage."[49]

The Phantom Menace often presents settings with CGI-heavy landscapes (or seascapes), as, for instance, with the underwater world of Otoh Gunga and the city-planet of Coruscant. Key to such shots' novelty and affective power is the stunning scale of the detailed animation. Like fractals, large structures seem to contain an infinite series of smaller ones. We can see this quite clearly in the establishing shots of Otoh Gunga, an underwater collection of illuminated globes containing nested illuminated globes (fig. 4.1). These structures loom large in the foreground and recede into the distance, evoking a sense of scale that, although synthetic, recalls the sublime by exceeding our perceptual if not rational faculties. As producer Rick McCallum boasts, "You have to see the film two or three times, it's so dense."[50] Adding to the affective impact of such detail is the CGI-aided movement saturating these landscapes. The vistas are, in critic David Sterritt's words, "constantly alive with motion."[51] For instance, the establishing shot of Naboo features multiple, cascading waterfalls and flocks of birds soaring through the sky; the establishing shots of Otoh Gunga are saturated with countless swimming fish and rising bubbles; and the establishing shots of Coruscant reveal airborne traffic streaming along stacked layers of invisible streets (fig. 4.2). Movement in such shots functions as another level of detail, rendering the technological feat of such vistas awe-inspiring.

At the movie's climax and conclusion such shots increasingly feature throngs of creatures of one form or another (human, alien, or droid) in mass displays of movement. If the film enthralled the viewer with the earlier CGI-heavy establishing shots, it is these life-filled landscapes that epitomize its technological achievement and ramp up its affective power. Lucas prepares the viewer for this new level of astonishment by altering the editing pattern according to which he presents the creature-filled landscapes in these final scenes. Whereas CGI-heavy landscapes introduce scenes earlier in the film, establishing the texture of new worlds before Lucas cuts in to closer and less spectacular shots, the later scenes culminate with these CGI tours de force. At the film's climax, for instance, an army of Gungans battles an

FIGURE 4.1 The underwater city of Otoh Gunga illustrates the level of detail facilitated by CGI in *Star Wars: Episode I—The Phantom Menace*. (Twentieth Century–Fox, 1999)

FIGURE 4.2 With establishing shots of the city-planet of Coruscant, movement contributes to the level of detail in *Star Wars: Episode I—The Phantom Menace*. (Twentieth Century–Fox, 1999)

equally immense battalion of droids—an almost entirely computer-generated scene that one reporter describes as the film's "crowning glory."[52] Here, the level of complexity and detail CGI makes possible is applied to creatures on both sides of the conflict, resulting in images of a battlefield alive with movement. The scene is introduced with a shot of dense fog, out of which emerge first a few and then more and more Gungan soldiers, all riding horselike animals. This strategy for

FIGURE 4.3 In *Star Wars: Episode I—The Phantom Menace* the sheer mass of Gungan soldiers blanketing the screen invites a sense of astonishment. (Twentieth Century–Fox, 1999)

gradually revealing the size of the Gungan army foregrounds the spectacle of this display of quantity and thus primes the audience to view the sheer mass of Gungan soldiers blanketing the succeeding long shot with a sense of awe and astonishment. Here, what appear to be hundreds of computer-generated creatures stream across a field. As the camera pans right to follow their flow, it reveals thousands more receding into the distance (fig. 4.3).[53]

The droid army is introduced in a similar way. First, a handful of ships slowly emerge over a hill. After the ships try unsuccessfully to penetrate the Gungans' shield—and after the film cuts to the parallel action of Queen Amidala and her protectors attempting to seize control of the city and disable the droid army's controls—we see one ship open to expel a rack containing layers upon layers of droid soldiers. A pan left reveals another ship unloading its own rack, multiplying the effect. Once we see the droids' masters activating their power, another series of shots emphasizes their mass presence. We start close-up on one droid's huddled body being activated, with a handful more activating droids arrayed behind it. Next, we cut to a shot from a greater distance, which now displays twice as many droids rising to their feet. Finally, Lucas presents the newly activated army in an extreme long shot, which reveals many batches of a hundred or so droids each, all collected neatly in rows, receding into the distance at frame right—

and poised to attack the Gungan masses we see huddled in disarray in the distance at frame left (fig. 4.4). After another series of shots show the droids reaching for and aiming their guns, we cut to one Gungan soldier who voices the significance of this spectacular display in typical Gungan baby talk: "Ouch time."

Lucas reiterates this strategy in the last scene of the film, which shows a parade celebrating the liberation of Naboo (recalling the celebrations appended to the 1997 Special Edition of *Return of the Jedi*; [Richard Marquand, 1983]). As with the Gungan-droid battle sequences described above—and in contrast to the editing pattern of most of the film heretofore—this concluding scene begins with a close shot before moving on to wider, CGI-infused shots. In this case we begin with an extreme close-up of a bugle-like instrument. Next, the film cuts to a close-up of the Gungan playing the instrument, surrounded by falling confetti. The Gungan appears to be marching, as does the fellow Gungan by his side. The falling confetti continues, now joined by cheering crowds barely visible in the background. Following is another image of the marching Gungan band, again from a greater camera distance, such that the frame now encompasses five Gungan musicians. After a shot from a similar distance—this one focusing on the torsos of marching drummers—a cut finds the "camera" at a greater distance again, now revealing a couple dozen Gungan drummers marching down a road flanked by humans dressed in military regalia, who separate the procession from the cheering crowds continuing to wave streamers in the background.

This succession of wider and wider views of the scene prepares the way for the scene's—and the film's—"money shot." This begins as an extreme low-angle shot of the tops of Naboo's regal monuments against a blue sky dotted with white clouds. Confetti floats through the air, and birds soar toward the top of the frame. Countering their movement (and intensifying it), the camera tilts town to follow the confetti, settling on an extreme long shot of the procession and onlookers. A digitally rendered feat, the shot contains an immense amount of detail in motion. There are hundreds if not thousands of onlookers waving streamers (digitally composited from small batches of photographed extras) and masses of marchers, including Gungans and other CG creatures, all amid falling CG confetti (fig. 4.5). This shot recalls the film's earlier use of motion-filled landscapes as establishing shots, employing

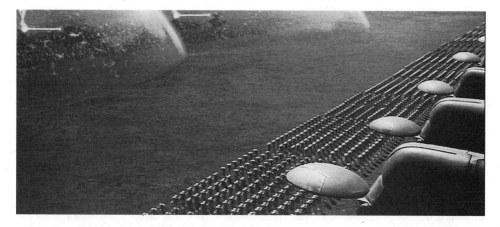

FIGURE 4.4 In *Star Wars: Episode I—The Phantom Menace* droid soldiers, organized neatly in rows, are poised to attack the Gungans in disarray in the distance. (Twentieth Century–Fox, 1999)

CGI to create an astonishing vista filled with intricate detail and movement. Lucas returns to similar extreme long shots as the Gungans approach Queen Amidala to commemorate their victory.

Hence, while CGI-infused long shots function for the bulk of the film as means for establishing setting, by the climactic and concluding scenes they play a different role. Whereas earlier scenes move from long shots to closer shots, these later scenes reverse this pattern, beginning with close shots and moving wider. This transformation accords with increasingly elaborate uses of CGI, rendering these CGI long shots culminations of rather than introductions to scenes.[54] While the earlier instances of CG landscape punctuate the film, alternating with less spectacular images conveying narrative information, these culminating uses of CG landscape are imbricated with the film's narrative. Although no less spectacular (quite the contrary), their spectacle has a narrative function, their use of detail evoking a sense of awe that conveys—rather than simply setting the stage for—the film's messages of danger and triumph.[55] Moreover, Lucas effects this shift by integrating the hitherto distinct foci of his CGI: character and landscape. With the Gungan and droid armies and the triumphant parade, CG characters and digitally multiplied humans *become* landscape—their coordinated yet distinct movements epitomizing the film's drive to render landscape in intricate, motion-filled detail.

FIGURE 4.5 In a bravura display of digital animation and image synthesis the final parade sequence in *Star Wars: Episode I—The Phantom Menace* contains an immense amount of detail in motion. (Twentieth Century–Fox, 1999)

Such spectacular shots, filled with synthetic life, in many ways exemplify what Kristen Whissel has called "the digital multitude." Focusing particularly on the kind of menacing multitude that in *The Phantom Menace* is embodied by the droid army, Whissel shows that such masses have been a frequent—and significant—presence in digital visual effects cinema. In particular, she argues that these multitudes function as a spatial emblem for temporal change, offering a visual indication of major historical transformation. They both signal a terrifying, apocalyptic force and offer a model of "collective unity and selflessness" that ultimately the protagonists must emulate in order to persevere. Although Whissel does not address *The Phantom Menace* directly (but does reference *Attack of the Clones*), her remarks shed light on the affective power of the Gungan-droid battle discussed above, with the droids threatening the overthrow of an era of peace on Naboo and the Gungan army presenting a ragtag collection of individuals banding together to create a future in continuity with the status quo. Ultimately, Whissel argues, the digital multitude emblematizes the role digital visual effects play in film history, both offering a sense of continuity with the past and marking a historical break.[56] *The Phantom Menace* illustrates that point, as well, insofar as its references to both the original *Star Wars* and *Triumph of the Will* at once draw on

previous strategies for eliciting awe and underscore the radical novelty of this most recent film's means.

Considering its resonances with *Triumph of the Will* shows how *The Phantom Menace* deploys the digital multitude to address not only a crucial juncture in the history of cinema but also contemporary concerns about the status of human life at that juncture. Whissel makes a similar point, observing that high-angle wide shots of the digital multitude "foreground the displacement of human actors and extras by digital beings in contemporary cinema, a historical fact that many films thematize and make pleasurable through the multitude's terrifying promise to foreclose upon human history altogether."[57] Looking closely at *The Phantom Menace*'s digitally created multitudes, particularly vis-à-vis the photographed multitudes presented in *Triumph of the Will*, reveals how such computer-generated masses can function not only as a threat to live actors (or more broadly, to human history itself) but, more specifically, as a means for picturing a perceived threat to the integrity and agency of bodies—a threat enacted, in a different way, by *The Celebration* as well.

That *The Phantom Menace*'s conclusion echoes the final scene in the original *Star Wars* allows us to discern the ways in which Lucas's aesthetic strategies and address to the viewer have transformed in conjunction with his use of CGI. The 1977 film displays a similar interest in mass arrays of figures, employing scores of extras to witness the concluding procession. Lucas's use of digital compositing and CGI in *The Phantom Menace*, however, enables him to increase the scale of such detail dramatically and invites an aesthetic that elicits awe not only through seemingly infinite patterns but also through variations in these patterns created through movement. The Gungans do not march precisely in unison, nor is the bustling of the crowd uniform. Similarly, in the earlier battle scene, when the CG droids pull out their weapons, their actions are timed differently enough that viewers recognize they could not have been effected with a single computer command. With live action, rendering real, diverse bodies uniform is an astonishing feat; with CGI (and in contradistinction to Kracauer's conceptualization of the mass ornament), it is the capacity to differentiate synthetic bodies through movement, creating masses that are not only regimented but sufficiently distinct to give the impression that each element required painstaking individual attention, that is awe-inspiring.[58]

The movement toward utilizing life forms as awe-inspiring land-scape falls in line with the oft-made suggestion that Lucas is more con-cerned with effects than with characters. Even before the advent of Jar Jar, Mark Hamill (Luke Skywalker) famously suspected that "if there were a way to make movies without actors, George would do it."[59] In addition to adding computer-generated "synthespians" to the cast of *The Phantom Menace*, Lucas tinkered extensively with his live actors' performances in postproduction, not only compositing different per-formances in single shots (such that the actions and reactions depicted in a single shot could derive from distinct takes) but also adding and removing lip movement to accommodate or edit out dialogue.[60] Lucas himself claimed that manipulating the images of actors was "exactly like using a word processor."[61] Jean-Pierre Geuens has criticized such deployment of digital technology to control the image, arguing that digital filmmaking encourages a nihilistic tendency in directors like Lucas to treat the rest of the world (including other people) as objects. He explains, "Such directors, no longer embroiled in the complexity, the otherness, and the resistance of the everyday world, would become truly omnipotent, their power absolute."[62]

Furthermore, with *The Phantom Menace* (and *Attack of the Clones*), digital technology allows Lucas to expand on the reference to *Triumph of the Will* he made in the original *Star Wars* and raises questions about the implications of this continued deployment of aesthetic strategies associated with fascist propaganda. The culminating procession scene in *Star Wars*, as the LucasArts Entertainment Company's own "Insid-er's Guide to *Star Wars*" explains, "emulates, almost shot-for-shot, a similar segment in *Triumph des Willens*"—specifically, the moment when Adolf Hitler, Heinrich Himmler, and Viktor Lutze march to the Nuremberg memorial monument.[63] However, the scores of extras Lucas employed for his original version of the procession, although *evoking* the seemingly endless masses flanking the Nazi leaders at Nuremburg, did not nearly replicate their scale. For the "prequels," with digital tools and significantly increased financial resources— which put Lucas in a position more akin to Riefenstahl's with *Triumph of the Will*, which reputedly entailed "an unlimited budget, a crew of 120, and a huge number of cameras"—he was able more closely to approach (although still not replicate) the sheer number of *Triumph of the Will's* masses.[64] Such configurations recall Siegfried Kracauer's

concept of the "mass ornament"—a term originally used to describe the Busby Berkeley–style spectaculars popular in Weimar Germany in the 1920s but that Kracauer eventually applied (drained of its progressive dimension) to *Triumph of the Will*. In Kracauer's discussion of Riefenstahl's film the "mass ornament" retains its reactionary significance as a figure that evacuates people of their individuality and presents them as "instrumental superunits."[65]

With *The Phantom Menace* Lucas extends his homage to *Triumph of the Will* beyond evoking such organized mass formations, adding to the awe-inspiring effect through a mass array of movement. Contending that "totalitarian propaganda endeavored to supplant a reality based upon the acknowledgment of individual values," Kracauer suggests that, in *Triumph of the Will*, movement contributes to this "transfiguration of reality." He explains: "The nervous life of the flames is played upon; the overwhelming effects of a multitude of advancing banners or standards are systematically explored. Movement produced by cinematic techniques sustains that of the objects. There is a constant panning, traveling, tilting up and down—so that spectators not only see passing a feverish world, but feel themselves uprooted in it."[66]

In its final scene *The Phantom Menace* seems self-consciously to evoke this strategy as well. If, as Kracauer observes regarding *Triumph of the Will*, "the city was a sea of waving swastika banners," the culminating shots of the procession in *The Phantom Menace* derive a good deal of their motion from a similar sea of streamers. Not only does the tilt down at the outset of the "money shot" echo the dynamism Kracauer describes, but the low angle with which it commences also seems to cite *Triumph of the Will*'s strategy of "[isolating] architectural details . . . against the sky." Such shots, Kracauer claims, further disrupt a grounding in reality; they "seem to assume the function of removing things and events from their own environment into strange and unknown space."[67] Such extensive reference to *Triumph of the Will* cannot but beg the question: in duplicating Riefenstahl's formal strategies for eliciting awe, does Lucas simultaneously reiterate her film's political message? As Robin Wood quips, "From the triumph of the Force to the Triumph of the Will is but a step."[68]

Lucas himself associated his interest in making the original *Star Wars* with actual wars—both the Vietnam War, the aftereffects of which he claims to have wanted to counter with "something more

positive," and World War II, which he explains was "a big deal when I was growing up," and which he has said he "loved."[69] This association, especially the drive to sanitize the portrayal of war, was carried over when the term *Star Wars* came to be used to describe Ronald Reagan's Strategic Defense Initiative.[70] Despite what some critics have suggested is an eerie resemblance between the rhetoric of "The Force" and fascist rhetoric, the *Star Wars* saga does not explicitly identify with fascist politics.[71] The movies' depiction of heroic defenders of freedom struggling against an evil imperial army outfitted in Nazi-inspired gear, however, makes Lucas's interest in repeatedly restaging Riefenstahl's film with his good guys in the place of Hitler and his cohort particularly mind-boggling—and perhaps best explained by what has been a popular belief that *Triumph of the Will*'s purportedly laudable form could be distinguished from its morally objectionable content.[72] In his 1977 review of *Star Wars* for *Film Comment*, for instance, Arthur Lubow claimed that Lucas's film successfully repurposed the form of awe Riefenstahl evoked to entertaining rather than propagandistic ends. "When the old *Liebfraumilch* is poured into new bottles," he wrote approvingly, "it packs a powerful wallop."[73]

Although *The Phantom Menace* is not nearly the pernicious piece of propaganda that *Triumph of the Will* is (for reasons ranging from its narrative content, cultural context, and industrial positioning to its widely noted affective shortcomings), thinking about it in terms of Kracauer's writing is useful insofar as it, first, highlights the way in which such imagery addresses contemporary (and changing) anxieties about the status of subjectivity in a specific cultural context and, second, underscores the political implications of such a project.[74] Although *The Phantom Menace* avoids simply duplicating *Triumph of the Will*'s political message, the tropes Kracauer associates with its fascist aesthetic, including the devaluation of people as things and the occlusion of the world of everyday life, remained pertinent at the close of the twentieth century, if on a quite different register. As we saw in chapter 3, the boundaries between human and computer (and among humans themselves) were widely understood to be in question during this period, with an increasingly digitally mediated world reputed to be transforming the nature of bodily experience, communication, and community. Considering *The Phantom Menace* via Kracauer suggests that Lucas's film not only displayed a landmark use of CG creatures

and environments but also harnessed the anxieties produced by such imagery to affective and political effect.

On one hand, of course, the use of CGI in *The Phantom Menace* departs from—and seems to mitigate the political implications of—Riefenstahl's fascist aesthetic insofar as it replaces human beings with fantastic creatures as the objects of control and reification. On the other hand, such a simple opposition between human and non-human assumes a cut-and-dried distinction that was, at the end of the twentieth century—in a context marked by video games and the Internet (media whose target audience overlapped significantly with Lucas's fan base)—increasingly difficult to make.[75] The fact that Lucas chose to depict the film's computer-generated aliens as racial and ethnic "others" indicates the uneasiness the use of CGI aroused (not to mention indicating the force xenophobia continued to exert in American popular culture at the end of the twentieth century). Indeed, the generalized feeling of xenophobia presented by the original films—made palatable, as Robin Wood argues, by displacement onto nonhuman characters—not only carries over into *The Phantom Menace* but becomes conflated with the distinction between live action and CGI.[76] Whether or not we accept Lucas's argument that creatures such as Jar Jar Binks and Watto do not reflect specific racist stereotypes, the film consistently portrays computer-generated aliens as either menacing (as with the inhabitants of Mos Eisley) or amusingly inept (as with the Gungans), leaving it to humans to orchestrate (and employ the Gungans in the service of) the liberation of Naboo.[77] While Lucas offers the fantastic look of his aliens as proof that they do not conform to racist stereotypes—"I mean, [Jar Jar is] *orange*. . . . He's a comic orange amphibian stereotype"—I would contend, following Wood, that CGI actually made such xenophobia seem acceptable to a wide audience by displacing fear of the different onto digital creations.[78] Moreover, in harnessing this type of reactionary, binarist depiction of the world (or the galaxy, as the case may be), *The Phantom Menace* obscures and assuages the crisis of human identity that was strongly felt at the end of the twentieth century. Rather than address this reevaluation of being—as Vivian Sobchack argues his use of droids did in the first movie—and thus gesture toward reimagining humanness in a technologically transformed world—as Kracauer originally hoped the mass ornament might do and Donna Haraway envisages

the cyborg doing—Lucas's use of CGI at the end of *The Phantom Menace* reifies posthuman life as movement, inviting viewers to delight at this devaluation.[79]

THE CELEBRATION

I love the images late on of the father, as if he's slowly disintegrating.
—Anthony Dod Mantle on *The Celebration*[80]

Whereas *The Phantom Menace* was a widely anticipated behemoth of a film made by one of the most powerful moguls in Hollywood, *The Celebration* was the product of a young filmmaker (twenty-nine years old at the time of its release) working with a modest budget (of under $1 million, compared to *The Phantom Menace*'s reported production budget of $115 million) in the small nation of Denmark—although in association with one of the world's most prominent auteurs, Lars von Trier.[81] While anticipation surrounding *The Phantom Menace*'s release was met with critical disappointment, *The Celebration* was something of a surprise hit. Reportedly received with skepticism by the Danish executives who first screened it, the film emerged from the 1998 Cannes Film Festival a sensation.[82] Winner of a special jury prize and the first competition film of the year to be acquired (by October Films for North American rights), Vinterberg's movie not only fared extremely well at the Danish box office (in its first months of release, it was second only to *Titanic*) but also, ultimately, grossed $12 million worldwide—many times its budget.[83]

Together with fellow Danish Cannes entry, Lars von Trier's *The Idiots*, *The Celebration* launched the Dogma 95 movement, an approach to filmmaking elaborated by von Trier and Vinterberg in 1995 via a manifesto and set of rules called "The Vow of Chastity." This manifesto explicitly opposed the "technological storm" that had purportedly overcome cinema and compelled filmmakers to "wash the last grains of truth away in the deadly embrace of sensation"—a storm that was soon to find its apotheosis in *The Phantom Menace* (although it should be noted that there was some disagreement as to whether the target of von Trier and Vinterberg's missive was Hollywood or the tradition of European, and specifically Danish, art cinema, with von Trier suggesting the former and Vinterberg the latter in interviews).[84]

Dogma 95, by contrast, proclaimed its "supreme goal . . . [was] to force the truth out of . . . characters and settings." And it stipulated that to do so, filmmakers must shoot on location; produce sound and image together; employ a handheld camera at all times; shoot in color with no special lighting; refrain from using optical work, filters, and "superficial action"; avoid temporal and geographical "alienation" and genre filmmaking; use an Academy 35mm film format; and withhold directorial credit.[85]

Many critics have noted Dogma 95's resonance with other modernist movements in cinema, including Italian neorealism, British Free Cinema, and, especially, the French New Wave (which the Dogma 95 manifesto explicitly invokes and repudiates), either to laud Dogma 95 as a welcome return or, more often, to condemn it as hackneyed, cynical, and lacking the political aspirations of its predecessors.[86] Others, however, have stressed the movement's contemporary resonances, whether to claim, as does Mette Hjort, that it instantiates a form of "alternative globalization" (simultaneously exemplifying "a small nation's response to Hollywood-style globalization" and modeling a form of "grassroots globalization"), or to argue, as does Jan Simons, that it should be understood not via the tradition of cinematic modernism (particularly the Bazinian realism often attributed to it) but in relation to von Trier's long-standing ambition to radically reconceptualize cinema as a game—an ambition that is "firmly based in an emergent new media culture of virtual realities."[87] Focusing specifically on *The Celebration*, I argue that Vinterberg's film should also be understood as more than a hackneyed return to earlier modernist movements—and beyond the issue of realism.

The Celebration largely plays by the rules set out in "The Vow of Chastity." In his "confession" Vinterberg claims that "only one genuine breach of the rules has actually taken place": in one shot he used a black drape to cover a window, not only contributing material not found on the location but also providing a "kind of lighting arrangement." As additional "moral breaches," he also confesses to have had knowledge about actors purchasing special clothing for the film, orchestrated the "construction of a non-existent hotel reception desk" out of materials found at the location, allowed the actor playing Christian to use a cell phone that was not actually his, and incorporated one take in which the camera was Scotch-taped to a boom, "and thus only partially

handheld."[88] Recording sound with image was reportedly especially difficult, since it required dialogue and reaction shots to be taken simultaneously, a problem Vinterberg addressed in the scene of Christian's speech by running three cameras simultaneously, each with sound. The inability to move sound also caused difficulty in postproduction, something editor Valdis Oskarsdottir approached by not attempting to "make the film smooth [but instead trying] to make it go with the emotions."[89] Although the movie was transferred to 35mm film for distribution, its origination on digital video seems to depart from the penultimate "vow." While von Trier and Vinterberg initially intended for Dogma 95 movies to be shot on film (since it "was thought to be less susceptible to manipulation than video"), they eventually agreed to specify that the 35mm requirement referred only to the distribution format, enabling von Trier, Vinterberg, and others following in their Dogma 95 footsteps to shoot on digital video.[90] Vinterberg's decision to shoot digitally, however, was a practical rather than an aesthetic or ideological one. Admitting that it "would have been far more Dogmalike to have shot the film in the medium in which it was to be shown," Vinterberg claims, "shooting on video was a compromise I didn't like. I'm still angry about it."[91]

Ironically, digital video would come to be equated with Dogma 95 filmmaking—and it was taken up by the American independent digital movement that followed in Dogma's wake.[92] Shooting on "prosumer" digital cameras was, in the first place, inexpensive enough that it could make otherwise potentially unbankable films feasible. As *Variety* announced in January 1999, "Just as inexpensive digital audio equipment has transformed thousands of musicians' spare bedrooms into professional-quality recording studios over the past decade, digital video now offers filmmakers the possibility of making theatrical-quality films for as little as a few thousand dollars."[93] Digital cameras made it possible to shoot *The Celebration* with a cast of almost fifty for under $1 million; Vinterberg explains that he was given the alternative of shooting on 35mm with a cast of three.[94] Additionally, despite Vinterberg's stated dissatisfaction with digital video, the format facilitated his adherence to such Dogma 95 dictates as reliance on handheld camerawork and available lighting, as I elucidate below. Although the immediacy or truth value of these tactics is certainly questionable— critics at the time identified them as a fad likely to become stale with

continued use—and although Dogma 95's challenge to establishment filmmaking is, as skeptics also pointed out, suspiciously reminiscent of the earlier movements mentioned above, Vinterberg's film does offer a unique aesthetic.[95] While certainly guided by the Dogma 95 credo, this aesthetic owes its novelty and reach to the digital cameras Vinterberg bemoaned. As *Newsweek* reported in March 1999, "When people look back at the seminal movie of 1998, it may not be 'Saving Private Ryan' but the Danish birthday-party-from-hell drama 'The Celebration.' Not because it won the New York and L.A. Film Critics awards for best foreign film but because it was shot on a Sony PC7, a consumer digital video camera."[96]

The two stylistic tropes most frequently associated with low-budget digital video—as utilized by Dogma 95 films such as *The Celebration* and *The Idiots*, as well as the American independent projects they inspired, such as *Julien Donkey-Boy*, *Chelsea Walls* (Ethan Hawke, 2001), and *Tadpole* (Gary Winick, 2002)—were its low-resolution images and the highly mobile, handheld cinematography facilitated by tiny cameras (the Sony PC-7 used on *The Celebration* was palm-sized).[97] While this aesthetic recalls previous filmmaking movements, and similarly posits itself as a challenge to establishment filmmaking, it also reflects specificities of the new digital cameras. Indeed, if we believe the availability of lighter and more mobile equipment by the late 1950s facilitated novel approaches to filmmaking such as Direct Cinema, we should not discount the equipment introduced forty years later—which further diminished the size and weight of the camera as well as its resolution—as simply provoking a return to an established style.[98]

Although a new approach to mobility related to palm-sized cameras might usefully be explored—and Vinterberg himself identifies the camera's inconspicuousness, what he calls "the hidden camera," as the advantage of video—I will focus here on what I believe is the more obviously qualitative transformation arising from the use of digital video: its tendency to produce disintegrated images under certain conditions.[99] As I did with *The Phantom Menace*, I argue that this results in a changed relationship between figure and ground. In this case, however, the resultant decomposition of the human figure perpetrates a form of violence on the viewer. Although Vinterberg's reference to aggression in the quote heading this chapter was surely meant as a comment on the movie's depiction of aggressive actions within

the diegesis, his filmmaking style also enacts a sort of aggression. As a result—and in contrast to *The Phantom Menace*—*The Celebration*'s digital images, with their challenge to a stable or centered subjectivity, emerge as a source of discomfort.

Commentary on *The Celebration* often referenced its hazy aesthetic. Critic Armond White, for instance, cited its origination in video as the root of what he called its "soft, almost vague" look. Canada's *Globe and Mail* suggested that the film was "often grainy to the point of confusion."[100] The *Guardian*'s Jonathan Romney offered a description evocative enough to merit recycling here from chapter 3: "Everything is seen through the tactile gauze of the electronic image. The picture shifts, shimmers and melts; in the night interiors, the picture thickens like dark grainy soup." The shimmering, disintegrating look—producing what another reviewer described as its "impeccably ugly shots"—is rooted in two interrelated characteristics of the digital video format: its resolution and its response to light.[101] Vinterberg harnesses each of these elements to subvert conventions of pictorial clarity, creating images that do violence to the human figure by threatening to dissolve it into the background.

Digital video resolution is variable with different cameras and digital formats.[102] Although high-definition video was believed to have a resolution and look close to—or even exceeding—35mm film (James Cameron suggested that the Sony 900 HD camera produced an image equivalent to a 65mm original negative) and Digital Betacam was considered higher resolution than 16mm film, "prosumer" digital camcorders like Vinterberg's Sony PC-7 produced significantly lower-resolution images than film.[103] In addition to other particularities of these cameras, including interlaced rather than successive images and a tendency to produce a greater depth of field than film cameras, the cameras' relatively low resolution was believed to be inappropriate for wide shots, where the lack of detail was particularly noticeable, and suitable, instead, for close-ups.[104] Cinematographer Uta Briesewitz, for example, contends that, generally, "wider shots are the weakest part for video. For instance, when you look at miniDV, the close-ups hold up okay, but when you go to the wider shots, it gets all mushy." As a result, explains cinematographer John Bailey, for *The Anniversary Party* (Alan Cumming and Jennifer Jason Leigh, 2001) he and the directors decided to "shoot in a way that limits the number of masters

and wide shots and emphasizes close-ups." Cinematographer Maryse Alberti (*Tape* [Richard Linklater, 2001]) concurs, suggesting that to shoot successfully on digital video, "you have to find a story that doesn't rely on the texture of a place. If your environment becomes a character, I'm not sure DV is such a good medium."[105]

In line with this thinking *The Celebration* shies away from traditional establishing shots. Instead, the mobile camera seems to search out the action, often moving from abstract, difficult-to-read (out-of-focus, quickly moving, obstructed, or insufficiently lit) shots to clearer views. For instance, the establishing shot of the family home begins dominated by a rusty, unreadable iron form in the foreground, behind which we see the car carrying the film's protagonist, Christian (Ulrich Thomsen), and his brother, Michael (Thomas Bo Larsen), approaching under a Danish flag. Only as the handheld camera tilts up and pans left to follow the car do we recognize the iron structure as a gate and see the family mansion in a long shot that nevertheless occupies little more than half of the frame, the remainder devoted to the gate's hypersituated stone support. Similarly, the sequence introducing Christian's sister, Helene (Paprika Steen), begins with a traveling shot of the side of the road, taken from a car window, before cutting to another moving shot, this one rising along the woman's body to rest in a close-up as she lights a cigarette in the backseat of a taxi. Vinterberg introduces the following scene with a tracking shot from behind a stairway banister, the camera finally rising and tilting down over the stairway to land in an extreme high-angle long shot of Helene embracing Christian. By drawing attention to the camera's mediating presence through defamiliarizing focus, lighting, angles, and movement, such unconventional establishing shots underscore the camera's point of view as subjective—emphasizing its status as what Jan Simons calls an "invisible observer"—not only evoking the ghostly presence of Christian's dead sister at times but also providing a visual cue to what critic Jonathan Romney identifies as the film's "theme of blindness and insight," preparing us for the ultimate revelation that the family's truth has long been suppressed.[106]

Despite the relative scarcity of *The Celebration*'s long shots, such shots provide a clear indication, early on in the film, of one of the ways in which its digital cinematography will guide its approach to cinematic storytelling. Vinterberg tends to treat exterior long shots not

as beautiful vistas or even as means for contextualizing characters but as subtle indications that something is not quite right. The opening of the film finds Christian in extreme long shot, walking down a country road flanked by what might be wheat fields (fig. 4.6). While echoing a conventional establishing shot, this image does not offer the clear portrayal of a picturesque vista presented, for instance, at the outset of *East of Eden* or rendered with CGI in *The Phantom Menace*. First of all, the camera is handheld, precluding any claim to an objectivity of perspective. Furthermore, the digital image is, as Briesewitz termed it, "all mushy," its resolution failing to provide sufficient detail to render the landscape clearly. Indeed, the image seems to shimmer—an effect that is heightened by the handheld camera—and the viewer must struggle to discern Christian's figure as it moves down the road.

The shot is interestingly counterposed with Christian's cell phone conversation, as he explains, "I'm fine . . . right now I'm looking across the fields. At the land of my father. It's beautiful." If the line suggests that Christian is "fine" while outside in the fields—and thus posits this exterior shot as a counterpoint to the rest of the film, most of which unfolds indoors and reveals that Christian is resolutely not fine—the image accompanying Christian's words compels us to detect their irony. Although we certainly might consider the landscape beautiful, this digital long shot is a far cry from the traditional image of a beautiful cinematic vista—its lack of polish resonating with Christian's apparent neglect for personal hygiene (in response to an unheard question, he answers, "Er . . . *Washed*? I shaved at the airport if you must know"). As the film will go on to suggest, the land of Christian's father is not as idyllic as the dialogue implies. This subtle stylistic questioning of beauty provides the first indication that the family reuniting for the sixtieth birthday of its patriarch, Helge (Henning Moritzen), is not as unblemished as it might like to appear; the film culminates with the revelation that Helge sexually abused Christian and his twin sister. It might be noted that the phone conversation that occurs against this vast background is the only time in the film we see Christian interacting with someone outside the family estate.[107] It thus might be tempting to associate this long shot with links to the outside world—a sense of connection that is markedly absent from the remainder of the film, producing a feeling of inwardness that echoes the narrative revelations about the family's history of incest and racism. Subsequent use

FIGURE 4.6 The low resolution of digital video is evident in the opening of *The Celebration*. (October Films, 1998)

of exterior long shots, however, suggests that, within the film's lexicon, this device tends to function in opposition to contextualization.

Rather than contribute to narrative clarity, the film's long shots often call attention to the act of seeing (through tactics such as extreme angles, obstructed or overtly mediated views, and insufficient lighting) in a way that compels the viewer to question their apparent meaning. Instead of detracting from such shots, the breakdown or mushiness of the digital image contributes to this effect. For instance, early on in the narrative, the party guests mingle outside. Initial shots of this scene are handheld close-ups and obstructed medium shots. Although the hypersituated objects (wine glasses, faces, and heads) are glaringly out of focus, the colors are bright and autumnal. When Vinterberg cuts to a long shot of the scene, the image is startlingly blurred, with muted colors and a hazy, filtered look (fig. 4.7). Only

FIGURE 4.7 A long shot of a welcoming reception is startlingly hazy in *The Celebration*. (October Films, 1998)

when the camera pans to reveal a window frame and the film cuts to a close-up of Christian do we recognize the shot, retrospectively, as his point of view through a windowpane. We recognize the disintegrating look of this long shot from the film's opening landscape, although here the impressionistic effect is enhanced by the glass of the window. Again, the long shot does not offer viewers a detailed or encompassing view but forces them to struggle to decipher the image and to question the idyllic scene.

This shot prepares us for another exterior long shot (which transitions into a medium long shot), of Helge chasing his grandson around the yard (fig. 4.8). Preceded by an image of Christian asleep in a chair next to the window and echoing (even exacerbating) the hazy look of the earlier point-of-view shot, this can be read as another view through the windowpane. At first glance the shot is an idealized vision of a playful

FIGURE 4.8 Helge plays with a young boy in a blurry medium long shot in *The Celebration*. (October Films, 1998)

grandfather; however, the imminent revelation that Helge abused his children retrospectively endows this image with ominous overtones. By introducing this shot with an image of Christian sleeping, Vinterberg also invites us to consider its resonance with Christian's own memories, suggesting that this apparently playful image might be better understood as predatory. Indeed, the shots following it, which show Helge letting the boy into an empty hallway and urging him to keep quiet, mislead the viewer into suspecting foul play in the present as well. While Helge's relationship with his grandson is not central to the narrative (or, perhaps more precisely, its significance is speculative rather than addressed at length), this shot—which, again, emphasizes and exaggerates the murkiness of digital long shots in general—suggests how Vinterberg's use of digital equipment has inspired aesthetic choices that depart from filmmaking norms in a way that has

tangible effects on how a device like the long shot functions both visually and narratively.

It is such long shots, all of which occur in the first quarter of the film—together with Christian's first confrontation with Helge, which takes place in a darkened room—that prepare the viewer for the film's aesthetic trajectory, for as the day turns into evening and light dims, the digital video image increasingly disintegrates. Adhering to the Dogma 95 pronouncement that "special lighting is not acceptable," Vinterberg shoots in increasingly low-light situations. In such situations digital video reacts quite differently from film. As a capture format digital video maintains analog video's sensitivity to light. This means not only that digital cameras can capture images in very low light but also that they produce detail in their blacks in a way that film cameras do not. Conversely, whereas film offers detail in highlights, digital video blows them out, resulting in hot, white areas devoid of detail.[108] Importantly, although digital cameras are capable of producing images in very low light, they do so at the expense of clarity, with video noise increasing along with light sensitivity.[109] These factors contributed to a debate among directors and cinematographers as to how to light for the new format. Some argued, citing digital video's lack of latitude, that it required just as much—if not more—attention to lighting as did film, while others favored the degraded look of low-light digital cinematography and advocated using natural lighting.[110]

The Celebration epitomizes the latter look. As Vinterberg shoots in darker and darker situations, the movie displays an increasing amount of video noise, with dark, dancing splotches becoming more and more visible, endowing the image with a feeling of movement that, paradoxically, recalls the swirling film grains whose absence in digital video was decried by skeptics. Cinematographer Anthony Dod Mantle describes the way in which the film stock he chose for conversion emphasized this movement: "In the end, I converted the video to a very high-speed, pushed film stock. That way, the digital noise starts to speak to the film grain. And I wanted this . . . organic mass to bubble up there on the screen."[111]

We can see the result of this strategy clearly in the scene where Helene reads a note from their dead sister, Linda, aloud to the gathered family (fig. 4.9). The note links Linda's suicide to Helge's abuse, thus confirming Christian's heretofore disputed accusations and

compelling Helge to proclaim that the abuse was "all [his children] were ever good for." Vinterberg cuts among close-ups and medium close-ups of Helene reading and of family members listening, emphasizing Christian and Helge in particular. These shots, taken in a dim dining room, crackle with video noise, which appears as dark spots that flit over the highlights in the image. Classical film theorists such as Jean Epstein and Béla Balázs argued that film close-ups reveal otherwise imperceptible elements of the world.[112] In these close-ups, by contrast, the video noise, which makes the highlights appear to teem while sparing the darker areas and thus rendering them more static, divides the frame into zones of movement and stillness. An important result of this effect is that this constant movement in light areas equalizes figure and ground, with the dancing blotches just as insistent on the light-colored walls behind Helene, Christian, and Helge as they are on the actors' faces. Helene and Christian, in particular, threaten to blend into their background, Helene because her blonde hair and cream-colored dress match the wall color quite closely and Christian because he is framed so tightly that his face, also a close match to the light wall, takes up much more of the frame than the black suit jacket visible at the shoulders. In opposition to Helene and Christian, whose lighting is quite flat, Helge sits in front of a candle and is thus lit with a bit more contrast, with some strong facial highlights offering a measure of differentiation from his background. In all of these close-ups, however, the prominent video noise functions not to bind these characters with their environment but to emphasize the intangibility and instability of figure *as well as* ground (an emphasis that is strengthened by the choice to use such plain backgrounds). The degraded digital video thus works powerfully in this scene not only because it acts as an emblem of the family's disintegration, as has often been suggested, but also because it threatens to dissolve these human figures into the digital grain—a form of visual violence that seems particularly appropriate to this narrative about rape.[113]

This confrontation marks an aesthetic turning point in the movie. If it began in daylight and moved into low-light cinematography as evening fell and the family dined, the abrupt ending of the meal also initiates a segment that will take place in near darkness, with images so degraded that they verge on abstraction. Only at the conclusion of the film, which takes place the following morning and acts as something

FIGURE 4.9 As Helene reads a note from her dead sister in a dimly lit room in *The Celebration*, video noise blends her figure into the background. (October Films, 1998)

of a coda, do we return to clearly legible images. The dark segment is preceded with the inappropriate suggestion by the evening's toast-master (Klaus Bondam), upon Helge's admission to abusing his children, that the family move on to "dancing, music and coffee next door"—after which Vinterberg cuts to a close-up of a match being lit and then pans the camera to reveal an extremely dark parlor full of indiscernible waltzing couples, blotches of video noise appearing to permeate the atmosphere. This dark, abstract look initiates the climax of the film, when Michael—the son that has hitherto defended his father and striven to impress him—lures Helge out of his home and nearly beats him to death, telling him he'll never see his grandchildren again. This scene appears to be lit by a single porch light, with medium shots extremely murky and long shots falling off into total blackness. Digital video enables the camera to see into dark areas with a level of

detail that would be difficult with film. In the images of Helge huddled on the ground, in particular, the dim lighting suffices just so that we can discern his bathrobe, shirt, and face, the very subtle highlights not so much providing a sense of depth as bleeding over the surface of the image, creating a muddy, almost entirely flat image in which Helge, rather than emerging from the shadowy background, dissolves into it (fig. 4.10). We can thus, again, view digital video itself as contributing a kind of violence to the human figure by rendering its boundaries so diffuse as to all but disappear.

This tendency toward disintegration can be usefully considered alongside another important, quite different, digital technique for questioning the boundaries of bodies: the morph. As used famously in Ron Howard's *Willow* (1988) and Michael Jackson's music video *Black or White*, directed by John Landis (1991), morphing employs computer technology to make the image of one figure appear to transform into another. This is done by identifying important points on the images of two distinct figures (for instance, Michael Jackson and a panther) and allowing the computer to plot a series of intermediary steps from the key nodes on one figure to those on the other.[114] Pioneering uses of CGI also emphasized the morphable nature of fantastic creatures, as exemplified by the water-based life form in *The Abyss* and the T-1000 "liquid metal" cyborg in *Terminator 2*. Commentators have noted the way in which the morph subverts stable forms of identity. Vivian Sobchack, for instance, argues that the morph "calls to the part of us that escapes our perceived sense of our 'selves' and partakes in the flux and ceaseless becomings of Being—that is, our bodies at the cellular level ceaselessly forming and reforming and not 'ourselves' at all"—although she admits that, as used in the mainstream media, it can belie the labor of transformation and function as a homogenizing force.[115]

While the form of digital disintegration we have seen in *The Celebration* resonates with the use of (and discourse on) the morph—particularly insofar as both strategies explore the ways in which digital technologies can be understood to problematize the boundaries between self and other and call into question the role sheer matter plays in daily life—the aesthetic I have been describing through Vinterberg's movie evokes a sense not of becoming but of unbecoming. It does not so much recall a phenomenological account of Being as the Freudian death instinct (although, here, deterioration does not return the

FIGURE 4.10 Shot in very low light, Helge's figure in *The Celebration* almost dissolves into the digital ether. (October Films, 1998)

human to matter but loses it in an intangible and ephemeral flow of information).[116] The end point of a morph is always a relatively explicit *something*—whether the identifiable faces in Jackson's video or the water and metal in James Cameron's CGI oeuvre (substances that, if lacking form, nevertheless remain easily identifiable as matter). The figures in Vinterberg's movie, by contrast, do not threaten to transform into something else but to disintegrate into nothing at all.

An additional difference between the form of digital disintegration we see in *The Celebration* and the morph lies in the relation between figure and environment. With the morph the distinction between figure and ground is pronounced. As Kevin Fisher argues, "The effective morph requires the relative, oppositional stability of either figure or ground." Either an object morphs "against a nonmorphing environment"—as in *Terminator 2* and most other uses of the device—or an

environment morphs while objects or characters do not, as in Peter Jackson's *Heavenly Creatures* (1994), where the young protagonists' dreary world morphs into a utopia.[117] In both cases the contrast between transformation and stasis distinguishes figure and environment from one another. The practical demands of effecting a morph exacerbate this distinction. Because the portion of background visible behind a figure changes as a morph progresses, filmmakers must either shoot figures against a bluescreen—inserting a continuous background afterwards—or use a motion-control camera, first shooting the figure in its environment and then reshooting the environment with identical camera movement in order, ultimately, to composite the figure from the first shot with the background from the second. While the second option allows actors to avoid working in front of a bluescreen, foreground and background elements remain separated. Mark J. P. Wolf thus concludes that morphing "suffers from many of the limitations that composite imagery in general does," including "restricted interaction with the environment."[118] In this way, too, the morph differs dramatically from the digital cinematography in *The Celebration*, since the latter—far from severing figure from ground—threatens to conflate the two.

As I argued in chapter 3, drawing on Laura U. Marks's writing on "haptic visuality," this disintegrated aesthetic emphasizes the bodily experience of spectatorship insofar as it both evokes a sense of tactility and requires viewers to work to constitute the image. The present discussion makes it possible to expand on that point to suggest that this form of address does not operate as an alternative or antidote to the prevailing feeling that digital technology shifts attention away from embodied experience; rather, this bodily address functions in conversation with anxieties about disembodiment, offering viewers a palpable experience of bodies under threat. In other words, what *The Celebration* offers to the viewer is a tactile encounter with digital disintegration, problematizing the boundaries of the human body and calling into question its materiality. As we saw in chapter 3, the new level of detail CGI provided in films such as *The Phantom Menace* also evoked a sense of tactility. The modes of affective address we have been examining here, however, invite different spectatorial stances vis-à-vis the new technology, with distinct political implications. The form of awe *The Phantom Menace* evokes suggests the overwhelming power of

digital technology—and those controlling it—and thus shifts attention away from viewers' own participation in the processes of ontological, social, and political change accompanying the pervasion of this technology. By contrast, the form of discomfort *The Celebration* elicits compels viewers to experience the ramifications of such change not as a static effect but as a laborious process with tangible effects—something, in short, not to be marveled at but to be marshaled.

Thus, as *The Phantom Menace* imbricates its digital multitudes with the vast landscapes they not only fill but constitute, in *The Celebration* digital cinematography similarly dissolves figure into ground. But whereas *The Phantom Menace* harnesses and reifies life as a means for indicating the force of a power superior to it (whether we read this as Lucas's artistic vision, a controlling political power, or the force of history itself), eliciting awe at its overwhelming reach, *The Celebration* destabilizes (and threatens to dissolve) the human figure, not only offering a visual emblem of the bodily violence thematized by the film but also effecting an aggressive address to the viewer, who must struggle to discern the images—and who is thus compelled to participate bodily in the experience of disintegration portrayed. In different ways each of these movies invites its viewer to experience how digital technology was reputed to be transforming subjectivity and, particularly, people's bodily relation to the world. This treatment of bodies onscreen and concomitant address to embodied viewers is quite different from the forms of representation and address we saw with widescreen, addressing not issues of scale and bodily submission but the value and integrity of bodies themselves. Far from simply devaluing embodiment, however, these films—like the discourses on digital cinema framing their creation and reception—encourage a reconceptualization of embodiment in light of an increasingly digitally mediated world. My final chapter explores such a reconceptualization by comparing how the appeal of 3D cinema was articulated in the 1950s and in the recent move to digital 3D.

POINTS OF CONVERGENCE

Conceptualizing the Appeal of 3D Cinema Then and Now

Watching old 3-D movies, you felt as if you were looking at a flat screen with occasional protrusions. Watching the rerelease of *Toy Story*—and especially the trailer for the 3-D version of *A Christmas Carol*—you feel as if you're looking through the surface of a snow globe and sometimes as if you're falling right into it.

—*New York Times*[1]

Months before the February 2012 release of *Star Wars: Episode I—The Phantom Menace* in digital 3D, a trailer for the new version of the film circulated online.[2] The trailer begins with an inset frame, a fraction the size of the video frame itself, within which play iconic scenes from the *Star Wars* cycle. Accompanying this montage, a voice-over proclaims, "The greatest saga of all time is coming to the big screen . . . " When, after a pause, the narrator continues, "in spectacular 3D!" the inset box disappears and the trailer offers an image filling the frame: a shot from the pod race scene in *The Phantom Menace*. Such a strategy for suggesting the spectacular effect of a new technology through reference to the purported paucity of an older one (here, via the initial tiny internal frame) is familiar. Recalling early exhibitors' practice of displaying the power of moving images themselves by beginning screenings with frozen frames, this strategy, as we have seen, was also deployed in the 1950s, when the first Cinerama and CinemaScope screenings began at the old Academy ratio before the larger screens were revealed. At the end of 2011, as exhibitors faced competition from new kinds of small screens, Regal Theaters ran trailers that presented the image

of a movie playing on a tiny computer monitor and then pictured this home screen exploding, allowing flames to fill the theatrical screen and driving home the trailer's message: "Go Big or Go Home." By aligning the old, two-dimensional *Star Wars* films with miniscule, nested images, the *Phantom Menace* trailer did not simply find a way to convey the comparative plenitude of the forthcoming 3D version without itself having recourse to 3D. Following the strategy used concurrently by Regal Theaters—and previously in advertising for the original *Star Wars* trilogy's 1997 theatrical rerelease—the *Phantom Menace* trailer identified the novel theatrical experience of digital 3D as an improvement over both the older theatrical model and the context of home viewing through which many potential patrons had become acquainted with the films, and within which the trailer itself circulated.

While this strategy has much in common with earlier approaches to displaying the spectacular attraction of new technologies, it is significant that the 1950s model on which the *Phantom Menace* trailer bases its approach to 3D is not only stereoscopic 3D itself but also, in large measure, widescreen. The scene employed to encapsulate what is to be gained by seeing the film in the new format—the scene of Anakin Skywalker racing through the desert in his flying pod—as mentioned in chapter 4, emulates the aerial sequence and chariot race of the widescreen films *This Is Cinerama* and *Ben-Hur*. The images from this scene included in the trailer entail movement along the z-axis in both directions, not only depicting space vehicles flying toward the camera from the depth of the mise-en-scène but also featuring a forward-moving camera penetrating that depth. Such imagery suggests that the new format will not only provide the type of emergence effects that tend to be associated with 1950s 3D (thrusting objects, in this case flying pods, into the audience space) but also enhance the type of immersive spectacle offered by the widescreen films (pulling the viewer into the diegetic space). This marketing of digital 3D through an evocation of 1950s widescreen exemplifies an attempt by contemporary studio executives to distinguish the new generation of stereoscopy from 3D's perceived failures in the past, aligning it instead with a more successful technological innovation. In doing so, it also points to a broader shift in the ideas and attitudes according to which 3D technology—and its impact on the experience of cinema—has itself been conceptualized.

The reemergence of 3D, in many ways, links contemporary cinematic experience with that offered sixty years ago when Hollywood, facing a crisis bearing a widely acknowledged resemblance to its current situation, utilized widescreen and stereoscopic 3D to reconceptualize the cinematic experience as one that remained relevant in the face of social and economic changes.[3] At the same time, as I have been arguing, the discourses surrounding the introduction of such technologies offer a privileged view of the historically specific constellations of concerns and attitudes according to which the experience of cinema is defined and evaluated. We risk ignoring the nuances of this recent instance of upheaval, including the ways in which digital 3D cinema's bodily address has been formulated vis-à-vis the broader experience of digital media, if we consider it only as a recycling of previous strategies.[4] Digital 3D offers a particularly useful lens through which to consider the implications of the research on widescreen and digital cinema described throughout this book, since this contemporary technology displays clear connections to both 1950s screen technologies—including widescreen as well as stereoscopic 3D—and the concept of digital cinema that emerged in the 1990s (which *The Phantom Menace*, initially released in 1999, was often taken to epitomize).

DIGITAL 3D

Three-dimensional movie technology did not disappear after the waning of the fad in the 1950s.[5] The 1960s and 1970s saw 3D applied to pornographic and horror films such as *The Bellboy and the Playgirls* (Francis Ford Coppola and Fritz Umgelter, 1962), *Flesh for Frankenstein* (Paul Morrissey and Antonio Margheriti, 1973), and *The Stewardesses* (Al Silliman Jr., 1969), and the early 1980s witnessed a second short-lived boom within mainstream cinema with the likes of *Friday the 13th, Part III* (Steve Miner, 1982) and *Jaws 3-D* (Joe Alves, 1983). The 1980s also saw 3D applied to large-format filmmaking for exhibition in theme parks, expos, museums, and science centers, with the IMAX Corporation first adopting the technology for *Transitions* (National Film Board of Canada) in 1986; in 1994 IMAX began moving into commercial theaters.[6] In 2004 Robert Zemeckis's *The Polar Express* earned ten times as much in IMAX 3D as it did in "flat" 35mm screenings and, according to *Variety*, "[sparked] renewed interest in 3-D Hollywood features."[7]

Citing that success, a March 2005 *Variety* story entitled "Will Gizmos Give Biz New Juice?" chronicled the push for 3D, together with digital projection, at the ShoWest convention for exhibitors, a charge reportedly led by "digital cinema's Fantastic Four," George Lucas, James Cameron, Robert Zemeckis, and Robert Rodriguez.[8] In 2005, as well, Disney reprocessed the animated children's film *Chicken Little* (Mark Dindal)—which had initially been produced as a 2D product—for projection in digital 3D. The film was shown in that format in eighty-four high-profile theaters in the United States, which, while representing only 2 percent of all theaters showing the film, produced more than 10 percent of its profits.[9]

In February 2007 a front-page story in *Variety* proclaiming, "3-D: The Eyes Have It!" pronounced the push for 3D successful, and interest in digital 3D built to a crescendo with the widely anticipated release of Cameron's blockbuster *Avatar* in December 2009.[10] During this time 3D's return in digital form was described, critiqued, and defended by the industry and the press in relation to the much-maligned 1950s 3D fad.[11] Commentators drew parallels to the industrial context within which 3D enjoyed its brief heyday more than fifty years prior. Not only was Hollywood experiencing a decline in attendance that recalled its plight in the early 1950s, but this crisis was again linked to a changing media landscape (which still included television, now in flat-screen, high-definition form, as well as the Internet and video games) and cultural climate (which now entailed not only convergence culture's multiplatform fluidity, which was feared to threaten the value of theatrical exhibition, but also the concomitant, perceived threat of digital piracy).[12] In the face of such challenges three-dimensional spectacle was again posited by the industry as a potential salvation, justifying surcharges, purportedly binding the cinematic experience to the theatrical setting, and making piracy much more difficult. (In 2010 *Avatar* became the fastest-pirated film, and 3D televisions became available to consumers in the United States; however, theatrical 3D has, as of early 2013, remained prevalent despite predictions that its success might be tapering off.)[13]

While drawing such parallels, commentators often portrayed the new digital technology as an improvement that would endow the format with a staying power that had previously proven elusive. In stereoscopic cinema the illusion of three-dimensional diegetic space is

created by projecting two images onscreen (either simultaneously or in quick succession) rather than one, each image presenting the same profilmic information from a slightly different angle, approximating the difference between the perspective of the left and right eye of an observer. Specially designed glasses then filter these images in such a way that, when wearing them, the spectator perceives each of the images separately in his or her two eyes. The resultant stereoscopic view of the profilmic information presents the depth cues binocular vision provides in everyday life (particularly when objects are closer than thirteen to sixteen feet), enabling the viewer to assess an object's position in space according to the way in which his or her eyes converge upon it. Filmmakers control the point of convergence through the relative position of the dual images onscreen. If the two images overlap one another exactly, the eyes converge at the screen plane, making the object appear at that plane (fig. 5.1). If the left-eye image appears on the screen to the left of the right-eye image (positive parallax), the eyes converge behind the plane of the screen, making the object appear in the distance (fig. 5.2). If the left- and right-eye images are flipped onscreen, the eyes converge in front of the screen plane (negative parallax), making the object appear in the space of the auditorium (fig. 5.3). In addition to convergence another factor affecting the 3D image is interocular distance (also called the "interaxial"), the distance between the two perspectives from which the dual images are presented (fig. 5.4). Interocular distance affects the perceived volume of diegetic space and objects: greater interocular distances create an effect of miniaturization, and smaller distances create an effect of gigantism.[14]

Digital technology affects 3D cinema in several different ways, during production as well as exhibition. Before the diffusion of digital 3D projection (which has occurred since 2005), the large-format film industry was experimenting with digital 3D production and postproduction tools. Digital tools for converting 2D footage to 3D in postproduction were developed in the late 1990s, and the first few years of the 2000s saw experimentation with digital 3D cameras.[15] These innovations were presented as aids to the efficiency of large-format production since large-format analog 3D cameras were cumbersome and expensive to operate. Those who were developing digital 3D cameras, however, particularly James Cameron and his colleagues, also

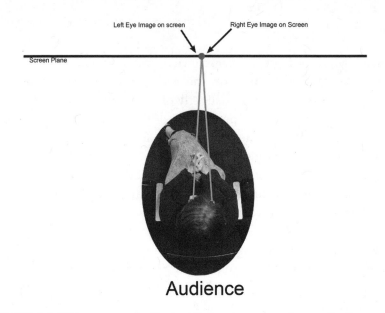

FIGURE 5.1 With stereoscopic 3D, when the two images overlap exactly, the viewer's eyes converge at the screen plane, and the image appears at that plane. (Image courtesy of and copyright 2012 Robert C. Hummel III)

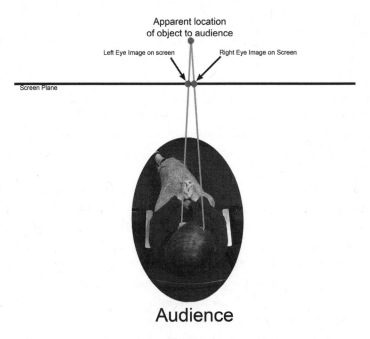

FIGURE 5.2 If the left-eye image appears on the screen to the left of the right-eye image (positive parallax), the viewer's eyes converge behind the screen plane, making the object appear in the distance. (Image courtesy of and copyright 2012 Robert C. Hummel III)

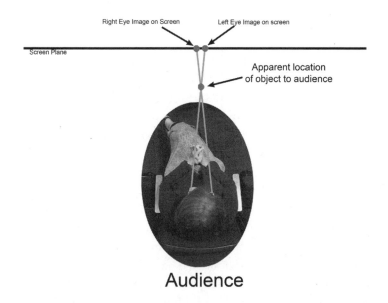

FIGURE 5.3 If the left- and right-eye images are flipped on the screen (negative parallax), the eyes converge in front of the screen plane, making the object appear in the space of the auditorium. (Image courtesy of and copyright 2012 Robert C. Hummel III)

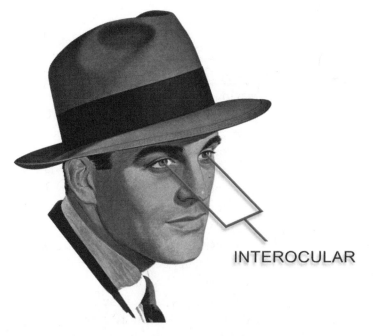

FIGURE 5.4 Another factor affecting the 3D image is interocular distance, the distance between the two eyes—or between the two perspectives from which the dual images are presented. (Image courtesy of and copyright 2012 Robert C. Hummel III)

sought to ameliorate what they took to be problems with analog 3D cameras, such as their limitations on manipulating convergence and interocular distance.[16] Those limitations are also overcome with digital animation—a major force in digital 3D since 2005—which also allows filmmakers minute control over convergence and interocular distance (and thus depth and volume).[17] The particular mechanics of digital 3D exhibition depend on the system employed, with systems such as RealD and Dolby requiring different kinds of glasses and screens; however, whereas most 3D systems in the 1950s utilized two projectors, the digital 3D systems use only one—a reduction that has been both heralded as improving the 3D spectacle (by cutting down on discrepancies between the two images) and decried as contributing to the dimness of digital 3D projection (a problem that is also linked to the projectors' shutter speed and exacerbated with films converted from 2D).[18]

While the industry generally presented these technical changes as improvements that rendered 3D more comfortable than it was in the 1950s, it also sought to distinguish digital 3D movies from the aesthetic practices associated with 3D in the past.[19] Some uses of digital 3D—especially in horror films and comedies such as *My Bloody Valentine* (Patrick Lussier, 2009) and *A Very Harold & Kumar 3D Christmas* (Todd Strauss-Schulson, 2011)—have continued titillating viewers through emergence effects.[20] As Scott Higgins notes, however, "major producers are waging a battle to wrest the process from its presentational roots," attempting to distance digital 3D from the fairground through its application to "quality" films, both in the genre of animated children's films dominating digital 3D output and in films aimed at adults, such as *Avatar*.[21] With emergence reputed to both call attention to the apparatus and detract from involvement with narrative, as Higgins argues, these producers have sought a less obtrusive approach to 3D, which is taken to be more commensurate with Hollywood narrative and therefore more sustainable. This approach, which Higgins identifies in *Coraline* (Henry Selick, 2009) and *Hugo* (Martin Scorsese, 2011)—and which we also find in recent films such as *The Amazing Spider-Man* (Marc Webb, 2012) and much of *Life of Pi* (Ang Lee, 2012)—is grounded "in qualities such as roundness, recession, and a modest 'bulge,'" where negative parallax is limited to the space just in front of the screen plane.[22] Indeed, commentators within and outside the industry have contended that filmmakers have learned

from previous mistakes and now know better than to rely on the in-your-face effects reputed to have dominated 1950s uses of the technology and to have put it at odds with Hollywood's enduring narrative tradition.[23] Over and against the emphasis on emergence associated with 1950s 3D, in short, those making a case for the sustainability of digital 3D have advocated for an "immersive" aesthetic more reminiscent of widescreen.[24]

At the same time that its lineage was widely acknowledged, digital 3D was also presented as a consummate digital technology.[25] Executives and journalists repeatedly referred to stereoscopy as digital cinema's "killer app"—a moniker that reflected anticipation that 3D would finally fuel the conversion to digital projection. Since the new stereoscopic systems required digital projection, the hope was that, in the words of RealD chairman and CEO Michael Lewis, "As more and more of these films come out and we see them perform well, there's going to be an even bigger push to get more screens out there."[26] In March 2008, with only forty-six hundred of approximately thirty-seven thousand movie screens in the United States converted for digital projection, the Walt Disney Company, Twentieth Century-Fox, Paramount, and Universal—anticipating a slew of 3D releases the following year, including *Monsters vs. Aliens* (Paramount-DreamWorks), *Up* (Disney), *Ice Age III* (Fox), *G-Force* (Disney), *A Christmas Carol* (Disney), and *Avatar* (Fox)—announced a deal to help fund the conversion of ten thousand theaters through Virtual Print Fees (although the digital systems would, reportedly, ultimately still cost theaters 1.7 times more than their analog counterparts).[27] By December 2010—at the end of what the *Hollywood Reporter* heralded the "year that was saved by 3D"—Curtis Clark, chair of the American Society of Cinematographers' Technology Committee, reported that "3-D has accelerated the expansion of digital projection, and it's reaching critical mass."[28] By the end of 2011, IHS Screen Digest estimated, 27,469 of the 42,390 screens in the United States and Canada had been converted for digital projection, with these almost equally divided between 3D-capable (13,695) and non-3D (13,774) digital screens.[29]

Digital 3D thus displays important connections both to the spectacular screen technologies of the 1950s, including widescreen and stereoscopic 3D (as well as their descendants, IMAX and IMAX 3D), and to the digital cinema movements of the late 1990s and early 2000s.

This convergence offers another indication of digital cinema's hetero-geneity—and one that might appear to render the concept of digital cinema so diffuse as to be conceptually unhelpful. With digital 3D we see the return of a spectacular technological attraction that would seem to reintroduce the types of bodily address attributed to analog 3D, as well as widescreen, in the 1950s. The question digital 3D raises here is thus: how do we account for the popular digital incarnation of a technology and mode of address that appear to hark back to a very different context and set of cultural concerns? Specifically, how can we reconcile this emphatically spectacular, theatrical, and spatial digital technology with a conceptualization of digital cinema that problema-tizes these concepts?

If we understand the address of digital cinema as simply a disem-bodied one, digital 3D may seem incommensurate since the experi-ence that this technology offers is not radically different from the one presented in the 1950s, when the capacity to elicit bodily effects was of paramount interest. As we have seen, however, the discourses surrounding the emergence of digital cinema did not so much ignore the body as render it a cause for concern. The resurrection in digital form of a technology reputed to address the body thus does not repre-sent a challenge or counterpoint to the discourses on digital cinema; rather, it exemplifies another (particularly loud and extreme) attempt to reevaluate and reformulate cinema's implications for embodiment. Indeed, a closer look at the ways in which the appeal of digital 3D has been conceptualized indicates significant differences from 1950s presentations of stereoscopic 3D, particularly with regard to the idea of embodiment.

The discourses on digital 3D show how embodiment is being recon-ceptualized as filmmakers and viewers grapple with new forms of spa-tiality in cinema and beyond. Specifically, the discourses surrounding (and applications of) digital 3D present a pervasive interest in drama-tizing the phenomenological experience of other (lost, hidden, uto-pian, and physically impossible) worlds. This observation aligns digi-tal 3D with Lev Manovich's claim that digital media are reconceiving narration as a form of navigation, with "narrative and time itself . . . equated with movement through 3-D space."[30] However, digital 3D also offers a strong reminder that this navigation should not be conceived as "virtual" in a way that implies a simple idea of disembodiment.

Supporting Thomas Elsaesser's contention that contemporary 3D is "symptomatic of the proliferation of screens that we encounter around us, picturing not a particular view, projecting not a particular kind of image, but, instead, producing a particular ideal spectator—floating, gliding, or suspended," the discourses on digital 3D show how spectatorial embodiment is being reformulated in conjunction with the new forms of spatiality offered by digital media.[31]

THE STEREO WINDOW, SPATIALITY, AND BODILY ADDRESS

Like widescreen, 3D is often touted as a technology that blurs the boundaries between image and theater space. With widescreen the apparent conflation of represented and actual space was attributed in large measure to the size of the image, which pushed the limits of the frame outside the viewer's central field of vision. With 3D such arguments pertain to the way the technology allows the cinematic image to appear to transgress the plane of the screen. One argument that has been made about spectatorship of 3D cinema is that the severing of convergence from the screen plane reorients viewers away from the screen itself. Louis Lumière made such a claim in 1936, explaining that the "stereoscopic effect is . . . complete" when "the spectator is unable to estimate his distance from the screen. It seems to him that he is in front of an open window, and the actors are moving within the very room."[32] Almost seventy years later, James Cameron—one of digital 3D's most vocal proponents—described the effect of stereoscopy in similar terms: "The boundaries of the screen form the edges of a window into a reality, and the objects seen in that reality, beyond that window, are as far away from the viewer as the camera was from the objects when they were shot. In this mental model, the distance between the viewer and the screen is meaningless."[33]

Both Lumière and Cameron thus imply that, with traditional 2D (nonstereoscopic) cinema, the eyes' convergence on the plane of the screen orients viewers such that their relation to the screen is significant. And Lumière and Cameron assert that 3D cinema transforms viewers' orientation so that their primary relationship is to the represented objects rather than the plane on which they are projected. In making this argument, both filmmakers analogize the 3D cinema

screen to a window, reflecting the widespread tendency to refer to the perceived frame of 3D images as a "stereo window"—an apparent opening behind which depicted objects can recede or through which they can seem to emerge. The stereo window, however, need not coincide with the plane of the screen. Prominent British 3D engineers Raymond and Nigel Spottiswoode advocated placing it in front of the screen plane. They explain that it is the position of the stereo window—not the screen itself—that "sets a limit to the nearness of the image . . . and if the window is advanced forward into the auditorium, the image can move freely up to it" without, they suggest, provoking spatial confusion, thereby increasing "the zone of freely usable stereoscopic space."[34]

The discourses on 3D cinema thus employ the familiar conception of screen as window not only to suggest the realism of the diegesis but also to emphasize a sense of continuity between the space of the cinematic spectacle and the space of the movie theater. The sense of spatiality offered by 3D has often been taken to be the technology's defining characteristic. Having seen the Soviet 3D feature *Robinson Crusoe* (*Robinzon Kruzo*, Aleksandr Andrievskii, 1947)—produced for the Moscow Stereokino, which featured a 3D system that did not require viewers to wear glasses—Sergei Eisenstein contended that, just as movement is fundamental to cinematography, space is the central concern with stereoscopy.[35] Similarly, Raymond Spottiswoode called 3D films "films in space," and the German company Zeiss Ikon gave the name *Raumfilm* (space film) to a series of 3D processes it developed in the 1930s.[36] The sense of space with which stereoscopy endows the cinematic image has often been conceptualized as something that reconfigures the relationship among objects on both sides of the screen (between actors, for instance, or between actor and viewer).[37] Lumière and Cameron emphasize this relationship in the observations cited above, as does Eisenstein when he aligns 3D cinema with theater and what he conceives as the latter's drive "to 'cover' the breach, to 'throw a bridge' across the gulf separating the spectator and the actor."[38]

However, 3D has also been understood as something that, at least potentially, could endow represented objects themselves with the illusion of volume—as the term *stereoscopy* (seeing solid) implies. Oliver Wendell Holmes conceived the stereoscope this way in 1859: "By means of these two different views of an object, the mind, as it

were, *feels round it* and gets an idea of its solidity. We clasp an object with our eyes, as with our arms, or with our hands, or with our thumb and finger, and then we know it to be something more than a surface."[39] Describing his own use of 3D in the 2011 film *Pina*, Wim Wenders also emphasizes this capacity to depict volume, explaining that, with this format, "the actors' bodies themselves appears [*sic*] so differently. All of a sudden, these bodies have VOLUME. They are round, and voluptuous, no longer flat surfaces as they have always been on the screen. That presence of the body has surprised me most, more than depth and space as such."[40] While the sense of continuous space described above emphasizes the potential for a sense of spatial proximity between viewers and the actors or objects depicted, as Eisenstein suggests, this appeal to volume, as Holmes and Wenders indicate, presents the propect of a more tactile form of address and raises questions about the material presence of the represented figures and objects.[41]

Taken together, these elements of the presentation of 3D—the way in which it evokes the illusion of depth, volume, and tactility and the way in which it invites the viewers' eyes to converge on objects rather than the screen plane—have been marshaled to support claims that 3D enhances cinema's realism, not only offering a more verisimilar reproduction of the world but also emulating the process of perception itself more accurately than traditional cinema could.[42] Cameron and his collaborators on the 3D HD IMAX documentary *Ghosts of the Abyss* (2003), for instance, framed their technical experimentation for the film as the pursuit of a form of cinematic vision most like human vision. In this case that approximation entailed developing a system for variable convergence, which allowed the filmmakers to shift convergence with the point of greatest interest in the frame (thus also aligning it with focus)—a process that, in matching the natural working of the eye, Cameron claimed, almost entirely eliminated the eyestrain often attributed to 3D cinema.[43]

The discourses on 3D cinema, however, have long been marked by debates about how realistic—and comfortable—the experience it offers is. In addition to the reputed distraction of the glasses required for most 3D systems, eyestrain and headaches have been attributed to filming and projection problems (issues that are theoretically fixable), as well as anomalies in the ways some viewers' eyes work

(a hurdle that even digital 3D cannot claim to surmount and that prevents some people from being able to see 3D at all).[44] Even though digital 3D ameliorates problems of misalignment attributed to older systems, its projection is marked by the loss of light as described above. Additionally, many commentators have noted the disjuncture 3D cinema creates between the points at which viewers' eyes converge and focus: when the viewer's eyes converge in front of or behind the screen plane, they still remain focused on the screen itself (even if the *camera's* focus matches the point of convergence, as in Cameron's system), resulting in a significant departure from the way vision works in day-to-day life.[45] Thus, a 2008 article in *American Cinematographer* explained, "In a 3-D movie environment, you can choose an angle of view and scale that, from your perspective, makes an object appear to be half a foot from your face even as your eyes are focused on the screen plane, which may be anywhere from 15' to 100' away from you." And it claimed that this disparity not only distinguishes 3D from "our reality" but results in the exaggeration of depth cues, such that "3-D movies seem to be more 3-D than reality."[46]

Additionally, stereoscopy's rendering of the relationships among objects and its portrayal of volume have both been reputed to be subject to distortion. One complaint has been that 3D makes it look as though there is too much space between the characters onscreen, with John A. Norling, producer of the pioneering 3D *Audioscopiks* (1935) reporting on the repeated statement "that boy and girl must play much closer together, for if they're apart by as much as one foot, 3-D will show them separated by three or four feet." Norling also acknowledges problems with the miniaturization and gigantism of bodies in 3D, particularly the rumor that "for 3-D, actresses should be plump; the svelte favorites of the past would have to stoke up on fat-producing food." He contends, however, that neither problem is inherent to 3D itself but that both result from improper interaxial spacing.[47]

There has also been a repeated contention that, as Norling put it in 1939, with 3D "the sensation of depth is as if given by a series of thin cardboard models placed in different planes; that while anaglyphs show depth they lack roundness."[48] Contemporary critic Dave Kehr attributes such paradoxical flatness to 1950s uses of 3D as well (which were, predominantly, presented in polarized prints rather than the anaglyphic format Norling mentions). Kehr links this complaint

with the issue of miniaturization described above: "There has always been a kind of toy-theater or pop-up-book feeling to theatrical 3-D presentations—a paradoxical sense that, as the image has gained in depth, it has also shrunk in stature. For a long time, the figures in 3-D movies seemed smaller than life, tiny players arranged on a miniature stage, and the figures themselves have lacked relief, as if they were two-dimensional cutouts." Not only does this issue problematize 3D cinema's capacity to depict volume, but, for Kehr, it also undermines its ability to present the type of continuous space that advocates of 3D emphasize. Kehr contends, "Space in stereoscopic films does not appear continuous so much as it seems to be built out of a series of flat planes stacked one atop another." While others have attributed this problem to less-than-ideal viewing positions (i.e., marginal seats in the theater), Kehr attributes it, in part, to the heavy, difficult-to-move cameras used with analog 3D—in order, ultimately, to contend that the type of digital animation used in *Avatar* ameliorates the problem.[49]

As should be clear from the ways in which 3D has been taken both to epitomize representational and perceptual verisimilitude and to depart from representational and perceptual norms, stereoscopic cinema has a good deal in common with the widescreen format popularized in the 1950s. Neither technology was new when it gained industrial momentum at that time; however, both were marshaled by Hollywood to endow cinema with a sense of experiential fullness purportedly missing from television. The studios marketed 3D from 1952 to 1954 using many of the same strategies we saw with concurrent widescreen campaigns. Indeed, with the major studios converting to widescreen production in 1953, many of these 3D films, starting with *It Came from Outer Space* (Jack Arnold, 1953) and including *Creature from the Black Lagoon*, were intended for projection in widescreen and promoted accordingly (although they were shot at 1.37:1 to accommodate small theaters that had not yet converted).[50] Beginning with *Bwana Devil*'s ad campaign, which promised "A lion in your lap! A lover in your arms!" the appeal of stereoscopy was, during the 1950s boom and echoing the strategy employed with widescreen, often presented as an ability to enhance the viewer's participation in the spectacle by transgressing the boundaries between the viewer and the represented space. We see this emphasis on what was called "audience participation" in the frequent claim that 3D enhanced the viewer's sense of

presence in the diegesis. For example, advertisements for *House of Wax* proclaimed, "Beauty and terror meet . . . in your seat."[51] Marketing for *Inferno* (Roy Ward Baker, 1953) claimed: "YOU are trapped in the great Devil's Canyon of the Mojave Desert! YOU hang from a cliff and lower yourself into the valley below! YOU are in the center of a thundering theatre-shaking landslide!" And posters for *Second Chance* (Rudolph Maté, 1953) promised that the film was "So Real: every man will feel he's kissing Linda Darnell. So Real: every girl will feel she's in the arms of Robert Mitchum."[52]

As with the discourses on widescreen, 3D films were promoted as offering a tactile address, with the trailer for *It Came from Outer Space*, for instance, promising that the film "has an added quality—objects actually seem to come out of the screen. So real, they almost touch you."[53] Describing the widespread skepticism with which the industrial and critical establishment had, by the early 1950s, approached stereoscopic 3D, the Spottiswoodes emphasized critics' concern that 3D was "merely a technical device for transferring the scene bodily to the spectator, a device which, when further perfected, would lead to the terrifying results envisaged by Aldous Huxley in his description of the Feelies in *Brave New World*."[54] Like the discourses on widescreen, which also aligned that technology with Huxley's feelies, the concern here was that stereoscopic cinema's address was so physical as to be vulgar.[55]

Furthermore, as with widescreen, such tactile contact was often advertised as offering closer contact with shapely female bodies, as we see in the poster for *Bwana Devil*, which features a beautiful woman emerging from a pictured screen (fig. 5.5). Particularly blatantly, advertising for *The French Line* (Lloyd Bacon, 1953) promised that the new technology would put viewers into intimate contact with Jane Russell's ample breasts: "J. R. in 3D: It will knock <u>both</u> your eyes out!" (fig. 5.6).[56] Keith M. Johnston proposes that the trailer for *Sangaree* (Edward Ludwig, 1953) also emphasized the way in which 3D technology would "allow breasts to thrust their way off the screen," and he parallels this use of the female form to advertise 3D technology to the way promotion for *How to Marry a Millionaire* linked Marilyn Monroe and CinemaScope.[57] Johnston identifies the appeal of such contact—which in 3D tended to couple the promise of contact with beautiful women and the threat of contact with gruesome monsters—as the result of "a contemporary (masculine) uncertainty over the female

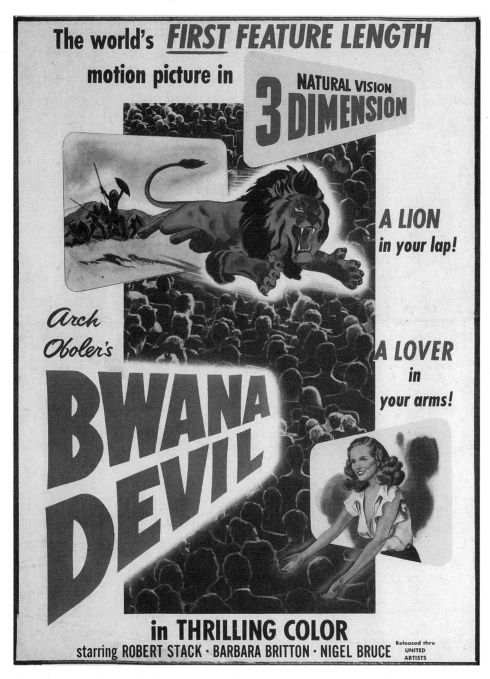

FIGURE 5.5 A poster for *Bwana Devil* (1952) promises close contact with a fierce lion and a female lover. (United Artists / Photofest)

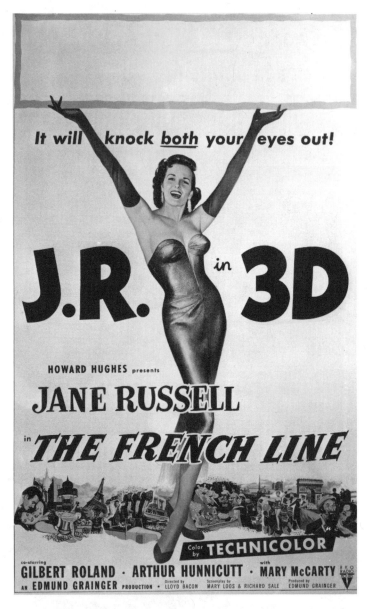

FIGURE 5.6 Promotion for *The French Line* (1953) suggests 3D would assault viewers with Jane Russell's breasts. (RKO / Photofest)

body, at once desirable and sexual but also alien and unknowable," that resonates with the discourses on widescreen.[58]

William Paul has argued that the two technological sensations of 1952 and 1953, while conceptualized and promoted in dialogue with one another—and while both promising to transgress the boundaries between image and theater space—generally went about this transgression in opposite directions. Whereas widescreen was promoted as offering viewers an experience of immersion in the cinematic spectacle, drawing the viewer into exotic worlds and experiences, stereoscopic 3D often functioned according to a logic of emergence, assaulting viewers in what Paul identifies as a phallic gesture rather than encompassing them in widescreen's more maternal embrace.[59] For instance, while Alexander Leydenfrost's famous publicity illustration for *This Is Cinerama* depicted that film's viewers in front of a giant roller coaster whose tracks recede into the depth of the portrayed space, suggesting that the viewers felt as though they might penetrate into that depth, promotion for 3D's 1952 breakout success *Bwana Devil* depicted the lion and lover the film promised to put in the viewer's lap and arms literally emerging from the screen. Paul argues that this assaultive orientation, like the need to don glasses, called attention to the spectacle of stereoscopic 3D to such an extent that it was not easily accommodated by classical Hollywood illusionism.[60]

As Paul and others have pointed out, the phenomenon of emergence also threatened cinema's illusionism by creating a palpable disjuncture between apparent spatial presence (the spectacle looked as if it occupied the same space as the viewers and could come into contact with them) and physical absence (such contact never actually took place).[61] Although in 1946 André Bazin famously heralded the possibility of recreating "a perfect illusion of the outside world in sound, color, and relief" in "The Myth of Total Cinema," in 1953 he observed that stereoscopic 3D "gives an effective impression that the objects are in space but in the form of intangible phantoms"—a situation that, he contended, "gives an impression of irreality that is even more perceptible than that of flat cinema in black and white."[62] Such skepticism is reflected broadly in commentary on digital 3D, which often portrays the appeal of the new take on the format via its offer of immersion rather than the kind of attention-grabbing and potentially phantom-like protrusions sometimes blamed for the downfall of 1950s 3D.[63]

Indeed, despite the continued production of 3D films making use of emergence, much of the discourse on digital 3D tends to downplay the technology's possibility for emergence in favor of a rhetoric of immersion that seems more akin to the 1950s promotion of widescreen (and through which digital 3D, like widescreen but unlike 1950s 3D, might, in line with Higgins's argument, be rendered sustainable).

Emergence was not, however, exclusively or unproblematically associated with 3D in the past. In addition to a succession of emergence effects, for instance, the 1935 *Audioscopiks* includes a segment in which the camera, mounted on a car, speeds forward into the represented depth. Eisenstein described the way in which, with stereoscopic cinema, the image not only "'pours' out of the screen into the auditorium" (what he identifies as its "most devastating effect") but also "pierces through to the depth of the screen, taking the spectator into previously unseen distance."[64] Edwin Land (who developed the polarization process that, it has been argued, made 3D viable in the 1950s) advised against utilizing emergence effects at all, claiming that "to intrude too obviously on the real world of the *auditorium* can detract from our ability to enjoy vicariously the world of the motion picture as it unfolds on the *screen*. . . . Our great goal should be to make movies as real as life around us, but this reality should be confined to the 'other side' of the proscenium."[65] Milton Gunzburg, whose Natural Vision Corporation developed the 3D system used to create *Bwana Devil*, identifies such a view as one that was widely shared at the time when he advocates breaking down what he characterizes as "the taboo . . . that all action must be held behind the screen."[66] Such acknowledgments of 3D's capacity to propel viewers into the depth of the diegesis and ideas about the inappropriateness of emergence—along with the recognition that many 1950s 3D films were themselves presented on wide screens—problematize a clear-cut distinction between 3D and widescreen along the lines of emergence and immersion.

Much public discourse on digital 3D also explicitly repudiated emergence in favor of rhetoric emphasizing immersion. Fox chairman Jim Gianopulos claimed that the new 3D was "not intrusive, and it's a completely immersive experience. Instead of pushing out, it pulls you in, so that you almost feel like you are in the room."[67] Claudio Miranda, cinematographer for *Tron: Legacy* (Joseph Kosinski, 2010), describes an interest in making "the screen appear like a box you're looking into,

and [keeping] things from leaping out unnaturally."[68] DreamWorks Animation head Jeffrey Katzenberg (having pledged to release all of the company's cartoons, beginning with *Monsters vs. Aliens*, in digital 3D) claimed that the format "provides filmgoers the chance to finally cross the threshold of the screen and enter other worlds."[69] In other words, rather than emphasizing the emergent (dangerous and sexually titillating) objects that 1950s 3D was often criticized for hurling at the audience, this discourse presented digital 3D as an opportunity for viewers to behold and enter new and exotic spaces.

Avatar producer Jon Landau lauded the technology as an opportunity for visual exploration, claiming that, with 3D, "you're looking at a window into a world."[70] Others emphasized the sensation of entering the depicted space. Cameron explained that with IMAX 3D, "It's like the screen ceases to exist and becomes a portal into reality."[71] Presenting preview clips of *Avatar* to fans at the 2009 Comic-Con convention, he introduced the film by asking, "How many of you have ever wanted to go to another planet?"[72] Similarly, Jules O'Loughlin, director of photography on the 3D thriller *Sanctum* (2011) (executive produced by Cameron), which centers on a fateful cave-diving expedition, explained that he and the film's director, Alister Grierson, "wanted to use 3-D to immerse the audience in a world they've never seen before, a world they would respond to viscerally. The audience should feel that they're inside these caves with our characters."[73] Critics (both outside and within academe) evaluated digital 3D according to such terms as well, as when Roger Ebert, in an exception to his general antipathy for the format, praised Werner Herzog's approach to stereoscopy in *Cave of Forgotten Dreams* (2010), explaining, "nothing will hurtle at the audience, and 3-D will allow us the illusion of being able to occupy the space with the paintings and look into them, experiencing them as a prehistoric artist standing in the cavern might have."[74] Kristin Thompson likewise identifies Herzog's journey into prehistoric caves as "the perfect use of 3D: showing people exciting places they will never get to see on their own."[75] Such rhetoric not only echoes the interest in immersion we saw with 1950s widescreen (and self-consciously distinguishes laudable uses of digital 3D from the emergence effects associated with 1950s stereoscopy) but also resurrects the emphasis on ersatz travel—replete with an appeal to the multisensory experience of presence—we saw with widescreen.

While widescreen offered viewers a vicarious experience of famous sights (from a performance at La Scala to the New York City skyline) and historical periods and legends (from ancient Rome to Arthurian England), digital 3D has often applied the technology to probing hidden, utopian, and (especially in conjunction with CGI) physically impossible spaces. Such probing encourages the "dramatic movement forward into diegetic space" that, as Sara Ross argues, "has become a staple strategy because of its ability to both showcase 3D spectacle and also bind visual novelty to story."[76] Indeed, we find digital 3D applied to exploration not only in IMAX documentaries such as James Cameron's journeys to the deep sea, *Ghosts of the Abyss* and *Aliens of the Deep* (2005)—journeys Cameron compares with the trips to outer space already a staple with IMAX, including the analog 3D IMAX feature *Space Station* (Toni Myers, 2002)—but also in mainstream narrative films utilizing the format to probe cyberspace (*Spy Kids 3D: Game Over* [Robert Rodriguez, 2003], *Tron: Legacy*), the interiors of the earth (*Journey to the Center of the Earth* [Eric Brevig, 2008], *Sanctum*), and fantastic worlds (*Alice in Wonderland* [Tim Burton, 2010], *Coraline*, *Avatar*).[77] While this lineage may seem to frame digital 3D (like the car-mounted 3D camera in *Audioscopiks* and the ride films offered by amusement parks) as simply the latest incarnation of the legacy of early cinema's phantom rides, I want to suggest, as I did in relation to Cinerama's own spin on the phantom-ride tradition, that there is something historically specific about these instances of technologically mediated exploration that we risk eliding if we simply recycle the concepts of spectacle and bodily address formulated in relation to earlier periods.[78] As Tom Gunning argues, early cinema's phantom rides took part in a transformation of landscape also catalyzed by other nineteenth-century technologies of vision, such as railway windows and panoramas—all of which, in different ways, restructured the spectator's experience of imaged space.[79] I have contended that widescreen, while recalling that tradition, addressed concerns about the body that emerged in dialogue with contemporaneous discourses on technology, nation, sex, and gender. While digital 3D again demonstrates an interest in rehearsing technology's implications for spatiality and embodiment, these modes of experience are being reconceptualized in conjunction with the diffusion of digital media such as the video games and computers thematized in some of the films. In particular,

these applications of digital 3D make it clear that, with the introduction of digital technologies for the creation, distribution, and exhibition of movies, cinema is not simply devaluing materiality but rather working through changing ideas about embodiment, especially the body's encounter with an increasingly digitally mediated world.

The resonances and disjunctures between 1950s analog 3D and twenty-first-century digital 3D can be clarified by juxtaposing prominent representatives of each. *Creature from the Black Lagoon* and *Avatar* display striking thematic similarities, exploring the dangers of scientific inquiry fueled by capitalist greed, warning of humankind's menace to the natural world, and depicting human beings' encounter with humanoid species. The fact that both of these films deploy stereoscopic 3D in detailing their protagonists' journeys to virgin natural worlds and in conveying the exhilarating and terrifying experience of humans' encounter with alterity is particularly notable. At the same time, the films use 3D in distinct ways. While the earlier film does make use of the emergence effect widely associated with 1950s uses of the technology, it also emphasizes and, indeed, thematizes the concept of immersion. The more recent film emphasizes immersion as well—in this case downplaying 3D's capacity for emergence. *Avatar*'s approach to immersion, however, also departs from the one we see in *Creature from the Black Lagoon*. Although both immersive experiences invite a sense of awe, with the recent film this awe derives not from the film's power over the viewer's body (an emphasis that links the ideas of emergence and immersion as they were conceptualized in conjunction with the new screen technologies of the 1950s) but from its ability to provide a visceral encounter with a digitally rendered world—a sensation that mirrors the experience of the film's paraplegic protagonist, Jake Sully (Sam Worthington), as he explores the alien region of Pandora with the heightened bodily freedom of his eponymous avatar.

CREATURE FROM THE BLACK LAGOON

Creature from the Black Lagoon is a relatively low-budget film recycling plot elements from other science fiction and horror movies including *King Kong* (Merian C. Cooper and Ernest Schoedsack, 1933) and *The Thing from Another World* (Christian Nyby and Howard Hawks, 1951); however, it was hugely successful upon its release in 1954 and retains

its iconic status decades later.[80] The Creature itself has been read as an emblem of social concerns pressing on 1950s America, including scientific hubris (and, especially, the threat of the atom bomb), the purported mystery of female sexuality, the threat of communism, and deviance from normative white masculinity—the latter addressing not only changing attitudes about race, gender, and sexuality but also contemporary anxieties about social conformity.[81] In focusing here on the film's deployment of 3D technology, I would like to emphasize the way in which the terror of potential contact with this Other derives from a sense of bodily susceptibility that aligns the concerns of *Creature from the Black Lagoon* quite closely with the discourses on widescreen.

The Creature's appearance in 3D resonates with Marilyn Monroe's in widescreen. In one of the most self-reflexive of her CinemaScope films, *The Seven Year Itch*, Monroe's character leaves a movie theater having just seen *Creature from the Black Lagoon* and comments on her empathy for the eponymous monster: "He was kind of scary looking, but he wasn't really all bad. I think he just craved a little affection— you know, a sense of being loved and needed and wanted." The scene begins with a shot of the theater's marquee, atop which is a cutout of the Creature holding the fainted figure of the film's female protagonist, Kay (Julia Adams), followed by a tilt down to find Monroe and Tom Ewell discussing the film as they emerge from the theater. This camera movement links Monroe, in her famous white dress, with Kay, pictured in a white bathing suit. However, Monroe's ensuing encounter with the "delicious" breeze surging from the subway grate beneath her also aligns her overt sexuality with the Creature's own libidinal cravings. Lois Banner has interpreted Monroe's stated affinity for this beast as an indication of the fissures marking her public persona, which balanced conformity to and deviance from hegemonic views of race, class, gender, and sexuality.[82] However we read the cultural allegory of the Creature itself, the affective appeal of its presentation in 3D, like that of Monroe's in widescreen, derived from the promise that the new technology would enhance the intimacy with which the viewer could encounter a spectacle of alterity.

Creature from the Black Lagoon deploys 3D technology to evoke this tactile encounter not only through the types of emergence effects generally associated with 1950s 3D but also by eliciting a sense of

immersion that would seem to align it with the experience of wide-screen more closely than tends to be acknowledged. In one of the most well-considered scholarly explorations of *Creature from the Black Lagoon's* use of 3D, Kevin Heffernan argues that the format was particularly suitable to the horror genre (within which he classifies the film), which, like 3D technology itself, negotiates what he identifies as "the conflicting demands between the cinema of attractions ('3-D gimmicks,' in the trade parlance of 1953) and the cinema of narrative integration."[83] Heffernan's reading of the film thus aligns it with the scholarly tendency to identify 3D's emergence effect with a form of spectacle at odds with norms for narrative realism. Such norms are considered more amenable to the phenomenon of immersion than emergence. The film itself, however, calls the immersion/emergence binary into question by thematizing immersion pervasively and—pace Heffernan and in conjunction with instances of emergence—by devoting many of its most notable uses of 3D to eliciting the experience of immersion for viewers. As Paul notes, approaches to 3D shifted within the technology's brief period of popularity in the 1950s, and by the time the technology was being applied to "quality" films at the end of 1953 and into 1954—as with *Dial M for Murder* (Alfred Hitchcock, 1954)—there was a tendency to downplay the emergence effect.[84] Although certainly not a "quality" film itself and although relying on emergence at several crucial moments, *Creature from the Black Lagoon's* concomitant interest in immersion might be understood as part of this tendency as well.

Creature from the Black Lagoon utilizes the emergence effect at key spectacular moments meant to elicit strong feelings in the viewer. The film's prologue, which dramatizes the big bang, flings debris out at the audience in a moment that clearly functions as an attraction, offering viewers a thrill at the new technology right off the bat. Within the narrative itself, emergence is frequently associated with hands. This first occurs with the skeleton fragment found by the scientists, which functions as the catalyst for their journey to the Black Lagoon in search of the mysterious creature whose fossilized hand reaches out at them—and us—from a piece of rock (fig. 5.7). The threatening nature of this fossilized creature is underscored by its capacity to transgress the stereo window and reach into the audience, creating a spectatorial address that associates dread with the prospect of tactile contact with an alternate life form and that will pervade the film as a whole.

FIGURE 5.7 In *Creature from the Black Lagoon* the protrusion of objects into the theater space elicits thrills. (Universal, 1954)

We see strange, groping hands at several other points in the film, first with one of the Creature's early victims, whose grasping hand, rigid with rigor mortis, reaches out as if for help, and subsequently with recurrent shots of the Creature's clawed hand reaching up out of the water and toward the unsuspecting characters (and into the more sus- pecting audience). Another notable use of the emergence effect occurs with a speargun, which is introduced early in the film as an emblem of sexual aggression when the leader of the expedition, Mark (Richard Denning), strokes it as he barges in on a tryst between Kay and David (Richard Carlson), Mark's rival for her attention. The gun is, predict- ably, fired toward the camera (and thus the audience) in a climactic battle with the Creature. In the cases of the hands and the speargun the protrusion of objects into the theater space elicits thrills insofar as it creates the illusion—and elicits the bodily sensation—of danger.[85]

Despite these instances of emergence, immersion is also an important element in both the film's story and its use of 3D technology. The narrative itself is structured around the penetration by a group of scientists into what is portrayed as the virgin depths of the Amazon—and then even further into the legendary Black Lagoon (from which, it is rumored, no one ever returns). The sequence that records the journey of the scientists' boat as it makes its way deep into the jungle, shot from a boat itself and confining the depth-effect to the space behind the stereo window, evokes an experience quite like that achieved by Cinerama with its phantom-ride sequences. In particular, the boat-mounted camera and tropical scenery recall *This Is Cinerama*'s extended Cypress Gardens sequence, which also offers viewers a visceral experience of gliding into a hidden and idyllic world.

Furthermore, the film both represents and evokes immersion with multiple, lengthy sequences in which the characters are submerged in water. These sequences, arguably displaying the film's most thrilling deployment of 3D technology, were highlighted in the marketing, which promised "underwater thrills in 3-D!" (fig. 5.8).[86] The trope of immersion in water is introduced early on in the film, with shots of fish swimming in an aquarium. Here the fish appear to enter the space in front of the screen plane; however, they are not so much thrust toward the viewer as they appear to coexist in the same space, thus eliciting an experience of immersion rather than emergence. In other words, rather than appearing to *transgress* a boundary (and thus emphasizing it in the process, as Paul argues emergence does), they deemphasize it, rendering the theater space an extension of the water space depicted by the film.[87] *Creature from the Black Lagoon*'s initial portrayal of underwater space thus decouples the spatiality of negative parallax (the illusion that depicted objects are located in front of the screen plane) from the directionality of emergence (the movement from the depths of the diegesis toward the camera/audience) and shows how a 3D spectacle that positions objects in the space of the theater can evoke the sensation of immersion. In this case, instead of pulling the viewer into the depth of the diegesis, the film creates the illusion that diegetic space pervades the theater space. Rather than the assaultive address

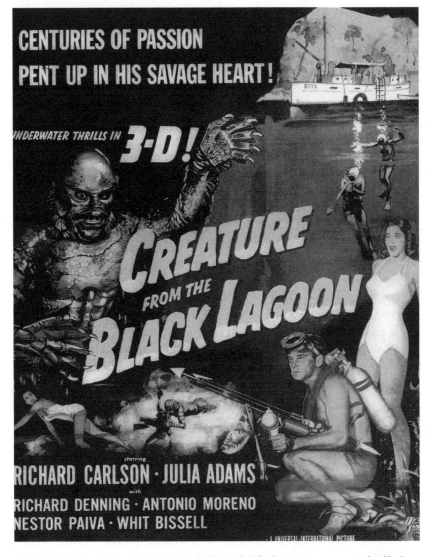

FIGURE 5.8 A window card for *Creature from the Black Lagoon* promotes the film's 3D "underwater thrills." (Universal, c. 1954)

associated with emergence, the effect here is one of engulfment, even if the engulfing substance is markedly insubstantial.

Underwater space becomes central to the narrative as significant encounters between the humans and the Creature occur in the lagoon. In the sequence that presents the first full-body view of the "gill

man"—a sequence Heffernan dubs the film's "famous 3-D set piece"—
the Creature lurks in the lagoon's depths while the unsuspecting Kay
dives in for a pleasure swim (figs. 5.9 and 5.10).[88] Within the diegesis
tactility is crucial to this moment. The scene's tension revolves around
suspense regarding if, when, and how the Creature will make physi-
cal contact with the vulnerable woman. When he finally does, it is
through a brush to her leg. Shortly thereafter, when he has escaped
from the fishing net in which the scientists had hoped to trap him,
leaving behind a claw, Kay recognizes the Creature that brushed her
leg not visually but, when she runs her own finger over the sharp edge
of his severed fingertip, through the sense of touch (fig. 5.11).

The possibility of a tactile encounter with the Creature is presented
to the viewer as well through the use of 3D. This sequence emphasizes
the three-dimensional effect not only by portraying the Creature and
the woman on different planes (largely behind the stereo window),
but also by submerging them in debris-laden water. It is the specks of
debris here that most often occupy the space in front of the stereo win-
dow, both linking the theater space to the deep space of the diegesis
and emphasizing the materiality of the water itself as a substance fill-
ing that space.[89] This effect is replicated with snorkel bubbles in a later
scene. The viscosity of the water makes tangible the space that we, the
audience, like poor Kay, share with the Creature. It also renders 3D
space—a space that was rumored to emphasize distance among char-
acters—as *volume*—something that seems to encompass characters
and viewers in the same material realm. An important element of the
terror of this sequence derives from the sense that, because the view-
ers, like the characters, are immersed in this shared, tangible space,
we might be subjected to a closer-than-comfortable encounter with
the Creature as well.

It should be clear that this portrayal and elicitation of immersion
is not incommensurate with emergence. There is a key moment when
the Creature swims directly toward the camera, creating the kind of
aggressive address described above. In the second crucial underwater
scene—this one a battle between the Creature, David, and Mark—the
speargun repeatedly fires toward the camera, achieving this form of
address as well. In David's final underwater battle with the Creature,
as the former is attempting to move the large trees the Creature has
submerged in an attempt to prevent the scientists' boat from leaving

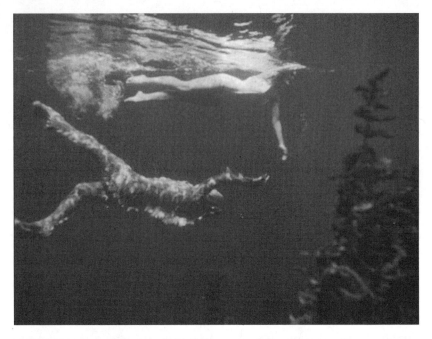

FIGURE 5.9 In *Creature from the Black Lagoon* the "gill man" swims dangerously close to Kay. (Universal, 1954)

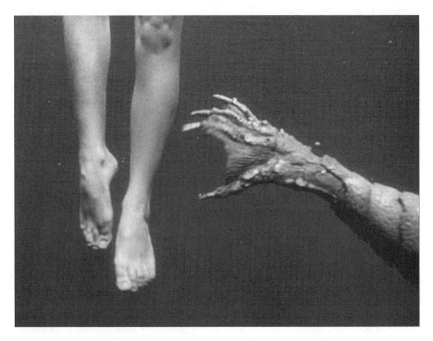

FIGURE 5.10 The Creature reaches for Kay's leg underwater in *Creature from the Black Lagoon*. (Universal, 1954)

FIGURE 5.11 Kay touches the Creature's severed claw in *Creature from the Black Lagoon*. (Universal, 1954)

the lagoon, David squirts the Creature with poison—again firing toward the camera and this time provoking the appearance of clouded water emerging into the theater space. While the experiences of emergence and immersion have been distinguished in terms of the different levels of awareness they provoke in the viewer, the case of *Creature from the Black Lagoon* thus shows how they can operate as two sides of the same coin: immersion can heighten the viewer's sense of susceptibility to emerging objects (insofar as it emphasizes the continuity of a space shared, potentially, with threatening beings) even as it functions to naturalize emergence effects.

Ultimately, the form of emergence we see in *Creature from the Black Lagoon* and the sense of immersion it offers function together to evoke (or threaten to evoke) the danger of close, tactile contact with other bodies. J. P. Telotte uses the film to illustrate what he contends, drawing on Paul Virilio's concept of "tele-contact," is unique about 3D cinema's spectatorial address: "the seemingly individualized ability to 'reach at

a distance.'"[90] It is contact with the Creature that threatens Kay and kills Mark within the diegesis and titillates the viewer in the theater. Such contact also threatens the Creature (as well as the fish with which he shares the lagoon), who is systematically weakened by immersion in water that has been poisoned by the scientists. The threat of such contact, and its link to immersion as well as emergence, is underscored by the presentation of Mark's dead body and the Creature's dying one, both submerged and uncannily still in the water—the former floating upward and the latter sinking downward, but both presenting death as the eerie spectacle of a lifeless body being carried by the force of the water that encompasses it.[91] Despite significant echoes of *Creature from the Black Lagoon* in *Avatar*—and despite a shared interest in applying 3D technology to immersion—the emphasis on such bodily vulnerability sets the appeal of the 1954 film apart from that of the more recent one.

AVATAR

A widely anticipated, colossal film, upon which the future of digital 3D purportedly depended, *Avatar* was frequently distinguished from 1950s 3D films by commentators in both the industry and the press.[92] Emphasizing the film's offer of immersion rather than emergence— its ability to "convince the viewer that he or she could step through the screen" rather than hurling things at him or her—commentators described Cameron's film in terms that seem more commensurate with stereoscopic 3D's 1950s competitor, widescreen.[93] Many of the film's most striking uses of 3D are either moving shots reminiscent of Cinerama's phantom rides or depictions of the dense space of the imaginary moon, Pandora. As I have shown, *Creature from the Black Lagoon* also evoked the experience of immersion in these two ways. Indeed, the films' similarities exceed the questionable politics of their colonialist narratives and extend, in particular, to their depiction of the fullness of 3D space. At the same time, these similarities put the significantly different appeals of these uses of space into relief. Whereas *Creature from the Black Lagoon* deploys the technology to present a viscous space that evokes the threat (and thrill) of tactile contact with an Other, in this sense falling in line with a focus of the widescreen cinema that had also pervaded Hollywood by 1954, *Avatar*

utilizes digital 3D to create a physically tangible yet impossible space that offers viewers a novel experience of bodily navigation.

While *Creature from the Black Lagoon* thematizes the possibility of tactile encounter through the recurrent use of hands, *Avatar* is explicitly concerned with reevaluating bodily movement in light of an imagined, technologically advanced future. This concern is indicated by its title, which, like the narrative itself, combines an orientalist fascination with non-Western religious cultures (the term *avatar* derives from Sanskrit, meaning to descend or step down and, in religious discourse, refers to a god's incarnation in human or animal form, as with the Hindu god Vishnu) with technofuturist enthusiasm (the avatar as digital embodiment and, indeed, digital creation; Na'vi connectedness as what one writer has called "the church of Facebook").[94] Just as paraplegic protagonist Jake Sully regains his mobility in the body of his fully functional avatar, the film uses 3D technology to offer its viewers a novel experience of bodily liberation.[95] It does so, particularly, in the many key sequences structured around movement, which harness the technology's capacity to evoke the sense that the viewer physically inhabits the diegetic space, rendering this experience as the inhabitation of physically impossible kinesis. The opening of the film explicitly links the technology's offer of kinetic spectacle with the bodily liberation Jake's diegetic avatar will supply, accompanying forward-moving aerial shots of the fantastic landscape of Pandora with voice-over narration in which Jake describes his dreams of flying—"I was free"—dreams that will come true over the course of the narrative, repeatedly offering the viewer, too, a three-dimensional spectacle of gravity-defying motion. While cinema has long invited viewers on novel journeys through space—with the widescreen spectacles of movement featured in the 1950s but one example—*Avatar*'s use of 3D to invite navigation through a computer-generated world addresses concerns about embodiment that are significantly inflected by contemporary digital media.

Public discourse on the film emphasized digital 3D's capacity to seemingly transport the viewer to a fantasy world. Twentieth Century–Fox reportedly tailored its ad campaign "to promote visiting a new world"—as is evidenced by posters that invited potential viewers to "enter the world" of Pandora as well as by Cameron's aforementioned remark about traveling to another planet (fig. 5.12).[96] Indeed,

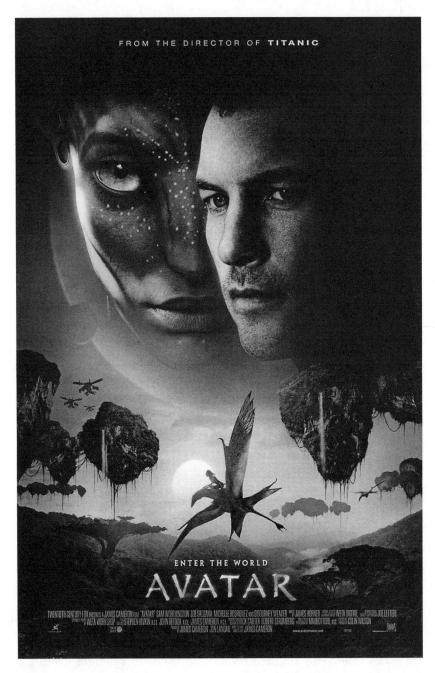

FIGURE 5.12 A poster for *Avatar* promises to transport the viewer to another world. (Twentieth Century–Fox, 2009)

the rumored depression afflicting viewers once they had to take leave of Cameron's fantastic imaginary realm and return to what Todd McGowan describes as the "drab everyday world outside the cinema" attests to (and perhaps contributed to the creation of) this idea of transport.[97] As critic Armond White saw it, "naïve viewers responded to the film the same way autistic children embrace comic books as their universe."[98]

The fantastic space of Pandora is, as has been widely noted, an ideologically loaded one—an image of plenitude that invites viewers into a world structured by a colonialist and orientalist worldview (at the same time that it, as Thomas Elsaesser argues, contradicts that worldview, ensuring multiple, divergent readings).[99] As Joshua Clover contends, the film's deployment of 3D makes sense as "a new space for James Cameron to assert dominion over—armed only with a quarter-billion dollars and all the technological augmentation it can buy. What happens to the Na'vi and humans is just a pretext for this drama, the anti-imperialist rhetoric a perfect inversion of Cameron's real logic."[100] Indeed, Cameron, who famously proclaimed himself "King of the World" when accepting his Academy Award for *Titanic*, is not shy about voicing his interest in territorial domination, fantasizing in an interview with *Rolling Stone* magazine: "If I were the guys that owned Google, I'd be building a rocket ship right now. I could claim Mars. I could own a fucking planet!"[101]

Without downplaying the significance of this point, it is also important that the space *Avatar* represents—and the form of spatiality it creates—are impossible ones. Clover concludes his discussion of the film by claiming that "*Avatar* is 'three-dimensional' in inverse proportion to the extent that it concerns the actual disposition of space. Its world, its situation, can be realized exactly because it bears no debt to the possible."[102] Claims about the impossibility and irreality of Cameron's world mark nonacademic coverage of the film as well, with articles featuring titles such as "The Impossible Reality of James Cameron" and "*Avatar*: The Unreal Thing."[103] Most evocative, perhaps, is the title of *New York Times* critic Manohla Dargis's feature, "Floating in the Digital Experience," which captures the impossible physical experience with which the film is most explicitly concerned: the defiance of gravity.[104]

Avatar depicts Pandora as a magical space filled with imaginary and luminous objects and creatures. At various points throughout

the film, the atmosphere of Pandora is filled with beams of sunlight, insects, seeds, mist, clouds, cascading water, foliage, and—as the "sky people" begin attacking—gas, fire, debris, cinder, and ash (figs. 5.13 and 5.14). Indeed, in downplaying emergence in favor of immersion, *Avatar* does not entirely forgo the space in front of the screen but, rather, populates it with these particles. As a result the film achieves its appeal to immersion not only by inviting the viewer into the deep space behind the screen plane but also by appearing to fill the theater space with such floating matter. As with *Creature from the Black Lagoon*, the result is the sensation that space itself is full, material, and tangible. Scientist character Grace (Sigourney Weaver) describes not only the biological and mineral offerings of the diegetic world but also the film's approach to its depiction in 3D when she claims, "The wealth of this world isn't just in the ground; it's all around us."

Dave Kehr identifies this approach as an improvement on the paradoxical flatness of traditional 3D and what he sees as the discontinuity of its space. Describing Cameron's achievement in surmounting that problem with *Avatar*, Kehr claims that there is "an undersea quality to his treatment of the film's 3-D space: he's filled in the gaps between objects with a continuous field of moving particles—dust mites, tiny insects, mist—that give a visual density to the ostensibly empty space. Everything seems to be swimming in the same, three-dimensional ether. It's an effect that overcomes that toy-theater sense of a series of flat planes grouped together and instead creates something continuous and perceptually whole." In contrasting this "continuum" with the "harsh and conspicuous" disjuncture among planes he attributes to 1950s 3D, Kehr claims that *Avatar*'s depiction of 3D space comes "closer to the way we actually perceive the world." He thus formulates another argument that digital 3D's immersiveness enhances the possibility of adaptation to "Hollywood realism," while 1950s 3D is portrayed as not only too spectacular (with emergence) but also disjointed (offering an insufficiently whole depiction of diegetic space).[105]

Despite Kehr's suggestion that Cameron's approach marks a significant improvement over 1950s uses of the technology, his view of *Avatar*'s "undersea quality" of "visual density," wherein objects and creatures float in a shared 3D "ether," not only affirms the film's marketing as an immersive spectacle but also recalls the emphasis on viscous space evidenced in *Creature from the Black Lagoon*. Despite

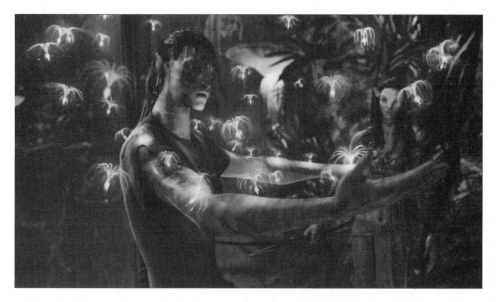

FIGURE 5.13 *Avatar* depicts Pandora as a magical space filled with luminous objects and creatures. (Twentieth Century–Fox, 2009)

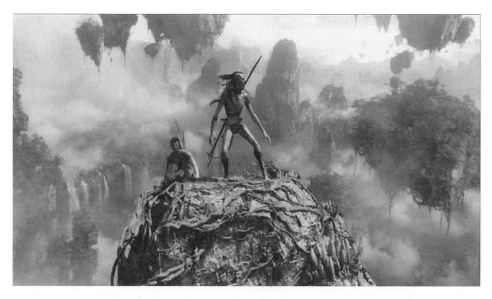

FIGURE 5.14 In *Avatar* the atmosphere of Pandora is full of substances such as mist. (Twentieth Century–Fox, 2009)

their shared focus on immersion, however, *Creature from the Black Lagoon* and *Avatar* utilize this phenomenon to different ends. The computer-generated detail in Cameron's film appeals to the idea of the haptic in a way that puts it in line with other CGI-heavy films such as *The Phantom Menace*.[106] Despite this evocation of tactility, however, neither the narrative itself nor the film's address to viewers centers around tactile contact with alterity in the way that *Creature from the Black Lagoon* does. Although both *Avatar* and *Creature from the Black Lagoon* feature a sexualized encounter between a human and humanoid Other, *Avatar* conveys the exhilaration and danger of that encounter most evocatively not through physical proximity but through the spectacle—and evocation—of bodily transport. Most significantly (and before the more forgettable sex scene), the film conveys Jake's romantic union with his Na'vi teacher, Neytiri (Zoë Saldana), by picturing the two characters soaring through the sky on the flying creatures they have tamed; the thrill of that relationship is conveyed not via the sense of touch but through the sensation of airborne mobility in a liberated body (fig. 5.15).[107] The appeal of this novel experience of gravity-defying mobility—harnessing 3D to promise viewers a feeling of physically impossible kinesis within a physically impossible milieu—is conveyed in advertisements for the 3D Panasonic televisions cross-promoted with *Avatar*, which portray Neytiri, against the background of the "floating mountains," riding a flying reptile and appearing to emerge from the plane of the television screen (fig. 5.16).

Avatar consistently presents Pandora as a place where quotidian bodily limitations might be overcome. Within the narrative the disjuncture between the bodily confinement of the human space and the freedom of the Na'vi realm is communicated not only through Jake's ability to surmount his paralysis when he enters his Na'vi avatar but also through the contrast between the scientists' means for entering their avatars (by ensconcing their human bodies in coffin-like capsules that allow for very little movement) and their experience *as* the avatars (playing sports, roaming the jungle, and the like). The film's mise-en-scène enhances this contrast, juxtaposing the boxlike rooms of the military base—where the characters' work confines them to relative stasis—with the open space of the Pandora forest. The claustrophobia of the human realm is epitomized when the camera occupies the space

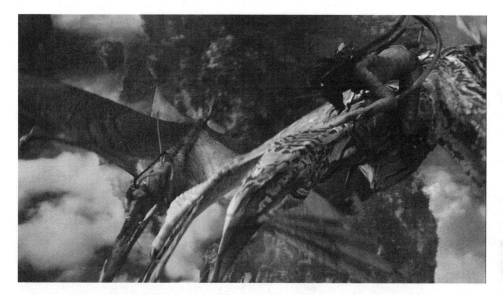

FIGURE 5.15 In *Avatar* the thrill of the central couple's relationship is conveyed through the sensation of airborne mobility. (Twentieth Century–Fox, 2009)

inside the cardboard box in which Jake's murdered twin brother lies in wait for cremation. The camera holds as the lid comes down from above, offering the sensation that the audience is enclosed with the corpse (fig. 5.17).

Such enclosure contrasts sharply with the Pandora sequences, which present space as something not to be confined within but to be penetrated. As Miriam Ross argues, with Cameron's emphasis on depth construction for the Pandora landscapes, "the visual world's endless and infinite quality becomes enhanced by the sensation that the landscapes could be indefinitely traversed through an extended journey into the background."[108] Moreover, some of the film's technological innovations facilitated and enhanced handheld 3D cinematography, including whittling the 3D camera down to 13 pounds from 150 (at a reported cost of $14 million) and the development of software that could magnify camera movements dramatically (enabling, for instance, a handheld lift of the camera to achieve the effect of a crane shot).[109] Like the film's opening, its concluding credit sequence is composed of forward-moving shots in which the camera appears to fly through the atmosphere of Pandora. The exhilaration of Jake's

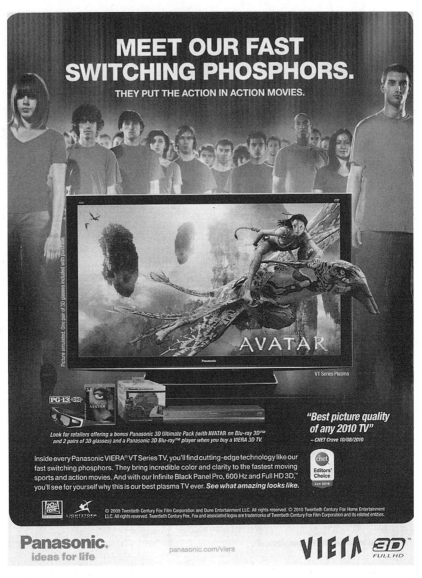

FIGURE 5.16 Advertisements for Panasonic televisions showcase the appeal of 3D by depicting Neytiri flying through the floating mountains—and off the screen. (*Entertainment Weekly*, Dec. 17, 2010)

FIGURE 5.17 In *Avatar* the camera occupies the space inside the coffin of Jake's brother as the lid closes from above. (Twentieth Century–Fox, 2009)

inhabitation of his avatar and integration into the Na'vi is, likewise, conveyed through such moving shots, beginning with the sequence in which Jake first enters his avatar's body and reexperiences the sensation of running legs (which also uses a series of moving shots to convey the character's rediscovered bodily freedom) and culminating with the sequences in which Jake passes his test for inclusion in the Na'vi, seals his bond with Neytiri, and cements his leadership of the Na'vi atop the legendary flying beast, Toruk—all of which revolve around the kinetic spectacle of flight.

This emphasis on flight takes part in what Kristen Whissel identifies as a tendency in digital cinema to dramatize a "new verticality." Examining contemporary global cinema making pervasive use of visual effects, Whissel notes a tendency to stage conflicts on a vertical axis. In this case CGI and digital image synthesis contribute to the capacity to portray actions that appear to transcend what is physically possible: "Struggles between protagonists and antagonists hinge upon the degree to which each is able to defy or master the laws of physics, making extreme vertical settings—skyscrapers, deep chasms, mountain peaks—pervasive and imperative."[110] Although *Avatar* was released several years after Whissel's article, Cameron's film clearly evidences

this dynamic, concerned as it is with confrontations between forces on the land and in the air. The Na'vi hunt aerially, from atop the flying creatures they tame. They deem the humans who seek to take their land the "sky people" since they approach the Na'vi land via helicopter. And the climactic battle between these two groups occurs on an insistently vertical axis, with the humans first attacking from the sky and the Na'vi then attacking from their own flying creatures, thus engaging in a power struggle wherein power lies with whoever is higher in the sky. Jake explicitly describes this dynamic in a voice-over explaining how he has tamed Toruk, a creature so powerful that it is itself never hunted from above (and is therefore unsuspecting when Jake descends upon it). The film's climax emphasizes this dynamic visually when the humans attack the Na'vi's massive Home Tree, sending it crashing to the ground in a massive spectacle of the force of gravity. Not only does the tree itself descend upon the Na'vi, but its fall is succeeded by a lingering rain of ash.

Whissel contends that this verticality offers a means for visualizing power and historical thresholds, with the "resulting spatialization of power and time [allowing] the new verticality to map spatial transience onto historical transition and radical forms of mobility onto the possibilities and perils of change." Linking the global appeal of such mapping to a geopolitical situation marked by economic polarization and various forms of extremism, she also associates this interest in historical thresholds with cinema's confrontation with digital media—a confrontation both embodied by films displaying a spectacular use of CGI and thematized by many of them.[111] *Avatar* falls in line with both of these conclusions, as well, insofar as it simultaneously positions itself (however disingenuously) as a polemic against corporate greed and employs the latest cinematic technologies (digital 3D, motion capture, and the rendering of humanoid species in "photorealistic" CGI) in dramatizing the resultant struggle for survival.

At the same time, the film's focus on utilizing these technologies to portray and evoke the bodily experience of a new and physically impossible form of mobility simultaneously takes part in what Scott Bukatman identifies as a focus in contemporary effects on the "interplay of controlled space and the evocation of weightless escape." Acknowledging the crisis in ideas about embodiment marking this

context, Bukatman contends that the "fantasied escapes from gravity" evident in contemporary effects "recall our bodies to us by momentarily allowing us to feel them differently," thus evidencing "the metaphoric, and often hyperbolic, return of the body as a site of continuing coherence in the face of disembodied technology." Science fiction, in particular, foregrounds and evokes such a return through its emphasis on kinesis, which is "often accompanied by a sense of utopian possibility, [wherein] movement becomes a passage across borders that promises resistance to external control."[112] *Avatar*, as we have seen, also dramatizes the tension between bodily restriction and a form of bodily freedom portrayed as kinesis, not only through the contrast the narrative sets up between the physical impairment of Jake's human body and the mobility of his Na'vi one but also through its use of 3D, which is employed to convey first the confined space of various "body-boxes" within the realm of the humans and then the wondrous, navigable space of Pandora.

The specificity of this approach to bodily mobility—and its relevance to the historical juncture at which it emerges—is brought into relief through comparison to the form of mobility offered by widescreen in the 1950s. Flight is central to Cinerama and CinemaScope films as well. *This Is Cinerama* features an extended segment entitled "America the Beautiful," which surveys the country from the front of a low-flying airplane. This sequence not only conveys the nationalist ideology with which Cinerama itself was identified, as John Belton has argued, but also appeals to viewers by offering to align their vision with this encompassing, aerial view—a point emphasized in the film's voice-over narration.[113] It is important in this case that the aerial perspective is that of an airplane, a technology that was itself on display in the film. *How to Marry a Millionaire* includes similar footage, shot from the front of an airplane as it lands at an airport in what one review calls an "obvious plot stop" to showcase the new cinematic technology.[114] What widescreen offers viewers in these cases is close, mimetic contact with another powerful technology.

In *Avatar*, by contrast, the most thrilling flight sequences feature various forms of alternate organic embodiment, including Jake's avatar body and the various flying reptiles with which it merges in the act of "tsaheylu" (bonding). As with Cameron's *Terminator 2*, which confronts an old-fangled, mechanical cyborg (Arnold Schwarzenegger's

T-100) with a cyborg-of-the-future rendered with the latest technologies for visual effects (in this case the T-1000 liquid metal creature achieved with morphing technology and CGI), *Avatar* pits more old-fashioned forms of bodily prosthesis (including the fighting robot operated by the power hungry Colonel Miles Quaritch, played by Stephen Lang, as well as the helicopters conveying the humans through the atmosphere of Pandora) against the cutting-edge avatar bodies inhabited by Jake and the scientists.[115] It is the latter bodies—and their capacity to connect with the bodies of other creatures, including the flying reptiles—whose experiences of flight mark the pivotal points in the plot and emotional trajectory of the film.

While the flight sequences in all of these films evoke the tradition of the phantom ride and its bodily address, the experience of embodiment elicited is framed differently. While the widescreen films offer a bodily experience of a powerful technology—in this sense participating in the give-and-take between empowerment and disempowerment that Erkki Huhtamo associates with such sequences in general—*Avatar* uses 3D to offer a visceral experience of the type of alternate form of embodiment acknowledged in the film's title. Over and against the "real," if ideologically rendered, countryside surveyed by *This Is Cinerama*, it is important that the landscape through which Jake's avatar soars is an impossible, digitally rendered one—an impossibility epitomized by the gravity-defying "floating mountains" through which Jake and Neytiri take their virgin flight. Such instances of the inhabitation of physically impossible digital spaces utilize the visceral address of 3D to invite viewers to experience what Huhtamo identifies as "one of the most significant achievements of artists working with interactive and virtual technologies," namely experimentation with "the *bilocation* brought forth by virtual reality: the simultaneous, interconnected presence of the body in two places, and in two existential forms."[116] In this sense *Avatar*, which utilizes digital 3D to offer a visceral experience of the physically impossible, takes part in what Huhtamo identifies as a tendency with digital media to expand—rather than replace—spectatorial physicality. While *Creature from the Black Lagoon*'s use of 3D appealed to viewers by promising a new form of tactile proximity to Otherness, *Avatar*'s deployment of the technology thus offered viewers a novel bodily encounter with a digitally mediated world.

POINTS OF CONVERGENCE

Douglas Trumbull's 1983 movie *Brainstorm* uses the widescreen format to portray digitally mediated vision. Although shot and shown on film, the movie thematizes the digital medium that has been understood as both a descendant of and competitor to cinema: virtual reality. When characters put on the headgear that will allow them to experience a new reality—the reality, significantly, of another's point of view, either transmitted live or previously recorded—and Trumbull cuts to a shot representing this new perspective, the shape of the film image itself changes, taking on the broad scope popularized by widescreen processes such as Cinerama and CinemaScope in the 1950s. The insinuation is that this wide format offers the best means of representing and evoking the type of immersive, perceptually realistic experience that virtual reality, too, has been understood to offer—an inheritance that has been traced in scholarship on new media as well.[117] As we have seen, *Avatar* utilizes widescreen's 1950s competitor, stereoscopic 3D, to similar ends.

The form of bodily immersion offered by the 1950s movie technologies, however, did not persist unchanged or uncontested as a means for understanding the experience of digital cinema. While the concept of bodily immersion has continued to resonate with Hollywood's use of digital visual effects (and, most recently, with its interest in digital 3D), the discourses surrounding the concept of digital cinema in the late 1990s problematized the idea that such immersion represents the primary means for an affective—and even sensual—experience of cinema. Even when elements from the 1950s discourses on widescreen and 3D reemerge in discussions of digital spectatorship, the terms according to which the more recent modes of cinematic experience have been framed must be reevaluated in light of their changed contexts. In particular, concepts such as immersion and embodiment take on different shades of meaning in these different contexts.

The discourses surrounding widescreen's (re)emergence in the 1950s described the new format's implications for cinematic experience in terms of its effect on the human body. Whereas Academy-ratio cinema presented an image contained within the viewer's field of vision, the new aspect ratios, it was argued, approached the span of human vision, allowing viewers' perception of the film image to approximate

everyday perception outside the movie theater. This perceptual veri-
similitude, it was suggested, permitted moviegoers to experience the
cinematic spectacle as they did their day-to-day lives—both "synaes-
thetically," with visual cues evoking the senses of touch and motion,
and "coenaesthetically," with the entire sensorium thus functioning
in concert.[118] Presenting spectacles such as daredevil phantom rides
in this way, the systems (particularly Cinerama) were also reputed to
elicit psychosomatic effects, evoking the bodily reactions that accom-
pany real-life danger. Furthermore, filmmakers employed the larger
screens to present images of the human body on a new scale. As we
saw in relation to Marilyn Monroe, in particular, CinemaScope was
used to present full bodies at (or approaching) a size previously achiev-
able only when sectioned in close-up. With James Dean's presentation
in *East of Eden* the format was also used to significantly magnify the
human figure.

The sense of immersion associated with widescreen thus did not
simply offer viewers a verisimilar perceptual experience of exotic
worlds. Rather, the sense of proximity it was believed to supply also
put them into intimate, mimetic contact with technologically enlarged
bodies. This new experience of scale simultaneously evoked a sense
of power (not only rendering the pictured human image on a mas-
sive platform but also inviting viewers to inhabit these new dimen-
sions) and suggested human vulnerability in the face of the powerful
apparatus, both opening imaged bodies to enhanced scrutiny and, to
borrow a phrase from a caption accompanying publicity photographs
of the CinemaScope screen, dwarfing the individual viewer.[119] While
the discourses surrounding widescreen in the 1950s thus displayed
tension regarding the format's implications for the human body, the
pleasures and anxieties articulated with reference to the perceived
transformation in the bodily experience of cinema often emphasized
issues of power and vulnerability. The discourses surrounding wide-
screen's 1950s competitor, stereoscopic 3D, shared this interest in
bodily susceptibility.

Concerns about bodily experience are also central to the discourses
surrounding the deployment of digital technologies in the 1990s and
2000s, but the terms according to which that experience is framed dif-
fer significantly from those used in conjunction with the 1950s screen
technologies. Image size has reemerged as an important issue since

the turn of the twenty-first century with the increasing prevalence of pocket-sized screens and the simultaneous interest, on the part of the film industry, in reasserting the value of theatrical screens, as with Regal's "Go Big or Go Home" campaign. Scale, however, was not of central concern in the discourses on the consolidation of digital cinema in the late 1990s. At that time, discussions of digital technology's ramifications for the experience of cinema often focused on the implications of new modes of communication. With information understood as immaterial and immediately transmissible and the human mind conceived according to a disembodied yet connected informational model, tensions, as we have seen, revolved around the body's role in perceptual experience—and around the implications of the new mode of enworlded experience for intersubjectivity. Concerns about the reconfigured relationship between self and world surface, too, in applications of digital cinematic technologies such as George Lucas's use of CGI in *The Phantom Menace* and Thomas Vinterberg's deployment of digital video cameras in *The Celebration*. Both of these films harness digital technology to dissolve the distinction between figure and ground. As we have seen, these two deployments of the new technology elicit very different types of cinematic experience, yet in both cases this affective address is bound to the new technology's confrontation with organic life. The recent embrace of digital 3D with *Avatar* and the discussions surrounding it, while hearkening back to the 1950s technologies in certain ways, addresses these concerns as well.

Considering such issues through a historically rooted concept of cinematic experience compels us to acknowledge the heterogeneous and conflicting ways in which terms such as *bodily experience* and *intersubjectivity* have been conceptualized and evaluated. Rather than make ontological claims about disembodiment and inwardness, I have, through my focus on appeals, posited these tensions themselves as useful indications that the stakes according to which we evaluate cinematic experience have changed significantly with the coming of digital technologies, as they did with the emergence of other once-new technologies such as widescreen. Paying attention to how these appeals are articulated at specific times and places, we can grapple with the ways in which the forms of experience cinema offers—even when cinema's forms appear simply to hark back to older models—continue to evolve in dialogue with contemporary concerns.

INTRODUCTION: MOVING MACHINES

1. Darryl Zanuck to All Producers and Executives, memorandum, March 12, 1953, in *Memo from Darryl F. Zanuck: The Golden Years at Twentieth Century–Fox*, ed. Rudy Behlmer (New York: Grove, 1993), 234 (emphasis in original).

2. For a testimony to the cliché of the "static, non-cinematic qualities of CinemaScope" see Andrew Sarris, review of *East of Eden*, *Film Culture* 3 (May–June 1955): 24.

3. This observation is guided, in particular, by James Lastra's work. See James Lastra, *Sound Technology and the American Cinema: Perception, Representation, Modernity* (New York: Columbia University Press, 2000).

4. See Mary Ann Doane's work on the way early cinema negotiates the experience of embodiment in modernity. Mary Ann Doane, "Technology's Body: Cinematic Vision in Modernity," in *A Feminist Reader in Early Cinema*, ed. Jennifer M. Bean and Diane Negra (Durham, NC: Duke University Press, 2002), 530–51. Also see Mary Ann Doane, "Scale and the Negotiation of 'Real' and 'Unreal' Space in the Cinema," in *Realism and the Audiovisual Media*, ed. Lúcia Nagib and Cecília Mello (Basingstoke, Hampshire, UK: Palgrave Macmillan, 2009), 63–81.

5. On the contribution of onscreen images to the "architecture of spectatorship" see Anne Friedberg, *The Virtual Window: From Alberti to Microsoft* (Cambridge, MA: MIT Press, 2006), 150–51. Also see Thomas Elsaesser, "The New Film History as Media Archaeology," *Cinémas* 14, no. 2–3 (2004): 101–3.

6. See Philip Rosen, ed., *Narrative, Apparatus, Ideology: A Film Theory Reader* (New York: Columbia University Press, 1986).

7. See Jean-Louis Baudry, "Ideological Effects of the Basic Cinematographic Apparatus," in Rosen, *Narrative, Apparatus, Ideology*, 286–98; Baudry, "The Apparatus: Metapsychological Approaches to the Impression of Reality in Cinema," in ibid., 299–318; and Jean-Louis Comolli, "Technique and Ideology: Camera, Perspective, Depth of Field" (part 1), in *Movies and Methods*, ed. Bill Nichols (Berkeley: University of California Press, 1985), 2:40–57; (parts 3 and 4) in Rosen, *Narrative, Apparatus, Ideology*, 421–43.

8. See Tom Gunning, "An Aesthetic of Astonishment: Early Film and the (In)Credulous Spectator," in *Viewing Positions: Ways of Seeing Film*, ed. Linda Williams (New Brunswick, NJ: Rutgers University Press, 1995), 114–33; Miriam Hansen, *Babel and Babylon: Spectatorship in American Silent Film* (Cambridge, MA: Harvard University Press, 1991); David Bordwell and Noël Carroll, eds., *Post-Theory: Reconstructing Film Studies* (Madison: University of Wisconsin Press, 1996); Vivian Sobchack, *The Address of the Eye: A Phenomenology of Film Experience* (Princeton, NJ: Princeton University Press, 1991); and Steven Shaviro, *The Cinematic Body* (Minneapolis: University of Minnesota Press, 1993).

9. See Miriam Hansen, "Early Cinema, Late Cinema: Transformations of the Public Sphere," in Williams, *Viewing Positions*, 135; and Anne Friedberg, "The End of Cinema: Multimedia and Technological Change," in *Reinventing Film Studies*, ed. Christine Gledhill and Linda Williams (London: Oxford University Press, 2000), 438–52.

10. For explorations of the ways the ontology and experience of cinema are transformed with the pervasion of digital technologies in production, postproduction, distribution, and exhibition see Lev Manovich, *The Language of New Media* (Cambridge, MA: MIT Press, 2002); Henry Jenkins, *Convergence Culture: Where Old and New Media Collide* (New York: New York University Press, 2006); Barbara Klinger, *Beyond the Multiplex: Cinema, New Technologies, and the Home* (Berkeley: University of California Press, 2006); Laura Mulvey, *Death 24x a Second: Stillness and the Moving Image* (London: Reaktion, 2006); and D. N. Rodowick, *The Virtual Life of Film* (Cambridge, MA: Harvard University Press, 2007). On the long-standing heterogeneity in cinematic practice see Thomas Elsaesser, "Digital Cinema and the Apparatus: Archaeologies, Epistemologies, Ontologies," in *Cinema and Technology: Cultures, Theories, Practices*, ed. Bruce Bennett, Marc Furstenau, and Adrian Mackenzie (New

York: Palgrave Macmillan, 2008), 226–40. On intermediality see Rick Altman, *Silent Film Sound* (New York: Columbia University Press, 2004); Steve J. Wurtzler, *Electric Sounds: Technological Change and the Rise of Corporate Mass Media* (New York: Columbia University Press, 2007); and André Gaudreault, *Film and Attraction: From Kinematography to Cinema*, trans. Timothy Barnard (Urbana: University of Illinois Press, 2011). On material diversity see Charles R. Acland, "Curtains, Carts and the Mobile Screen," *Screen* 50, no. 1 (Spring 2009): 148–66; and Haidee Wasson, ed., "In Focus: Screen Technologies," *Cinema Journal* 51, no. 2 (Winter 2012): 141–72. Other important arguments against the idea of a radical break can be found in Philip Rosen, *Change Mummified: Cinema, Historicity, Theory* (Minneapolis: University of Minnesota Press, 2001), 301–49; John Belton, "Digital Cinema: A False Revolution," *October* 100 (Spring 2002): 98–114; Tom Gunning, "Moving Away from the Index: Cinema and the Impression of Reality," *differences* 18, no. 1 (2007): 29–52; and Dudley Andrew, *What Cinema Is! Bazin's Quest and Its Charge* (Chichester, West Sussex, UK: Wiley-Blackwell, 2010).

11. Baudry, "The Apparatus," 312.

12. Rosen, introduction to part 3, *Narrative, Apparatus, Ideology*, 282. Also see Frank Kessler, "The Cinema of Attractions as *Dispositif*," in *The Cinema of Attractions Reloaded*, ed. Wanda Strauven (Amsterdam: Amsterdam University Press, 2006), 60.

13. See Baudry, "Ideological Effects of the Basic Cinematographic Apparatus," 294–95; and Baudry, "The Apparatus," 313.

14. See Frank Kessler, "Programming and Performing Early Cinema Today: Strategies and *Dispositifs*," in *Early Cinema Today: The Art of Programming and Live Performance*, ed. Martin Loiperdinger (New Barnet, Herts, UK: John Libbey, 2011), 138–39. This plurality was also discussed in the roundtable "What Is Left of Apparatus Theory in the Age of Multiple Screens and Exhibition Platforms?" Conference on the Impact of Technological Innovations on the Historiography and Theory of Cinema, Montreal, Nov. 3, 2011. See Daniel Fairfax, "Conference Report: The Impact of Technological Innovations on the Historiography and Theory of Cinema," *Cinema Journal* 52, no. 1 (Fall 2012): 129–30.

15. Kessler, "The Cinema of Attractions as *Dispositif*," 61.

16. See Michel Foucault, *The Archaeology of Knowledge and the Discourse on Language*, trans. A. M. Sheridan Smith (New York: Pantheon, 1972). As Giorgio Agamben argues, the formations (or "positivities") that Foucault advocates analyzing in *The Archaeology of Knowledge* are intimately related to the concept of *dispositif* that Foucault later describes as "the network that can be established" among a heterogeneous set of elements including discourses, institutions, and architectural forms. While Foucault's concept of *dispositif*

shares with Baudry's an emphasis on subject positioning, Baudry's focus on the psychic dimension of cinema's *dispositif* (and his reliance on psychoanalysis) distinguishes his formulation significantly from Foucault's. Giorgio Agamben, "What Is an Apparatus?" in *What Is an Apparatus? And Other Essays*, trans. David Kishik and Stefan Pedatella (Stanford: Stanford University Press, 2009), 2, 3–12; see also Siegfried Zielinski, "Historic Modes of the Audiovisual Apparatus," *Iris* 17 (1994): 8–9.

17. See Foucault, *The Archaeology of Knowledge*, 208–9; and Jonathan Crary, *Techniques of the Observer: On Vision and Modernity in the Nineteenth Century* (Cambridge, MA: MIT Press, 1990), 7.

18. A favorite representative of such idealism has been André Bazin. However, against the widespread repudiation of Bazin by 1970s film theory, more recent scholarship has asserted his continued relevance, contending that allegations of "naive realism" were based on oversimplifications of Bazin's ideas. See Rosen, *Change Mummified*, 3–41; Andrew, *What Cinema Is!*; and Dudley Andrew and Hervé Joubert-Laurencin, eds., *Opening Bazin: Postwar Film Theory and Its Afterlife* (Oxford: Oxford University Press, 2011).

19. Comolli, "Technique and Ideology," in Rosen, *Narrative, Apparatus, Ideology*, 424, 430–31 (emphasis in original).

20. Ibid., 431.

21. See John Belton, *Widescreen Cinema* (Cambridge, MA: Harvard University Press, 1992), 6–8; and Lastra, *Sound Technology and the American Cinema*, 11–12.

22. See Altman, *Silent Film Sound*; Gaudreault, *Film and Attraction*; Elsaesser, "The New Film History as Media Archaeology"; and Erkki Huhtamo and Jussi Parikka, eds., *Media Archaeology: Approaches, Applications, and Implications* (Berkeley: University of California Press, 2011).

23. Lastra, *Sound Technology and the American Cinema*, 11.

24. Marshall McLuhan, *Understanding Media: The Extensions of Man* (1964; Cambridge, MA: MIT Press, 1994), 23; Friedrich A. Kittler, *Gramophone, Film, Typewriter*, trans. Geoffrey Winthrop-Young and Michael Wutz (Stanford: Stanford University Press, 1999), xl–xli. On the issue of technological determinism and the debate between European media archaeologists including Kittler and Anglo-speaking critics focusing on media and cultural studies see Wendy Hui Kyong Chun, "Introduction: Did Somebody Say New Media?" in *New Media, Old Media: A History and Theory Reader*, ed. Wendy Hui Kyong Chun and Thomas Keenan (New York: Routledge, 2006), 4. Also see W. J. T. Mitchell and Mark B. N. Hansen, introduction to *Critical Terms for Media Studies* (Chicago: University of Chicago Press, 2010), xxi–xxii.

25. Raymond Williams, *Television: Technology and Cultural Form* (1974; London: Routledge, 2003), 131–32.

26. Baudry, "Ideological Effects of the Basic Cinematographic Apparatus," 291 (emphasis in original).

27. Linda Williams, *Hard Core: Power, Pleasure, and the "Frenzy of the Visible"* (Berkeley: University of California Press, 1989), 3. Also see Linda Williams, "Discipline and Fun: *Psycho* and Postmodern Cinema," in Gledhill and Williams, *Reinventing Film Studies*, 351–78. Williams, it should be noted, also emphasizes ways in which what she calls "body genres" can challenge hegemonic configurations of power. See *Hard Core*, 184–264, 272–75; and Linda Williams, "Film Bodies: Gender, Genre, and Excess," *Film Quarterly* 44, no. 4 (Summer 1991): 2–13.

28. I borrow the concept of "classical cinema's 'others'" from Thomas Elsaesser, *The Persistence of Hollywood* (New York: Routledge, 2012), 313.

29. This distinction can be traced to the one that German thinkers including Edmund Husserl, Helmuth Plessner, and Walter Benjamin made in the 1920s between the concepts of *Leib* (the lived body) and *Körper* (the physiological body). See Miriam Hansen, *Cinema and Experience: Siegfried Kracauer, Walter Benjamin, and Theodor W. Adorno* (Berkeley: University of California Press, 2012), 141. Also see Anne Rutherford, "Cinema and Embodied Affect," *Senses of Cinema* 25 (March-April 2003): http://sensesofcinema.com/2003/feature-articles/embodied_affect/ (accessed Jan. 2, 2013).

30. Sobchack, *The Address of the* Eye, 7. Also see Vivian Sobchack, *Carnal Thoughts: Embodiment and Moving Image Culture* (Berkeley: University of California Press, 2004); and Jennifer M. Barker, *The Tactile Eye: Touch and the Cinematic Experience* (Berkeley: University of California Press, 2009).

31. Shaviro, *The Cinematic Body*, 50–65.

32. Each chapter in *The Cinematic Body* ends with the word *abjection*.

33. Laura U. Marks, *The Skin of the Film: Intercultural Cinema, Embodiment, and the Senses* (Durham, NC: Duke University Press, 2000), 183–87, 231. Also see Laura U. Marks, *Touch: Sensuous Theory and Multisensory Media* (Minneapolis: University of Minnesota Press, 2002), 1–20. In media studies see work recently done to reassert the role of embodiment in the experience of digital media, particularly N. Katherine Hayles, *How We Became Posthuman: Virtual Bodies in Cybernetics, Literature, and Informatics* (Chicago: University of Chicago Press, 1999); and Mark B. N. Hansen, *New Philosophy for New Media* (Cambridge, MA: MIT Press, 2004).

34. N. Katherine Hayles serves as a useful guide for thinking through the imbrication and historical variability of "the body" and embodiment. She acknowledges that although "a study of anatomy textbooks written across the centuries will confirm that ideas of the body change as the culture changes, it is less obvious that our experiences of embodiment also change," yet she also argues that "refusing to grant embodiment a status prior to

relation opens the possibility that changes in the environment (themselves emerging from systemic and organized changes in the flux) are deeply inter-related with changes in embodiment. Living in a technologically engineered and information-rich environment brings with it associated shifts in habits, postures, enactments, perceptions—in short, changes in the experiences that constitute the dynamic lifeworld we inhabit as embodied creatures" (N. Katherine Hayles, "Flesh and Metal," *Configurations* 10, no. 2 [Spring 2002]: 299).

35. André Gaudreault has offered an important critique of the label "early cinema," proposing the term *kine-attractography* in its stead; however, I retain the former term here for its accessibility. See Gaudreault, *Film and Attraction*, 40–47.

36. See Tom Gunning, "The Cinema of Attractions: Early Film, Its Spectator and the Avant-Garde," in *Early Cinema: Space, Frame, Narrative*, ed. Thomas Elsaesser and Adam Barker (London: BFI, 1990), 56–62; and Gunning, "An Aesthetic of Astonishment."

37. See Miriam Hansen, "Benjamin, Cinema and Experience: 'The Blue Flower in the Land of Technology,'" *New German Critique* 40 (Winter 1987): 179–224; Gunning, "An Aesthetic of Astonishment," 125–29; Hansen, *Babel and Babylon*, esp. 23–59; and Tom Gunning, "The Whole Town's Gawking: Early Cinema and the Visual Experience of Modernity," *Yale Journal of Criticism* 7, no. 2 (1994): 189–201. On cinema and modernity also see Leo Charney and Vanessa Schwartz, eds., *Cinema and the Invention of Modern Life* (Berkeley: University of California Press, 1995); Ben Singer, *Melodrama and Modernity: Early Sensational Cinema and Its Contexts* (New York: Columbia University Press, 2001); Jennifer Bean, "Technologies of Early Stardom and the Extraordinary Body," *Camera Obscura* 16, no. 3.48 (2001): 9–57; Mary Ann Doane, *The Emergence of Cinematic Time: Modernity, Contingency, the Archive* (Cambridge, MA: Harvard University Press, 2002); and Francesco Casetti, *Eye of the Century: Film, Experience, Modernity*, trans. Erin Larkin with Jennifer Pranolo (New York: Columbia University Press, 2008).

38. See, e.g., Siegfried Kracauer, "Boredom," in *The Mass Ornament: Weimar Essays*, ed. and trans. Thomas Y. Levin (Cambridge, MA: Harvard University Press, 1995), 331–34; Siegfried Kracauer, "Cult of Distraction," in ibid., 323–28; Walter Benjamin, "The Storyteller," trans. Harry Zohn, in *Selected Writings*, ed. Michael W. Jennings et al., trans. Rodney Livingstone, Edmund Jephcott, Howard Eiland, et al., 4 vols. (Cambridge, MA: Harvard University Press, 1996–2003), 3:143–66; and Benjamin, "On Some Motifs in Baudelaire," in ibid., 4:313–55. For a detailed discussion of this concept of experience see Hansen, *Cinema and Experience*.

39. Hansen, *Babel and Babylon*, 12–13.

40. Oskar Negt and Alexander Kluge, *Public Sphere and Experience: Toward an Analysis of the Bourgeois and Proletarian Public Sphere*, trans. Peter Labanyi, Jamie Owen Daniel, and Assenka Oksiloff (Minneapolis: University of Minnesota Press, 1993), 2. On the relationship between Negt and Kluge's ideas about the public sphere and the concept of experience elaborated by Kracauer, Benjamin, and Adorno, see Miriam Hansen, "Foreword," in ibid., xvii–xx; and Hansen, *Cinema and Experience*, xiii–xv.

41. Hansen, "Early Cinema, Late Cinema," 146.

42. For another view of experience offered in response to semiotic accounts of subjectivity (although in this case articulated in semiotic terms and within a feminist project), see Teresa de Lauretis, *Alice Doesn't: Feminism, Semiotics, Cinema* (Bloomington: Indiana University Press, 1984), 158–86. De Lauretis posits the concept of experience as a means for addressing the relationship between women as actual, historically located beings and the concept of "woman" as constructed by hegemonic discourses. Describing the experience of the female subject as "that complex of habits, dispositions, associations and perceptions, which en-genders one as female," she argues that this subjectivity is produced both semiotically *and* historically; she thus emphasizes the role embodied beings, including real women, can have in the production of meaning (182). In the sense that this concept of experience is understood to mediate the individual and the social, emphasizing the potentially progressive role historically located, embodied beings can play in their engagement with social structures, de Lauretis's account resonates with the one attributed here to Kracauer, Benjamin, and Negt and Kluge.

43. Despite differences in attitude and approach, Benjamin's ideas about technology resonate with Heidegger's concept of enframing (*Gestell*): "that way of revealing which holds sway in the essence of modern technology and which is itself nothing technological" (Martin Heidegger, "The Question Concerning Technology," in *The Question Concerning Technology and Other Essays*, trans. William Lovitt [New York: Harper and Row, 1977], 20). Also see Hansen, *Cinema and Experience*, 49, 153–54.

44. See, e.g., Walter Benjamin, "The Work of Art in the Age of Its Technological Reproducibility" (2nd version), in *Selected Writings*, 3:101–33; and Benjamin, "On Some Motifs in Baudelaire."

45. Benjamin, "The Work of Art," 3:108.

46. As Miriam Hansen has elucidated, this emphasis is particularly clear in the essay's second version, which functioned as Benjamin's urtext. See Hansen, *Cinema and Experience*, 183–204.

47. Also see ibid., 80, 202–4.

48. For an argument against what David Bordwell calls the "history-of-vision doctrine" modeled on Benjamin, see David Bordwell, *On the History*

of Film Style (Cambridge, MA: Harvard University Press, 1997), 141–49; and David Bordwell, *Figures Traced in Light: On Cinematic Staging* (Berkeley: University of California Press, 2005), 245–49. For an extensive response to Bordwell's earlier argument see Singer, *Melodrama and Modernity*, 101–30. While I agree with Singer that Bordwell's critique relies on an "overly reductive" conception of the "modernity thesis," I want simply to point here to the fact that the object of that debate, which centers on whether what Bordwell calls "epochal explanations" can account for film style, differs from the issue at hand in my project (Singer, *Melodrama*, 129; Bordwell, *Figures*, 244). My object (and, indeed, one of the main goals of proponents of the "modernity thesis," unacknowledged by Bordwell in the above-mentioned critiques) is, ultimately, to make an argument about spectatorship—a topic that should not be dismissed as implying what Bordwell calls "top down" scholarship. In fact, "all the fascinating historical information brought to light about trains and museum layout and international expositions"—which Bordwell argues results in a top-down approach to film style—emerges from the perspective of spectatorship as what he advocates as "inductive and data-driven" research, although into a different object, namely the context of film experience (Bordwell, *Figures*, 248).

49. See Benjamin, "The Work of Art," 3:120; Susan Buck-Morss, "Aesthetics and Anaesthetics: Walter Benjamin's Artwork Essay Reconsidered," *October* 62 (Autumn 1992): 3–41; and Hansen, *Cinema and Experience*, xvi, 78–79.

50. Benjamin, "Surrealism: The Last Snapshot of the European Intelligentsia," in *Selected Writings*, 2:217; Hansen, *Cinema and Experience*, 202.

51. For the allegation that Benjamin's work exhibits technological determinism, see Fredric Jameson, *Marxism and Form: Twentieth-Century Dialectical Theories of Literature* (Princeton, NJ: Princeton University Press, 1971), 74.

52. See, e.g., Gunning, "The Cinema of Attractions," 61; Hansen, "Early Cinema, Late Cinema," 137; and Scott Bukatman, "The Artificial Infinite: On Special Effects and the Sublime," in *Matters of Gravity: Special Effects and Supermen in the 20th Century* (Durham, NC: Duke University Press, 2003), 91.

53. Elsaesser, "The New Film History as Media Archaeology," 89, 101. Also see Kessler, "The Cinema of Attractions as *Dispositif*."

54. On the history and resonances of the term *new media* see Chun, "Introduction: Did Somebody Say New Media?" 1–3.

55. See Rodowick, *The Virtual Life of Film*, 2–31; Elsaesser, "Digital Cinema and the Apparatus," 226–32; Andrew, *What Cinema Is!* xiv; and Hansen, *Cinema and Experience*, xvi–xvii.

56. On the way in which the concept of convergence downplays cinema's earlier relationships with other media, see Gunning, "Moving Away from the Index," 36. On such complex relationships also see Paul Young, *The*

Cinema Dreams Its Rivals: Media Fantasy Films from Radio to the Internet (Minneapolis: University of Minnesota Press, 2006).

57. See Will Straw, "Proliferating Screens," *Screen* 41, no. 1 (Spring 2000): 115–19; and Haidee Wasson, "The Networked Screen: Moving Images, Materiality, and the Aesthetics of Size," in *Fluid Screens, Expanded Cinema*, ed. Janine Marchessault and Susan Lord (Toronto: University of Toronto Press, 2007), 74–95.

58. See, e.g., John Belton, Sheldon Hall, and Steve Neale, eds., *Widescreen Worldwide* (New Barnet, Herts, UK: John Libbey, 2010); Keith M. Johnston, "Now Is the Time (to Put On Your Glasses): 3-D Film Exhibition in Britain, 1951–55," *Film History* 23, no. 1 (Jan. 2011): 93–103; and Kristen Whissel, "Tales of Upward Mobility: The New Verticality and Digital Special Effects," *Film Quarterly* 59, no. 4 (Summer 2006): 23–34.

59. Walter Benjamin, *One-Way Street*, in *Selected Writings*, 1:476.

1. "SMOTHERED IN BAKED ALASKA": THE ANXIOUS APPEAL OF WIDESCREEN CINEMA

1. Otis L. Guernsey Jr., review of *How to Marry a Millionaire*, *New York Herald Tribune*, Nov. 11, 1953.

2. For scholarly discussions of audience participation see John Belton, *Widescreen Cinema* (Cambridge, MA: Harvard University Press, 1992), 187–96; William Paul, "The Aesthetics of Emergence," *Film History* 5, no. 3 (1993): 321–55; and William Paul, "Breaking the Fourth Wall: 'Belascoism,' Modernism, and a 3-D *Kiss Me Kate*," *Film History* 16, no. 3 (2004): 229–42. For references to audience participation in press and marketing see "Hail Cinerama's B.O. Promise," *Variety*, Oct. 8, 1952, 26; "Cinerama's Socko Kickoff," *Variety*, Oct. 8, 1952, 6; CinemaScope ad, *Variety*, July 22, 1953, 10–11; Thomas Pryor, "Metro Will Use Fox 3-D Process," *New York Times*, March 19, 1953, 34; brochure for CinemaScope demonstration screenings, CinemaScope: clippings, 1950–1969 folder, New York Public Library for the Performing Arts, Lincoln Center; and *This Is Cinerama* souvenir programs, Cinerama (corporation) folder, New York Public Library for the Performing Arts.

3. See, in particular, André Bazin, "Will CinemaScope Save the Film Industry?" in *Bazin at Work: Major Essays and Reviews from the Forties and Fifties*, ed. Bert Cardullo, trans. Alain Piette and Bert Cardullo (New York: Routledge, 1997), 77–92; Charles Barr, "CinemaScope: Before and After," *Film Quarterly* 16, no. 4 (Summer 1963): 4–24; Matthew Bernstein, ed., "American Widescreen," special issue, *Velvet Light Trap* 21 (Summer 1985); Belton, *Widescreen Cinema*, esp. 183–210; Paul, "The Aesthetics of Emergence," esp. 336–45; and Paul, "Breaking the Fourth Wall," esp. 233–34. Other important work on

widescreen includes William Paul, "Screening Space: Architecture, Technology, and the Motion Picture Screen," *Michigan Quarterly Review* 35, no. 1 (Winter 1996): 143–73; John Belton, ed., "Widescreen," special issue, *Film History* 15, no. 1 (2003); David Bordwell, "CinemaScope: The Modern Miracle You See Without Glasses," in *Poetics of Cinema* (New York: Routledge, 2008), 281–325; and John Belton, Sheldon Hall, and Steve Neale, eds., *Widescreen Worldwide* (New Barnet, Herts, UK: John Libbey, 2010).

4. On Hollywood in the 1950s see Tino Balio, ed., *Hollywood in the Age of Television* (Boston: Unwin Hyman, 1990); Christopher Anderson, *Hollywood TV: The Studio System in the Fifties* (Austin: University of Texas Press, 1994); and Peter Lev, *The Fifties: Transforming the Screen, 1950–1959* (Berkeley: University of California Press, 2003). On social and economic changes in postwar America and their relationship to cinema and television see Belton, *Widescreen Cinema*, 69–84; and Lynn Spigel, *Make Room for TV: Television and the Family Ideal in Postwar America* (Chicago: University of Chicago Press, 1992).

5. Belton, Hall, and Neale, introduction to *Widescreen Worldwide*, 3. On the studios' move into lower-budget widescreen production, particularly with black-and-white CinemaScope films beginning in 1956, also see Lisa Dombrowski, "Cheap but Wide: The Stylistic Exploitation of CinemaScope in Black-and-White, Low-Budget American Films," in ibid., 63–70. Hollywood's interest in television, it should be noted, predates this period. See Timothy R. White, "Hollywood's Attempt at Appropriating Television: The Case of Paramount Pictures," in Balio, *Hollywood in the Age of Television*, 145–63; Anderson, *Hollywood TV*, 33–45; and Kira Kitsopanidou, "The Widescreen Revolution and 20th Century–Fox's Eidophor in the 1950s," *Film History* 15, no. 1 (2003): 33. Ironically, Twentieth Century–Fox pioneered not only CinemaScope but also the pan-and-scan technology used to reformat widescreen films for television. When NBC led the way in programming post-1948 Hollywood films in prime time as part of its move into telecasting in color, its "NBC Saturday Night at the Movies" series debuted in 1961 with *How to Marry a Millionaire*—a film that had played an integral role in marketing CinemaScope as a spectacular alternative to television. See Belton, *Widescreen Cinema*, 216–18; and Tino Balio, introduction to part 1 of *Hollywood in the Age of Television*, 37.

6. "The Year in Films," *Time*, Dec. 28, 1953, www.time.com/time/magazine/article/0,9171,858457,00.html (accessed Jan. 2, 2013).

7. Clement Greenberg, "Avant-Garde and Kitsch," *Partisan Review* 6, no. 5 (1939): 34–49; Theodor Adorno and Max Horkheimer, "The Culture Industry: Enlightenment as Mass Deception," in *Dialectic of Enlightenment: Philosophical Fragments*, ed. Gunzelin Schmid Noerr, trans. Edmund Jephcott (Stanford: Stanford University Press, 2002), 94–136; Theodor Adorno, "The Schema

of Mass Culture," in *The Culture Industry: Selected Essays on Mass Culture*, ed. J. M. Bernstein (London: Routledge, 1991), 61–97. Also see Marshall McLuhan, *The Mechanical Bride: Folklore of Industrial Man* (Boston: Beacon, 1951); and Bernard Rosenberg and David Manning White, eds., *Mass Culture: The Popular Arts in America* (Glencoe, IL: Free Press and Falcon's Wing Press, 1957).

8. Ralph Goodman, "Freud and the Hucksters," *Nation*, Feb. 14, 1953, 143. This concern found its apotheosis in Vance Packard's best-selling exposé of the advertising industry, *The Hidden Persuaders* (New York: David McKay, 1957). Also see Lydia Strong, "They're Selling Your Unconscious," *Saturday Review*, Nov. 13, 1954, 11–12, 60–63; and "Inside the Consumer: The New Debate: Does He Know His Own Mind?" *Newsweek*, Oct. 10, 1955, 89–93. I owe these news article references to Charles R. Acland, *Swift Viewing: The Popular Life of Subliminal Influence* (Durham, NC: Duke University Press, 2012), 105. Not only did Hollywood reflect this interest in advertising (and negotiate its own conflicted place in the evolving mass media landscape) in CinemaScope films such as *Will Success Spoil Rock Hunter?* (Frank Tashlin, 1957), but it was reportedly a screening of the CinemaScope film *Picnic* (Joshua Logan, 1955) that hosted a mythologized 1957 test of the subliminal messages, "eat popcorn" and "drink Coca-Cola" (ibid., 91).

9. On Cold War–era concerns about political conditioning (and the latter's relationship to commercial forms of conditioning) see Andreas Killen and Stefan Andriopoulos, eds., "On Brainwashing: Mind Control, Media, and Warfare," special issue, *Grey Room* 45 (Fall 2011). On the HUAC hearings and the blacklist see Brian Neve, "HUAC, the Blacklist, and the Decline of Social Cinema," in Lev, *The Fifties*, 65–86.

10. For voicing of these concerns see McLuhan, *The Mechanical Bride*, v; and Packard, *The Hidden Persuaders*, 3.

11. Susan Stewart's argument that the figure of the gigantic "mirrors the abstractions of institutions—either those of religion, the state, or, as is increasingly the case, the abstractions of technology and corporate power" sheds light on the aptness of widescreen to a context in which Hollywood sought aggressively to assert such power. Indeed, the dual function Stewart attributes to the gigantic—which, she claims, "is appropriated by the state and its institutions and put on parade with great seriousness" while simultaneously continuing "its secular life in the submerged world of the carnival grotesque"—is also evident in the tensions we find in the discourses on widescreen, which at once trumpet the format's grandiose portrayals of revered subjects and suggest that this large presentation renders bodies unfamiliar and potentially vulgar. See Susan Stewart, *On Longing: Narratives of the Miniature, the Gigantic, the Souvenir, the Collection* (Durham, NC: Duke University Press, 1993), 102, 81.

12. See Vivian Sobchack, "The Scene of the Screen: Envisioning Photographic, Cinematic and Electronic 'Presence,'" in *Carnal Thoughts: Embodiment and Moving Image Culture* (Berkeley: University of California Press, 2004), esp. 158–62.

13. On immersion see Erkki Huhtamo, "Encapsulated Bodies in Motion: Simulators and the Quest for Total Immersion," in *Critical Issues in Electronic Media*, ed. Simon Penny (Albany: State University of New York Press, 1995), 159–86; Oliver Grau, *Virtual Art: From Illusion to Immersion*, trans. Gloria Custance (Cambridge, MA: MIT Press, 2003); and Alison Griffiths, *Shivers Down Your Spine: Cinema, Museums, and the Immersive View* (New York: Columbia University Press, 2008). On multiple-screen (and split-screen) display see Beatriz Colomina, "Enclosed by Images: The Eameses' Multimedia Architecture," *Grey Room* 02 (Winter 2001): 6–29; and Anne Friedberg, *The Virtual Window: From Alberti to Microsoft* (Cambridge, MA: MIT Press, 2006), 191–239. Also see chap. 3n55 below.

14. Belton, *Widescreen Cinema*, 14. Academy ratio is often identified as 1.33:1, which was the standard until the coming of sound.

15. Ibid., 24–28, 34–68; John Belton, "Fox and 50mm Film," in Belton, Hall, and Neale, *Widescreen Worldwide*, 13–18; Sergei Eisenstein, "The Dynamic Square," in *Film Essays and a Lecture*, ed. Jay Leyda (New York: Praeger, 1970), 48–65.

16. Belton, Hall, and Neale, introduction to *Widescreen Worldwide*, 2.

17. Belton, *Widescreen Cinema*, 69–84. In addition to the cultural interest in recreation emphasized by Belton, others have noted resonances between the form of spatiality offered by widescreen and phenomena including modern architecture and automobile culture. At the time, Charles Einfeld, Fox's vice president of advertising and publicity, associated the contemporary taste for width with ranch houses and recent automobiles. See Charles Einfeld, "CinemaScope and the Public," in *New Screen Techniques*, ed. Martin Quigley Jr. (New York: Quigley Publishing, 1953), 186. Responding to widescreen in *Cahiers du cinéma*, Jacques Rivette declared, "The search for depth is out of date" (Jacques Rivette, "The Age of *metteurs en scène*," trans. Liz Heron, in *Cahiers du cinéma: The 1950s: Neo-Realism, Hollywood, New Wave*, ed. Jim Hillier [Cambridge, MA: Harvard University Press, 1985], 277); and François Truffaut asked, "Hasn't modern architecture bricked up the old vertical window and opened up the window-wall, the glass-paneled bay, whose shape is oblong (blocks of flats, Le Corbusier, *Rope*, etc. . . .)?" (François Truffaut, "A Full View," trans. Liz Heron, in ibid., 273). For a scholarly exploration of these issues see Anne Friedberg, "Urban Mobility and Cinematic Visuality: The Screens of Los Angeles—Endless Cinema or Private Telematics," *Journal of Visual Culture* 1, no. 2 (2002): 183–204; and

Friedberg, *The Virtual Window*, 123–33, 175–78. Also see Spigel, *Make Room for TV*, 99–109.

18. Belton, *Widescreen Cinema*, 77.

19. *Photoplay*, for instance, called Cinerama a "brand new movie-going adventure" ("Let's Go to the Movies," *Photoplay*, Jan. 1953, 22). And advertising for Cinerama framed Cinerama-equipped theaters as tourist destinations, going so far as to insist that "you will never see Cinerama in your local or neighborhood theatre" (Cinerama advertisement, *Look*, May 4, 1954, 8). Also see Belton, *Widescreen Cinema*, 95–96.

20. See Fred Waller, "The Archeology of Cinerama," *Film History* 5, no. 3 (Sept. 1993): 289–97; Hazard Reeves, "This Is Cinerama," *Film History* 11, no. 1 (1999): 85–97; "Wide-Screen Motion Pictures" pamphlet, Sept. 1955 edition, 5, S.M.P.E.—Wide Screen folder, box 24, Earl I. Sponable Collection, Columbia University Libraries; and Belton, *Widescreen Cinema*, 85–112.

21. Because of the curvature of the screen, the perceived aspect ratio also depended on the viewer's positioning in the theater. A pamphlet published in 1955 by the Society of Motion Picture and Television Engineers, for instance, states that Cinerama's aspect ratio "varies with viewing position" and "is 2.06 to 1 as viewed from center projector" ("Wide-Screen Motion Pictures" pamphlet, Sept. 1955 edition, 5). For attribution of a variable aspect ratio to screen curvature see Anton Wilson, *Anton Wilson's Cinema Workshop*, 4th ed. (Hollywood: American Cinematographer, 2004), 76. On Cinerama's camera aspect ratio see Arthur C. Miller and Walter Strenge, eds., *American Cinematographer Manual*, 3rd ed. (Hollywood: American Society of Cinematographers, 1969), 584. On Cinerama's projected aspect ratio see John Belton, "Glorious Technicolor, Breathtaking CinemaScope, and Stereophonic Sound," in Balio, *Hollywood in the Age of Television*, 191. Also see the American Widescreen Museum's discussion of this issue at www.widescreenmuseum.com/widescreen/cinerama_specs.htm (accessed Jan. 12, 2013).

22. Belton, *Widescreen Cinema*, 105–7.

23. For the complaint that the glasses necessary for 3D were unattractive and uncomfortable, see "An Eyeful at the Movies," *Life*, Dec. 15, 1952, 146. Advertising heralded CinemaScope as "The Modern Miracle You See Without the Use of Glasses." See, e.g., the advertisement for *The Robe* in *Variety*, July 29, 1953, 16. For a detailed discussion of the dialogue between widescreen and stereoscopic 3D in the 1950s see Paul, "The Aesthetics of Emergence."

24. Belton, *Widescreen Cinema*, 116. Also see Arthur Gavin, "2-D, 3-D, Widescreen, or All Three . . . ," *American Cinematographer*, May 1953, 210–12, 232–34.

25. Belton, *Widescreen Cinema*, 116.

26. In a letter to the editor of the *New York Times*, for instance, viewer Dorothy Ross complained, "Now we are treated to the sight of headless and

footless torsos march-marching about. I never saw a dream walking but I have seen any number of torsos talking. And it ain't good." The letter's date, together with the fact that the films it mentions were made in Academy ratio, suggests that Ross is referring to this cropping process even though she does not mention it directly. Dorothy Ross, "Wide-Screen Blues," *New York Times*, Oct. 25, 1953, X5.

27. David Bordwell, "Film Style and Technology, 1930–1960," in David Bordwell, Janet Staiger, and Kristin Thompson, *The Classical Hollywood Cinema: Film Style & Mode of Production to 1960* (New York: Columbia University Press, 1985), 260.

28. The first three CinemaScope films used lenses constructed by Chrétien; later films used lenses manufactured (and adapted from Chrétien's design) by Bausch & Lomb. On CinemaScope technology see E. I. Sponable, H. E. Bragg, and L. D. Grignon, "Design Considerations of CinemaScope Film," *Journal of the SMPTE* 63 (July 1954): 1–4; Herbert E. Bragg, "The Development of CinemaScope," *Film History* 2 (1988): 359–71; Stephen Huntley, "Sponable's CinemaScope: An Intimate Chronology of the Invention of the CinemaScope Optical System," *Film History* 5, no. 3 (Sept. 1993): 298–320; Belton, *Widescreen Cinema*, 113–57; and Belton, "Fox and 50mm Film."

29. CinemaScope's aspect ratio was originally 2.66:1, but it was standardized at 2.55:1. In 1956 Fox reduced it to 2.35:1 to accommodate an optical as well as a magnetic soundtrack on its prints, thus eliminating the need to create separate magnetic and optical release prints (Belton, *Widescreen Cinema*, 124, 152).

30. Ibid., 133–37; see also John Belton, "The Curved Screen," *Film History* 16, no. 3 (2004): 280–82.

31. See Belton, *Widescreen Cinema*, 125–27; and Tom Vincent, "Standing Tall and Wide: The Selling of VistaVision," in Belton, Hall, and Neale, *Widescreen Worldwide*, 25–39.

32. See Belton, *Widescreen Cinema*, 158–82.

33. Ibid., 152–54; see also Belton, "Fox and 50mm Film," 21.

34. Paul, "The Aesthetics of Emergence," 327–45.

35. "Strictly for the Marbles," *Time*, June 8, 1953, www.time.com/time/magazine/article/0,9171,935935,00.html (accessed Jan. 2, 2013).

36. *This Is Cinerama* souvenir program. Also see Belton, *Widescreen Cinema*, 97–98.

37. Advertisement for CinemaScope, *Variety*, July 22, 1953, 10–11.

38. Belton, *Widescreen Cinema*, 76.

39. Paul, "Breaking the Fourth Wall," 232.

40. This point recalls the argument Paul has made that widescreen evoked a passive mode of spectatorship. See Paul, "The Aesthetics of Emergence," 337.

Based on his subsequent research on the way in which the phrase "audience participation" was employed in theater, Paul has contended that his earlier suggestion that the "phrase [audience participation] would make more sense if we could give 'participate' more of a passive meaning to suggest that we become *part* of the image on the screen" was "clearly wrong" (Paul, "Breaking the Fourth Wall," 241n23 [emphasis in original]). Far from simply validating the earlier argument, I take the discourses examined here to indicate tensions surrounding how activity and passivity have been conceived.

41. See Hedda Hopper, "Cinerama Will Amaze You!" *Chicago Daily Tribune*, Dec. 21, 1952, D11; Ralph Walker, "The Birth of an Idea," in Quigley, *New Screen Techniques*, 116; and Einfeld, "CinemaScope and the Public," 182. Also see Belton, *Widescreen Cinema*, 99. Belton notes that "contemporary psychologists actually consider the human visual field to be about 1.5:1" (Belton, "Fox and 50mm Film," 18).

42. For overall discussion of these effects see Mary Jean Kempner, "Cinerama," *Vogue*, Jan. 1953, 171; Harland Manchester, "Fred Waller's Amazing Cinerama," *Reader's Digest*, March 1953, 46; and Chester Morrison, "3D: High, Wide and Handsome," *Look*, June 30, 1953, 28. On peripheral vision see Walker, "The Birth of an Idea," 112–13; and Fred Waller, "Cinerama Goes to War," in Quigley, *New Screen Techniques*, 119–20. On increased scope pulling the audience into the screen image see Darryl Zanuck, "CinemaScope Production," in ibid., 156. Also see Paul, "The Aesthetics of Emergence," esp. 336–39.

43. See "Information for the Theatre," Third Revision, Publicity—"Information for the Theatre," (booklets) folder, box 107, Sponable Collection; R. J. O'Donnell, "The Threshold of Great Things," *Daily Film Renter*, June 30, 1953, 9; Publicity—Outside, 1953 folder, box 108, Sponable Collection; "Unshackling the Screen," *Motion Picture Herald*, Feb. 7, 1953, 7; and Belton, "Fox and 50mm Film," 15.

44. There is significant variation in reporting on the size of the Cinerama screen at the Broadway Theater. Many estimates, including those provided in the promotional materials for *This Is Cinerama*, put the dimensions at approximately 75 feet wide around the curve, 51 feet straight across from tip to tip, and 26 feet high. A couple other venues, including *Motion Picture Herald*, put the dimensions at approximately 64 feet by 23 feet, with *Motion Picture Herald* citing the straight lateral distance as 56.5 feet. Based on *Motion Picture Herald*'s specificity, I believe the 64 foot by 23 foot estimate is more accurate. See Otis L. Guernsey Jr., review of *This Is Cinerama*, *New York Herald Tribune*, Oct. 1, 1952, 24; Bosley Crowther, "Looking at Cinerama," *New York Times*, Oct. 5, 1952, sec. 2, p. 1; "*This Is Cinerama* on Broadway," *Motion Picture Herald*, Oct. 11, 1952, Better Theatres section, 14; "Speaking of Pictures," *Life*, Oct. 27, 1952, 20; "Unshackling the Screen," 7; Joe Schoenfeld, "Pix Execs Hail 20th's

CinemaScope for Its Practicality and Low Cost," *Variety*, March 25, 1953, 22; and *This Is Cinerama* souvenir programs. Also see Daniel J. Sherlock, "*Wide Screen Movies* Corrections," www.film-tech.com/warehouse/tips/WSMC20. pdf (accessed Jan. 12, 2013). For the claim that the Cinerama screen was six times larger than the traditional screen, see Guernsey, review of *This Is Cinerama*, 24; and "Cinerama's Socko Kickoff," 6. There is also some disagreement over the average screen size before 1953, with estimates ranging from 18 feet by 13.5 feet to 20 feet by 16 feet. Prominent theater architect and consultant Benjamin Schlanger, who chaired the Society of Motion Picture and Television Engineers' (SMPTE) Theater Engineering Committee when it conducted its May 1953 Theater Survey, cited the lower of these figures in October 1953 but in 1956 identified the pre-1953 average picture width as 18–20 feet. See Ben Schlanger, "Sizing the Picture for 'Wide-Screen,'" *Motion Picture Herald*, Oct. 10, 1953, Better Theatres section, 16; and Ben Schlanger, "Dynamic Frame: Small Screen Intimacy with the Big Picture," *Motion Picture Herald*, Sept. 15, 1956, 46. Thank you to John Belton and Martin Hart for helping me sort through these discrepancies.

45. See review of *The Robe*, *Variety*, Sept. 23, 1953, 6; and review of *The Robe*, *Newsweek*, Sept. 28, 1953, 96.

46. See Thomas M. Pryor, "Fox Films Embark on 3-Dimension Era," *New York Times*, Feb. 2, 1953, 17; and Louis Berg, "What's Ahead on the Wide Screen?" *This Week*, Feb. 21, 1954, 14, in CinemaScope: clippings, 1950–1969 folder, New York Public Library for the Performing Arts.

47. See "*This Is Cinerama* on Broadway," 14; and Guernsey, review of *This Is Cinerama*, 24.

48. Although CinemaScope films were eventually projected onto flat screens, much discussion of the system's audience participation effect was attributed to the initial requirement that installations employ curved screens. See Paul, "The Aesthetics of Emergence," 325, 327. On screen curvature see also "CinemaScope Technical Bulletin for Theatre Supply Dealers," no. 1, p. 3, Publicity—General, N.D. folder, box 106, Sponable Collection. On stereo sound see also Sponable, Bragg, and Grignon, "Design Considerations of CinemaScope Film," 3; and Spyros Skouras to Darryl Zanuck, Jan. 11, 1955, Zanuck, Darryl 1953–1960 folder, box 116, Sponable Collection. On negative responses to CinemaScope's curved screen see Belton, "The Curved Screen," 281–82.

49. On the idea that screen curvature afforded a feeling of engulfment, see Kempner, "Cinerama," 171; and Pryor, "Fox Films Embark on 3-Dimension Era," 17. On the idea that stereophonic sound elicited this effect, see Hopper, "Cinerama Will Amaze You!" D11; and Manchester, "Fred Waller's Amazing Cinerama," 48. On the idea that widescreen pulled the audience into the film,

see *This Is Cinerama* souvenir programs; and Otis L. Guernsey Jr., "Zanuck: CinemaScope Is Industry's Salvation," *New York Herald Tribune*, (n.d.), CinemaScope: clippings, 1950–1969 folder, New York Public Library for the Performing Arts.

50. See "CinemaScope Technical Bulletin for Theatre Supply Dealers," no. 1, p. 3, Publicity—General, N.D. folder, box 106, Sponable Collection. This downplaying of the proscenium was also a goal in earlier theater designs by architects including Frederick Kiesler in the late 1920s and Ben Schlanger in the early 1950s. See Friedberg, *The Virtual Window*, 169; and Paul, "The Aesthetics of Emergence," 334–35.

51. See Hopper, "Cinerama Will Amaze You!" D11; and Leon Shamroy, "Filming 'The Robe,'" in Quigley, *New Screen Techniques*, 177.

52. Griffiths, *Shivers Down Your Spine*, 3. On the experience of immersion and its polysensory address also see Grau, *Virtual Art*, 14–15; and Lauren Rabinovitz, "More Than the Movies: A History of Somatic Visual Culture Through *Hale's Tours*, Imax, and Motion Simulation Rides," in *Memory Bytes: History, Technology, and Digital Culture*, ed. Lauren Rabinovitz and Abraham Geil (Durham, NC: Duke University Press, 2004), esp. 102–6.

53. Guernsey, review of *How to Marry a Millionaire*.

54. The latter publicity still is reprinted in Belton, *Widescreen Cinema*, 97.

55. *Time*, June 8, 1953, cover. William Paul offers an interesting discussion of this image as a means to distinguish the experience of emergence he links with stereoscopic 3D from the sense of immersion he associates with widescreen. See Paul, "The Aesthetics of Emergence," 338–39.

56. See Aldous Huxley, *Brave New World*, in *"Brave New World" and "Brave New World Revisited"* (New York: Harper and Row, 1965), 126–29.

57. Cited in "3-D's Editorial Fanfare," *Variety*, March 18, 1953, 4.

58. Arthur Mayer, "A Flat Future," *Variety*, April 15, 1953, 2.

59. These worries, indeed, are prescient of the parallel drawn a few years later by Huxley himself between the future he had imagined in *Brave New World* and the context of the 1950s. See Huxley, *Brave New World Revisited*, in *"Brave New World" and "Brave New World Revisited,"* 1.

60. See, e.g., Griffiths, *Shivers Down Your Spine*, 3–4; Grau, *Virtual Art*, 7; and Jan Holmberg, "Ideals of Immersion in Early Cinema," *Cinémas* 14, no. 1 (2003): 131–32. Also see Belton, *Widescreen Cinema*, 195.

61. "*This Is Cinerama* on Broadway," 14; Earl I. Sponable, "CinemaScope in the Theatre," in Quigley, *New Screen Techniques*, 188.

62. "*This Is Cinerama* on Broadway," 14.

63. Lynn Farnol, "Finding Customers for a Product," in Quigley, *New Screen Techniques*, 142.

64. *This Is Cinerama* souvenir program (emphasis in original).

65. See Bosley Crowther, "'Oklahoma' Arrives," *New York Times*, Oct. 16, 1955, X1; and Crowther, "Looking at Cinerama."

66. See Crowther, "Looking at Cinerama"; Cinerama ad, *Variety*, Oct. 8, 1952, 27; and "Movie Revolution," *Time*, Oct. 13, 1952, www.time.com/time/magazine/article/0,9171,817086,00.html (accessed Jan. 2, 2013). Also see Belton, *Widescreen Cinema*, 188.

67. Paul, "The Aesthetics of Emergence," 329. On Fox's attempt to associate CinemaScope with "quality," see "Red Carpet for 1st C'Scope Pix," *Variety*, Sept. 9, 1953, 4. On the attempt to distance CinemaScope from Cinerama's "vulgar associations as a cheap form of mass entertainment," see Belton, *Wide-screen Cinema*, 191. For examples of *Sight and Sound*'s critiques of widescreen, see Richard Kohler, "The Big Screens," *Sight and Sound* 24, no. 3 (Jan.–March 1955): 120–21; and Walter Lassally, "The Big Screens," *Sight and Sound* 24, no. 3 (Jan.–March 1955): 124.

68. For descriptions of similar reactions to the panorama, *Hayle's Tours*, and IMAX see Griffiths, *Shivers Down Your Spine*, 56; and Rabinovitz, "More Than the Movies," 105–6.

69. See Guernsey, review of *This Is Cinerama*, 24; "*This Is Cinerama* on Broadway," 14; George Schutz, "Cinerama and the Future," *Motion Picture Herald*, Oct. 4, 1952, 19; "Cinerama's Socko Kickoff," 6; and Cinerama ad, *Variety*, Oct. 8, 1952, 27.

70. Lowell Thomas, "This is Cinerama," *Magazine Digest*, Sept. 1953, 40.

71. "Speaking of Pictures," *Life*, Oct. 27, 1952, 20.

72. "Strictly for the Marbles."

73. Philip T. Hartung, "The Screen: Better with a Dramamine," *Commonweal* 57, no. 7 (Nov. 21, 1952): 165.

74. *This Is Cinerama* souvenir program.

75. "*This Is Cinerama* on Broadway," 14.

76. "Cinerama's Socko Kickoff," 6.

77. Bosley Crowther, "The Three-Dimensional Riddle," *New York Times*, March 29, 1953, 56.

78. "The New Pictures," *Time*, Sept. 28, 1953, www.time.com/time/magazine/article/0,9171,818950,00.html (accessed Jan. 2, 2013).

79. Berg, "What's Ahead on the Wide Screen?" 14.

80. "Speaking of Pictures," *Life*, Nov. 9, 1953, 20.

81. For the argument that CinemaScope elicited a new form of vision, see Francesca Liguoro and Giustina D'Oriano, "The Frontiers of Vision," in *Le cinémascope entre art et industrie*, ed. Jean-Jacques Meusy (Paris: Association française de recherche sur l'histoire du cinéma, 2003), 297–307.

82. Bosley Crowther, "Of Size and Scope: The Wide Screen Viewed in Light of *How to Marry a Millionaire*," *New York Times*, Nov. 15, 1953, X1.

83. On Monroe's connection with CinemaScope see Lisa Cohen, "The Horizontal Walk: Marilyn Monroe, CinemaScope, and Sexuality," *Yale Journal of Criticism* 11, no. 1 (1998): 259–88; and Kathrina Glitre, "Conspicuous Consumption: The Spectacle of Widescreen Comedy in the Populuxe Era," in Belton, Hall, and Neale, *Widescreen Worldwide*, 133–43.

84. For the first issue of *Playboy*, published in December 1953, Hugh Hefner apparently wanted to include three-dimensional nude photographs of Marilyn Monroe (to be seen with glasses), but it was financially unfeasible. The publisher contended, however, that the contrast of colors and textures in the two-dimensional spread ended up achieving a similar result. Beatriz Preciado, "Pornotopia," in *Cold War Hothouses*, ed. Beatriz Colomina, Annmarie Brennan, and Jeannie Kim (New York: Princeton Architectural Press, 2004), 234.

85. Abel Green, "Show Biz 1953—Wotta Year," *Variety*, Jan. 6, 1954, 3; Richard Dyer, *Heavenly Bodies: Film Stars and Society* (New York: St. Martin's, 1986), 27.

86. See Joe Schoenfeld, "CinemaScope Wins H'W'D Favor," *Daily Variety*, March 19, 1953, 3.

87. See Bosley Crowther, "CinemaScope Seen at Roxy Preview," *New York Times*, April 25, 1953, 10; and Morrison, "3D: High, Wide and Handsome," 32. Also see the photograph of Monroe holding a lens that appeared on the cover of Bausch & Lomb's house journal, reprinted in Huntley, "Sponable's Cinema-Scope," 313. Thank you to John Belton for calling my attention to this image.

88. See "CinemaScope's First Anniversary Marked," *Los Angeles Times*, Sept. 24, 1954, C10.

89. Jean Negulesco, "New Medium—New Methods," in Quigley, *New Screen Techniques*, 175.

90. Glitre, "Conspicuous Consumption," 133.

91. Clifford M. Sage, "Curtain Going Up," *Dallas Times Herald*, Nov. 4, 1952.

92. See "The New Pictures," *Time*, Sept. 28, 1953; review of *The Robe*, *Newsweek*, Sept. 28, 1953, 96; and Bosley Crowther, "Now CinemaScope!" *New York Times*, Sept. 27, 1953, 119. For a discussion of the way in which screen scale conspires with composition to present giant images of the face in Samuel Fuller's *Forty Guns* (1957), see Dombrowski, "Cheap but Wide," 67–69.

93. Barbara Berch Jamison, "Body and Soul: A Portrait of Marilyn Monroe Showing Why Gentlemen Prefer That Blonde," *New York Times*, July 12, 1953, X5. Also see Glitre, "Conspicuous Consumption," 134.

94. Darryl Zanuck, quoted in Robert Coughlan, "Spyros Skouras and His Wonderful CinemaScope," *Life*, July 20, 1953, 81 (emphasis in original).

95. In his 1972 book on stars, Edgar Morin links "superstars like Marilyn Monroe" with widescreen as mutual saviors of the film industry, and he describes the "charms" offered by the female stars constituting the

"mammary renaissance" as "stereoscopic" (Edgar Morin, *The Stars*, trans. Richard Howard [1972; Minneapolis: University of Minnesota Press, 2005], 2, 21). Marjorie Rosen describes Monroe and her imitators—including Jayne Mansfield, whose proportions Frank Tashlin's *The Girl Can't Help It* (1956) mocks along with CinemaScope's—as embodiments of the "Mammary Woman" that she, too, claims "lifted box-office receipts" in the 1950s (Marjorie Rosen, *Popcorn Venus: Women, Movies and the American Dream* [New York: Coward, McCann and Geoghegan, 1973], 281–82). On marketing research into orality and its use in advertising in the mid-1950s (including a discussion of the "voluptuousness" of ice cream that illuminates Monroe's association with baked Alaska), see Packard, "Back to the Breast, and Beyond," in *The Hidden Persuaders*, 98–104.

96. Crowther, "Picture of Hollywood in the Depths," *New York Times*, June 14, 1953; Hildegarde Johnson, "3-D Pinup Girls," *Photoplay*, Sept. 1953, 88. Stereoscopic 3D's tendency toward miniaturization was described by 3D pioneer John A. Norling as a distortion resulting from the incorrect spacing of 3D cameras' twin lenses. Despite *Photoplay*'s claim that CinemaScope slimmed Monroe in *How to Marry a Millionaire*, the idea that widescreen made actors look thinner actually runs counter to the fact that CinemaScope lenses' uneven squeeze ratios, while making figures at the edges of the frame skinnier, rendered those at the center wider. See John A. Norling, "Basic Principles of 3-D Photography and Projection," in Quigley, *New Screen Techniques*, 38–39; Huntley, "Sponable's CinemaScope," 306–7; Belton, *Widescreen Cinema*, 144–45, 155–57; and Bordwell, "CinemaScope: The Modern Miracle You See Without Glasses," 288–89.

97. Coughlan, "Spyros Skouras," 83.

98. Johnson, "3-D Pinup Girls," 44.

99. Also see Keith M. Johnston's discussion of the way in which 3D trailers advertised the technology via the female body—a strategy he links explicitly to trailers for widescreen films including *How to Marry a Millionaire*. Keith M. Johnston, "Three Times as Thrilling! The Lost History of 3-D Trailer Production, 1953–54," *Journal of Popular Film and Television* (2008): 155–57, 159.

100. Schoenfeld, "Pix Execs," 22. Also see Schoenfeld, "CinemaScope Wins H'W'D Favor," 3.

101. Lisa Cohen links this designation with the horizontality of the CinemaScope frame. See Cohen, "The Horizontal Walk," 260. For examples of photograph captions describing the size of Monroe's image on the new screens, see Crowther, "CinemaScope Seen at Roxy Preview," 10; and Coughlan, "Spyros Skouras," 83. On Monroe's "horizontal walk" see Thomas Harris, "The Building of Popular Images: Grace Kelly and Marilyn Monroe," in *Stardom: Industry of Desire*, ed. Christine Gledhill (London: Routledge, 1991), 43.

102. "Strictly for the Marbles." Also see "Taking CinemaScope Lying Down," *Life*, Nov. 23, 1953, 137; Lassally, "The Big Screens," 126; and Cohen, "The Horizontal Walk," 278.

103. The red velvet covering the chaise also recalls her famous "Golden Dreams" calendar photograph, taken by Tom Kelley and used as the centerfold in the December 1953 issue of *Playboy*, which positions Monroe against a red velvet background.

104. "The New Pictures," *Time*, Nov. 23, 1953, www.time.com/time/magazine/article/0,9171,860174,00.html (accessed Jan. 2, 2013); Johnson, "3-D Pinup Girls," 42.

105. Recent discussions of high-definition technology provide an interesting parallel to this discourse, although with widescreen these claims rested on image size rather than resolution. See Virginia Heffernan, "True Colors," *New York Times*, Oct. 17, 2008, MM18; and Belton, *Widescreen Cinema*, 159–60.

106. Johnson, "3-D Pinup Girls," 88. While this may seem to contradict the idea that "3-D" eliminated the plumping effect of "flat" films, the suggestion is that the "realism" of the new processes both brought out natural assets and exposed beauty tricks.

107. Crowther, "Picture of Hollywood," 64.

108. Johnson, "3-D Pinup Girls," 44. On fan magazines' address to women see Gaylyn Studlar, "The Perils of Pleasure? Fan Magazine Discourse as Women's Commodified Culture in the 1920s," in *Silent Film*, ed. Richard Abel (New Brunswick, NJ: Rutgers University Press, 1996), 263–97; and Donald Crafton, *The Talkies: American Cinema's Transition to Sound, 1926–1931* (Berkeley: University of California Press, 1997), 483. As these citations indicate, much work on fan magazines revolves around the 1920s, when their popularity boomed. *Photoplay*'s advertisements, however, which continued to emphasize women's products in the early 1950s, suggest its sustained address to women.

109. See, e.g., *Photoplay*, June 1953, 77; and *Photoplay*, Nov. 1953, 62.

110. *Photoplay*, Nov. 1953, 62–63.

111. *Photoplay*, Sept. 1953, 88.

112. On the way in which the "association of the female body with widescreen" offered heterosexual female viewers the pleasure of "consuming images of fashion and glamour," see Glitre, "Conspicuous Consumption," 134.

113. Edith Gwynn, "Hollywood Party Line," *Photoplay*, Feb. 1954, 23 (emphasis in original).

114. Dyer, *Heavenly Bodies*, 7–8.

115. Morin, *The Stars*, 26, 25. Laura Mulvey notes that by the 1950s Monroe "stood for a brand of classless glamour, available to anyone using American cosmetics, nylons and peroxide" (Laura Mulvey, "*Gentlemen Prefer Blondes*:

Anita Loos/Howard Hawks/Marilyn Monroe," in *Howard Hawks: American Artist*, ed. Jim Hillier and Peter Wollen [London: BFI, 1996], 216).

116. Thank you to James Lastra for suggesting this reading.

117. Studlar, "The Perils of Pleasure?" 272–75.

118. Glitre also contends that the overt artificiality of *How to Marry a Millionaire*, as with Frank Tashlin's comedies, "is *part* of the film's overall style," which she links with widescreen films' paradoxical capacity to operate as commodities and to critique consumerism (Glitre, "Conspicuous Consumption," 137, 141–42 [emphasis in original]). I am making a different argument here, namely that this display operates not as critique but as a source of pleasure in itself—one harnessed for promoting the technology. On the reflexivity of Monroe's films see Matthew Solomon, "Reflexivity and Metaperformance: Marilyn Monroe, Jayne Mansfield, and Kim Novak," in *Larger Than Life: Movie Stars of the 1950s*, ed. R. Barton Palmer (New Brunswick, NJ: Rutgers University Press, 2010), 107–29.

119. See Belton, *Widescreen Cinema*, 202.

120. Tom Gunning, "An Aesthetic of Astonishment: Early Film and the (In)Credulous Spectator," in *Viewing Positions: Ways of Seeing Film*, ed. Linda Williams (New Brunswick, NJ: Rutgers University Press, 1995), 116–19. This observation also recalls Griffiths's conceptualization of the "revered gaze" elicited by immersive media, "a response marked as much by recognition of the labor and effort involved in creating the spectacle as in the spectacle itself" (Griffiths, *Shivers Down Your Spine*, 286).

121. Crowther drew this parallel at the time of *This Is Cinerama*'s release. See Crowther, "Looking at Cinerama," X1.

122. John Beaufort, "*Cinerama Holiday* on the Screen," *Christian Science Monitor*, Feb. 15, 1955, 4. Also see "Cinerama's Socko Kickoff," 6. The prologues beginning *This Is Cinerama* and *Cinerama Holiday* are presented in black and white; those initiating *Seven Wonders of the World* and *Search for Paradise* are in color.

123. Guernsey, review of *The Robe*, *New York Herald Tribune*, Sept. 17, 1953. Also see David Heuring, "Indelible Impressions: Eight ASC Members Recall Films That Helped to Shape Their Careers in Cinematography: John Hora, ASC 'The Robe' (1953)," *American Cinematographer*, April 1999, 79–80.

124. See Crowther, "Screen: Mammoth Show," *New York Times*, Oct. 18, 1956, 37; and Michael Todd Company to Theatre Managers, memorandum, Wide Screen—Todd-AO—General 1953–1960 Folder, box 120, Sponable Collection.

125. Theatrical trailer, *How to Marry a Millionaire*, directed by Jean Negulesco (1953; Los Angeles: 20th Century Fox, 2001), DVD.

126. This potentially owes, at least in part, to the difference in format between the trailer and the footage shot for the film. Indeed, although shooting alternative Academy-ratio versions of CinemaScope films was a common practice by other studios in the first two years after CinemaScope was introduced, Fox claimed to have shot only *The Robe* in an alternative version. Given that Fox had shot a CinemaScope test of a scene from the Academy-ratio *Gentlemen Prefer Blondes*, however, it is not outside the realm of possibility that it could have shot Academy-ratio footage from *How to Marry a Millionaire* for use in the trailer if it had deemed it desirable. The decision to forgo moving footage should therefore be attributed, at least in part, to creative considerations. Even if moving images from the film were impossible to include in the trailer, however, such technological justification does not mitigate the impact of the trailer's use of still images. On alternative versions see Sheldon Hall, "Alternative Versions in the Early Years of CinemaScope," in Belton, Hall, and Neale, *Widescreen Worldwide*, 113–31.

127. Belton, *Widescreen Cinema*, 90. Also see Tom LeCompte, "Cinerama: The Secret Weapon of the Cold War," *American Heritage of Invention and Technology* 21, no. 2 (2005): 10–17; and James H. Krukones, "Peacefully Coexisting on a Wide Screen: Kinopanorama vs. Cinerama, 1952–66," *Studies in Russian and Soviet Cinema* 4, no. 3 (2010): 283–305.

128. Advertisement for *The Robe*, *Variety*, July 29, 1953, 15–17. Also see John Belton, "CinemaScope: The Economics of Technology," *Velvet Light Trap* 21 (Summer 1985): 38.

129. Bosley Crowther, "New Giant Screen," *New York Times*, April 24, 1955, X1.

130. See Amy Lawrence, "James Mason: A Star Is Born Bigger Than Life," in Palmer, *Larger Than Life*, 98–104; and Harper Cossar, *Letterboxed: The Evolution of Widescreen Cinema* (Lexington: University Press of Kentucky, 2011), 120–40.

131. Berton Roueché, "Ten Feet Tall," *New Yorker*, Sept. 10, 1955, 47–77.

132. On Monroe's relation to 1950s attitudes about sex see Dyer, *Heavenly Bodies*, 19–66. On cinema's move to "mature" themes see Lev, *The Fifties*, 89–90.

133. Dyer, *Heavenly Bodies*, esp. 27–42, 50–62.

134. "'Adult' Yarns Hit Film Paydirt," *Variety*, Feb. 4, 1953, 20.

135. Kempner, "Cinerama," 173.

136. Crowther, "Big and Beautiful," *New York Times*, Jan. 17, 1954, X1.

137. Morrison, "3D: High, Wide and Handsome," 32. Griffiths similarly describes the monstrous appearance of the human body in IMAX, which she likens to Jonathan Swift's description of the gigantic female body in *Gulliver's*

Travels. See Griffiths, *Shivers Down Your Spine*, 109. Also see Stewart, *On Longing*, 87–88.

138. Roland Barthes, "On CinemaScope," trans. Jonathan Rosenbaum, www.jonathanrosenbaum.com/?p=20187 (accessed Jan. 2, 2013).

139. Bazin, "Will CinemaScope Save the Film Industry?" 90–91. In his essay on CinemaScope Barthes claims that the "balcony of History is ready," but he warns, "What remains to be seen is what we'll be shown there; if it will be *Potemkin* or *The Robe*, Odessa or Saint-Sulpice, History or Mythology" (Barthes, "On CinemaScope"). Despite Bazin's enthusiasm for the Cinema-Scope process, he was disappointed with *The Robe*. See André Bazin, "The End of Montage," trans. Catherine Jones and Richard Neupert, *Velvet Light Trap* 21 (Summer 1985): 14–15. Also see André Bazin, "The Myth of Total Cinema," in *What Is Cinema?* ed. and trans. Hugh Gray (Berkeley: University of California Press, 1967), 1:17–22; Tom Gunning, "The World in Its Own Image: The Myth of Total Cinema," in *Opening Bazin: Postwar Film Theory and Its Afterlife*, ed. Dudley Andrew with Hervé Joubert-Laurencin (Oxford: Oxford University Press, 2011), 119–26; Dudley Andrew, *What Cinema Is! Bazin's Quest and Its Charge* (Chichester, West Sussex, UK: Wiley-Blackwell, 2010); James Spellerberg, "CinemaScope and Ideology," *Velvet Light Trap* 21 (Summer 1985): 31–32; and Huhtamo, "Encapsulated Bodies in Motion," 163.

140. See Belton, *Widescreen Cinema*, 2, 202; and Spellerberg, "CinemaScope and Ideology," 30–32.

141. See Laura Mulvey, "Visual Pleasure and Narrative Cinema," in *Narrative, Apparatus, Ideology: A Film Theory Reader*, ed. Philip Rosen (New York: Columbia University Press, 1986), 198–209; and Mary Ann Doane, *The Desire to Desire: The Woman's Film of the 1940s* (Bloomington: Indiana University Press, 1987).

142. See Vivian Sobchack, *The Address of the Eye: A Phenomenology of Film Experience* (Princeton, NJ: Princeton University Press, 1991); Steven Shaviro, *The Cinematic Body* (Minneapolis: University of Minnesota Press, 1993); and Laura U. Marks, *The Skin of the Film: Intercultural Cinema, Embodiment, and the Senses* (Durham, NC: Duke University Press, 2000).

143. See Shaviro, *The Cinematic Body*, 56–65; Gaylyn Studlar, *In the Realm of Pleasure: Von Sternberg, Dietrich, and the Masochistic Aesthetic* (New York: Columbia University Press, 1988); and Paul, "The Aesthetics of Emergence," 339.

144. Deleuze argues that it is the mother, rather than the father (as Freud claims), that plays the key role in masochism. Studlar extends this idea to suggest that masochistic desire is for symbiosis with the mother. See Gilles Deleuze, "Coldness and Cruelty," in Gilles Deleuze and Leopold von Sacher-

Masoch, *Masochism* (New York: Zone Books, 1991); and Studlar, *In the Realm of Pleasure*, 13–18.

145. For the observation that Monroe "confirmed 1950s femininity while burlesquing it," see Lois W. Banner, "The Creature from the Black Lagoon: Marilyn Monroe and Whiteness," *Cinema Journal* 47, no. 4 (Summer 2008): 8. Also see Graham McCann, *Marilyn Monroe* (New Brunswick, NJ: Rutgers University Press, 1988); and S. Paige Baty, *American Monroe: The Making of a Body Politic* (Berkeley: University of California Press, 1995).

146. Dziga Vertov, *Kino-Eye: The Writings of Dziga Vertov*, ed. Annette Michelson, trans. Kevin O'Brien (Berkeley: University of California Press, 1984), 42; Griffiths, *Shivers Down Your Spine*, 77. Griffiths also evokes Vertov in her description of "the super-mobile gaze of the IMAX camera" (ibid., 101).

147. Miriam Hansen has suggested that Vertov's *Man with a Movie Camera* (1929), "in important ways, provides a cinematic intertext for [Benjamin's] artwork essay, in particular its earlier versions." This intertext is especially evident in that essay's formulation of the concepts of playful innervation and the optical unconscious, particularly in the well-known passage contending that film "came . . . and exploded this prison-world" of urban modernity constituted by "our bars and city streets, our offices and furnished rooms, our railroad stations and our factories," enabling people to "set off calmly on journeys of adventure among its far-flung debris"—and thus inviting, in Hansen's words, "mimetic explorations and imaginative reconfigurations of city life" (Miriam Hansen, *Cinema and Experience: Siegfried Kracauer, Walter Benjamin, and Theodor W. Adorno* [Berkeley: University of California Press, 2012], 87, 200); Walter Benjamin, "The Work of Art in the Age of Its Technological Reproducibility" (2nd version), trans. Edmund Jephcott and Harry Zohn, in *Selected Writings*, ed. Michael W. Jennings et al., trans. Rodney Livingstone, Edmund Jephcott, Howard Eiland, et al., 4 vols. (Cambridge, MA: Harvard University Press, 1996–2003), 3:117. Also see Miriam Hansen, "Room-for-Play: Benjamin's Gamble with Cinema," *October* 109 (Summer 2004): 21–22.

148. See, in particular, Walter Benjamin, *One-Way Street*, in *Selected Writings*, 1:444–88; Walter Benjamin, "Dream Kitsch: Gloss on Surrealism," *Selected Writings*, 2:3–5; Walter Benjamin, "Surrealism," *Selected Writings*, 2:207–24; Walter Benjamin, "Doctrine of the Similar," *Selected Writings*, 2:694–98; Walter Benjamin, "On the Mimetic Faculty," *Selected Writings*, 2:720–22; and Benjamin, "The Work of Art in the Age of Its Technological Reproducibility" (2nd version). Also see Michael Taussig, *Mimesis and Alterity: A Particular History of the Senses* (New York: Routledge, 1993); and Hansen, *Cinema and Experience*, esp. 132–55.

149. Adorno and Horkheimer, "The Culture Industry," 136.

150. Benjamin, "The Work of Art in the Age of Its Technological Reproducibility," 3:124n10. On the anesthetizing impulse and its political dangers see Susan Buck-Morss, "Aesthetics and Anaesthetics: Walter Benjamin's Artwork Essay Reconsidered," *October* 62 (Autumn 1992): 3–41.

151. See Shaviro, *The Cinematic Body*, 52–53, 87; and Mark B. N. Hansen, *New Philosophy for New Media* (Cambridge, MA: MIT Press, 2004), 1–3.

2. *EAST OF EDEN* IN CINEMASCOPE: INTIMACY WRIT LARGE

1. Bosley Crowther, "Big and Beautiful," *New York Times*, Jan. 17, 1954, X1.

2. Quoted in Aline Mosby, "Kazan Says Big Screen Won't Last," unidentified source, August 1954, CinemaScope: clippings 1950–1969 folder, Theatre Collection, New York Public Library for the Performing Arts, Lincoln Center.

3. Thomas H. Pauly, *An American Odyssey: Elia Kazan and American Culture* (Philadelphia: Temple University Press, 1983), 196; Mosby, "Kazan Says Big Screen Won't Last."

4. Quoted in Jeff Young, ed., *Kazan on Kazan* (London: Faber and Faber, 1999), 201.

5. Quoted in Mosby, "Kazan Says Big Screen Won't Last."

6. Andrew Sarris, review of *East of Eden*, *Film Culture* 3 (May-June 1955): 24.

7. On widescreen aesthetics see, in particular, André Bazin, "Will CinemaScope Save the Cinema?" trans. Catherine Jones and Richard Neupert, *Velvet Light Trap* 21 (Summer 1985): 8–14; Charles Barr, "CinemaScope: Before and After," *Film Quarterly* 16, no. 4 (Summer 1963): 4–24; David Bordwell, "Widescreen Aesthetics and Mise en Scene Criticism," *Velvet Light Trap* 21 (Summer 1985): 18–25; John Belton, *Widescreen Cinema* (Cambridge, MA: Harvard University Press, 1992), 197–210; David Bordwell, "CinemaScope: The Modern Miracle You See Without Glasses," in *Poetics of Cinema* (New York: Routledge, 2008), 281–325; and John Belton, Sheldon Hall, and Steve Neale, eds., *Widescreen Worldwide* (New Barnet, Herts, UK: John Libbey, 2010).

8. For a detailed discussion of Kazan's staging in depth see Lisa Dombrowski, "Choreographing Emotions: Kazan's CinemaScope Staging," in *Kazan Revisited*, ed. Lisa Dombrowski (Middletown, CT: Wesleyan University Press, 2011), 163–77.

9. William Paul, "Screening Space: Architecture, Technology, and the Motion Picture Screen," *Michigan Quarterly Review* 35, no. 1 (Winter 1996): 143–73, 165. On generic norms for "the proper amplitude" of bodies and images see Susan Stewart, *On Longing: Narratives of the Miniature, the Gigantic, the Souvenir, the Collection* (Durham, NC: Duke University Press, 1993), 94–95.

10. On *East of Eden*'s canted angles see John McCarten, "Steinbeck, Lay That Bible Down," *New Yorker*, March 19, 1955, 141; Sarris, review of *East of Eden*; Arthur Gavin, "The Photography of 'East of Eden,'" *American Cinematographer*, March 1955, 170; Jim Hillier, "*East of Eden*," *Movie* 19 (Winter 1971–72): 22; Robin Wood, "The Kazan Problem," *Movie* 19 (Winter 1971–72): 30; and Bordwell, "CinemaScope: The Modern Miracle You See Without Glasses," 305. On Warner Bros.' suggestion that Kazan keep the camera at least six feet from the actors, see Young, *Kazan on Kazan*, 200.

11. On the close-up's destabilizing effect for early film audiences see Tom Gunning, "In Your Face: Physiognomy, Photography, and the Gnostic Mission of Early Film," *Modernism/Modernity* 4, no. 1 (1997): 22–26. For claims that widescreen close-ups were monstrous, see review of *The Robe*, *Newsweek*, Sept. 28, 1953, 98; and Crowther, "Big and Beautiful."

12. "The New Pictures," *Time*, Sept. 28, 1953, www.time.com/time/magazine /article/0,9171,818950,00.html (accessed Jan. 2, 2013).

13. Souvenir Program for *This Is Cinerama*, Cinerama (corporation) folder, Theatre Collection, New York Public Library for the Performing Arts.

14. Tom Gunning, "Landscape and the Fantasy of Moving Pictures: Early Cinema's Phantom Rides," in *Cinema and Landscape*, ed. Graeme Harper and Jonathan Rayner (Bristol, UK: Intellect., 2010), 64.

15. CinemaScope ad, *Variety*, Dec. 30, 1953, 17. Also see John Belton, "Cinema-Scope: The Economics of Technology," *Velvet Light Trap* 21 (Summer 1985): 42.

16. "CinemaScope: Information for the Theatre," Third Revision, p. 5, Publicity—"Information for the Theatre" (booklets) folder, box 107, Earl I. Sponable Collection, Columbia University Libraries.

17. Belton, *Widescreen Cinema*, 191, 194, 191. On the concept of audience participation as it applied to 1950s theater and film see William Paul, "Breaking the Fourth Wall: 'Belascoism,' Modernism, and a 3-D *Kiss Me Kate*," *Film History* 16 (2004): 229–42.

18. Leon Shamroy, "On the Hollywood Scene," *Morning Telegraph*, Sept. 18, 1953, CinemaScope: clippings 1950–1969 folder, Theatre Collection, New York Public Library for the Performing Arts.

19. "CinemaScope—What It Is; How It Works," *American Cinematographer*, March 1953, 132.

20. Charles G. Clarke, "CinemaScope Techniques," 10, Publicity—Addresses and Papers folder, box 106, Sponable Collection. This material was also published as a 1955 article for *American Cinematographer*, and a British version can be found on the American Widescreen Museum website at www. widescreenmuseum.com/widescreen/page0-1.htm (accessed Jan. 12, 2013).

21. See "CinemaScope: Information for the Theatre," 6–7; and Belton, *Widescreen Cinema*, 192.

22. Darryl Zanuck, memo on *How to Marry a Millionaire*, March 25, 1953, Zanuck, Darryl 1953–1960 folder, box 116, Sponable Collection; Darryl Zanuck, memo on *The Robe*, March 25, 1953, Zanuck, Darryl 1953–1960 folder, box 116, Sponable Collection. These are excerpted in *Memo from Darryl F. Zanuck: The Golden Years at Twentieth Century–Fox*, ed. Rudy Behlmer (New York: Grove, 1993), 234–36. Also see Henry Koster, "Directing in Cinema-Scope," in *New Screen Techniques*, ed. Martin Quigley Jr. (New York: Quigley Publishing, 1953), 171, 173; and Leon Shamroy, "Filming the Big Dimension," *American Cinematographer*, May 1953, 232.

23. Zanuck, memo on *The Robe*, March 25, 1953; Zanuck, memo on *How to Marry a Millionaire*, March 25, 1953.

24. See Clarke, "CinemaScope Techniques," 1–2; Shamroy, "Filming the Big Dimension," 230; and Joe Schoenfeld, "Pix Execs Hail 20th's CinemaScope for Its Practicality and Low Cost," *Variety*, March 25, 1953, 22.

25. Zanuck, memo on *How to Marry a Millionaire*, March 25, 1953; Zanuck, memo on *The Robe*, March 25, 1953; Clarke, "CinemaScope Techniques," 8.

26. See Shamroy, "Filming the Big Dimension," 217; Shamroy, "Filming *The Robe*," in Quigley, *New Screen Techniques*, 178; Henry Koster, "Directing in CinemaScope," in ibid., 171–73; Zanuck, "CinemaScope in Production," in ibid., 157; and Henry King, cited in "The Big Screens," *Sight and Sound* 24, no. 4 (Spring 1955): 211.

27. Zanuck, memo on *How to Marry a Millionaire*, March 25, 1953 (emphasis in original).

28. Shamroy, "On the Hollywood Scene"; Shamroy, "Filming the Big Dimension," 232.

29. Bordwell, "CinemaScope: The Modern Miracle You See Without Glasses," 288–89; see also David W. Samuelson, "Golden Years," *American Cinematographer*, Sept. 2003, 71.

30. See Belton, *Widescreen Cinema*, 143–48; and Samuelson, "Golden Years," 71.

31. Bordwell, "CinemaScope: The Modern Miracle You See Without Glasses," 290–91; Zanuck, memo on *The Robe*, March 25, 1953.

32. Bordwell, "CinemaScope: The Modern Miracle You See Without Glasses," 291.

33. Zanuck, memo on *The 12-Mile Reef*, March 26, 1953, Zanuck, Darryl 1953–1960 folder, box 116, Sponable Collection.

34. See Barry Salt, *Film Style and Technology: History and Analysis*, 2nd ed. (London: Starword, 1992), 246; and Bordwell, "CinemaScope: The Modern Miracle You See Without Glasses," 291, 305, 312–13. There was some debate about how (and whether) CinemaScope lenses affected depth of field, with Fox engineer Earl Sponable suggesting that the anamorphic lens *increased*

depth of field and another engineer clarifying that this increase occurred in the horizontal direction. See the discussion printed with James R. Benford, "The CinemaScope Optical System," *Journal of the Society of Motion Picture and Television Engineers* 62 (Jan. 1954): 70. On the move to black-and-white film stock for CinemaScope films and its implications for film style see Lisa Dombrowski, "Cheap but Wide: The Stylistic Exploitation of CinemaScope in Black-and-White, Low-Budget American Films," in Belton, Hall, and Neale, *Widescreen Worldwide*, 63–70.

35. Bordwell, "CinemaScope: The Modern Miracle You See Without Glasses," 316.

36. Richard Kohler, "The Big Screens," *Sight and Sound* 24, no. 3 (Jan.–March 1955): 120.

37. Rudolf Arnheim, *Film as Art* (Berkeley: University of California Press, 1957), 5.

38. Kohler, "The Big Screens," 120–21; Walter Lassally, "The Big Screens," *Sight and Sound* 24, no. 3 (Jan.–March 1955): 124.

39. Sergei Eisenstein, "The Dynamic Square," in *Film Essays and a Lecture*, ed. Jay Leyda (New York: Praeger, 1970), 48–65. The speech was delivered on September 17, 1930. The article based on the speech was first published in *Close Up* in 1931.

40. Bazin, "Will CinemaScope Save the Cinema?" 14; André Bazin, "The End of Montage," trans. Catherine Jones and Richard Neupert, *Velvet Light Trap* 21 (Summer 1985): 14–15.

41. Also see David Bordwell's distinction between Bazin's interest in a realist ontology for cinema and the *Cahiers du cinéma* critics' focus on realism as a criterion for evaluating films, in Bordwell, "Widescreen Aesthetics and Mise en Scene Criticism," 19–20.

42. Eric Rohmer, "The Cardinal Virtues of CinemaScope," trans. Liz Heron, in *Cahiers du Cinéma: The 1950s: Neo-Realism, Hollywood, New Wave*, ed. Jim Hillier (Cambridge, MA: Harvard University Press, 1985), 281; Jacques Rivette, "The Age of *metteurs en scène*," trans. Liz Heron, in ibid., 278.

43. V. F. Perkins, "*River of No Return*," *Movie* 2 (Sept. 1962): 18.

44. Barr, "CinemaScope: Before and After," 10.

45. Bordwell, "Widescreen Aesthetics and Mise en Scene Criticism," 22–23; David Bordwell, "Film Style and Technology, 1930–1960," in David Bordwell, Janet Staiger, and Kristin Thompson, *The Classical Hollywood Cinema: Film Style & Mode of Production to 1960* (New York: Columbia University Press, 1985), 363, 361. Barry Salt, too, notes that CinemaScope films had a slight tendency toward longer takes, although he argues that take lengths were already in the process of increasing when widescreen emerged (see Salt, *Film Style and Technology*, 246).

46. Belton, *Widescreen Cinema*, 197–200.

47. Marshall Deutelbaum, "Basic Principles of Anamorphic Composition," *Film History* 15, no. 1 (2003): 73–74.

48. Zanuck, memo on *How to Marry a Millionaire*, March 25, 1953.

49. Shamroy, "Filming the Big Dimension," 217.

50. Rivette, "The Age of *metteurs en scène*," 276.

51. Elia Kazan to Molly Kazan, June 14, 1954, *East of Eden* Miscellaneous folder, Personal 1955–1955/1982 box, Elia Kazan Collection, Wesleyan University Cinema Archives (hereafter WUCA). This letter, like the others cited below, is unaddressed and undated but coupled with an envelope addressed to Molly Kazan. The date I have supplied is the postmark date on the envelope.

52. Salt points to the bilateral symmetry of compositions in *Rebel Without a Cause* as an exception to the norm (Salt, *Film Style and Technology*, 247).

53. Bordwell, "CinemaScope: The Modern Miracle You See Without Glasses," 305.

54. Belton, *Widescreen Cinema*, 196.

55. Bosley Crowther, "Right Direction," *New York Times*, March 20, 1955, X1.

56. For an example of 1 and 2 see Brian Neve, *Elia Kazan: The Cinema of an American Outsider* (London: I. B. Tauris, 2009), 98–99. For an example of 3 see Richard Schickel, *Elia Kazan: A Biography* (New York: HarperCollins, 2005), 318. Neve suggests, citing Kazan, that the film related to the director's HUAC testimony insofar as his experience of the latter fueled an interest in problematizing easy distinctions between right and wrong (Neve, *Elia Kazan*, 99). In relation to 1, also see Leo Braudy's more general discussion of "the Oedipal politics that shadowed the period"—and their reflection in Dean (as well as Marlon Brando and Montgomery Clift)—in Leo Braudy, "'No Body's Perfect': Method Acting and 50s Culture," *Michigan Quarterly Review* 35 (1996): 202–3.

57. Hillier, "East of Eden," 22; Wood, "The Kazan Problem," 30. In contrast with the *Movie* critics' distaste for the film, we should note André Bazin's passing comment (a polemic within his discussion of the western) that the "most convincing examples of the use of CinemaScope have been in psychological films such as *East of Eden*" (Bazin, "The Evolution of the Western," in *What Is Cinema?* ed. and trans. Hugh Gray [Berkeley: University of California Press, 1971], 2:157).

58. Schickel, *Elia Kazan*, 321.

59. See Michael DeAngelis, *Gay Fandom and Crossover Stardom: James Dean, Mel Gibson, and Keanu Reeves* (Durham, NC: Duke University Press, 2001), 71–117; and Shelly Frome, *The Actors Studio: A History* (Jefferson, NC: McFarland, 2001).

60. See Dombrowski, "Choreographing Emotions," 166–72.

61. Kazan, note on *East of Eden* script, cited in ibid., 166.

62. Dombrowski, "Choreographing Emotions," 170.

63. Cynthia Contreras, "The Elements of Anamorphic Composition: Two Case Studies" (PhD diss., CUNY, 1989), 46–47.

64. Gunning, "Landscape and the Fantasy of Moving Pictures," 42.

65. For cognitivist accounts of sympathy and empathy in cinema see Noël Carroll, *The Philosophy of Horror; or, Paradoxes of the Heart* (New York: Routledge, 1990), 88–96; and Murray Smith, *Engaging Characters: Fiction, Emotion, and the Cinema* (Oxford: Clarendon, 1995), 73–109. Widescreen's immersive address and moving camera seem to offer a particularly good means for evoking the "autonomic reactions" that Smith describes as one way films elicit empathy.

66. Barr, "CinemaScope: Before and After," 10.

67. Jonathan Rosenbaum similarly describes the film as "an experience designed to be undergone, not an object to be contemplated," although he attributes this effect primarily to Kazan's direction rather than to the format. See Jonathan Rosenbaum, "Elia Kazan, Seen from 1973," in Dombrowski, *Kazan Revisited*, 30.

68. By contrast, he attributes the idea of canting the camera to his cinematographer, Ted McCord. See Elia Kazan to Dorothy B. Jones, Jan. 3, 1957, *East of Eden* Material 1952–1983 folder, Personal 1955–1955/1982 box, Kazan Collection, WUCA. Also see Young, *Kazan on Kazan*, 201.

69. Kazan, quoted in Young, *Kazan on Kazan*, 201. Stevens's observation about CinemaScope's appropriateness for filming snakes is echoed famously by Fritz Lang, who claims in Jean-Luc Godard's *Le mépris* (*Contempt*, 1963) that the format "wasn't meant for human beings. Just for snakes and funerals." According to Harper Cossar this phrase has also been attributed to Cecil B. DeMille. See Harper Cossar, *Letterboxed: The Evolution of Widescreen Cinema* (Lexington: University Press of Kentucky, 2011), 267n1.

70. Kazan, quoted in Young, *Kazan on Kazan*, 200–201.

71. Ibid., 200.

72. See Stuart Byron and Martin L. Rubin, "Elia Kazan Interview," *Movie* 19 (Winter 1971–72): 8.

73. "CinemaScope—What It Is; How It Works," 134.

74. Darryl Zanuck to Spyros Skouras, Jan. 27, 1953, in Behlmer, *Memo from Darryl F. Zanuck*, 223.

75. Darryl Zanuck to All Producers and Executives at Fox, memorandum, March 12, 1953, in ibid., 234.

76. Behlmer, *Memo from Darryl F. Zanuck*, 224–30. At the time he made *On the Waterfront* (and *East of Eden*), Kazan had a remaining contractual

obligation to make a film at Fox—ultimately fulfilled after Zanuck's reign with *Wild River* (1960). Kazan originally submitted *East of Eden* for Fox's consideration, as well, but Zanuck's tepid response (he was apparently more interested in the general idea of a Steinbeck-Kazan project than in the material itself) and Jack Warner's offer of final cut propelled him to turn to Warner Bros. See Kazan to Darryl Zanuck, Dec. 11, 1952, *East of Eden* Material 1952–1983 folder, Personal 1955–1955/1982 box, Kazan Collection, WUCA; Neve, *Elia Kazan*, 80, 93–94, 138; and Elia Kazan, *A Life* (New York: Knopf, 1988), 529, 534.

77. Darryl Zanuck to Kazan, July 15, 1954, in Behlmer, *Memo from Darryl F. Zanuck*, 230.

78. Martin Scorsese, quoted in Schickel, *Elia Kazan*, 316.

79. Elia Kazan, *Kazan on Directing* (New York: Alfred A. Knopf, 2009), 148.

80. See R. J. O'Donnell, "The Threshold of Great Things," *Daily Film Renter*, June 30, 1953, in Publicity—Outside, 1953 and n.d. folder, box 108, Sponable Collection; Ben Schlanger, "Dynamic Frame: Small Screen Intimacy with the Big Picture," *Motion Picture Herald*, Sept. 15, 1956, 46; and Rose Pelswick, "Impressive Spectacle in New Film Medium," *New York Journal-American*, Sept. 17, 1953, in *Robe, The* 1953–1962 folder, box 110, Sponable Collection.

81. Clarke, "CinemaScope Techniques," 6.

82. See Chester Morrison, "3D: High, Wide and Handsome," *Look*, June 30, 1953, 32; Crowther, "Big and Beautiful"; and review of *The Robe*, *Newsweek*, Sept. 28, 1953, 98.

83. Voicing what Kristin Thompson identifies as a post-1917 idea that close shots should be used to narrative purpose, a 1921 scenario manual suggests that close-ups are usually used "to show a close, detailed view of that which is not sufficiently clear or which lacks emphasis in a more distant and general scene. In the case of a human face, it is occasionally necessary or desirous to show the details of expression, conveying an emotion" (Frederick Palmer, *Palmer Plan Handbook* [1921], cited in Kristin Thompson, "The Formulation of the Classical Style, 1909–28," in Bordwell, Staiger, and Thompson, *The Classical Hollywood Cinema*, 201.

84. Eric Rohmer observes "how many close-ups are made possible by the very existence of the little bottle of cortisone" (Rohmer, "Nicholas Ray: Bigger Than Life," in *The Taste for Beauty*, trans. Carol Volk [Cambridge: Cambridge University Press, 1989], 144). Harper Cossar also offers an extended discussion of the use of close-ups in *Bigger Than Life*; however, he considers them primarily a generically motivated means for encouraging "the viewers' squeamishness at the close proximity of the characters' pain and anguish" (Cossar, *Letterboxed*, 124). Without denying that association, I want to emphasize the way in which the film's thematic focus on magnification—flagged in

its title—demands considering these close-ups (and even medium shots) in terms of scale as well as proximity.

85. For the suggestion that *East of Eden* influenced Ray, see Tony Sloman, "The Pleasures of CinemaScope," *BFFS Monthly Journal* 100 (Nov. 1981): 7. On Ray's screening of *East of Eden* see Kazan to Molly Kazan, Sept. 29, 1954, and Oct. 1, 1954, *East of Eden* Miscellaneous folder, Personal 1955–1955/1982 box, Kazan Collection, WUCA.

86. Bosley Crowther, "New Giant Screen," *New York Times*, April 24, 1955, X1.

87. Review of *The Robe*, *Newsweek*, Sept. 28, 1953, 98.

88. Kazan, *A Life*, 538; Kazan to Molly Kazan, June 14, 1954, *East of Eden* Miscellaneous folder, Personal 1955–1955/1982 box, Kazan Collection, WUCA.

89. Kazan to Molly Kazan, June 4, 1954, emphasis in original, *East of Eden* Miscellaneous folder, Personal 1955–1955/1982 box, Kazan Collection, WUCA.

90. "The New Pictures, Mar. 21, 1955," *Time*, March 21, 1955, www.time.com/time/magazine/article/0,9171,936645,00.html (accessed Jan. 1, 2013); review of *East of Eden*, *Look*, April 5, 1955, 100.

91. Nicholas Ray, "Rebel—The Life Story of a Film," *Daily Variety*, 23rd Anniversary issue, 1956, 56, folder B33-F5, box 33, Kazan Collection, WUCA.

92. Crowther, "Right Direction," X1. Also see review of *East of Eden*, *Look*, April 5, 1955, 100; and Lee Rogow, "Essay for Elia," *Saturday Review*, March 19, 1955, 25. On Kazan's consideration of Brando for the part see Kazan, *A Life*, 534. On Dean's idolization of Brando see Claudia Springer, *James Dean Transfigured: The Many Faces of Rebel Iconography* (Austin: University of Texas Press, 2007), 2.

93. Sarris, review of *East of Eden*, 24.

94. See Frome, *The Actors Studio*, 20–71.

95. Ibid., 9–19, 27–29, 80–81. After Strasberg's death, Adler reputedly told her acting class that it would "take a hundred years before the harm that man has done to the art of acting can be corrected" (quoted in Kazan, *A Life*, 143).

96. Kazan, *A Life*, 65–67, 143.

97. Ibid., 66, 144. Also see Neve, *Elia Kazan*, 100.

98. Kazan, *Kazan on Directing*, 185.

99. Kazan, *A Life*, 538, 535. Kazan contended that "Dean had the most natural talent after Marlon. But he lacked technique; he had no proper training" (Kazan, *Kazan on Directing*, 186).

100. See Michael DeAngelis's discussion of the critical reception of Dean's performance in this film, which, DeAngelis observes, was described as "no less stylistically excessive than melodramatic form, the aspect ratio of CinemaScope, or the WarnerColor process" (DeAngelis, *Gay Fandom and Crossover Stardom*, 83).

101. McCarten, "Steinbeck, Lay That Bible Down," 141.

102. Bosley Crowther, "'East of Eden' Has Debut," *New York Times*, March 10, 1955, 33.

103. Stewart, *On Longing*, 88.

104. Ray, "Rebel—The Life Story of a Film," 56; Kazan to Helen Bower of the *Detroit Free Press*, March 22, 1955, *East of Eden* Material 1952–1983, Personal 1955–1955/1982 box, Kazan Collection, WUCA.

105. On the relationship between the concept of authenticity conveyed by Method acting and 1950s American culture, see Braudy, "'No Body's Perfect.'"

106. Richard Dyer, *Heavenly Bodies: Film Stars and Society* (New York: St. Martin's, 1986), 32–38.

107. The stars have been linked through the traumatic nature of their childhoods. See Frome, *The Actors Studio*, 121. On Monroe's vulnerability see Dyer, *Heavenly Bodies*, 46–50. On Dean's see DeAngelis, *Gay Fandom and Crossover Stardom*, 75.

108. See Frome, *The Actors Studio*, 121–32; and Foster Hirsch, *A Method to Their Madness* (New York: Norton, 1984), 327–29.

109. Braudy, "'No Body's Perfect,'" 196.

110. Crowther, "Right Direction," X1.

111. See Thomas Elsaesser, "Tales of Sound and Fury," in *Home Is Where the Heart Is: Studies in Melodrama and the Woman's Film*, ed. Christine Gledhill (London: BFI, 1987), 43–69; and Peter Brooks, *The Melodramatic Imagination: Balzac, Henry James, Melodrama, and the Mode of Excess* (New Haven, CT: Yale University Press, 1995).

112. See Thomas Schatz, *Hollywood Genres: Formulas, Filmmaking, and the Studio System* (New York: McGraw Hill, 1981), 223. Schatz's list of the most important melodramas of the 1950s displays a heavy tendency toward CinemaScope. It is worth noting that, except for *The Tarnished Angels* (black and white, 1958), Douglas Sirk's most famous 1950s melodramas were not filmed in CinemaScope; movies such as *All That Heaven Allows* (1955), *Written on the Wind* (1956), and *Imitation of Life* (1959) were made to be shown at the non-anamorphic 1.85:1 aspect ratio favored by Universal. While less extreme than CinemaScope, however, this aspect ratio was also part and parcel of the widescreen revolution. See Belton, *Widescreen Cinema*, 116.

113. Brooks, *The Melodramatic Imagination*, xi.

114. Crowther, "Right Direction," X1.

115. Dyer, *Heavenly Bodies*, 51.

116. Christine Gledhill, "Signs of Melodrama," in *Stardom: Industry of Desire*, ed. Christine Gledhill (London: Routledge, 1991), 221, 223–24.

117. Lee Strasberg, quoted in Alma Law and Mel Gordon, *Meyerhold, Eisenstein and Biomechanics: Actor Training in Revolutionary Russia* (Jefferson, NC: McFarland, 1996), 63. Also see Kazan, *A Life*, 66.

118. Kazan, *A Life*, 65–66.

119. Ibid., 66, 450; see also Kazan, "On What Makes a Director," in *Kazan on Directing*, 237.

120. See Law and Gordon, *Meyerhold, Eisenstein and Biomechanics*, 36–37, 236.

121. Nikolai Basilov, "Profile of the Actor Graduating from the Meyerhold State Theatre School," in Law and Gordon, *Meyerhold, Eisenstein and Biomechanics*, 153.

122. Strasberg, quoted in Hirsch, *A Method to Their Madness*, 141.

123. See Sergei Eisenstein, "The Montage of Film Attractions," in *S. M. Eisenstein: Selected Works*, vol.1, ed. and trans. Richard Taylor (London: BFI, 1988), 39–58; and Walter Benjamin, "The Work of Art in the Age of Its Technological Reproducibility" (2nd version), trans. Edmund Jephcott and Harry Zohn, in *Selected Writings*, ed. Michael W. Jennings et al., trans. Rodney Livingstone, Edmund Jephcott, Howard Eiland, et al., 4 vols. (Cambridge, MA: Harvard University Press, 1996–2003), 3:101–33. Also see Miriam Hansen, "Benjamin and Cinema: Not a One-Way Street," *Critical Inquiry* 25, no. 2 (Winter 1999): 306–43.

124. Hansen, "Benjamin and Cinema," 318.

125. Dyer, *Heavenly Bodies*, 8, 19–66. Dyer also reads Dean's rebel as not particularly disruptive to the status quo, except insofar as the actor, together with Montgomery Clift, "did something to launch a non-macho image of a man" (Richard Dyer, *Stars* [London: BFI, 1998], 53).

3. DIGITAL CINEMA'S HETEROGENEOUS APPEAL: DEBATES ON EMBODIMENT, INTERSUBJECTIVITY, AND IMMEDIACY

1. Matt Zoller Seitz, review of *The Matrix*, *New York Press*, March 31, 1999, Arts section, 9.

2. On the cinema studies' disciplinary confrontation with new media see D. N. Rodowick, *The Virtual Life of Film* (Cambridge, MA: Harvard University Press, 2007), 2–24, 181–89; Thomas Elsaesser, "Digital Cinema and the Apparatus: Archaeologies, Epistemologies, Ontologies," in *Cinema and Technology: Cultures, Theories, Practices*, ed. Bruce Bennett, Marc Furstenau, and Adrian Mackenzie (New York: Palgrave Macmillan, 2008), 226–40; Dudley Andrew, *What Cinema Is! Bazin's Quest and Its Charge* (Chichester, West Sussex, UK: Wiley-Blackwell, 2010), xiv–xviii; and Miriam Hansen, *Cinema and Experience: Siegfried Kracauer, Walter Benjamin, and Theodor W. Adorno* (Berkeley: University of California Press, 2012), xvi–xvii.

3. Despite Lev Manovich's stated interest in emphasizing "the continuities between the new media and the old," his well-known claim that, with the pervasion of digital technologies, cinema is no longer "the art of the index,"

but rather "a particular case of animation," exemplifies the former camp. See Lev Manovich, *The Language of New Media* (Cambridge, MA: MIT Press, 2002), 285, 295, 302 (emphasis removed). For a strong argument against a radical break between analog and digital cinema see John Belton, "Digital Cinema: A False Revolution," *October* 100 (Spring 2002): 98–114.

4. Rodowick, *The Virtual Life of Film*, 31; Elsaesser, "Digital Cinema and the Apparatus," 232; Andrew, *What Cinema Is!* xviii. Also see Thomas Elsaesser, "The New Film History as Media Archaeology," *Cinémas* 14, no. 2–3 (2004): 99; and Tom Gunning, "Gollum and Golem: Special Effects and the Technology of Artificial Bodies," in *From Hobbits to Hollywood: Essays on Peter Jackson's "Lord of the Rings,"* ed. Ernest Mathijs and Murray Pomerance (Amsterdam: Rodopi, 2006), 321.

5. Manuel Castells, *The Rise of the Network Society*, 2nd ed. (Oxford: Blackwell, 2000), 29 (emphasis removed). Prominent work emphasizing such transformation includes Manovich, *The Language of New Media*; Henry Jenkins, *Convergence Culture: Where Old and New Media Collide* (New York: New York University Press, 2006); and Anne Friedberg, *The Virtual Window: From Alberti to Microsoft* (Cambridge, MA: MIT Press, 2006).

6. See, e.g., Nataša Ďurovičová and Kathleen Newman, eds., *World Cinemas, Transnational Perspectives* (New York: Routledge, 2010); Steve J. Wurtzler, *Electric Sounds: Technological Change and the Rise of Corporate Mass Media* (New York: Columbia University Press, 2007); Alison Griffiths, *Shivers Down Your Spine: Cinema, Museums, and the Immersive View* (New York: Columbia University Press, 2008); Elsaesser, "Digital Cinema and the Apparatus"; Charles R. Acland, "Curtains, Carts and the Mobile Screen," *Screen* 50, no. 1 (Spring 2009): 148–66; and Haidee Wasson, ed., "In Focus: Screen Technologies," *Cinema Journal* 51, no. 2 (Winter 2012): 141–72.

7. Hyperbolic examples range from Nicholas Negroponte, *Being Digital* (New York: Alfred A. Knopf, 1995); to Jean Baudrillard, *The Ecstasy of Communication*, trans. Bernard Schutze and Caroline Schutze, ed. Sylvère Lotringer (New York: Semiotext[e], 1988); and Paul Virilio, *The Information Bomb*, trans. Chris Turner (London: Verso, 2000). Also see Gilles Deleuze, "Postscript on Control Societies" (1990), in *Negotiations*, trans. Martin Joughin (New York: Columbia University Press, 1995), 177–82. For more recent (and evenhanded) considerations of information technologies' implications for freedom and control see Alexander Galloway, *Protocol: How Control Exists After Decentralization* (Cambridge, MA: MIT Press, 2004); and Wendy Hui Kyong Chun, *Control and Freedom: Power and Paranoia in the Age of Fiber Optics* (Cambridge, MA: MIT Press, 2006).

8. See Castells, *The Rise of the Network Society*; N. Katherine Hayles, "Cybernetics," in *Critical Terms for Media Studies*, ed. W. J. T. Mitchell and

Mark B. N. Hansen (New York: University of Chicago Press, 2010), 145–56; and Jeffrey Sconce, *Haunted Media: Electronic Presence from Telegraphy to Television* (Durham, NC: Duke University Press, 2000). For a critique of this idea of flow (in favor of the concept of fluidity) see Janine Marchessault and Susan Lord, introduction to *Fluid Screens, Expanded Cinema* (Toronto: University of Toronto Press, 2007), 4–5.

9. Norbert Wiener, "Men, Machines, and the World About" (1954), in *The New Media Reader*, ed. Noah Wardrip-Fruin and Nick Montfort (Cambridge, MA: MIT Press, 2003), 71. Also see Norbert Wiener, *Cybernetics: Or, Control and Communication in the Animal and Machine* (Cambridge, MA: MIT Press, 1948).

10. Because most movies employing digital technologies, particularly during the period in question here, remained hybrid (retaining the use of film in production and/or distribution), I have chosen to continue using the terms *film* and *filmmaking* in this chapter and the next. On such hybridity see Philip Rosen, *Change Mummified: Cinema, Historicity, Theory* (Minneapolis: University of Minnesota Press, 2001), 301–49.

11. For this theoretical argument see Friedrich A. Kittler, *Gramophone, Film, Typewriter*, trans. Geoffrey Winthrop-Young and Michael Wutz (Stanford: Stanford University Press, 1999), 1–2. For a discussion of the practical convergence of media see Jenkins, *Convergence Culture*, 1–24.

12. One notable exception was the practice, discussed in chapter 1, of cropping Academy-ratio films at the exhibition stage in order to present them as widescreen films. This practice, however, was both unsatisfactory to audiences and short-lived.

13. Geoffrey Nowell-Smith and Peter Thomas, "Editorial," *Convergence* 9, no. 4 (2003): 5. Also see Rosen, *Change Mummified*, 301–49.

14. See Gene Youngblood, *Expanded Cinema* (New York: P. Dutton, 1970), 194–256; Michael Allen, "From *Bwana Devil* to *Batman Forever*: Technology in Contemporary Hollywood Cinema," in *Contemporary Hollywood Cinema*, ed. Steve Neale and Murray Smith (London: Routledge, 1998), 123–26; and Andrew Johnston, "Pulses of Abstraction: Episodes from a History of Animation" (PhD diss., University of Chicago, 2011), 182–218.

15. On *Westworld* see Michael Crichton, "Note from Michael," www.crichton-official.com/movies-westworld-mcnotes.html (accessed Jan. 2, 2013). On *Star Wars* and *Close Encounters of the Third Kind* see Julie Turnock, "Plastic Reality: Special Effects, Art and Technology in 1970s U.S. Filmmaking" (PhD diss., University of Chicago, 2008), 209–16. For accounts of the timeline I offer here, see Holly Willis, *New Digital Cinema: Reinventing the Moving Image* (New York: Wallflower, 2005), 1–18; Rodowick, *The Virtual Life of Film*, 7–8;

Belton, "Digital Cinema: A False Revolution"; and David Bordwell, *Pandora's Digital Box: Films, Files, and the Future of Movies* (Madison, WI: Irvington Way Institute Press, 2012, 24–27.

16. In the spring of 1997 *Variety* reported that the Cannes Film Festival would announce the creation of a "multimedia day" capped by the presentation of a Cinema Digital Technologies Award (Rex Weiner, "Cannes Adds Tech Day," *Daily Variety*, April 22, 1997, 2). *Res*, a magazine devoted to independent digital filmmaking, presented its premiere issue in the fall of 1997. In November 1997 *Wired* featured a special report, "Hollywood 2.0," elaborating on the different ways digital technology was transforming the industry (James Daly, "Hollywood 2.0 Special Report," *Wired*, Nov. 1997, 200–215). In April 1998 the American Society of Cinematographers launched *American Videographer—The International Journal of Video & Digital Production Techniques*. Mainstream publications traced the rise of digital cinema in a number of articles, including Michel Marriott, "If Only DeMille Had Owned a Desktop," *New York Times*, Jan. 7, 1999, G1; David Ansen, Ray Sawhill, et al., "Now at a Desktop Near You," *Newsweek*, March 15, 1999, 80; Bruce Haring, "Movies Roll with the Digital Age: High-End Video Boosts Creativity," *USA Today*, March 17, 1999, 8D; Walter Murch, "A Digital Cinema of the Mind? Could Be," *New York Times*, May 2, 1999, Arts and Leisure section; Rob Sabin, "Taking Film Out of Films," *New York Times*, Sept. 5, 1999, Arts and Leisure section; Ted Fishman, "Digital Video: Moviemaking Magic or More Info Smog?" *USA Today*, Nov. 15, 1999, 29A; "You Oughta Be in Videos," *Newsweek*, Jan. 24, 2000, 62; and Rob Sabin, "The Movies' Digital Future Is in Sight and It Works," *New York Times*, Nov. 26, 2000, Arts and Leisure section. *Variety* traced the rise of digital cinema through stories such as Holly Willis, "Digital Filmmaking a Low-Budget Choice," *Daily Variety*, July 16, 1998, 89; Andrew Hindes, "Digital Video Gains Cache with Filmmakers," *Variety*, Jan. 25, 1999, www.variety.com/index.asp?layout=print_story&articleid=VR1117490575&categoryid=17 (accessed Jan. 2, 2013); Todd McCarthy, "Digital Cinema Is the Future . . . Or Is It?" *Variety*, June 25, 1999, www.variety.com/index.asp?layout=print_story&articleid=VR1117503451&categoryid=5 (accessed Jan. 2, 2013); Christopher Grove, "Jury Still Out on Digital Video Pix," *Daily Variety*, July 30, 1999, special section; and Andrew Thompson, "Digital Part of Mandate to Push Envelope," *Daily Variety*, July 31, 2000, special section, 2.

17. Belton, "Digital Cinema: A False Revolution," 103. Also see Michael Allen, "Digital Cinema: Virtual Screens," in *Digital Cultures*, ed. Glen Creeber and Royston Martin (Berkshire, UK: McGraw Hill, 2009), 61–69.

18. See, e.g., Janet Maslin, "The Calm Instead of the Storm at Cannes," *New York Times*, May 21, 1998; and Todd McCarthy, "At Cannes '98, Dogma 95

Has Its Day," *Variety*, May 29, 1998, www.variety.com/article/VR1117471366 (accessed Jan. 2, 2013). Both of these stories focused on the Dogma 95 concept rather than the films' origin in digital video; however, by January 1999 *The Celebration*, in particular, was widely deemed "a breakthrough in the field" for its digital cinematography. See Monica Roman, "Wave Sets Digital Vid Prod'n Arm," *Variety*, Jan. 19, 1999, www.variety.com/article/VR1117490323. html (accessed Jan. 2, 2013). Also see Jason Silverman, "Sundance Enters Digital Era," *Wired*, Jan. 21, 1999, www.wired.com/culture/lifestyle/news/1999/01/17440 (accessed Jan. 2, 2013).

19. These included Next Wave Films' Agenda 2000, announced in January 1999; Open City Films' Blow Up Pictures, also announced in January 1999; and the Independent Film Channel's Independent Digital Entertainment (InDigEnt), announced in August 1999. See Roman, "Wave Sets Digital Vid Prod'n Arm"; Hindes, "Digital Video Gains Cache with Filmmakers"; and Benedict Carver, "IFC Aims Digital Lens at 10 Low-Budget Pix," *Variety*, August 4, 1999, 1.

20. Michael Krantz, "The Next Great Gadget," *Time*, Jan. 20, 1997, www .time.com/time/magazine/article/0,9171,985796,00.html (accessed Jan. 2, 2013). On DVD and home viewing see Laura Mulvey, *Death 24x a Second: Stillness and the Moving Image* (London: Reaktion, 2006); and Barbara Klinger, *Beyond the Multiplex: Cinema, New Technologies, and the Home* (Berkeley: University of California Press, 2006).

21. See Ansen, Sawhill, et al., "Now at a Desktop Near You"; Haring, "Movies Roll with the Digital Age"; Michael Stroud, "*Star Wars*' Digital Experiment," *Wired*, March 16, 1999, www.wired.com/culture/lifestyle/news/1999/03/18495 (accessed Jan. 2, 2013); and Stephanie Argy, "Digital Cameras Democratize Filmmaking," *Variety*, April 19, 1999, A4. On digital projection see Belton, "Digital Cinema: A False Revolution," 103–14, and Bordwell, *Pandora's Digital Box*, 41–63. On web shorts see Klinger, *Beyond the Multiplex*, 191–238.

22. John Belton, "Painting by the Numbers: The Digital Intermediate," *Film Quarterly* 61, no. 3 (Spring 2008): 58–65.

23. For examples of the term *digital cinema* (or *electronic cinema*) arising in discussions of digital projection see Katharine Stalter, "Digital Cinema Hovers on Hi-Tech Horizon," *Variety*, June 12–18, 1995, 9; and "An Electronic Adventure: Sony, UA, Keystone in Digital Pic Transmission," *Daily Variety*, Jan. 23, 1997, 4. The earliest examples I have found of the term being used more broadly in the nonacademic press include Katharine Stalter, "Hummel Leads U.K. Tech Sesh," *Daily Variety*, June 25, 1995, 10; Jonathan Romney, "Watch Out Stallone," *Guardian*, March 21, 1996, T12; and Patrick Goldstein, "Bring On the Debris," *Los Angeles Times*, May 12, 1996, 6. Without necessarily using the term *digital cinema*, industry insiders involved in visual effects

were discussing the prospect of a totally digital filmmaking process earlier, as evidenced as early as 1993 in the pages of the newly launched magazine *Wired*. See Matt Rothman, "Digital Deal," *Wired*, July-August 1993, 63–65; Daniel Todd, "Directors of Digital Production," *Wired*, Dec. 1993, 58–60; David Pescovitz, "The Future of Movies," *Wired*, April 1995, 68; Paula Parisi, "Cameron Angle," *Wired*, April 1996, 130–35, 175–79; and Kevin Kelly and Paula Parisi, "Beyond *Star Wars*," *Wired*, Feb. 1997, 160–66, 210–17.

24. See Silverman, "Sundance Enters Digital Era"; Ansen, Sawhill, et al., "Now at a Desktop Near You"; and J. P. Telotte, "The *Blair Witch Project* Project: Film and the Internet," *Film Quarterly* 54, no. 3 (Spring 2001): 32–39.

25. This is not to say that the idea of an integrated digital cinema grew out of the independent movement. Earlier discussions of big-budget digital visual effects also foresaw this possibility, as evidenced by the *Wired* articles cited in note 23 above. However, the prospect emerged from under visual effects' shadow—and in general-interest journalism—a bit later, as elaborated in note 16.

26. For details on the conception and production of *The Celebration* see Jack Stevenson, *Dogme Uncut: Lars von Trier, Thomas Vinterberg, and the Gang That Took on Hollywood* (Santa Monica: Santa Monica Press, 2003), 73–84; and Mogens Rukov, "Adventures of a Productive Idiot," *Guardian*, Oct. 26, 2002, www.guardian.co.uk/stage/2002/oct/26/theatre.artsfeatures (accessed Jan. 2, 2013). For examples of publicity surrounding the use of digital cameras in *Attack of the Clones*, see Corey Levitan, "'Star' Master," *New York Post*, May 12, 2002, 51; Andrew Zipern, "'Star Wars' Charts Course in Digital Video," *New York Times*, May 13, 2002, C4; and Gary Dretzka, "'Episode II'—Reply of the Creator," *Daily News*, May 13, 2002, 33.

27. See Willis, *New Digital Cinema*, 22; and Keith Griffiths, "The Manipulated Image," *Convergence* 9, no. 4 (2003): 13. Hollywood and independent cinema were in dialogue surrounding these issues. For instance, in October 1999 *Time* magazine announced that Steven Spielberg wanted to make a film under Dogma 95 rules. See Richard Corliss, "Putting on the Dogme," *Time*, Oct. 11, 1999, www.time.com/time/magazine/article/0,9171,992209,00.html (accessed Jan. 2, 2013).

28. D. N. Rodowick, for instance, suggests that electronic imaging works to render the spatiality and temporality of the image discontinuous, altering the temporality of film in a way he ultimately associates with digital technology specifically. See Rodowick, *The Virtual Life of Film*, esp. 135–41. For another argument that analog video transforms the materiality and temporality of cinema in a way that aligns it with the digital, see Timothy Binkley, "Camera Fantasia: Computed Visions of Virtual Realities," *Millennium Film Journal* 20–21 (Fall-Winter 1988–89): 15–16.

29. Rosen, *Change Mummified*, 316.

30. Belton, "Digital Cinema: A False Revolution," 104; John Belton, *Widescreen Cinema* (Cambridge, MA: Harvard University Press, 1992), 14.

31. As I discuss in greater detail later in this chapter, some commentators did claim that digital cinematography and projection brought about perceptual changes; however, these were understood to be subliminal.

32. John Belton, "Digital 3D Cinema: Digital Cinema's Missing Novelty Phase," *Film History* 24, no. 2 (2012): 190.

33. See, e.g., Michel Marriott, "Digital Projectors Use Flashes of Light to Paint a Movie," *New York Times*, May 27, 1999, G7; Andrew Revkin, "Showing in Theaters: The Digital Revolution; Cinemas Test a Projector Prototype That Makes Spools of Film Obsolete," *New York Times*, July 3, 1999, B1; Zipern, "'Star Wars' Charts Course in Digital Video"; and Eric Taub, "Shooting 'Star Wars,' Bit by Bit," *New York Times*, May 23, 2002, G8.

34. In doing so, the heterogeneity charted here plays a similar role to the work on screens that Haidee Wasson collected for a recent "In Focus" section of *Cinema Journal*, showing that "film is productively understood as a family of technologies, an assemblage of things and systems that are multiply articulated across its history and its contexts" (Wasson, introduction to "In Focus: Screen Technologies," 143).

35. Friedberg, *The Virtual Window*, 244.

36. On the profusion of screens despite assertions about "the dematerialization of the audiovisual," see Will Straw, "Proliferating Screens," *Screen* 41, no. 1 (Spring 2000): 118.

37. "Trumbull's Vision," interview by Jeff Greenwald, *Wired*, Jan. 1997, 129.

38. "Spielberg in the Twilight Zone," interview by Lisa Kennedy, *Wired*, June 2002, 113.

39. The idea that cinematic sight could be delivered directly to the mind resonates with contemporaneous experiments in artificial vision, wherein the visual cortex of blind patients is mapped and stimulated in order to simulate sight of objects in the world. It should be noted, however, that such physical stimulation of the brain diverges from ideas about an immaterial flow of information prevalent in the discourses on digital cinema. See Steven Kotler, "Vision Quest," *Wired*, Sept. 2002, www.wired.com/wired/archive/10.09/vision_pr.html (accessed Jan. 2, 2013). Also see Richard A. Normann et al., "A Neural Interface for a Cortical Vision Prosthesis," *Vision Research* 39 (1999): 2577–87; and William H. Dobelle, "Artificial Vision for the Blind by Connecting a Television Camera to the Visual Cortex," *American Society of Artificial Internal Organs (ASAIO) Journal* 46, no. 1 (Jan.-Feb. 2000): 3–9. Thanks to Edward Yeterian for discussing these issues with me.

40. Thank you to Caitlin McGrath for drawing my attention to this reference.

41. Ray Kurzweil, *The Age of Spiritual Machines: When Computers Exceed Human Intelligence* (New York: Penguin, 1999), 126. N. Katherine Hayles has forcefully debunked such a view; see N. Katherine Hayles, *How We Became Posthuman: Virtual Bodies in Cybernetics, Literature, and Informatics* (Chicago: University of Chicago Press, 1999).

42. *Time*, June 19, 2000, cover, 82–83.

43. "Spielberg in the Twilight Zone," 113.

44. See Scott Bukatman, *Terminal Identity: The Virtual Subject in Postmodern Science Fiction* (Durham, NC: Duke University Press, 1993), esp. 32–35.

45. Murch, "A Digital Cinema of the Mind?"

46. See Mark Dillon, "A Computerized 'Conceiving Ada,'" *American Cinematographer*, Sept. 1998, 18, 20, 22. Also see Meredith Tromble, ed., *The Art and Films of Lynn Hershman Leeson: Secret Agents, Private I* (Berkeley: University of California Press, 2005), 97–99.

47. See Marshall McLuhan, *Understanding Media: The Extensions of Man* (1964; Cambridge, MA: MIT Press, 1994); and Jenkins, *Convergence Culture*.

48. On such disembodiment see Baudrillard, *The Ecstasy of Communication*, 18; and Kittler, *Gramophone, Film, Typewriter*, 1–2. Also see Vivian Sobchack, "The Scene of the Screen: Envisioning Photographic, Cinematic, and Electronic 'Presence,'" in *Carnal Thoughts: Embodiment and Moving Image Culture* (Berkeley: University of California Press, 2004), esp. 158–62; and Bukatman, *Terminal Identity*, esp. 106–8, 241–98.

49. For explorations of the continued importance of materiality and embodiment to the experience of new media see, in particular, Hayles, *How We Became Posthuman*; Laura U. Marks, *Touch: Sensuous Theory and Multisensory Media* (Minneapolis: University of Minnesota Press, 2002), esp. 147–91; and Mark B. N. Hansen, *New Philosophy for New Media* (Cambridge, MA: MIT Press, 2004).

50. Hayles, *How We Became Posthuman*, 4–5, 50–83.

51. On Hershman Leeson's continued investment in such a project see Tromble, *The Art and Films of Lynn Hershman Leeson*, esp. 169–81.

52. Hayles, *How We Became Posthuman*, 4–5, 80–83, 286–87. Also see Sherry Turkle, *Life on the Screen: Identity in the Age of the Internet* (New York: Simon and Schuster, 1995), 265–66; Tara McPherson, "Self, Other and Electronic Media," in *The New Media Book*, ed. Dan Harries (London: BFI, 2002), 183–94; and Chun, *Control and Freedom*, 129–70.

53. Kittler, *Gramophone, Film, Typewriter*, 1.

54. See Donna Haraway, "A Cyborg Manifesto: Science, Technology, and Socialist-Feminism in the Late Twentieth Century," *Socialist Review* 80

(1985): 65–108; and Judith Halberstam and Ira Livingston, eds., *Posthuman Bodies* (Bloomington: Indiana University Press, 1995). Also see Hayles, *How We Became Posthuman*; and N. Katherine Hayles, "Flesh and Metal," *Configurations* 10, no. 2 (Spring 2002): 297–320.

55. On the contemporary experience of multiple screens see Friedberg, *The Virtual Window*, 192–239. On the relation between multiple screens and the "logic of information flow" see Beatriz Colomina, "Enclosed by Images: The Eameses' Multimedia Architecture," *Grey Room* 02 (Winter 2001): 6–29. Colomina's focus on Charles and Ray Eames's experimentation with multiple screens in the 1950s highlights interesting resonances between the discourses on digital cinema and widescreen, especially Cinerama. In 1952, the year *This Is Cinerama* debuted, the Eameses collaborated with George Nelson and Alexander Girard to produce a "show for a typical class" at the University of Georgia. The resultant production utilized a massive, multimedia apparatus—including, notably, three screens, as well as multiple tape recorders and synthetic odors—to create an "intense sensory environment so as to 'heighten awareness'" of the lesson at hand: a hypothetical course on "Communications" (14). The project included a film produced by the Eameses, called *A Communications Primer* (1953), which elucidates contemporary information theory and includes a credit acknowledging Claude Shannon, Warren Weaver, Norbert Wiener, and John von Neumann for "ideas, direction, and material." Colomina links this experiment not only to wartime research in communications but also to the War Situation Room, designed by friends of the Eameses, including Buckminster Fuller, Eero Saarinen, and Henry Dreyfus, and entailing "a wall of parallel projected images of different kinds of information" (16). Thus we see the interest in information flows mapped in this chapter articulated not through the diminutive, internal "screens" often envisaged in the late 1990s but through the kind of massive, immersive, multisensory apparatus that widescreen also strove to embody in the 1950s.

56. Paul Virilio, *Polar Inertia*, trans. Patrick Camiller (1990; London: Sage, 2000), 66, 70 (emphasis in original).

57. Sean Cubitt, *Digital Aesthetics* (London: Sage, 1998), 87.

58. See Barbara Creed, "The Cyberstar: Digital Pleasures and the End of the Unconscious," *Screen* 41, no. 1 (Spring 2000): esp. 85–86.

59. Anthony Lane, "Star Bores," *New Yorker*, May 2, 1999, 80. Also see David Sterritt, "Lucas Improves 'Star Wars' Franchise with 'Clones,'" *Christian Science Monitor*, May 16, 2002, 17.

60. Hayden Christensen, quoted in Gary Dretzka, "'Episode II'—Reply of the Creator," 33.

61. Dave Kehr, "When a Cyberstar Is Born," *New York Times*, Nov. 18, 2001, Arts section.

62. Maximilian Schell on KTTV Fox 11 News, excerpt on digital actors, June 8, 1998, UCLA Film Archive.

63. David Belasco, cited in Tom Gunning, *D. W. Griffith and the Origins of American Narrative Film: The Early Years at Biograph* (Urbana: University of Illinois Press, 1991), 89. My thanks to Tom Gunning for drawing my attention to this parallel.

64. McLuhan, *Understanding Media*, 67.

65. Kate Davis, quoted in Nick James, "Digital Deluge," *Sight and Sound* 11, no. 10 (Oct. 2001): http://old.bfi.org.uk/sightandsound/feature/31 (accessed Jan. 2, 2013).

66. Anthony Kaufman, "Cannes Revisited Through Digital Debate," *Indie-WIRE*, June 6, 2000, www.indiewire.com/article/festivals_cannes_revisited_through_digital_debate (accessed Jan. 2, 2013).

67. Samira Makhmalbaf, "The Digital Revolution and the Future of Cinema," address at the Cannes Film Festival, May 2000, www.iranchamber.com/cinema/articles/digital_revolution_future_cinema.php (accessed Jan. 2, 2013).

68. Jay David Bolter and Richard Grusin, *Remediation: Understanding New Media* (Cambridge, MA: MIT Press, 1999).

69. Ibid., 26 (emphasis mine).

70. See Wendy Hui Kyong Chun, "Introduction: Did Somebody Say New Media?" in *New Media, Old Media: A History and Theory Reader*, ed. Wendy Hui Kyong Chun and Thomas Keenan (New York: Routledge, 2006), 2.

71. Barbara Creed makes a similar point in a different context, claiming, "In the coming era of digitized representation the crucial questions have less to do with reality than with communication" (Creed, "The Cyberstar," 83).

72. Holly Willis, for instance, includes it in her book on independent digital cinema. See Willis, *New Digital Cinema*, 29–30.

73. Telotte, "The *Blair Witch Project* Project," 38–39.

74. See the film's official website: www.thelastbroadcastmovie.com (accessed Jan. 2, 2013). Avalos is quoted in John Turk, "Digital Habitat: Lance Weiler and Stefan Avalos," *Res* 1, no. 2 (Winter 1998): 46–47.

75. Sconce, *Haunted Media*, 7.

76. For discussions of ghostly presence in still photography and cinema see, in particular, André Bazin, "The Ontology of the Photographic Image," in *What Is Cinema?* ed. and trans. Hugh Gray (Berkeley: University of California Press, 1967), 1:9–16; and Roland Barthes, *Camera Lucida: Reflections on Photography*, trans. Richard Howard (New York: Farrar, Straus and Giroux, 1981).

Also see Laura Mulvey's discussion of Bazin's and Barthes's views on cinema's relation to death in Mulvey, *Death 24x a Second*, esp. 54–84.

77. Alexander Galloway, *Gaming: Essays on Algorithmic Culture* (Minneapolis: University of Minnesota Press, 2006), 41, 53, 56.

78. Ibid., 56, 47, 49, 53. Also see Vivian Sobchack's discussion of subjective camera in *Westworld* (Vivian Sobchack, *Screening Space: The American Science Fiction Film*, 2nd ed. [New Brunswick, NJ: Rutgers University Press, 1987], 85). For another discussion of the dynamics of vision in the horror film see Carol Clover, *Men, Women and Chain Saws: Gender in the Modern Horror Film* (Princeton, NJ: Princeton University Press, 1992), 60, 166–230.

79. These films thus reflect what Jeffrey Sconce identifies as "an uncanny and perhaps even sinister component in 'living' electronic media" deriving from the sense that media such as radio, television, and computers create "virtual beings that appear to have no physical form" (Sconce, *Haunted Media*, 4).

80. This sentiment is perhaps best summed up by the well-known *New Yorker* cartoon captioned, "On the internet, nobody knows you're a dog" (Peter Steiner cartoon, *New Yorker*, July 5, 1993, 61). Also see "Cartoon Captures Spirit of the Internet," *New York Times*, Dec. 14, 2000, Technology section. Thank you to James Lastra for making this connection.

81. See Rosen, *Change Mummified*, 326–33; and Jenkins, *Convergence Culture*, 1–24.

82. Murch, "A Digital Cinema of the Mind?"

83. Kathy A. McDonald, "Post, Prod'n Merging: Digital Tools Trim Budgets," *Variety*, March 10, 1999, A8.

84. Todd Moyer, quoted in ibid.

85. Nick DeMartino, quoted in ibid.

86. For examples of this lament see Murch, "A Digital Cinema of the Mind?"; and Kehr, "When a Cyberstar Is Born." Also see Jean-Pierre Geuens, "The Digital World Picture," *Film Quarterly* 55, no. 4 (2002): 16–27.

87. George Lucas, quoted in "Back in Force!" in *"Star Wars: The Phantom Menace,"* special issue, *TV Guide*, May 15–21, 1999, 19.

88. Lucas, quoted in Dretzka, "'Episode II'—Reply of the Creator," 33.

89. Matt Zoller Seitz, review of *The Phantom Menace*, *New York Press*, May 19–25, 1999, 15.

90. Steve. M. Katz, quoted in Jay Holben, "Visions of the Future," *American Cinematographer*, April 1998, 36. On previs as a cost-saving device see ibid., 36. Also see Ron Magid, "Digitizing the Dynamic Duo," *American Cinematographer*, Dec. 1997, 100–101.

91. Jeffrey Okun, quoted in "Visions of the Future," 34.

92. Marc Graser, "Will H'w'd Freak at Endless Tweaks?" *Variety*, July 22, 2002, 9. Also see McDonald, "Post, Prod'n Merging."

93. Graser, "Will H'w'd Freak at Endless Tweaks?"

94. Charles Musser, *The Emergence of Cinema: The American Screen to 1907* (New York: Charles Scribner's Sons, 1990), 193–293; Janet Staiger, "The Hollywood Mode of Production to 1930," in David Bordwell, Janet Staiger, and Kristin Thompson, *The Classical Hollywood Cinema: Film Style & Mode of Production to 1960* (New York: Columbia University Press, 1985), 119, 125–27, 137–40.

95. For the idea that digital projection would allow filmmakers to create different cuts for different target audiences, see Juanita Diana's comments in McDonald, "Post, Prod'n Merging." On Lucas's strategies for maintaining control over his projects see Jon Lewis, "The Perfect Money Machine(s): George Lucas, Steven Spielberg, and Auteurism in the New Hollywood," in *Looking Past the Screen: Case Studies in American Film History and Method*, ed. Jon Lewis and Eric Smoodin (Durham, NC: Duke University Press, 2007), 70–72.

96. Murch, "A Digital Cinema of the Mind?" Also see Geuens, "The Digital World Picture."

97. Marriott, "If Only DeMille Had Owned a Desktop."

98. Makhmalbaf, "The Digital Revolution and the Future of Cinema."

99. A. O. Scott, "Documentarians Become Talking Heads for Change," *New York Times*, June 9, 2000, E21.

100. Ansen, Sawhill, et al., "Now at a Desktop Near You"; Romesh Ratnesar and Joel Stein, "Everyone's a Star.Com," *Time*, March 27, 2000, www.time.com/time/magazine/article/0,9171,996443,00.html (accessed Jan. 2, 2013); Makhmalbaf, "The Digital Revolution and the Future of Cinema."

101. Ansen, Sawhill, et al., "Now at a Desktop Near You"; Fishman, "Digital Video"; Peter H. Lewis, "An Auteur Is Born, via iMac," *New York Times*, Jan. 6, 2000, Technology-Circuits section.

102. Jenkins, *Convergence Culture*, 25–58. Also see Pierre Lévy, *Collective Intelligence: Mankind's Emerging World in Cyberspace*, trans. Robert Bononno (New York: Plenum Trade, 1997). For a less utopian account of this participatory culture see Lev Manovich, "The Practice of Everyday (Media) Life: From Mass Consumption to Mass Cultural Production?" *Critical Inquiry* 35 (Winter 2009): 319–31.

103. Adam Heimlich, "Getting Diggy with It: A Future Without Film," *Newark Star-Ledger*, May 16, 1999, 13; *Newsday* review of *The Phantom Menace*, cited in "The Critics Speak," *Newsday*, May 19, 1999, B7; *USA Today* review of *The Phantom Menace*, cited in ibid.

104. For reference to the "photorealism" of CGI in the press see Rick Lyman, "Movie Stars Fear Inroads by Upstart Digital Actors," *New York Times*, July 8, 2001, Technology section. For a scholarly discussion of computer animation and its aspiration to photorealism see Manovich, *The Language of New Media*, 191–97.

105. Seitz, review of *The Phantom Menace*, 17 (emphasis mine).

106. Kehr, "When a Cyberstar Is Born."

107. Seitz, review of *The Matrix*, 8; Seitz, review of *The Phantom Menace*, 17.

108. See Oliver Grau, *Virtual Art: From Illusion to Immersion*, trans. Gloria Custance (Cambridge, MA: MIT Press, 2003); and Griffiths, *Shivers Down Your Spine*.

109. Dyanna Taylor, quoted in Kevin Mortimer, "Taylor Adds Digital Video to Her Palette," *American Videographer* 1, no. 1 (April 1998): 8. For a more recent example of this discussion see Virginia Heffernan, "True Colors," *New York Times*, Oct. 19, 2008, MM18. For a scholarly discussion of the "uncanny valley" associated with computer-generated characters, see Stephen Prince, *Digital Visual Effects in Cinema: The Seduction of Reality* (New Brunswick, NJ: Rutgers University Press, 2012), 121–26.

110. For discussions of this aspiration to seamlessness and photorealism as a stylistic approach (rather than something inherently tied to CGI), see Michele Pierson, *Special Effects: Still in Search of Wonder* (New York: Columbia University Press, 2002), 158; and Turnock, "Plastic Reality," 80.

111. John Dykstra, quoted in Magid, "Digitizing the Dynamic Duo," 101.

112. Eric Korn, "Part the Seas for Part the First?" *Times Literary Supplement*, July 23, 1999, 19.

113. John Anderson, "Lost in Cyberspace," *Newsday*, March 31, 1999, B3.

114. John Bailey, "Film or Digital? Don't Fight. Coexist," *New York Times*, Feb. 18, 2001, Arts section. Similarly, *Sight and Sound* implies that digital video may not be "an adequate aesthetic substitute for the swirl of grain and the flicker from the projector that make 35mm such a medium for magic" (James, "Digital Deluge").

115. Discussions of digital cameras, too, often claimed that the image produced duplicated the look of film while simultaneously stressing the advantages of the new technology, such as the capacity for longer takes. See Zipern, "'Star Wars' Charts Course in Digital Video"; and Taub, "Shooting 'Star Wars,' Bit by Bit."

116. Murch, "A Digital Cinema of the Mind?"

117. Mike Levi, quoted in Marriott, "Digital Projectors Use Flashes of Light."

118. Sabin, "Taking Film Out of Films."

119. Yuri Tsivian, *Early Cinema in Russia and Its Cultural Reception*, trans. Alan Bodger (London: Routledge, 1994), 216, 105–8.

120. Robert Spadoni, "The Uncanny Body of Early Sound Film," *Velvet Light Trap* 51 (Spring 2003): 4–16.

121. Wendy Hui Kyong Chun identifies mediums' "portrayal as transparent rather than intervening" historically with the rise of the concept of mass media in the late nineteenth and twentieth centuries. See Chun, "Introduction: Did Somebody Say New Media?" 3.

122. See Stephen Prince, "The Emergence of Filmic Artifacts: Cinema and Cinematography in the Digital Era," *Film Quarterly* 57, no. 3 (Spring 2004): 31–32; and David Bordwell, *Pandora's Digital Box*, 197–201.

123. Bailey, "Film or Digital?"

124. McCarthy, "Digital Cinema Is the Future . . . Or Is It?"

125. Ibid.

126. We can trace this emphasis on movement—and its function for the affective experience of cinema, as well as for the related experience of its realism—through a century of film theory. See, e.g., Jean Epstein, "Magnification" (1921) and "On Certain Characteristics of *Photogénie*" (1924), in *French Film Theory and Criticism: A History/Anthology*, vol. 1, *1907–1939*, ed. Richard Abel (Princeton, NJ: Princeton University Press, 1988), 235–41, 314–18; Siegfried Kracauer, *Theory of Film: The Redemption of Physical Reality* (1960; Princeton, NJ: Princeton University Press, 1997); Christian Metz, *Film Language: A Semiotics of the Cinema*, trans. Michael Taylor (Chicago: University of Chicago Press, 1991), 3–15; Gilles Deleuze, *Cinema 1: The Movement-Image*, trans. Hugh Tomlinson and Barbara Habberjam (Minneapolis: University of Minnesota Press, 1986); and Tom Gunning, "Moving Away from the Index: Cinema and the Impression of Reality," *differences* 18, no. 1 (2007): 29–52.

127. Thomas Vinterberg, quoted in Anthony Kaufman, review of *The Celebration*, *Res* 1, no. 4 (Fall 1998): 9.

128. Anthony Dod Mantle, quoted in Scott Macaulay, "Against the Grain," *Filmmaker* 7, no. 3 (Spring 1999): 34.

129. See Lars von Trier and Thomas Vinterberg, "The Dogme Manifesto" and "Vow of Chastity," in Stevenson, *Dogme Uncut*, 21–23.

130. Jonathan Romney, review of *Festen*, *Guardian*, March 5, 1999, 8.

131. Seitz, review of *The Phantom Menace*, 16.

132. Romney, review of *Festen*, 8.

133. Marks, *Touch*, 18; Laura U. Marks, *The Skin of the Film: Intercultural Cinema, Embodiment, and the Senses* (Durham, NC: Duke University Press, 2000), 162–93, 183.

134. This apparent move might seem to align cinema's dominance by these technologies with general ideas of simulation in contemporary mediated culture, particularly as described by Jean Baudrillard—a connection popularized by *The Matrix*. As Philip Rosen has argued, however, aligning digital simulation with Baudrillard's concept is a mistake. Baudrillard's concept of simulation is not limited to the idea that representations have lost their mooring to an underlying truth but, rather, presents an alternative to the category of representation itself by suggesting that mediation has become so ubiquitous that it no longer makes sense to think of a subject position outside of it (a point markedly misrepresented by *The Matrix*). By contrast, Rosen observes, "neither the subject nor the inside-outside oppositions are necessarily irrelevant in digital simulation, which means that the digital remains in the realm of representation" (Rosen, *Change Mummified*, 339). Also see Jean Baudrillard, *Simulations*, trans. Paul Foss, Paul Patton, and Philip Beitchman (New York: Semiotext[e], 1983).

135. See Peter Wollen, *Signs and Meaning in the Cinema* (Bloomington: University of Indiana Press, 1969): 125–26. As Tom Gunning points out, Wollen is also careful to distinguish Bazin's project, which aimed "to found an aesthetic," from semiotician Charles Saunders Peirce's attempt, in elucidating the concept of the index as one of three types of signs, "to found a logic" (126). See Gunning, "Moving Away from the Index," 31–33. An example of such attribution of indexicality to analog cinema—in order, ultimately, to suggest that digital cinema disrupts that indexicality—can be found in Manovich, *The Language of New Media*, esp. 293–308.

136. Rodowick, *The Virtual Life of Film*, 116.

137. Manovich, *The Language of New Media*, 295.

138. Rosen emphasizes the fact that "practically infinite manipulability" represents a change of degree rather than kind, with digital technology vastly increasing the speed with which "manipulations" can be made and made visible; see Rosen, *Change Mummified*, 319–26.

139. Another term that has been used to describe CGI's illusionism, notably by film scholar Stephen Prince, is "perceptual realism." To suggest, however, that CGI simulates perception is less accurate than to claim that it simulates photography. Indeed, often those aesthetic qualities that mark CG images as realistic, such as lens flares, are qualities associated with the contingency of photography (and, even, as Julie Turnock argues, a specific era and approach to photography, namely "1970s materialist docurealism") rather than with the way people view the world in day-to-day life. See Stephen Prince, "True Lies: Perceptual Realism, Digital Images, and Film Theory," *Film Quarterly* 49, no. 3 (Spring 1996): 27–37; and Julie Turnock, "The ILM Version: Recent

Digital Effects and the Aesthetics of 1970s Cinematography," *Film History* 24 (2012): 158–68.

140. Binkley, "Camera Fantasia," 8.

141. See Rosen, *Change Mummified*, 3–41, 301–49; Mary Ann Doane, *The Emergence of Cinematic Time: Modernity, Contingency, the Archive* (Cambridge, MA: Harvard University Press, 2002), 206–32; Tom Gunning, "What's the Point of an Index? Or, Faking Photographs," *Nordicom Review* 25, no. 1–2 (Sept. 2004): 39–49; Daniel Morgan, "Rethinking Bazin: An Essay on Ontology and Realist Aesthetics," *Critical Inquiry* (Spring 2006): 443–81; and Niels Niessen, "Lives of Cinema: Against Its 'Death,'" *Screen* 52, no. 3 (Autumn 2011): 307–26.

142. See Thomas Elsaesser, "Digital Cinema: Delivery, Event, Time," in *Cinema Futures: Cain, Abel or Cable? The Screen Arts in the Digital Age*, ed. Thomas Elsaesser and Kay Hoffmann (Amsterdam: Amsterdam University Press, 1998), 201–22; Gunning, "Moving Away from the Index"; and Andrew, *What Cinema Is!*

143. See, in particular, Bazin's discussions of neorealism in *What Is Cinema?* 2:16–101; and Kracauer, *Theory of Film*, esp. 285–311.

144. Andrew, *What Cinema Is!* xiv; Hansen, *Cinema and Experience*, 279.

4. AWE AND AGGRESSION: THE EXPERIENCE OF ERASURE IN *THE PHANTOM MENACE* AND *THE CELEBRATION*

1. Armond White, review of *The Phantom Menace*, *Film Comment* 35, no. 4 (July/August 1999): 78.

2. Thomas Vinterberg, quoted in Shari Roman, *Digital Babylon: Hollywood, Indiewood and Dogme 95* (Hollywood: IFILM, 2001), 81.

3. See Matt Zoller Seitz, review of *The Phantom Menace*, *New York Press*, May 19–25, 1999, 15; and Jason Silverman, "Sundance Enters Digital Era," *Wired*, Jan. 21, 1999, www.wired.com/print/culture/lifestyle/news/1999/01/17440 (accessed Jan. 2, 2013).

4. See Miriam Hansen, "Early Cinema, Late Cinema: Transformations of the Public Sphere," in *Viewing Positions: Ways of Seeing Film*, ed. Linda Williams (New Brunswick, NJ: Rutgers University Press, 1995), 134–52; Vivian Sobchack, "The Scene of the Screen: Envisioning Photographic, Cinematic, and Electronic 'Presence,'" in *Carnal Thoughts: Embodiment and Moving Image Culture* (Berkeley: University of California Press, 2004), 135–62; Thomas Elsaesser, "Digital Cinema: Delivery, Event, Time," in *Cinema Futures: Cain, Abel or Cable? The Screen Arts in the Digital Age*, ed. Thomas Elsaesser and Kay Hoffmann (Amsterdam: Amsterdam University Press, 1998), 201–22; Mary Ann Doane, "The Close-Up: Scale and Detail in the Cinema," *differences* 14, no. 3 (Fall 2003): 89–111; Laura Mulvey, *Death 24x a Second: Stillness and the*

Moving Image (London: Reaktion, 2006); Barbara Klinger, *Beyond the Multiplex: Cinema, New Technologies, and the Home* (Berkeley: University of California Press, 2006); and Anne Friedberg, *The Virtual Window: From Alberti to Microsoft* (Cambridge, MA: MIT Press, 2006), esp. 192–239.

5. Thomas Elsaesser, "The New Film History as Media Archaeology," *Cinémas* 14, no. 2–3 (2004): 101.

6. Henry Jenkins, *Convergence Culture: Where Old and New Media Collide* (New York: New York University Press, 2006). Also see Thomas Schatz, "The New Hollywood," in *Movie Blockbusters*, ed. Julian Stringer (London: Routledge, 2003), 15–44; and Jon Lewis, "The Perfect Money Machine(s): George Lucas, Steven Spielberg, and Auteurism in the New Hollywood," in *Looking Past the Screen: Case Studies in American Film History and Method*, ed. Jon Lewis and Eric Smoodin (Durham, NC: Duke University Press, 2007), 61–86.

7. Jenkins, *Convergence Culture*, 151, 133. Also see Will Brooker, *Using the Force: Creativity, Community and "Star Wars" Fans* (New York: Continuum, 2002).

8. Geoff King, "Spectacle, Narrative, and the Spectacular Hollywood Blockbuster," in Stringer, *Movie Blockbusters*, 114.

9. Michele Pierson, *Special Effects: Still in Search of Wonder* (New York: Columbia University Press, 2002), 96, 94.

10. King, "Spectacle, Narrative, and the Spectacular Hollywood Blockbuster," 116.

11. Lars von Trier and Thomas Vinterberg, "The Vow of Chastity," reprinted in *p.o.v.: A Danish Journal of Film Studies* 10 (Dec. 2000): 7. Mette Hjort, while describing *The Celebration* as a film with "crossover effects," explains that Dogma 95 was "to a significant extent a festival phenomenon" (Mette Hjort, *Small Nation, Global Cinema* [Minneapolis: University of Minnesota Press, 2005], 44). Also see Palle Schantz Lauridsen, "*The Celebration*: Classical Drama and Docu Soap Style," *p.o.v.: A Danish Journal of Film Studies* 10 (Dec. 2000): 64.

12. Lev Manovich, *The Language of New Media* (Cambridge, MA: MIT Press, 2002), 244–59. Also see Yvonne Spielmann, "Expanding Film into Digital Media," *Screen* 40, no. 2 (Summer 1999): 131–45.

13. On such density in the *Star Wars* Special Edition and prequels also see Julie Turnock, "Plastic Reality: Special Effects, Art and Technology in 1970s U.S. Filmmaking" (PhD diss., University of Chicago, 2008), 154n38.

14. Susan Sontag, "Fascinating Fascism," in *Movies and Methods: An Anthology*, ed. Bill Nichols (Berkeley: University of California Press, 1976), 1:42.

15. See Michael Rubin, *Droidmaker: George Lucas and the Digital Revolution* (Gainesville, FL: Triad, 2006). Also see Benjamin Bergery, "Digital Cinema, by George," *American Cinematographer*, Sept. 2001, 67; and Industrial Light & Magic's website, www.ilm.com (accessed Jan. 2, 2013).

16. See Ron Magid, "An Expanded Universe," *American Cinematographer*, Feb. 1997, 60–70. Also see Pierson, *Special Effects*, 94–96; and Brooker, *Using the Force*, 63–77.

17. Seitz, review of *The Phantom Menace*, 15–16.

18. On the typical numbers of effects shots see Rick McCallum in the electronic press kit for *The Phantom Menace*, UCLA Film Archive. On the effects in *Titanic* see Mark Nollinger, "'Phantom' Magic," *TV Guide*, June 12–18, 1999, 21–22. On the effects in *The Matrix* see Marc Graser, "F/X Costs, Complications Confounding Pic Budgets," *Variety*, March 29, 1999, 7. On *The Phantom Menace*'s effects shots see Adam Heimlich, "Getting Diggy with It: A Future Without Film," *Star-Ledger*, May 16, 1999, 13.

19. Ron Magid, "Master of His Universe: George Lucas Discusses 'The Phantom Menace' and the Impact of Digital Filmmaking on the Industry's Future," *American Cinematographer*, Sept. 1999, 26.

20. Seitz, review of *The Phantom Menace*, 15.

21. Chris Petrikin, "A Force to Be Reckoned With," *Variety*, April 12–18, 1999, 7; Richard Morgan, "'Phantom' Licensees Already in Hyperdrive," ibid., 9.

22. Todd S. Purdum, "Hollywood Journal; With the Force, in the Movie Line," *New York Times*, April 29, 1999, A18.

23. Michel Marriott, "On a Galaxy of Sites, 'Star Wars' Fever Rises," *New York Times*, May 6, 1999, G7.

24. Cartoon by Jack Ziegler, *New Yorker*, May 10, 1999, 6.

25. Cited in Janet Maslin, "In the Beginning, the Future," *New York Times*, May 19, 1999, E1.

26. Bernard Weinraub, "'Star Wars' Fans Give 'Menace' a Little Less Force Than Expected," *New York Times*, May 24, 1999, E3.

27. Seitz, review of *The Phantom Menace*, 15.

28. Weinraub, "'Star Wars' Fans Give 'Menace' a Little Less Force Than Expected." On fans' disappointment with *The Phantom Menace* see Brooker, *Using the Force*, 79–99. As of January 2, 2013, *The Phantom Menace* ranked fifth of all time at the domestic box office and eleventh worldwide, and *Titanic*'s domestic and worldwide records had been surpassed by *Avatar*. If there was a sense of disappointment related to *The Phantom Menace*'s release, it surely had to do with the amount of anticipation surrounding the movie and comparison to *Titanic*. Box-office data is from Box Office Mojo, http://boxofficemojo .com (accessed Jan. 2, 2013).

29. In June 1998, for instance, KTTV Fox 11 News in Los Angeles featured a segment on the prospect of "synthespians," citing the idea that "celebrities can continue to make movies long after they are gone" (KTTV Fox 11 News at 10, excerpt on digital actors [June 8, 1998], UCLA Film Archive). In April and

May 1999—just as the anticipatory fervor over *The Phantom Menace* was cresting—*American Cinematographer* offered stories about the processes of creating and animating digital "actors." See Debra Kaufman, "Production Slate: More Human Than Human," *American Cinematographer*, April 1999, 22–29; and Debra Kaufman, "The Post Process: Digital Human Catalogue," *American Cinematographer*, May 1999, 14–16. Also see Paula Parisi, "The New Hollywood Silicon Stars," *Wired*, Dec. 1995, 142–45, 202–10; and Debra Kaufman, "Photo Genesis," *Wired*, July 1999, 125. For scholarly work on digitally animated characters see Barbara Creed, "The Cyberstar: Digital Pleasures and the End of the Unconscious," *Screen* 41, no. 1 (Spring 2000): 79–86; Tom Gunning, "Gollum and Golem: Special Effects and the Technology of Artificial Bodies," in *From Hobbits to Hollywood: Essays on Peter Jackson's "Lord of the Rings,"* ed. Ernest Mathijs and Murray Pomerance (Amsterdam: Rodopi, 2006), 319–49; and Stephen Prince, *Digital Visual Effects in Cinema: The Seduction of Reality* (New Brunswick, NJ: Rutgers University Press, 2012), 99–144. Also see Dan North, "Kill Binks: Why the World Hated Its First Digital Actor," in *Culture, Identities and Technology in the "Star Wars" Films*, ed. Carl Silvio and Tony M. Vinci (Jefferson, NC: McFarland, 2007), 155–74.

30. Maslin, "In the Beginning, the Future." Producer Rick McCallum identified the successful creation and integration of CG characters as a central goal for the film: "To create CG characters who could interact seamlessly with live actors was the dream" (*Phantom Menace* electronic press kit, UCLA Film Archive).

31. See Heimlich, "Getting Diggy with It," 13; Nollinger, "'Phantom' Magic," 23; Seitz, review of *The Phantom Menace*, 15–17; and White, review of *The Phantom Menace*, 78.

32. Pierson, *Special Effects*, 101.

33. Warren Buckland, "Between Science Fact and Science Fiction: Spielberg's Digital Dinosaurs, Possible Worlds, and the New Aesthetic Realism," *Screen* 40, no. 2 (Summer 1999): 182; Pierson, *Special Effects*, 158; Turnock, "Plastic Reality," 80.

34. See Tom Gunning, "The Cinema of Attractions: Early Film, Its Spectator and the Avant-Garde," in *Early Cinema: Space, Frame, Narrative*, ed. Thomas Elsaesser and Adam Barker (London: BFI, 1990), 61; Sean Cubitt, "Le réel, c'est l'impossible: The Sublime Time of Special Effects," *Screen* 40, no. 2 (Summer 1999): 123–30; Scott Bukatman, "The Artificial Infinite: On Special Effects and the Sublime," *Matters of Gravity* (Durham, NC: Duke University Press, 2003), 81–110; and Pierson, *Special Effects*, esp. 93–136.

35. Pierson, *Special Effects*, 96–97, 149–54.

36. Bukatman, "The Artificial Infinite," 95. As David Bordwell notes, the original *Star Wars* had an average shot length (ASL) of 3.4 seconds, which was

"quite short for the 1970s" (David Bordwell, "Intensified Continuity: Visual Style in Contemporary American Film," *Film Quarterly* 55, no. 3 [2002]: 27n27).

37. Pierson, *Special Effects*, 49; Bukatman, "The Artificial Infinite," 109. Also see Cubitt, "Le réel, c'est l'impossible."

38. On the original *Star Wars'* reference to *Triumph of the Will* see Robin Wood, *Hollywood from Vietnam to Reagan—and Beyond*, exp. and rev. ed. (New York: Columbia University Press, 2003), 152. On Lucas's lack of concern with human characters and actors see John Podhoretz, review of *The Phantom Menace*, *New York Post*, May 18, 1999, 56.

39. See, in particular, Siegfried Kracauer, "The Mass Ornament," in *The Mass Ornament: Weimar Essays*, ed. and trans. Thomas Y. Levin (Cambridge, MA: Harvard University Press, 1995), 75–86; and Walter Benjamin, "The Work of Art in the Age of Its Technological Reproducibility" (2nd version), trans. Edmund Jephcott and Harry Zohn, in *Selected Writings*, ed. Michael W. Jennings et al., trans. Rodney Livingstone, Edmund Jephcott, Howard Eiland, et al., 4 vols. (Cambridge, MA: Harvard University Press, 1996–2003), 3:101–33, esp. 120–22. Also see Kracauer, *From Caligari to Hitler: A Psychological History of the German Film*, rev. ed., ed. Leonardo Quaresima (1947; Princeton, NJ: Princeton University Press, 2004).

40. Marc Graser, "Digital Delay for Next 'Wars,'" *Variety*, June 14, 1999, www.variety.com/index.asp?layout=print_story&articleid=VR1117503046& categoryid=13 (accessed Jan. 2, 2013).

41. See Bergery, "Digital Cinema, by George," 67–68.

42. According to Lucas the only element in *Attack of the Clones* shot on film— from a scene in the Jedi temple out of *The Phantom Menace*—amounted to a photographic set, since he and his team "erased all of the characters and put in a new background and new actors" (Lucas, quoted in Ron Magid, "Exploring a New Universe: George Lucas Discusses His Ongoing Effort to Shape the Future of Digital Cinema," *American Cinematographer*, Sept. 2002, 46).

43. See Nollinger, "'Phantom' Magic"; Ron Magid, "Virtual Realities: Synthetic Architecture and Vistas Complete *The Phantom Menace*'s Epic Settings," *American Cinematographer*, Sept. 1999, 82–93, esp. 82–83; and Ron Magid, "A New-Age Armada: A Fleet of CG Models and Traditional Miniatures Take Flight Across the 'Phantom Menace' Universe," *American Cinematographer*, Sept. 1999, 106–17.

44. On the film's digital projection see Michel Marriott, "Digital Projectors Use Flashes of Light to Paint a Movie," *New York Times*, May 27, 1999, G7; and John Belton "Digital Cinema: A False Revolution," *October* 100 (Spring 2002): 103.

45. One effects artist, for instance, explains that "it was important to be able to mix and match without being able to tell that this was computer

graphics or that this was a model or that this was live action" (*Phantom Menace* electronic press kit).

46. Manovich, *The Language of New Media*, 245, 248, 252, 249.

47. One reviewer claimed that the film itself was "a spiffy theme park that's part video game, part sprawling myth" (review of *The Phantom Menace*, *USA Today*, cited in "The Critics Speak," *Newsday*, May 19, 1999, B7). For the claim that *The Phantom Menace* references *Ben-Hur*, see ibid.; and Seitz, review of *The Phantom Menace*, 17. On the relationship between such cinematic spectacles and contemporary immersive media such as computer games and virtual reality (as well as other phenomena including theme park rides), see Erkki Huhtamo, "Encapsulated Bodies in Motion: Simulators and the Quest for Total Immersion," in *Critical Issues in Electronic Media*, ed. Simon Penny (Albany: State University of New York Press, 1995), 159–86; and Constance Balides, "Immersion in the Virtual Ornament: Contemporary 'Movie Ride' Films," in *Rethinking Media Change: The Aesthetics of Transition*, ed. David Thorburn and Henry Jenkins (Cambridge, MA: MIT Press, 2003), 315–36.

48. Marc Graser, "'Phantom' Races to Nintendo," *Variety*, May 17, 1999, 12.

49. Magid, "Virtual Realities," 82; Maslin, "In the Beginning, the Future."

50. *Phantom Menace* electronic press kit.

51. David Sterritt, review of *The Phantom Menace*, *Christian Science Monitor*, May 19, 1999, 12.

52. Heimlich, "Getting Diggy with It," 13. On the almost exclusive use of CGI in this scene see Nollinger, "'Phantom' Magic," 26.

53. Visual Effects Supervisor Dennis Muren puts the number of Gungans in this scene at seven thousand (Muren, quoted in Nollinger, "'Phantom' Magic," 26–27).

54. This editing pattern is certainly not unprecedented in mainstream American cinema. In his description of classical Hollywood style David Bordwell suggests that, as an alternative to the most common method of introducing scenes via long shot, scenes may "begin by framing a detail and then by means of various devices . . . soon reveal the totality of the space" (David Bordwell, "The Classical Hollywood Style," in David Bordwell, Janet Staiger, and Kristin Thompson, *The Classical Hollywood Cinema: Film Style & Mode of Production to 1960* (New York: Columbia University Press, 1985), 63. The difference here is that these shots are not simply delayed establishing shots; they function not so much to convey information about setting as to provide an affective jolt. Shilo T. McClean describes such a function as a possible use of such CG vistas, explaining that they "can be used to astonish the spectator, twisting their expectations and revealing the diegetic world in a surprising or unexpected way," thus straddling "the fine line between narrative tool

and spectacular display" (Shilo T. McClean, *Digital Storytelling: The Narrative Power of Visual Effects in Film* [Cambridge, MA: MIT Press, 2007], 208).

55. For a discussion of a similar interpenetration of spectacle and narrative in the original *Star Wars* see Turnock, "Plastic Reality," 222–28. For a more general argument about the imbrication of spectacle and narrative in blockbusters see Geoff King, *Spectacular Narratives: Hollywood in the Age of the Blockbuster* (London: I. B. Taurus, 2000).

56. Kristen Whissel, "The Digital Multitude," *Cinema Journal* 49, no. 4 (Summer 2010): 90–110, 105 (emphasis removed), 110. While the concept of the "digital multitude" may seem to reverberate with the notion of the multitude elaborated by Michael Hardt and Antonio Negri, Lucas's collection of digital bodies is more akin to the masses described by Siegfried Kracauer, particularly with Kracauer's later, more pessimistic account of the mass ornament in *From Caligari to Hitler*. For Hardt and Negri the multitude is a potentially democratic social formation "composed of innumerable internal differences that can never be reduced to a unity or a single identity—different cultures, races, ethnicities, genders, and sexual orientations; different forms of labor; different ways of living; different views of the world; and different desires"; it is an "internally different, multiple social subject whose constitution and action is based not on identity or unity (or, much less, indifference) but on what it has in common." Lacking such multiplicity or collective agency, the figures constituting Lucas's digital masses, like what Hardt and Negri identify as "the crowd or the mob or the rabble," can (both in their address to viewers and within the diegesis) "have social effects—often horribly destructive effects—but cannot act of their own accord" (Michael Hardt and Antonio Negri, *Multitude: War and Democracy in the Age of Empire* [New York: Penguin, 2004], xiv, 100).

57. Whissel, "The Digital Multitude," 99.

58. Animation supervisor Rob Coleman describes the way in which the battle droids' march cycles were created "so they're not exactly lockstep," and scattered Gungan soldiers were given different actions from the rest "so you don't get a sense of seeing repeated actions" (Rob Coleman, quoted in Ron Magid, "CG Star Turns: The Art of 3-D Character Animation Is Pushed to New Heights for 'The Phantom Menace,'" *American Cinematographer*, Sept. 1999, 102, 104). Also see Whissel, "The Digital Multitude," 104.

59. Mark Hamill, quoted in Steve Silberman, "G Force," *Wired*, May 1999, www.wired.com/wired/archive/7.05/lucas.html (accessed Jan. 2, 2013).

60. Ron Magid, "Edit-Suite Filmmaking: Avid's Film Composer System and Variety of Covert Visual Effects Were Used During the Editing Phase to Complete 'The Phantom Menace,'" *American Cinematographer*, Sept. 1999, 118.

61. Lucas, quoted in Bergery, "Digital Cinema, by George," 71.

62. Jean-Pierre Geuens, "The Digital World Picture," *Film Quarterly* 55, no. 4 (2002): 23. On Lucas's status as a "postproduction director" and his related capacity to control his projects, see Lewis, "The Perfect Money Machine(s)," 70–72.

63. LucasArts Entertainment Company, "Insider's Guide to *Star Wars*," CD-ROM, cited in John Shelton Lawrence and Robert Jewett, *The Myth of the American Superhero* (Grand Rapids, MI: Wm. B. Eerdmans, 2002), 275.

64. Susan Sontag, "Fascinating Fascism," 34.

65. Kracauer, "The Mass Ornament"; Kracauer, *From Caligari to Hitler*, 297–303, 301.

66. Ibid., 298, 302.

67. Ibid., 302

68. Wood, *Hollywood from Vietnam to Reagan—and Beyond*, 152.

69. Lucas, quoted in Jane Caputi, "Seeing Elephants: The Myths of Phallotechnology," *Feminist Studies* 14, no. 3 (Autumn 1988): 497, 500.

70. In 1985 Lucas unsuccessfully sought legal means to divorce his film title from Reagan's project. See Will Brooker, "New Hope: The Postmodern Project of *Star Wars*," in *Liquid Metal: The Science Fiction Film Reader*, ed. Sean Redmond (London: Wallflower, 2004), 303.

71. For the claim that "the Force" is akin to "the metaphysical ethics of Fascism," see Lawrence and Jewett, *The Myth of the American Superhero*, 277. For the contention that the film is not explicitly fascist, see Peter Lev, "Whose Future? *Star Wars*, *Alien*, and *Blade Runner*," *Literature Film Quarterly* 26, no. 1 (1998): 31.

72. On approaches to *Triumph* based on a distinction between form and content, see Bill Nichols's introduction to "Fascinating Fascism," in *Movies and Methods*, 1:31. On the use of Nazi imagery to depict Darth Vader and his storm troopers, see Lawrence and Jewett, *The Myth of the American Superhero*, 275.

73. Arthur Lubow, "A Space 'Iliad': The *Star Wars* War: I," *Film Comment* 13, no. 4 (July-August 1977): 20.

74. For testimony to *The Phantom Menace*'s failure at eliciting affective engagement see Anthony Lane, "Star Bores," *New Yorker*, May 24, 1999, 80; Sterritt, review of *The Phantom Menace*, 13; and Rod Dreher, review of *The Phantom Menace*, *New York Post*, May 18, 1999, 57.

75. On the overlap between Internet users and *Star Wars* fans see Marriott, "On a Galaxy of Sites, 'Star Wars' Fever Rises." On the plan for four new video games based on *The Phantom Menace*, to join the five other games based on the original trilogy that were already on the market, see Graser, "'Phantom' Races to Nintendo," 12.

76. Wood, *Hollywood from Vietnam to Reagan—and Beyond*, 149.

77. To be clear, Lucas's decision to apply CGI to aliens and droids rather than humans (like Spielberg's choice to use dinosaurs) certainly represented a practical means for circumventing the difficulties of creating photorealistic CG humans. It is the way in which these CG characters are treated as "other" (whether dangerous, untrustworthy, or simply inferior to the humans), replicating a black-and-white, us-versus-them vision of the world, that is at issue here. On the difficulties of achieving photorealism with CG human characters—and what Stephen Prince identifies as the success of *The Curious Case of Benjamin Button* (David Fincher, 2008) in this regard—see Prince, *Digital Visual Effects in Cinema*, 117–44.

78. Lucas, quoted in Magid, "Master of His Universe," 30 (emphasis in original).

79. Vivian Sobchack, *Screening Space: The American Science Fiction Film*, 2nd ed. (New Brunswick, NJ: Rutgers University Press, 1987), 238–39; Kracauer, "The Mass Ornament"; Donna Haraway, "A Cyborg Manifesto: Science, Technology, and Socialist-Feminism in the Late Twentieth Century," *Socialist Review* 80 (1985): 65–108.

80. Anthony Dod Mantle, quoted in Richard Kelly, *The Name of This Book Is Dogme95* (London: Faber and Faber, 2000), 102.

81. Vinterberg emphasized that, within the context of Danish filmmaking, *The Celebration*'s budget was only slightly less than average. Jan Simons, *Playing the Waves: Lars von Trier's Game Cinema* (Amsterdam: Amsterdam University Press, 2007), 170. On *The Celebration*'s budget also see Geoffrey Macnab, "The Big Tease: 'Dogma 95' Was Not Just a PR Joke," *Sight and Sound* 9, no. 2 (Feb. 1999): http://iipa.chadwyck.com (accessed Nov. 9, 2009). On *The Phantom Menace*'s budget see www.boxofficemojo.com (accessed Jan. 2, 2013).

82. See Jack Stevenson, *Dogme Uncut: Lars von Trier, Thomas Vinterberg, and the Gang That Took on Hollywood* (Santa Monica: Santa Monica Press, 2003), 87. Cinematographer Anthony Dod Mantle claims that "if it hadn't done so well at Cannes, I think people would have just slammed it completely" (Dod Mantle, quoted in Kelly, *The Name of This Book Is Dogme95*, 102). On the sensation *The Celebration* caused at Cannes, see Bruce Haring, "Movies Roll with the Digital Age: High-End Video Boosts Creativity, Independent Films," *USA Today*, March 17, 1999, 8D.

83. On the jury prize and box-office success see Monica Roman, "'Celebration' Up for Oscar," *Variety*, Nov. 4, 1998, www.variety.com/article/VR1117488120.html (accessed Jan. 2, 2013); on the acquisition by October Films see Benedict Carver, "October's 'Celebration,'" *Variety*, May 18, 1998, www.variety.com/article/VR1117470968.html (accessed Jan. 2, 2013); on the film's worldwide gross see Stevenson, *Dogme Uncut*, 87.

84. Lars von Trier and Thomas Vinterberg, Dogma 95 manifesto, reprinted as "DOGMA 95," in *p.o.v.: A Danish Journal of Film Studies* 10 (Dec. 2000): 6. For von Trier's depiction of Dogma 95 as an attack on American cinema see von Trier, quoted in Mette Hjort, "Dogma 95: A Small Nation's Response to Globalisation," in *Purity and Provocation: Dogma 95*, ed. Mette Hjort and Scott MacKenzie (London: BFI, 2003), 38–39. For Vinterberg's claim that Dogma was never meant as an indictment of Hollywood, see Peter Brunette, "A Tough Family Portrait with Even Tougher Ideals," *New York Times*, Oct. 4, 1998, Arts and Leisure section; and John Anderson, "Something Rotten in Denmark Is Daddy," *Newsday*, Oct. 5, 1998, B8.

85. Von Trier and Vinterberg, "The Vow of Chastity," in *p.o.v.: A Danish Journal of Film Studies* 10 (Dec. 2000): 7.

86. Such exploration of Dogma 95's relationship to previous modernist cinematic movements can be found in Richard Raskin, ed., "Aspects of Dogma," special issue of *p.o.v.: A Danish Journal of Film Studies* 10 (Dec. 2000); and Hjort and MacKenzie, *Purity and Provocation*. For reference to the debate about Dogma 95's politics and the argument that Dogma 95 *was* a political movement insofar as it "[amounted] to a novel and insightful response to the inequities of globalising processes," see Hjort, "Dogma 95: A Small Nation's Response to Globalisation," 31.

87. Hjort, *Small Nation, Global Cinema*, 36–37; Simons, *Playing the Waves*, 8.

88. Thomas Vinterberg, "The Confession of Thomas Vinterberg," in Roman, *Digital Babylon*, 88.

89. Thomas Vinterberg, quoted in Macnab, "The Big Tease."

90. Berys Gaut, "Naked Film: Dogma and Its Limits," in Hjort and MacKenzie, *Purity and Provocation*, 90–91; Von Trier, quoted in Kelly, *The Name of This Book Is Dogme95*, 138.

91. Vinterberg, quoted in Macnab, "The Big Tease."

92. See Benedict Carver, "IFC Aims Digital Lens at 10 Low-Budget Pix," *Variety*, August 4, 1999, 1. For a discussion of Dogma 95 as a particularly apt approach to new media see Simons, *Playing the Waves*; and Jan Simons, "Von Trier's Cinematic Games," *Journal of Film and Video* 60, no. 1 (Spring 2008): 3–13.

93. Andrew Hindes, "Digital Video Gains Cache with Filmmakers," *Variety*, Jan. 25, 1999, www.variety.com/article/VR1117490575.html (accessed Jan. 2, 2013). Also see Monica Roman, "Wave Sets Digital Vid Prod'n Arm"; and Carver, "IFC Aims Digital Lens at 10 Low-Budget Pix," 1.

94. See Macnab, "The Big Tease."

95. See Godfrey Cheshire, review of *The Celebration*, *Variety*, May 18, 1998, www.variety.com/review/VE1117477500.html (accessed Jan. 2, 2013); Janet Maslin, "A Family Making Orphanhood Look Good," *New York Times*, Oct. 7,

1998, Arts section; Armond White, review of *The Celebration*, *New York Press*, Oct. 14–20, 1998, 6.

96. David Ansen, Ray Sawhill, et al., "Now at a Desktop Near You," *Newsweek*, March 15, 1999, 80.

97. See Todd McCarthy, "At Cannes '98, Dogma 95 Has Its Day," *Variety*, May 29, 1998, www.variety.com/article/VR1117471366.html (accessed Jan. 2, 2013). On the size of the Sony PC-7 see Patricia Thomson, "'The Idiots' Plays by Von Trier's Rules," *American Cinematographer*, Jan. 2000, 20.

98. On the relationship between new technologies and Direct Cinema see Kristin Thompson and David Bordwell, *Film History: An Introduction*, 2nd ed. (New York: McGraw-Hill, 2003), 483–85.

99. Vinterberg, quoted in Macnab, "The Big Tease." On the mobility of the camera in *The Celebration* also see Thomas Lind Laursen, "The Agitated Camera: A Diagnosis of Anthony Dod Mantle's Camera Work in *The Celebration*," *p.o.v.: A Danish Journal of Film Studies* 10 (Dec. 2000): 77–87.

100. White, review of *The Celebration*; Liam Lacey, review of *The Celebration*, *Globe and Mail*, Nov. 19, 1998, D3.

101. Jonathan Romney, review of *Festen*, *Guardian*, March 5, 1999, 8; Peter Matthews, review of *The Celebration*, *Sight and Sound* 9, no. 3 (March 1999): www.iipa.chadwyck.com (accessed Nov. 9, 2009).

102. Although there are standards for the output resolution of specific formats (for instance, 720 × 480 pixels for DVC, DVCAM, and Digital Betacam), final resolution is also bound up with (and, it has been argued, determined by) imaging resolution, which is variable with different digital cameras. See John Galt and Larry Thorpe, "Demystifying Digital Camera Specifications" (lecture, Panavision-Canon, April 3, 2008), www.freshdv.com/2008/05/demystifying-digital-camera-specs-part1.html (accessed Jan. 2, 2013). Also see Maxie D. Collier, *The IFILM Digital Video Filmmaker's Handbook* (Hollywood: IFILM, 2001): 8–9, 64. My thanks to Caveh Zahedi, Christopher Munch, and Matthew Weiss for help with this issue.

103. On high-definition video's resolution approaching that of 35mm film see Stephanie Argy, "Hi-Def Digital Offers Quality," *Variety*, July 30, 1999, special section. For James Cameron's remarks on the Sony 900 HD camera see Magid, "Exploring a New Universe," 48. On Digital Betacam's resolution see Holly Willis, "Electronic Age: Digital Filmmaking a Low-Budget Choice," *Variety*, July 16, 1998, 89. On "the limited resolving power of video as compared to film," see John Bailey, "Digital, Digital Getdown," *American Cinematographer*, Nov. 2000, 119.

104. On depth of field see Mike Figgis, *Digital Filmmaking* (New York: Faber and Faber, 2007), 23. On interlaced and progressive scan images see Stephanie Argy, "Shooting Digitally," *American Cinematographer*, April 2000,

75; and Stephanie Argy, "Striking 'Digital Prints,'" *American Cinematographer*, April 2001, 78.

105. Uta Briesewitz, quoted in Patricia Thomson, "Horror in Hi-Def," *American Cinematographer*, April 2001, 67; Bailey, "Digital, Digital Getdown," 119; Maryse Alberti, quoted in Argy, "Striking 'Digital Prints,'" 80–81.

106. Simons, *Playing the Waves*, 151; Romney, review of *Festen*. On these "ghost view" shots also see Lauren, "The Agitated Camera," 81. Edward Branigan discusses the way similar "perception shots" function in classical film (where the shots are more adamantly tied to a diegetic character who "experiences difficulty in seeing"), arguing that devices such as focus and lighting "become metaphors for vision" (Edward Branigan, *Point of View in the Cinema: A Theory of Narration and Subjectivity in Classical Film* [New York: Mouton, 1984], 80, 81 [emphasis removed]).

107. See Ellen Rees, "In My Father's House Are Many Mansions: Transgressive Space in Three Dogme 95 Films," *Scandinavica* 43, no. 2 (2004): 168.

108. Michael Schwartz, quoted in Argy, "Striking 'Digital Prints,'" 81. Also see Stephen Prince, "The Emergence of Filmic Artifacts: Cinema and Cinematography in the Digital Era," *Film Quarterly* 57, no. 3 (Spring 2004): 32.

109. See Collier, *Digital Video Filmmaker's Handbook*, 21, 111.

110. On the need for careful lighting see Maryse Alberti's comments in Argy, "Striking 'Digital Prints,'" 81. For reference to this debate and an advocacy of low-light digital cinematography see Figgis, *Digital Filmmaking*, 69.

111. Dod Mantle, quoted in Kelly, *The Name of This Book Is Dogme95*, 102.

112. See Jean Epstein, "Magnification," in *French Film Theory and Criticism: A History/Anthology*, vol. 1, *1907–1939*, ed. Richard Abel (Princeton, NJ: Princeton University Press, 1988), esp. 235, 238; and Béla Balázs, "The Close-Up" and "The Face of Man," in *Theory of the Film: Character and Growth of a New Art* (North Stratford, NY: Ayer, 1997), esp. 54–55, 65, 74–76.

113. For the suggestion that this aesthetic was appropriate to the subject matter, see Laursen, "The Agitated Camera," 77; Vinterberg, quoted in Macnab, "The Big Tease"; and Dod Mantle, quoted in Kelly, *The Name of This Book Is Dogme95*, 101.

114. See Mark J. P. Wolf, "A Brief History of Morphing," in *Meta-morphing: Visual Transformation and the Culture of Quick-Change*, ed. Vivian Sobchack (Minneapolis: University of Minnesota Press, 2000), 91–95.

115. Vivian Sobchack, "'At the Still Point of the Turning World': Meta-morphing and Meta Stasis," in Sobchack, *Meta-morphing*, 136. Also see Kevin Fisher, "Tracing the Tesseract: A Conceptual Prehistory of the Morph," in ibid., 118. For a discussion of the *Terminator 2* character and its relation to what is understood as a feminine sense of fluidity, see Scott Bukatman,

Terminal Identity: The Virtual Subject in Postmodern Science Fiction (Durham, NC: Duke University Press, 1993), 303–11.

116. See Sigmund Freud, *Beyond the Pleasure Principle*, trans. James Strachey (New York: Bantam, 1959). Sobchack, too, cites Freud's concept of the death instinct in opposition to the sense of becoming at the root of the morph. See Sobchack, "'At the Still Point of the Turning World,'" 145–46.

117. Fisher, "Tracing the Tesseract," 104.

118. Wolf, "A Brief History of Morphing," 96–97.

5. POINTS OF CONVERGENCE: CONCEPTUALIZING THE APPEAL OF 3D CINEMA THEN AND NOW

1. "Living in 3-D," *New York Times*, Oct. 19, 2009, A26.

2. See www.starwars.com/watch/episode-i-3d.html (accessed Jan. 2, 2013).

3. For acknowledgment of the similarity between Hollywood's crises in the 1950s and 2000s see Jonathan Bing, "Will Gizmos Give Biz New Juice?" *Variety*, March 21–27, 2005, 10; and Dave Kehr, "3-D's Quest to Move Beyond Gimmicks," *New York Times*, Jan. 10, 2010, MT3.

4. In an article published as I was completing final work on this manuscript, Thomas Elsaesser makes a strong case for the contemporary uniqueness of digital 3D (even as he contends that, if we account for applications of 3D beyond feature filmmaking, from science to the military, we recognize that the technology never actually went away). Whereas 3D tended to function as a special effect in 1950s Hollywood cinema, he contends, it is now participating in a broader movement toward "resetting our idea of what an image is, and, in the process, is changing our sense of spatial and temporal orientation and our embodied relation to data-rich simulated environments." A component of this argument is to point out that theatrical digital 3D cinema is really the "tail that wags the dog": in a situation where "a US theatrical release is now, economically speaking, merely an appendage to the Hollywood entertainment machine," promoting "3-D on the big screen *today*" is ultimately "a way of investing in 3-D on the small screen *tomorrow*" (Thomas Elsaesser, "The 'Return' of 3-D: On Some of the Logics and Genealogies of the Image in the Twenty-First Century," *Critical Inquiry* 39, no. 2 [Winter 2013]: 241, 221, 223, 228 [emphasis in original]).

5. For scholarly studies of 3D cinema also see, in particular, William Paul, "The Aesthetics of Emergence," *Film History* 5, no. 3 (1993): 321–55; John Belton, ed., "3-D Cinema," special issue, *Film History* 16, no. 3 (2004); Philip Sandifer, "Out of the Screen and into the Theater: 3-D Film as Demo," *Cinema Journal* 50, no. 3 (Spring 2011): 62–78; Barbara Klinger, "*Cave of Forgotten Dreams*: Meditations on 3D," *Film Quarterly* 65, no. 3 (Spring 2012): 38–43;

John Belton, "Digital 3D Cinema: Digital Cinema's Missing Novelty Phase," *Film History* 24, no. 2 (2012): 187–95; and Scott Higgins, "3D in Depth: *Coraline, Hugo*, and a Sustainable Aesthetic," *Film History* 24, no. 2 (2012): 196–209. Also see Miriam Ross's insightful article on the affective address of 3D in *Avatar*, which was also published as I completed work on this manuscript: Miriam Ross, "The 3-D Aesthetic: *Avatar* and Hyperhaptic Visuality," *Screen* 53, no. 4 (Winter 2012): 381–97.

6. The Sony IMAX Theater in New York opened in 1994 with a 3D screening of *Into the Deep* (Howard Hall, 1994); as of 2003 two-thirds of commercial IMAX screens were equipped for 3D. Ray Zone, *3-D Revolution: The History of Modern Stereoscopic Cinema* (Lexington: University Press of Kentucky, 2012), 180. On IMAX and IMAX 3D also see Charles R. Acland, "IMAX Technology and the Tourist Gaze," *Cultural Studies* 12, no. 3 (1998): 429–45; Alison Griffiths, *Shivers Down Your Spine: Cinema, Museums, and the Immersive View* (New York: Columbia University Press, 2008), 79–113; and Allison Whitney, "The Eye of Daedalus: A History and Theory of IMAX Cinema" (PhD diss., University of Chicago, 2005).

7. John Young, "10 Highlights in 3-D," *Variety*, June 18–24, 2007, A5; see also Belton, "Digital 3D Cinema," 191.

8. Bing, "Will Gizmos Give Biz New Juice?"

9. Belton, "Digital 3D Cinema," 191.

10. Ben Fritz and Nicole LaPorte, "3-D: The Eyes Have It!" *Variety*, Feb. 5–11, 2007, 1.

11. See Sharon Waxman, "Top Directors See the Future, and They Say It's in 3-D," *New York Times*, May 22, 2007; Peter Debruge, "Heavy Hitters Bet Big on Third Dimension," *Variety*, June 18–24, 2007, A5–A6; Pamela McClintock, "3-D Gives B.O. Another Dimension," *Variety*, Dec. 10–16, 2007, 10; Pamela McClintock, "Distribs Say Auds Ready for 3-D Vision," *Variety*, March 17–23, 2008, 7; and Manohla Dargis, "A New Eden, Both Cosmic and Cinematic," *New York Times*, Dec. 18, 2009, C1.

12. See Bing, "Will Gizmos Give Biz New Juice?"; Fritz and LaPorte, "3-D: The Eyes Have It!" 1; and McClintock, "Distribs Say Auds Ready for 3-D Vision," 10.

13. Hollywood ultimately embraced 3D television, with *Avatar* being used to promote Panasonic systems. See Charles R. Acland, "*Avatar* as Technological Tentpole," *Flow* 11, Jan. 22, 2010, http://flowtv.org/2010/01/avatar-as-technological-tentpole-charles-r-acland-concordia-university (accessed Jan. 3, 2013); and Brian Stelter and Brad Stone, "Television Begins a Push into the 3rd Dimension," *New York Times*, Jan. 5, 2010, A1. For Jeffrey Katzenberg's embrace of 3D television see Edward C. Baig, "3D Gets Close Enough to Touch," *USA Today*, Jan. 6, 2010, B1. On piracy of *Avatar* see Dave Itzkoff, "'Avatar' Commandeers Film Piracy Record," *New York Times*, Jan. 5, 2010.

For speculation that interest in 3D might be waning, see Daniel Engber, "Is 3-D Dead in the Water?" *Slate*, August 24, 2010, www.slate.com/articles/arts/culturebox/2010/08/is_3d_dead_in_the_water.html (accessed Jan. 3, 2013); and Kristin Thompson's blog posts, "Do Not Forget to Return Your 3D Glasses" (July 27, 2011) and "As the Summer Winds Down, Is 3D Doing the Same?" (August 30, 2011), www.davidbordwell.net (accessed Jan. 3, 2013).

14. For a discussion of these factors see Rob Hummel, "3-D Cinematography," *American Cinematographer*, April 2008, 52–63. Although a common belief has been that interocular distance should approximate the spacing of the human eyes, engineers insist that the interocular distance between the taking lenses must take into account the conditions of projection. See ibid., 53; and John A. Norling, "Basic Principles of 3-D Photography and Projection," in *New Screen Techniques*, ed. Martin Quigley Jr. (New York: Quigley Publishing, 1953), 37–39.

15. See Debra Kaufman, "The Big Picture," *American Cinematographer*, May 1998, 84, 86–87; Nora Lee, "Exploring a New Dimension," *American Cinematographer*, August 2001, 80–84; and Jay Holben, "Taking the Plunge," *American Cinematographer*, July 2003, 58–71.

16. See Holben, "Taking the Plunge," 63; John Calhoun, "Voyage to the Bottom of the Sea," *American Cinematographer*, March 2005, 61; and Jay Holben, "Conquering New Worlds," *American Cinematographer*, Jan. 2010, 32.

17. See Higgins, "3D in Depth," 200.

18. Single-strip systems for analog 3D both predated the 1950s and marked the brief 3D boom in the 1980s; however, these systems still displayed problematic discrepancies between the frame pairs (due to uneven illumination and differences in center spacing)—as well as the dimness also attributed to digital 3D. See Zone, *3-D Revolution*, 79–91. On the differences among digital 3D systems see Hummel, "3-D Cinematography," 60–61; and David S. Cohen, "Three-Way Battle over 3-D Starts to Heat Up," in "Cinema Expo/3-D: The Killer App," special section, *Variety*, June 16–22, 2008, A1, A4. On the supposed superiority of integrated digital prints see Fritz and LaPorte, "3-D: The Eyes Have It!" 1. On the loss of light with digital 3D projection see Belton, "Digital 3D Cinema," 191–92.

19. For the claim that contemporary 3D is more comfortable than 1950s 3D, see Holben, "Taking the Plunge," 63; and Fritz and LaPorte, "3-D: The Eyes Have It!" 1.

20. See Rob Engle's comments in Zone, *3-D Revolution*, 370.

21. Higgins, "3D in Depth," 198.

22. Ibid., 207.

23. See, e.g., McClintock, "3-D Gives B.O. Another Dimension," 10; McClintock, "Distribs Say Auds Ready for 3-D Vision," 7; "Living in 3-D"; and Dargis, "A New Eden."

24. Scholars have identified this move away from emergence as problematic for 3D's appeal. See Kristin Thompson, "Has 3D Already Failed? The Sequel, Part Two: RealDsgusted," Jan. 25, 2011, www.davidbordwell. net/blog/2011/01/25/has-3d-already-failed-the-sequel-part-2-realdsgusted (accessed Jan. 3, 2013); and Belton, "Digital 3D Cinema," 194.

25. See Belton, "Digital 3D Cinema," 190.

26. Michael Lewis, cited in Debruge, "Heavy Hitters Bet Big on Third Dimension," A6. Also see Michael Hiltzik, "3-D Method Auditions for Serious Film Role," *Los Angeles Times*, Nov. 14, 2005, C1; and "Cinema Expo/3-D: The Killer App," *V Plus* special section, *Variety*, June 16–22, 2008, A1–A4.

27. David Halbfinger, "Studios Announce a Deal to Help Cinemas Go 3-D," *New York Times*, March 12, 2008; David Halbfinger, "With Theaters Barely Digital, Studios Push 3-D," *New York Times*, March 13, 2008. Also see McClintock, "Distribs Say Auds Ready for 3-D Vision."

28. *Hollywood Reporter*, cited in Kristin Thompson, "Has 3D Already Failed: The Sequel, Part One: RealDlighted," Jan. 20, 2011, www.davidbordwell.net/ blog/2011/01/20/has-3d-already-failed-the-sequel-part-one-realdlighted (accessed Jan. 3, 2013); Curtis Clark, quoted in Simon Wakelin, "3-D, New Camera Assessments on Technology Committee's Agenda," *American Cinematographer*, Dec. 2010, 92.

29. Motion Picture Association of America, 2011 Theatrical Market Statistics Report, 6, www.mpaa.org/policy/industry (accessed Jan. 3, 2013).

30. Lev Manovich, *The Language of New Media* (Cambridge, MA: MIT Press, 2002), 245. Also see Thomas Elsaesser, "Digital Cinema: Delivery, Event, Time," in *Cinema Futures: Cain, Abel or Cable?* ed. Thomas Elsaesser and Kay Hoffmann (Amsterdam: Amsterdam University Press, 1998), 217–18; and Elsaesser, "The 'Return' of 3-D," 240–43.

31. Elsaesser, "The 'Return' of 3-D," 238.

32. L. Lumière, "Stereoscopy on the Screen," *Journal of the Society of Motion Picture Engineers* 27 (Sept. 1936): 318.

33. James Cameron, quoted in Holben, "Taking the Plunge," 63.

34. Raymond Spottiswoode and Nigel Spottiswoode, *The Theory of Stereoscopic Transmission and Its Application to the Motion Picture* (Berkeley: University of California Press, 1953), 156. John Norling, as well as the Spottiswoodes, advocated endowing the stereo window with a clearly delineated frame, something that could be achieved by coinciding the field margins in front of the profilmic objects. See J. A. Norling, "Three-Dimensional Motion Pictures," *Journal of the Society of Motion Picture Engineers* 33 (Dec. 1939): 625–26; and Spottiswoode and Spottiswoode, *The Theory of Stereoscopic Transmission and Its Application to the Motion Picture*, 45.

35. Sergei Eisenstein, "About Stereoscopic Cinema," trans. Catherine de la Roche, *Penguin Film Review* 8 (Jan. 1949): 37. Semen Ivanov, who developed

the 3D system used for *Robinson Crusoe*, is sometimes named as the director of that film. On Ivanov and *Robinson Crusoe*, see Nikolai Mayorov, "A First in Cinema . . . Stereoscopic Films in Russia and the Soviet Union," *Studies in Russian & Soviet Cinema* 6, no. 2 (Sept. 2012): 217–39.

36. Raymond Spottiswoode, "Progress in Three-Dimensional Films at the Festival of Britain," *Journal of the Society of Motion Picture and Television Engineers* 58 (April 1952): 303. On Zeiss Ikon and Raumfilm see R. M. Hayes, *3-D Movies: A History and Filmography of Stereoscopic Cinema* (Jefferson, NC: McFarland, 1989), 10–12; and Ray Zone, *Stereoscopic Cinema and the Origins of 3-D Film, 1838–1952* (Lexington: University Press of Kentucky, 2007), 153–55.

37. See Sheldon Hall's analysis of the way Alfred Hitchcock utilizes this new spatiality as a "mechanism for the production of suspense" in *Dial M for Murder*. Sheldon Hall, "Dial M for Murder," *Film History* 16, no. 3 (2004): 246.

38. Eisenstein, "About Stereoscopic Cinema," 42.

39. Oliver Wendell Holmes, "The Stereoscope and the Stereograph," 75 (emphasis in original).

40. Wim Wenders, quoted in Benjamin B, "Wim Wenders: About *Pina* & 3D," blog for the American Society of Cinematographers, Sept. 9, 2011, www.theasc.com/asc_blog/thefilmbook/2011/09/09/wim-wenders-about-pina-3d (accessed Jan. 3, 2013) (emphasis in original).

41. On the stereoscope's role in foregrounding the embodiment of vision in the nineteenth century—wherein, significantly, tangibility "has been transformed into a purely visual experience" (124)—see Jonathan Crary, *Techniques of the Observer: On Vision and Modernity in the Nineteenth Century* (Cambridge, MA: MIT Press, 1990), esp. 116–36.

42. James Lastra notes that such claims about 3D cinema's capacity to simulate human perception come into conflict with representational norms. See James Lastra, *Sound Technology and the American Cinema: Perception, Representation, Modernity* (New York: Columbia University Press, 2000), 220–21.

43. Holben, "Taking the Plunge," 63.

44. On the distraction posed by the glasses see "An Eyeful at the Movies," *Life*, Dec. 15, 1952, 146; and Dave Itzkoff, "An Open Plea to the Makers of 3-D Movies," *New York Times*, June 15, 2009. On the frequency of complaints about headaches see Kristin Thompson, "Has 3D Already Failed? The Sequel, Part Two: RealDsgusted." For attribution of eyestrain to problems in production and projection see Norling, "Basic Principles of 3-D Photography and Projection," 35–36, 51. For attribution of eyestrain and headaches to anomalies in viewers' vision see Roger Ebert, "Why I Hate 3-D (And You Should Too)," *Newsweek*, May 9, 2010, www.thedailybeast.com/newsweek/2010/04/30/why-i-hate-3-d-and-you-should-too.html (accessed Jan. 3, 2013). In the 1950s

claims circulated that 3D spectatorship was actually therapeutic for the eyes. See M. L. Gunzburg, "What Is Natural Vision?" in Quigley, *New Screen Techniques*, 57; and Groverman Blake, review of *Bwana Devil*, *Cincinnati Times-Star*, Feb. 14, 1953, 5. In *Bwana Devil* (Cinema 1952) clipping file, Theatre Collection, New York Public Library for the Performing Arts, Lincoln Center.

45. For discussions of the disjuncture between convergence and focus see William H. Ryan, "Polaroid and 3-D Films," in Quigley, *New Screen Techniques*, 31; and Roger Ebert, "Why 3D Doesn't Work and Never Will. Case Closed," *Roger Ebert's Journal*, Jan. 23, 2011, http://blogs.suntimes.com/ebert/2011/01/post_4.html (accessed Jan. 3, 2013).

46. Hummel, "3-D Cinematography," 56.

47. Norling, "Basic Principles of 3-D Photography and Projection," 38–40. Raymond and Nigel Spottiswoode portrayed these forms of distortion as creative possibilities. See Spottiswoode and Spottiswoode, *The Theory of Stereoscopic Transmission and Its Application to the Motion Picture*, 5. Also see Scott Higgins's discussion of *Coraline*'s manipulation of interocular distance as an expressive tool (Higgins, "3D in Depth," 199–206).

48. Norling, "Three-Dimensional Motion Pictures," 617.

49. Dave Kehr, "3-D or Not 3-D," *Film Comment* 46, no. 1 (Jan.-Feb. 2010): 65. Norling explains that "if the viewing angle is greater than the camera angle the scene will appear to shrink in depth; objects will appear to become flatter" (Norling, "Three-Dimensional Motion Pictures," 621). This observation emphasizes the fact that, with 3D, the appearance of the film is dependent on the viewer's situation in the theater; different seats yield different cinematic images. On this point also see Rob Hummel, "3-D Cinematography," 56.

50. Bob Furmanek and Greg Kintz, "An In-depth Look at *Creature from the Black Lagoon*," 3-D Film Archive, www.3dfilmarchive.com/an-in-depth-look-at-creature-from-the-black-lagoon-1 (accessed Jan. 7, 2013).

51. Mort Blumenstock, "The 'House of Wax' Campaign," in Quigley, *New Screen Techniques*, 97.

52. I owe thanks to Quentin Gille for sharing his collection of 1950s 3D poster images.

53. Keith M. Johnston, "Three Times as Thrilling! The Lost History of 3-D Trailer Production, 1953–54," *Journal of Popular Film and Television* 36, no. 3 (2008): 152.

54. Spottiswoode and Spottiswoode, *The Theory of Stereoscopic Transmission and Its Application to the Motion Picture*, 4.

55. See Aldous Huxley, *Brave New World* (New York: Harper and Brothers, 1946), 198–202.

56. See Johnston, "Three Times as Thrilling!" 156. Also see Rick Mitchell, "The Tragedy of 3-D Cinema," *Film History* 16, no. 3 (2004): 212; and Peter

Lev, *The Fifties: Transforming the Screen, 1950–1959* (Berkeley: University of California Press, 2003), 111.

57. The widescreen-format trailer Johnston mentions in his discussion of *How to Marry a Millionaire* differs from the Academy-ratio theatrical trailer I discuss in chapter 1; however, both trailers link CinemaScope with the bodies of the film's female stars.

58. Johnston, "Three Times as Thrilling!" 156, 159, 157.

59. Paul, "The Aesthetics of Emergence," 337–39.

60. Ibid., 345.

61. William Paul, "Breaking the Fourth Wall: 'Belascoism,' Modernism, and a 3-D *Kiss Me Kate*," *Film History* 16, no. 3 (2004): 230; see also Sandifer, "Out of the Screen and into the Theater," 69, 73. As one contemporary observer described his experience of a 3D movie: objects "hurtled out of the screen with terrifying imminence. But nothing ever touched me" (Weare Holbrook, "My 3-D Black Eye," MFL + 2393 folder, Theatre Collection, New York Public Library for the Performing Arts).

62. André Bazin, "The Myth of Total Cinema," in *What Is Cinema?* ed. and trans. Hugh Gray (Berkeley: University of California Press, 1967), 1:20; André Bazin, "Will CinemaScope Save the Cinema?" *Velvet Light Trap* 21 (Summer 1985): 13.

63. "Living in 3-D." Also see Jim Gianopulos, quoted in McClintock, "3-D Gives B.O. Another Dimension," 10.

64. Eisenstein, "About Stereoscopic Cinema," 38.

65. Dr. Land, cited in Ryan, "Polaroid and 3-D Film," 33 (emphasis in original). For the claim that Land's polarization process contributed to the 1950s 3D boom, see Kehr, "3-D's Quest to Move Beyond Gimmicks."

66. M. L. Gunzburg, "What Is Natural Vision?" in Quigley, *New Screen Techniques*, 59. On Gunzburg, Natural Vision, and *Bwana Devil* see Zone, *3-D Revolution*, 7–16.

67. Jim Gianopulos, quoted in McClintock, "3-D Gives B.O. Another Dimension," 10.

68. Claudio Miranda, quoted in Noah Kadner, "Back to the Grid," *American Cinematographer*, Jan. 2011, 54.

69. Jeffrey Katzenberg, "Katzenberg Defends 3-D as Format of the Future," *Variety*, Sept. 29, 2008, 11. On DreamWorks' commitment to 3D see Debruge, "Heavy Hitters Bet Big on Third Dimension," A5.

70. Jon Landau, quoted in Sharon Waxman, "Top Directors See the Future."

71. James Cameron, quoted in Leslie Felperin, "That's Entertainment," *Sight and Sound* 13, no. 6 (June 2003): 10.

72. James Cameron, quoted in Michael Cieply and Brooks Barnes, "Studios Bring Another Dimension to Comic-Con," *New York Times*, July 24, 2009, B1.

73. Jules O'Loughlin, quoted in Gary Simon, "Total Immersion," *American Cinematographer*, Feb. 2011, 37.

74. Roger Ebert, "Why I Hate 3-D (And You Should Too)."

75. Kristin Thompson, "Has 3D Already Failed? The Sequel, Part Two: RealDsgusted."

76. Sara Ross, "Invitation to the Voyage: The Flight Sequence in Contemporary 3D Cinema," *Film History* 24, no. 2 (2012): 210.

77. Describing his work on *Aliens of the Deep*, Cameron contended, "We're drawing exploration analogs between the deep ocean and outer space" (quoted in Calhoun, "Voyage to the Bottom of the Sea," 59). Also see Klinger, "*Cave of Forgotten Dreams*," 40. We also find this emphasis on exploration in 3D industrials. See Ray Zone, "Into the Third Dimension: Canon Brings 3-D to Video," *American Cinematographer*, August 2001, 94; and Ray Zone, "Pushing Stereoscopy: A Unique 3-D Video System," *American Cinematographer*, Sept. 2002, 105.

78. On ride films see Lauren Rabinovitz, "More Than the Movies: A History of Somatic Visual Culture Through *Hale's Tours*, Imax, and Motion Simulation Rides," in *Memory Bytes: History, Technology, and Digital Culture*, ed. Lauren Rabinovitz and Abraham Geil (Durham, NC: Duke University Press, 2004), 99–125.

79. Tom Gunning, "Landscape and the Fantasy of Moving Pictures: Early Cinema's Phantom Rides," in *Cinema and Landscape: Film, Nation and Cultural Geography*, ed. Jonathan Rayner and Graeme Harper (Bristol, UK: Intellect, 2010), 31–70.

80. See Kevin Heffernan, *Ghouls, Gimmicks, and Gold: Horror Films and the American Movie Business, 1953–1968* (Durham, NC: Duke University Press, 2004), 38–41. Also see Frank D. McConnell, "Song of Innocence: The Creature from the Black Lagoon," *Journal of Popular Film* 2, no. 1 (Winter 1973): 15–28; Mark Jancovich, *Rational Fears: American Horror in the 1950s* (Manchester: Manchester University Press, 1996), 167–95; and J. P. Telotte, "Making Telecontact: 3-D Film and *The Creature from the Black Lagoon*," *Extrapolation* 45, no. 3 (Fall 2004): 294–304.

81. In addition to the works cited above see Cyndy Hendershot, "The Bomb and Sexuality: *Creature from the Black Lagoon* and *Revenge of the Creature*," *Literature and Psychology* 45, no. 4 (1999): 74–89; and Gerhard Wisenfeldt, "Dystopian Genesis: The Scientist's Role in Society, According to Jack Arnold," *Film and History* 40, no. 1 (Spring 2010): 58–74. For similar readings of monster movies generally see Noël Carroll, "Back to Basics," *Wilson Quarterly* 10, no. 3 (Summer 1986): 61; Walter Evans, "Monster Movies: A Sexual Theory," in *Movies as Artifacts: Cultural Criticism of Popular Film*, ed. Michael T. Marsden, John G. Nachbar, Sam L. Grogg Jr. (Chicago: Nelson-Hall, 1982), 129–36;

Brian Murphy, "Monster Movies: They Came from Beneath the Fifties," in ibid., 176–88; and Margaret Tarratt, "Monsters from the Id," in *Film Genre Reader II*, ed. Barry Keith Grant (Austin: University of Texas Press, 1995), 330–49.

82. Lois Banner, "The Creature from the Black Lagoon: Marilyn Monroe and Whiteness," *Cinema Journal* 47, no. 4 (Summer 2008): 4–29.

83. Heffernan, *Ghouls, Gimmicks, and Gold*, 24.

84. See Paul, "The Aesthetics of Emergence," 337, 331.

85. Philip Sandifer observes that such emergent objects tend not to move directly toward the viewer but, rather, follow paths that, "if continued, would push them around the audience." This avoids a situation in which an object could appear visually—yet fail materially—to collide with the viewer. See Sandifer, "Out of the Screen and into the Theater," 72–73.

86. See Elsaesser, "The 'Return' of 3-D," 236.

87. See Paul, "The Aesthetics of Emergence," 335.

88. Heffernan, *Ghouls, Gimmicks, and Gold*, 39. Also see McConnell, "Song of Innocence," 22.

89. See Furmanek and Kintz, "An In-depth Look at *Creature from the Black Lagoon*."

90. Telotte, "Making Tele-contact," 296. Rather than emphasizing only emergence, Telotte suggests that this reach can move both into and out of the diegesis. He identifies both viewers' apparent capacity to "reach at a distance" and what he sees "as its correlative, the capacity of what we saw to 'reach' each of us in various ways" (ibid).

91. *Revenge of the Creature* (Jack Arnold, 1955) ends with a similar shot of the Creature descending in the water.

92. Rjurik Davidson estimates the film's budget at approximately $250 million for production and $150 million for promotion. See Rjurik Davidson, "Avatar: Evaluating a Film in a World of Its Own," *Screen Education* 57 (2010): 12. As of January 2013, *Avatar* retains its status as the most lucrative film ever, both domestically and worldwide. See http://boxofficemojo.com/alltime (accessed Jan. 3, 2013).

93. John Scott Lewinski, "The 3-D Revolution," *Popular Science*, Jan. 2010, 60. Also see, e.g., Dargis, "A New Eden"; and Kenneth Turan, review of *Avatar*, *Los Angeles Times*, Dec. 17, 2009, D1.

94. Caleb Crain, cited in Joshua Clover, "The Struggle for Space," *Film Quarterly* 63, no. 3 (Spring 2010): 6. Rob White notes the term *avatar*'s "conjunction of mysticism (Hindu divine incarnation) and computer jargon (on-screen user graphic)" (Rob White, "Only Connect," *Film Quarterly* 63, no. 3 [Spring 2010]: 5). On the origin and religious uses of the term also see Kirsten Strayer, "Reinventing the Inhuman: Avatars, Cylons, and *Homo Sapiens* in

Contemporary Science-Fiction Television Series," *Literature Film Quarterly* 38, no. 3 (July 2010): 195–96.

95. See Ian Christie, "Clash of the Wonderlands: 3D Cinema," *Sight and Sound* 21, no. 11 (Nov. 2011): http://old.bfi.org.uk/sightandsound/feature/49789 (accessed Jan. 3, 2013).

96. Armond White, "The Lost Dimension," *First Things* (June/July 2010): 77. Also see Christie, "Clash of the Wonderlands."

97. McGowan claims that "spectators have reported severe depression after leaving screenings of *Avatar* and . . . support groups for dealing with post-viewing melancholia have even cropped up" (Todd McGowan, "Maternity Divided: *Avatar* and the Enjoyment of Nature," *Jump Cut* 52 [2010]: www.ejumpcut.org/archive/jc52.2010/mcGowanAvatar/index.html [accessed Jan. 3, 2013]).

98. White, "The Lost Dimension," 77.

99. Thomas Elsaesser, *The Persistence of Hollywood* (New York: Routledge, 2012), 290–95.

100. Clover, "The Struggle for Space," 7.

101. James Cameron, quoted in Erik Hedegaard, "The Impossible Reality of James Cameron," *Rolling Stone*, Dec. 24, 2009–Jan. 7, 2010, 95.

102. Clover, "The Struggle for Space," 7.

103. Hedegaard, "The Impossible Reality of James Cameron"; Joe Morgenstern, "*Avatar*: The Unreal Thing," *Wall Street Journal*, Dec. 18, 2009, http://online.wsj.com/article/SB10001424052748704238104574601950676501972.html?mod=article-outset-box (accessed Jan. 5, 2013).

104. Manohla Dargis, "Floating in the Digital Experience," *New York Times*, Jan. 3, 2010, AR1.

105. Kehr, "3-D or Not 3-D," 66–67.

106. Miriam Ross argues that the use of depth in 3D films such as *Avatar* extends such a tactile address, creating a "hyperhaptic visuality" (Ross, "The 3-D Aesthetic," 383–84).

107. Also see Ross, "Invitation to the Voyage," 215–19; and Klinger, "*Cave of Forgotten Dreams*," 40.

108. Ross, "The 3-D Aesthetic," 390.

109. Hedegaard, "The Impossible Reality of James Cameron"; Holben, "Conquering New Worlds," 35–36.

110. Kristen Whissel, "Tales of Upward Mobility: The New Verticality and Digital Special Effects," *Film Quarterly* 59, no. 4 (Summer 2006): 26.

111. Ibid., 26, 25, 33.

112. Scott Bukatman, *Matters of Gravity: Special Effects and Supermen in the 20th Century* (Durham, NC: Duke University Press, 2003), 3, xiii, 7, 125.

113. See John Belton, *Widescreen Cinema* (Cambridge, MA: Harvard University Press, 1992), 89–90.

114. Review of *How to Marry a Millionaire*, *Variety*, Nov. 11, 1953, 6.

115. On the distinction between the T-100 and T-1000 cyborgs in *Terminator 2*, see Scott Bukatman, *Terminal Identity: The Virtual Subject in Postmodern Science Fiction* (Durham, NC: Duke University Press, 1993), 304–11. Also see Elsaesser, *The Persistence of Hollywood*, 299.

116. Erkki Huhtamo, "Encapsulated Bodies in Motion: Simulators and the Quest for Total Immersion," in *Critical Issues in Electronic Media*, ed. Simon Penny (Albany: State University of New York Press, 1995), 170, 177.

117. See Oliver Grau, *Virtual Art: From Illusion to Immersion*, trans. Gloria Custance (Cambridge, MA: MIT Press, 2003), 4–5, 155–57. Trumbull reputedly wanted, but was unable, to use his 65mm Showscan system—which, like widescreen, attempted to provide an immersive experience by employing a larger, curved screen (as well as, in Showscan's case, a sixty-frames-per-second shutter speed)—to shoot *Brainstorm*. See Julie Turnock, "Plastic Reality: Special Effects, Art and Technology in 1970s U.S. Filmmaking" (PhD diss., University of Chicago, 2008), 313. Turnock, too, underscores the resonance between the immersive cinematic experience offered by Showscan and the virtual reality depicted by the film (299–315).

118. On the "synaesthetic" and "coenaesthetic" experience of cinema see Vivian Sobchack, "What My Fingers Knew: The Cinesthetic Subject, or Vision in the Flesh," *Carnal Thoughts: Embodiment and Moving Image Culture* (Berkeley: University of California Press, 2004), esp. 67–69.

119. The brochure for the CinemaScope demonstration screenings includes a photograph of three men, standing at different points in front of a giant CinemaScope screen, the caption reading: "Curved CinemaScope screen dwarfs men standing in front of it" (brochure for CinemaScope demonstration screenings, CinemaScope: clippings, 1950–1969 folder, Theatre Collection, New York Public Library for the Performing Arts). The same photograph, with a caption reading "20th Century–Fox's CinemaScope screen . . . dwarfs the individual," appears accompanying William R. Weaver, "20th-Fox Will Cast Its Lot with CinemaScope," *Motion Picture Herald*, March 21, 1953, 19.

SELECTED BIBLIOGRAPHY

Abel, Richard, ed. *French Film Theory and Criticism: A History/Anthology*. Vol. 1, *1907–1939*. Princeton, NJ: Princeton University Press, 1988.

Acland, Charles R. "*Avatar* as Technological Tentpole." *Flow* 11 (Jan. 22, 2010), http://flowtv.org/2010/01/avatar-as-technological-tentpole-charles-r-acland-concordia-university.

——. "Curtains, Carts and the Mobile Screen." *Screen* 50, no. 1 (Spring 2009): 148–66.

——. "IMAX Technology and the Tourist Gaze." *Cultural Studies* 12, no. 3 (1998): 429–45.

——. *Swift Viewing: The Popular Life of Subliminal Influence*. Durham, NC: Duke University Press, 2012.

Adorno, Theodor. *The Culture Industry: Selected Essays on Mass Culture*. Edited by J. M. Bernstein. London: Routledge, 1991.

Adorno, Theodor, and Max Horkheimer. *Dialectic of Enlightenment: Philosophical Fragments*. Edited by Gunzelin Schmid Noerr. Translated by Edmund Jephcott. Stanford: Stanford University Press, 2002.

Agamben, Giorgio. *What Is an Apparatus? And Other Essays*. Translated by David Kishik and Stefan Pedatella. Stanford: Stanford University Press, 2009.

Allen, Michael. "Digital Cinema: Virtual Screens." In *Digital Cultures*, edited by Glen Creeber and Royston Martin, 61–85. Berkshire, UK: McGraw Hill, 2009.

——. "From *Bwana Devil* to *Batman Forever*: Technology in Contemporary Hollywood Cinema." In Neale and Smith, *Contemporary Hollywood Cinema*, 109–29.

Altman, Rick. *Silent Film Sound*. New York: Columbia University Press, 2004.

Anderson, Christopher. *Hollywood TV: The Studio System in the Fifties*. Austin: University of Texas Press, 1994.

Andrew, Dudley. *What Cinema Is! Bazin's Quest and Its Charge*. Chichester, West Sussex, UK: Wiley-Blackwell, 2010.

Andrew, Dudley, and Hervé Joubert-Laurencin, eds. *Opening Bazin: Postwar Film Theory and Its Afterlife*. Oxford: Oxford University Press, 2011.

Arnheim, Rudolf. *Film as Art*. Berkeley: University of California Press, 1957.

Balázs, Béla. *Theory of the Film: Character and Growth of a New Art*. North Stratford, NY: Ayer, 1997.

Balides, Constance. "Immersion in the Virtual Ornament: Contemporary 'Movie Ride' Films." In *Rethinking Media Change: The Aesthetics of Transition*, edited by David Thorburn and Henry Jenkins, 315–36. Cambridge, MA: MIT Press, 2003.

Balio, Tino, ed. *Hollywood in the Age of Television*. Boston: Unwin Hyman, 1990.

Banner, Lois W. "The Creature from the Black Lagoon: Marilyn Monroe and Whiteness." *Cinema Journal* 47, no. 4 (Summer 2008): 4–29.

Barker, Jennifer M. *The Tactile Eye: Touch and the Cinematic Experience*. Berkeley: University of California Press, 2009.

Barr, Charles. "CinemaScope: Before and After." *Film Quarterly* 16, no. 4 (Summer 1963): 4–24.

Barthes, Roland. *Camera Lucida: Reflections on Photography*. Translated by Richard Howard. New York: Farrar, Straus and Giroux, 1981.

——. "On CinemaScope." Translated by Jonathan Rosenbaum. JonathanRosenbaum.com. Jan. 10, 1983. www.jonathanrosenbaum.com/?p=20187.

Baty, Paige S. *American Monroe: The Making of a Body Politic*. Berkeley: University of California Press, 1995.

Baudrillard, Jean. *The Ecstasy of Communication*. Translated by Bernard Schutze and Caroline Schutze. Edited by Sylvère Lotringer. New York: Semiotext(e), 1988.

——. *Simulations*. Translated by Paul Foss, Paul Patton, and Philip Beitchman. New York: Semiotext(e), 1983.

Baudry, Jean-Louis. "The Apparatus: Metapsychological Approaches to the Impression of Reality in Cinema." In Rosen, *Narrative, Apparatus, Ideology*, 299–318.

——. "Ideological Effects of the Basic Cinematographic Apparatus." In Rosen, *Narrative, Apparatus, Ideology*, 286–98.

Bazin, André. "The End of Montage." Translated by Catherine Jones and Richard Neupert. *Velvet Light Trap* 21 (Summer 1985): 14–15.

——. "A Little Late." Translated by Catherine Jones and Richard Neupert. *Velvet Light Trap* 21 (Summer 1985): 15–16.

——. *What Is Cinema?* Edited and translated by Hugh Gray. 2 vols. Berkeley: University of California Press, 1967–71.

——. "Will CinemaScope Save the Cinema?" Translated by Catherine Jones and Richard Neupert. *Velvet Light Trap* 21 (Summer 1985): 8–14.

Bean, Jennifer. "Technologies of Early Stardom and the Extraordinary Body." *Camera Obscura* 16, no. 3.48 (2001): 9–57.

Behlmer, Rudy, ed. *Memo from Darryl F. Zanuck: The Golden Years at Twentieth Century–Fox.* New York: Grove, 1993.

Belton, John. "CinemaScope: The Economics of Technology." *Velvet Light Trap* 21 (Summer 1985): 35–43.

——. "CinemaScope and Historical Methodology." *Cinema Journal* 28, no. 1 (Autumn 1988): 22–44.

——. "The Curved Screen." *Film History* 16, no. 3 (2004): 277–85.

——. "Digital Cinema: A False Revolution." *October* 100 (Spring 2002): 98–114.

——. "Digital 3D Cinema: Digital Cinema's Missing Novelty Phase." *Film History* 24, no. 2 (2012): 187–95.

——. "Fox and 50mm Film." In Belton, Hall, and Neale, *Widescreen Worldwide*, 9–24.

——. "Glorious Technicolor, Breathtaking CinemaScope, and Stereophonic Sound." In Balio, *Hollywood in the Age of Television*, 185–211.

——. "Painting by the Numbers: The Digital Intermediate." *Film Quarterly* 61, no. 3 (Spring 2008): 58–65.

——. *Widescreen Cinema.* Cambridge, MA: Harvard University Press, 1992.

Belton, John, Sheldon Hall, and Steve Neale, eds. *Widescreen Worldwide.* New Barnet, Herts, UK: John Libbey, 2010.

Benford, James R. "The CinemaScope Optical System." *Journal of the Society of Motion Picture and Television Engineers* 62 (Jan. 1954): 64–70.

Benjamin, Walter. *Selected Writings.* Edited by Michael W. Jennings et al. Translated by Rodney Livingstone, Edmund Jephcott, Howard Eiland, et al. 4 vols. Cambridge, MA: Harvard University Press, 1996–2003.

"The Big Screens." *Sight and Sound* 24, no. 4 (Spring 1955): 209–12.

Binkley, Timothy. "Camera Fantasia: Computed Visions of Virtual Realities." *Millennium Film Journal* 20–21 (Fall-Winter 1988–89): 7–43.

Bolter, Jay David, and Richard Grusin. *Remediation: Understanding New Media.* Cambridge, MA: MIT Press, 1999.

Bondebjerg, Ib. "Dogma 95 and the New Danish Cinema." In Hjort and MacKenzie, *Purity and Provocation*, 70–85.

Bordwell, David. *Figures Traced in Light: On Cinematic Staging.* Berkeley: University of California Press, 2005.

——. "Intensified Continuity: Visual Style in Contemporary American Film." *Film Quarterly* 55, no. 3 (2002): 16–28.

——. *On the History of Film Style.* Cambridge, MA: Harvard University Press, 1997.

——. *Pandora's Digital Box: Films, Files, and the Future of Movies.* Madison, WI: Irvington Way Institute Press, 2012.

——. *Poetics of Cinema.* New York: Routledge, 2008.

——. "Widescreen Aesthetics and Mise en Scene Criticism." *Velvet Light Trap* 21 (Summer 1985): 18–25.

Bordwell, David, and Noël Carroll, eds. *Post-Theory: Reconstructing Film Studies.* Madison: University of Wisconsin Press, 1996.

Bordwell, David, Janet Staiger, and Kristin Thompson. *The Classical Hollywood Cinema: Film Style & Mode of Production to 1960.* New York: Columbia University Press, 1985.

Bragg, Herbert E. "The Development of CinemaScope." *Film History* 2 (1988): 359–71.

Branigan, Edward. *Point of View in the Cinema: A Theory of Narration and Subjectivity in Classical Film.* Berlin: Mouton, 1984.

Braudy, Leo. "'No Body's Perfect': Method Acting and 50s Culture." *Michigan Quarterly Review* 35 (1996): 191–215.

Brooker, Will. "New Hope: The Postmodern Project of *Star Wars*." In *Liquid Metal: The Science Fiction Film Reader*, edited by Sean Redmond, 298–307. London: Wallflower, 2004.

——. *Using the Force: Creativity, Community and "Star Wars" Fans.* New York: Continuum, 2002.

Brooks, Peter. *The Melodramatic Imagination: Balzac, Henry James, Melodrama, and the Mode of Excess.* New Haven, CT: Yale University Press, 1995.

Buckland, Warren. "Between Science Fact and Science Fiction: Spielberg's Digital Dinosaurs, Possible Worlds, and the New Aesthetic Realism." *Screen* 40, no. 2 (Summer 1999): 177–92.

Buck-Morss, Susan. "Aesthetics and Anaesthetics: Walter Benjamin's Artwork Essay Reconsidered." *October* 62 (Autumn 1992): 3–41.

Bukatman, Scott. *Matters of Gravity: Special Effects and Supermen in the 20th Century.* Durham, NC: Duke University Press, 2003.

——. *Terminal Identity: The Virtual Subject in Postmodern Science Fiction.* Durham, NC: Duke University Press, 1993.

Byron, Stuart, and Martin L. Rubin. "Elia Kazan Interview." *Movie* 19 (Winter 1971–72): 1–13.

Caputi, Jane. "Seeing Elephants: The Myths of Phallotechnology." *Feminist Studies* 14, no. 3 (Autumn 1988): 487–524.

Carroll, Noël. "Back to Basics." *Wilson Quarterly* 10, no. 3 (Summer 1986): 58–69.

——. *The Philosophy of Horror; or, Paradoxes of the Heart.* New York: Routledge, 1990.

Casetti, Francesco. *Eye of the Century: Film, Experience, Modernity.* Translated by Erin Larkin with Jennifer Pranolo. New York: Columbia University Press, 2008.

Castells, Manuel. *The Rise of the Network Society.* 2nd ed. Malden, MA: Blackwell, 2000.

Charney, Leo, and Vanessa Schwartz, eds. *Cinema and the Invention of Modern Life.* Berkeley: University of California Press, 1995.

Christie, Ian. "Clash of the Wonderlands: 3D Cinema." *Sight and Sound* 21, no. 11 (Nov. 2011): http://old.bfi.org.uk/sightandsound/feature/49789.

Chun, Wendy Hui Kyong. *Control and Freedom: Power and Paranoia in the Age of Fiber Optics.* Cambridge, MA: MIT Press, 2006.

Chun, Wendy Hui Kyong, and Thomas Keenan, eds. *New Media, Old Media: A History and Theory Reader.* New York: Routledge, 2006.

Clover, Carol. *Men, Women and Chain Saws: Gender in the Modern Horror Film.* Princeton, NJ: Princeton University Press, 1992.

Clover, Joshua. "The Struggle for Space." *Film Quarterly* 63, no. 3 (Spring 2010): 6–7.

Cohen, Lisa. "The Horizontal Walk: Marilyn Monroe, CinemaScope, and Sexuality." *Yale Journal of Criticism* 11, no. 1 (1998): 259–88.

Collier, Maxie D. *The IFILM Digital Video Filmmaker's Handbook.* Hollywood: IFILM, 2001.

Colomina, Beatriz. "Enclosed by Images: The Eameses' Multimedia Architecture." *Grey Room* 02 (Winter 2001): 6–29.

Comolli, Jean-Louis. "Technique and Ideology: Camera, Perspective, Depth of Field (Part 1)." In Nichols, *Movies and Methods,* 2:40–57.

——. "Technique and Ideology: Camera, Perspective, Depth of Field (Parts 3 and 4)." In Rosen, *Narrative, Apparatus, Ideology,* 421–43.

Comolli, Jean-Louis, and Jean Narboni. "Cinema/Ideology/Criticism." In *Film Theory and Criticism,* 4th ed., edited by Gerald Mast, Marshall Cohen, and Leo Braudy, 682–89. Oxford: Oxford University Press, 1992.

Contreras, Cynthia. "The Elements of Anamorphic Composition: Two Case Studies." PhD diss., CUNY, 1989.

Cossar, Harper. *Letterboxed: The Evolution of Widescreen Cinema*. Lexington: University Press of Kentucky, 2011.

Crafton, Donald. "Mindshare: Telephone and Radio Compete for the Talkies." In *Allegories of Communication: Intermedial Concerns from Cinema to the Digital*, edited by John Fullerton and Jan Olsson, 141–56. Rome: John Libbey, 2004.

——. *The Talkies: American Cinema's Transition to Sound, 1926–1931*. Berkeley: University of California Press, 1997.

Crary, Jonathan. *Techniques of the Observer: On Vision and Modernity in the Nineteenth Century*. Cambridge, MA: MIT Press, 1990.

Creed, Barbara. "The Cyberstar: Digital Pleasures and the End of the Unconscious." *Screen* 41, no. 1 (Spring 2000): 79–86.

Cubitt, Sean. *Digital Aesthetics*. London: Sage, 1998.

——. "Le réel, c'est l'impossible: The Sublime Time of Special Effects." *Screen* 40, no. 2 (Summer 1999): 123–30.

Davidson, Rjurik. "Avatar: Evaluating a Film in a World of Its Own." *Screen Education* 57 (2010): 10–17.

DeAngelis, Michael. *Gay Fandom and Crossover Stardom: James Dean, Mel Gibson, and Keanu Reeves*. Durham, NC: Duke University Press, 2001.

de Lauretis, Teresa. *Alice Doesn't: Feminism, Semiotics, Cinema*. Bloomington: Indiana University Press, 1984.

Deleuze, Gilles. *Cinema 1: The Movement-Image*. Translated by Hugh Tomlinson and Barbara Habberjam. Minneapolis: University of Minnesota Press, 1986.

——. "Coldness and Cruelty." In *Masochism: "Coldness and Cruelty" and "Venus in Furs."* Translated by Jean McNeil and Aude Willm, 15–140. New York: Zone Books, 1991.

——. "Postscript on Control Societies." In *Negotiations*. Translated by Martin Joughin, 177–82. New York: Columbia University Press, 1995.

Deutelbaum, Marshall. "Basic Principles of Anamorphic Composition." *Film History* 15, no. 1 (2003): 72–80.

Doane, Mary Ann. "The Close-Up: Scale and Detail in the Cinema." *differences* 14, no. 3 (Fall 2003): 89–111.

——. *The Desire to Desire: The Woman's Film of the 1940s*. Bloomington: Indiana University Press, 1987.

——. *The Emergence of Cinematic Time: Modernity, Contingency, the Archive*. Cambridge, MA: Harvard University Press, 2002.

——. "Scale and the Negotiation of 'Real' and 'Unreal' Space in the Cinema." In *Realism and the Audiovisual Media*, edited by Lúcia Nagib and Cecília Mello, 63–81. Basingstoke, Hampshire, UK: Palgrave Macmillan, 2009.

——. "Technology's Body: Cinematic Vision in Modernity." In *A Feminist*

Reader in Early Cinema, edited by Jennifer M. Bean and Diane Negra, 530–51. Durham, NC: Duke University Press, 2002.

Dobelle, William H. "Artificial Vision for the Blind by Connecting a Television Camera to the Visual Cortex." *American Society of Artificial Internal Organs (ASAIO) Journal* 46, no. 1 (Jan.-Feb. 2000): 3–9.

Dombrowski, Lisa. "Cheap but Wide: The Stylistic Exploitation of Cinema-Scope in Black-and-White, Low-Budget American Films." In Belton, Hall, and Neale, *Widescreen Worldwide*, 63–70.

——. "Choreographing Emotions: Kazan's CinemaScope Staging." In Dombrowski, *Kazan Revisited*, 163–77.

——, ed. *Kazan Revisited*. Middletown, CT: Wesleyan University Press, 2011.

Ďurovičová, Nataša, and Kathleen Newman, eds. *World Cinemas, Transnational Perspectives*. New York: Routledge, 2010.

Dyer, Richard. *Heavenly Bodies: Film Stars and Society*. New York: St. Martin's, 1986.

——. *Stars*. London: BFI, 1998.

Eisenstein, Sergei. "About Stereoscopic Cinema." Translated by Catherine de la Roche. *Penguin Film Review* 8 (Jan. 1949): 35–44.

——. "The Dynamic Square." In *Film Essays and a Lecture*, edited by Jay Leyda, 48–65. New York: Praeger, 1970.

——. "The Montage of Film Attractions." In *S. M. Eisenstein: Selected Works*. Vol. 1, *Writings, 1922–34*, edited and translated by Richard Taylor, 39–58. London: BFI, 1988.

Elsaesser, Thomas. "Digital Cinema and the Apparatus: Archaeologies, Epistemologies, Ontologies." In *Cinema and Technology: Cultures, Theories, Practices*, edited by Bruce Bennett, Marc Furstenau, and Adrian Mackenzie, 226–40. New York: Palgrave Macmillan, 2008.

——. "Digital Cinema: Delivery, Event, Time." In Elsaesser and Hoffmann, *Cinema Futures: Cain, Abel or Cable?* 201–22.

——. "The New Film History as Media Archaeology." *Cinémas* 14, no. 2–3 (2004): 75–117.

——. *The Persistence of Hollywood*. New York: Routledge, 2012.

——. "The 'Return' of 3-D: On Some of the Logics and Genealogies of the Image in the Twenty-First Century." *Critical Inquiry* 39, no. 2 (Winter 2013): 217–46.

——. "Tales of Sound and Fury." In *Home Is Where the Heart Is: Studies in Melodrama and the Woman's Film*, edited by Christine Gledhill, 43–69. London: BFI, 1987.

Elsaesser, Thomas, and Adam Barker, eds. *Early Cinema: Space, Frame, Narrative*. London: BFI, 1990.

Elsaesser, Thomas, and Kay Hoffmann, eds. *Cinema Futures: Cain, Abel or Cable? The Screen Arts in the Digital Age*. Amsterdam: Amsterdam University Press, 1998.

Epstein, Jean. "Magnification." In Abel, *French Film Theory and Criticism*, 235–41.

———. "On Certain Characteristics of *Photogénie*." In Abel, *French Film Theory and Criticism*, 314–18.

Evans, Walter. "Monster Movies: A Sexual Theory." In *Movies as Artifacts: Cultural Criticism of Popular Film*, edited by Michael T. Marsden, John G. Nachbar, and Sam L. Grogg Jr., 129–36. Chicago: Nelson-Hall, 1982.

Fairfax, Daniel. "Conference Report: The Impact of Technological Innovations on the Historiography and Theory of Cinema." *Cinema Journal* 52, no. 1 (Fall 2012): 127–31.

Figgis, Mike. *Digital Filmmaking*. New York: Faber and Faber, 2007.

Fisher, Kevin. "Tracing the Tesseract: A Conceptual Prehistory of the Morph." In Sobchack, *Meta-morphing: Visual Transformation and the Culture of Quick-Change*, 103–29.

Freud, Sigmund. *Beyond the Pleasure Principle*. Translated by James Strachey. New York: Bantam, 1959.

Friedberg, Anne. "The End of Cinema: Multimedia and Technological Change." In Gledhill and Williams, *Reinventing Film Studies*, 438–52.

———. "Urban Mobility and Cinematic Visuality: The Screens of Los Angeles— Endless Cinema or Private Telematics." *Journal of Visual Culture* 1, no. 2 (2002): 183–204.

———. *The Virtual Window: From Alberti to Microsoft*. Cambridge, MA: MIT Press, 2006.

Frome, Shelly. *The Actors Studio: A History*. Jefferson, NC: McFarland, 2001.

Foucault, Michel. *The Archaeology of Knowledge and the Discourse on Language*. Translated by A. M. Sheridan Smith. New York: Pantheon, 1972.

Furmanek, Bob, and Greg Kintz. "An In-depth Look at *Creature from the Black Lagoon*." 3-D Film Archive, www.3dfilmarchive.com/ an-in-depth-look-at-creature-from-the-black-lagoon-1.

Galloway, Alexander. *Gaming: Essays on Algorithmic Culture*. Minneapolis: University of Minnesota Press, 2006.

———. *Protocol: How Control Exists After Decentralization*. Cambridge, MA: MIT Press, 2004.

Gaudreault, André. *Film and Attraction: From Kinematography to Cinema*. Translated by Timothy Barnard. Urbana: University of Illinois Press, 2011.

Gaut, Berys. "Naked Film: Dogma and Its Limits." In Hjort and MacKenzie, *Purity and Provocation*, 89–101.

Geuens, Jean-Pierre. "The Digital World Picture." *Film Quarterly* 55, no. 4 (2002): 16–27.

Gever, Martha. *Entertaining Lesbians: Celebrity, Sexuality, and Self-Invention.* New York: Routledge, 2003.

Gledhill, Christine. "Signs of Melodrama." In Gledhill, *Stardom*, 207–29.

——, ed. *Stardom: Industry of Desire.* London: Routledge, 1991.

Gledhill, Christine, and Linda Williams, eds. *Reinventing Film Studies.* London: Oxford University Press, 2000.

Glitre, Kathrina. "Conspicuous Consumption: The Spectacle of Widescreen Comedy in the Populuxe Era." In Belton, Hall, and Neale, *Widescreen Worldwide*, 133–43.

Grau, Oliver. *Virtual Art: From Illusion to Immersion.* Translated by Gloria Custance. Cambridge, MA: MIT Press, 2003.

Greenberg, Clement. "Avant-Garde and Kitsch." *Partisan Review* 6, no. 5 (1939): 34–49.

Griffiths, Alison. *Shivers Down Your Spine: Cinema, Museums, and the Immersive View.* New York: Columbia University Press, 2008.

Griffiths, Keith. "The Manipulated Image." *Convergence* 9, no. 4 (2003): 12–26.

Gunning, Tom. "An Aesthetic of Astonishment: Early Film and the (In)Credulous Spectator." In Williams, *Viewing Positions*, 114–33.

——. "The Cinema of Attractions: Early Film, Its Spectator and the Avant-Garde." In Elsaesser and Barker, *Early Cinema*, 56–62.

——. *D. W. Griffith and the Origins of American Narrative Film: The Early Years at Biograph.* Urbana: University of Illinois Press, 1991.

——. "Gollum and Golem: Special Effects and the Technology of Artificial Bodies." In *From Hobbits to Hollywood: Essays on Peter Jackson's "Lord of the Rings,"* edited by Ernest Mathijs and Murray Pomerance, 319–49. Amsterdam: Rodopi, 2006.

——. "In Your Face: Physiognomy, Photography, and the Gnostic Mission of Early Film." *Modernism/Modernity* 4, no. 1 (1997): 1–29.

——. "Landscape and the Fantasy of Moving Pictures: Early Cinema's Phantom Rides." In *Cinema and Landscape: Film, Nation and Cultural Geography*, edited by Jonathan Rayner and Graeme Harper, 31–70. Bristol, UK: Intellect, 2010.

——. "Moving Away from the Index: Cinema and the Impression of Reality." *differences* 18, no. 1 (2007): 29–52.

——. "What's the Point of an Index? Or, Faking Photographs." *Nordicom Review* 25, no. 1–2 (Sept. 2004): 39–49.

——. "The Whole Town's Gawking: Early Cinema and the Visual Experience of Modernity." *Yale Journal of Criticism* 7, no. 2 (1994): 189–201.

——. "The World in Its Own Image: The Myth of Total Cinema." In Andrew and Joubert-Laurencin, *Opening Bazin*, 119–26.

Halberstam, Judith, and Ira Livingston, eds. *Posthuman Bodies*. Bloomington: Indiana University Press, 1995.

Hall, Sheldon. "Alternative Versions in the Early Years of CinemaScope." In Belton, Hall, and Neale, *Widescreen Worldwide*, 113–31.

——. "Dial M for Murder." *Film History* 16, no. 3 (2004): 243–55.

Hansen, Mark B. N. *New Philosophy for New Media*. Cambridge, MA: MIT Press, 2004.

Hansen, Miriam. *Babel and Babylon: Spectatorship in American Silent Film*. Cambridge, MA: Harvard University Press, 1991.

——. "Benjamin and Cinema: Not a One-Way Street." *Critical Inquiry* 25, no. 2 (Winter 1999): 306–43.

——. "Benjamin, Cinema and Experience: 'The Blue Flower in the Land of Technology.'" *New German Critique* 40 (Winter 1987): 179–224.

——. *Cinema and Experience: Siegfried Kracauer, Walter Benjamin, and Theodor W. Adorno*. Berkeley: University of California Press, 2012.

——. "Early Cinema, Late Cinema: Transformations of the Public Sphere." In Williams, *Viewing Positions*, 134–52.

——. "Room-for-Play: Benjamin's Gamble with Cinema." *October* 109 (Summer 2004): 3–45.

Haraway, Donna. "A Cyborg Manifesto: Science, Technology, and Socialist-Feminism in the Late Twentieth Century." Chap. 8 in *Simians, Cyborgs, and Women: The Reinvention of Nature*, 149–91. New York: Routledge, 1991.

Hardt, Michael, and Antonio Negri. *Multitude: War and Democracy in the Age of Empire*. New York: Penguin, 2004.

Harris, Thomas. "The Building of Popular Images: Grace Kelly and Marilyn Monroe." In Gledhill, *Stardom*, 40–44.

Hayes, R. M. *3-D Movies: A History and Filmography of Stereoscopic Cinema*. Jefferson, NC: McFarland, 1989.

Hayles, N. Katherine. "Cybernetics." In Mitchell and Hansen, *Critical Terms for Media Studies*, 145–56.

——. "Flesh and Metal." *Configurations* 10, no. 2 (Spring 2002): 297–320.

——. *How We Became Posthuman: Virtual Bodies in Cybernetics, Literature, and Informatics*. Chicago: University of Chicago Press, 1999.

Heffernan, Kevin. *Ghouls, Gimmicks, and Gold: Horror Films and the American Movie Business, 1953–1968*. Durham, NC: Duke University Press, 2004.

Heidegger, Martin. "The Question Concerning Technology." In *The Question Concerning Technology and Other Essays*, translated by William Lovitt, 3–35. New York: Harper and Row, 1977.

Hendershot, Cyndy. "The Bomb and Sexuality: *Creature from the Black Lagoon* and *Revenge of the Creature.*" *Literature and Psychology* 45, no. 4 (1999): 74–89.

Higgins, Scott. "3D in Depth: *Coraline, Hugo,* and a Sustainable Aesthetic." *Film History* 24, no. 2 (2012): 196–209.

Hillier, Jim, ed. *Cahiers du Cinéma: The 1950s: Neo-Realism, Hollywood, New Wave.* Cambridge, MA: Harvard University Press, 1985.

——. "*East of Eden.*" *Movie* 19 (Winter 1971–72): 22–23.

Hirsch, Foster. *A Method to Their Madness.* New York: Norton, 1984.

Hjort, Mette. "Dogma 95: A Small Nation's Response to Globalisation." In Hjort and MacKenzie, *Purity and Provocation,* 31–47.

Hjort, Mette, and Scott MacKenzie, eds. *Purity and Provocation: Dogma 95.* London: BFI, 2003.

Holmberg, Jan. "Ideals of Immersion in Early Cinema." *Cinémas* 14, no. 1 (2003): 129–47.

Holmes, Oliver Wendell. "The Stereoscope and the Stereograph." In *Classic Essays on Photography*, edited by Alan Trachtenberg, 71–82. New Haven, CT: Leete's Island Books, 1980

Huhtamo, Erkki. "Encapsulated Bodies in Motion: Simulators and the Quest for Total Immersion." In *Critical Issues in Electronic Media*, edited by Simon Penny, 159–86. Albany: State University of New York Press, 1995.

Huhtamo, Erkki, and Jussi Parikka, eds. *Media Archaeology: Approaches, Applications, and Implications.* Berkeley: University of California Press, 2011.

Huntley, Stephen. "Sponable's CinemaScope: An Intimate Chronology of the Invention of the Cinemascope Optical System." *Film History* 5, no. 3 (Sept. 1993): 298–320.

Huxley, Aldous. *"Brave New World" and "Brave New World Revisited."* New York: Harper and Row, 1965.

James, Nick. "Digital Deluge." *Sight and Sound* 11, no. 10 (Oct. 2001): http://old.bfi.org.uk/sightandsound/feature/31/.

Jameson, Fredric. *Marxism and Form: Twentieth-Century Dialectical Theories of Literature.* Princeton, NJ: Princeton University Press, 1971.

Jancovich, Mark. *Rational Fears: American Horror in the 1950s.* Manchester: Manchester University Press, 1996.

Jenkins, Henry. *Convergence Culture: Where Old and New Media Collide.* New York: New York University Press, 2006.

Johnston, Andrew. "Pulses of Abstraction: Episodes from a History of Animation." PhD diss., University of Chicago, 2011.

Johnston, Keith M. "Now Is the Time (to Put On Your Glasses): 3-D Film Exhibition in Britain, 1951–55." *Film History* 23, no. 1 (Jan. 2011): 93–103.

——. "Three Times as Thrilling! The Lost History of 3-D Trailer Production, 1953–54." *Journal of Popular Film and Television* 36, no. 3 (2008): 150–60.

Jones, Kent. "The Quiet Side of Kazan." In Dombrowski, *Kazan Revisited*, 13–24.

Kazan, Elia. *Elia Kazan: A Life*. New York: Alfred A. Knopf, 1988.

———. *Kazan on Directing*. New York: Alfred A. Knopf, 2009.

Kehr, Dave. "3-D or Not 3-D." *Film Comment* 46, no. 1 (Jan.-Feb. 2010): 60–67.

Kelly, Richard. *The Name of This Book Is Dogme95*. London: Faber and Faber, 2000.

Kessler, Frank. "The Cinema of Attractions as *Dispositif*." In Strauven, *The Cinema of Attractions Reloaded*, 57–69.

———. "Programming and Performing Early Cinema Today: Strategies and *Dispositifs*." In *Early Cinema Today: The Art of Programming and Live Performance*, edited by Martin Loiperdinger, 137–46. New Barnet, Herts, UK: John Libbey, 2011.

Killen, Andreas, and Stefan Andriopoulos, eds. "On Brainwashing: Mind Control, Media, and Warfare." Special issue, *Grey Room* 45 (Fall 2011).

King, Geoff. "Spectacle, Narrative, and the Spectacular Hollywood Blockbuster." In Stringer, *Movie Blockbusters*, 114–27.

———. *Spectacular Narratives: Hollywood in the Age of the Blockbuster*. London: I. B. Tauris, 2000.

Kitsopanidou, Kira. "The Widescreen Revolution and 20th Century–Fox's Eidophor in the 1950s." *Film History* 15, no. 1 (2003): 32–56.

Kittler, Friedrich A. *Gramophone, Film, Typewriter*. Translated by Geoffrey Winthrop-Young and Michael Wutz. Stanford: Stanford University Press, 1999.

Klinger, Barbara. *Beyond the Multiplex: Cinema, New Technologies, and the Home*. Berkeley: University of California Press, 2006.

———. "*Cave of Forgotten Dreams*: Meditations on 3D." *Film Quarterly* 65, no. 3 (Spring 2012): 38–43.

Kohler, Richard. "The Big Screens." *Sight and Sound* 24, no. 3 (Jan.–March, 1955): 120–24.

Kracauer, Siegfried. *From Caligari to Hitler: A Psychological History of the German Film*. 1947. Rev. ed. Edited by Leonardo Quaresima. Princeton, NJ: Princeton University Press, 2004.

———. *The Mass Ornament: Weimar Essays*. Edited and translated by Thomas Y. Levin. Cambridge, MA: Harvard University Press, 1995.

———. *Theory of Film: The Redemption of Physical Reality*. 1960. Princeton, NJ: Princeton University Press, 1997.

Krukones, James H. "Peacefully Coexisting on a Wide Screen: Kinopanorama vs. Cinerama, 1952–66." *Studies in Russian and Soviet Cinema* 4, no. 3 (2010): 283–305.

Kurzweil, Ray. *The Age of Spiritual Machines: When Computers Exceed Human Intelligence*. New York: Penguin, 1999.

Lambert, Gavin. "Report on New Dimensions." *Sight and Sound* 22, no. 4 (April–June 1953): 157–60.

Lassally, Walter. "The Big Screens." *Sight and Sound* 24, no. 3 (Jan.–March 1955): 124–26.

Lastra, James. *Sound Technology and the American Cinema: Perception, Representation, Modernity*. New York: Columbia University Press, 2000.

Lauridsen, Palle Schantz. "*The Celebration*: Classical Drama and Docu Soap Style." *p.o.v.: A Danish Journal of Film Studies* 10 (Dec. 2000): 63–75.

Laursen, Thomas Lind. "The Agitated Camera: A Diagnosis of Anthony Dod Mantle's Camera Work in *The Celebration*." *p.o.v.: A Danish Journal of Film Studies* 10 (Dec. 2000): 77–87.

Law, Alma, and Mel Gordon. *Meyerhold, Eisenstein and Biomechanics: Actor Training in Revolutionary Russia*. Jefferson, NC: McFarland, 1996.

Lawrence, Amy. "James Mason: A Star Is Born Bigger Than Life." In Palmer, *Larger Than Life*, 86–106.

Lawrence, John Shelton, and Robert Jewett. *The Myth of the American Superhero*. Grand Rapids, MI: Wm. B. Eerdmans, 2002.

LeCompte, Tom. "Cinerama: The Secret Weapon of the Cold War." *American Heritage of Invention and Technology* 21, no. 2 (2005): 10–17.

Lev, Peter. *The Fifties: Transforming the Screen, 1950–1959*. Berkeley: University of California Press, 2003.

———. "Whose Future? *Star Wars*, *Alien*, and *Blade Runner*." *Literature Film Quarterly* 26, no. 1 (1998): 30–37.

Lévy, Pierre. *Collective Intelligence: Mankind's Emerging World in Cyberspace*. Translated by Robert Bononno. New York: Plenum Trade, 1997.

Lewis, Jon. "The Perfect Money Machine(s): George Lucas, Steven Spielberg, and Auteurism in the New Hollywood." In *Looking Past the Screen: Case Studies in American Film History and Method*, edited by Jon Lewis and Eric Smoodin, 61–86. Durham, NC: Duke University Press, 2007.

Liguoro, Francesca, and Giustina D'Oriano. "The Frontiers of Vision." In *Le cinémascope entre art et industrie*, edited by Jean-Jacques Meusy, 297–307. Paris: Association française de recherche sur l'histoire du cinéma, 2003.

Lubow, Arthur. "A Space 'Iliad': The *Star Wars* War: I." *Film Comment* 13, no. 4 (July–August 1977): 20.

MacKenzie, Scott. "Manifest Destinies: Dogma 95 and the Future of the Film Manifesto." In Hjort and MacKenzie, *Purity and Provocation*, 48–57.

Macnab, Geoffrey. "The Big Tease: 'Dogma 95' Was Not Just a PR Joke." *Sight and Sound* 9, no. 2 (Feb. 1999): 16–18.

Manovich, Lev. *The Language of New Media*. Cambridge, MA: MIT Press, 2002.

———. "The Practice of Everyday (Media) Life: From Mass Consumption to Mass Cultural Production?" *Critical Inquiry* 35 (Winter 2009): 319–31.

Marchessault, Janine, and Susan Lord, eds. *Fluid Screens, Expanded Cinema*. Toronto: University of Toronto Press, 2007.

Marks, Laura U. *The Skin of the Film: Intercultural Cinema, Embodiment, and the Senses*. Durham, NC: Duke University Press, 2000.

———. *Touch: Sensuous Theory and Multisensory Media*. Minneapolis: University of Minnesota Press, 2002.

Mayorov, Nikolai. "A First in Cinema . . . Stereoscopic Films in Russia and the Soviet Union." *Studies in Russian and Soviet Cinema* 6, no. 2 (Sept. 2012): 217–39.

McCann, Graham. *Marilyn Monroe*. New Brunswick, NJ: Rutgers University Press, 1988.

McClean, Shilo T. *Digital Storytelling: The Narrative Power of Visual Effects in Film*. Cambridge, MA: MIT Press, 2007.

McConnell, Frank D. "Song of Innocence: *The Creature from the Black Lagoon*." *Journal of Popular Film* 2, no. 1 (Winter 1973): 15–28.

McGowan, Todd. "Maternity Divided: *Avatar* and the Enjoyment of Nature." *Jump Cut* 52 (2010): www.ejumpcut.org/archive/jc52.2010/mcGowan Avatar/index.html.

McKernan, Brian. *Digital Cinema: The Revolution in Cinematography, Postproduction, and Distribution*. New York: McGraw-Hill, 2005.

McLuhan, Marshall. *The Mechanical Bride: Folklore of Industrial Man*. Boston: Beacon, 1951.

———. *Understanding Media: The Extensions of Man*. 1964. Cambridge, MA: MIT Press, 1994.

McPherson, Tara. "Self, Other and Electronic Media." In *The New Media Book*, edited by Dan Harries, 183–94. London: BFI, 2002.

McQuire, Scott. "Impact Aesthetics: Back to the Future in Digital Cinema? Millennial Fantasies." *Convergence* 6, no. 2 (2000): 41–61.

Metz, Christian. *Film Language: A Semiotics of the Cinema*. Translated by Michael Taylor. Chicago: University of Chicago Press, 1991.

Mitchell, Rick. "The Tragedy of 3-D Cinema." *Film History* 16, no. 3 (2004): 208–15.

Mitchell, W. J. T., and Mark B. N. Hansen. *Critical Terms for Media Studies*. Chicago: University of Chicago Press, 2010.

Morgan, Daniel. "Rethinking Bazin: An Essay on Ontology and Realist Aesthetics." *Critical Inquiry* 32 (Spring 2006): 443–81.

Morin, Edgar. *The Stars*. Translated by Richard Howard. 1972. Minneapolis: University of Minnesota Press, 2005.

Mulvey, Laura. *Death 24x a Second: Stillness and the Moving Image*. London: Reaktion, 2006.

———. "*Gentlemen Prefer Blondes*: Anita Loos/Howard Hawks/Marilyn Monroe." In *Howard Hawks: American Artist*, edited by Jim Hillier and Peter Wollen, 214–29. London: BFI, 1996.

——. "Visual Pleasure and Narrative Cinema." In Rosen, *Narrative, Apparatus, Ideology*, 198–209.

Murphy, Brian. "Monster Movies: They Came from Beneath the Fifties." In *Movies as Artifacts: Cultural Criticism of Popular Film*, edited by Michael T. Marsden, John G. Nachbar, and Sam L. Grogg Jr., 176–88. Chicago: Nelson-Hall, 1982.

Musser, Charles. *The Emergence of Cinema: The American Screen to 1907*. New York: Charles Scribner's Sons, 1990.

Neale, Steve, and Murray Smith, eds. *Contemporary Hollywood Cinema*. London: Routledge, 1998.

Negroponte, Nicholas. *Being Digital*. New York: Alfred A. Knopf, 1995.

Negt, Oskar, and Alexander Kluge. *Public Sphere and Experience: Toward an Analysis of the Bourgeois and Proletarian Public Sphere*. Translated by Peter Labanyi, Jamie Owen Daniel, and Assenka Oksiloff. Minneapolis: University of Minnesota Press, 1993.

Neve, Brian. *Elia Kazan: The Cinema of an American Outsider*. London: I. B. Tauris, 2009.

——. "HUAC, the Blacklist, and the Decline of Social Cinema." In Lev, *The Fifties*, 65–86.

Nichols, Bill, ed. *Movies and Methods*. 2 vols. Berkeley: University of California Press, 1976–85.

——. "The Work of Culture in the Age of Cybernetic Systems." *Screen* 29, no. 1 (Winter 1988): 22–46.

Niessen, Niels. "Lives of Cinema: Against Its 'Death.'" *Screen* 52, no. 3 (Autumn 2011): 307–26.

Normann, Richard A., Edwin Maynard, Patrick Rousche, and David Warren. "A Neural Interface for a Cortical Vision Prosthesis." *Vision Research* 39 (1999): 2577–87.

North, Dan. "Kill Binks: Why the World Hated Its First Digital Actor." In *Culture, Identities and Technology in the "Star Wars" Films*, edited by Carl Silvio and Tony M. Vinci, 155–74. Jefferson, NC: McFarland, 2007.

Nowell-Smith, Geoffrey, and Peter Thomas. "Editorial." *Convergence* 9, no. 4 (2003): 5–9.

Orgeron, Marsha. "Making *It* in Hollywood: Clara Bow, Fandom, and Consumer Culture." *Cinema Journal* 42, no. 4 (Summer 2003): 76–97.

Packard, Vance. *The Hidden Persuaders*. New York: David McKay, 1957.

Palmer, R. Barton, ed. *Larger Than Life: Movie Stars of the 1950s*. New Brunswick, NJ: Rutgers University Press, 2010.

Paul, William. "The Aesthetics of Emergence." *Film History* 5, no. 3 (1993): 321–55.

——. "Breaking the Fourth Wall: 'Belascoism,' Modernism, and a 3-D *Kiss Me Kate*." *Film History* 16, no. 3 (2004): 229–42.

——. "Screening Space: Architecture, Technology, and the Motion Picture Screen." *Michigan Quarterly Review* 35, no. 1 (Winter 1996): 143–73.

Pauly, Thomas H. *An American Odyssey: Elia Kazan and American Culture*. Philadelphia: Temple University Press, 1983.

Perkins, V. F. "*River of No Return*." *Movie* 2 (Sept. 1962): 18–19.

Pierson, Michele. *Special Effects: Still in Search of Wonder*. New York: Columbia University Press, 2002.

Preciado, Beatriz. "Pornotopia." In *Cold War Hothouses*, edited by Beatriz Colomina, Annmarie Brennan, and Jeannie Kim, 216–53. New York: Princeton Architectural Press, 2004.

Prince, Stephen. *Digital Visual Effects in Cinema: The Seduction of Reality*. New Brunswick, NJ: Rutgers University Press, 2012.

——. "The Emergence of Filmic Artifacts: Cinema and Cinematography in the Digital Era." *Film Quarterly* 57, no. 3 (Spring 2004): 24–33.

——. "True Lies: Perceptual Realism, Digital Images, and Film Theory." *Film Quarterly* 49, no. 3 (Spring, 1996): 27–37.

Quigley, Martin, Jr., ed. *New Screen Techniques*. New York: Quigley Publishing, 1953.

Rabinovitz, Lauren. "More Than the Movies: A History of Somatic Visual Culture Through *Hale's Tours*, Imax, and Motion Simulation Rides." In *Memory Bytes: History, Technology, and Digital Culture*, edited by Lauren Rabinovitz and Abraham Geil, 99–125. Durham, NC: Duke University Press, 2004.

Rees, Ellen. "In My Father's House Are Many Mansions: Transgressive Space in Three Dogme 95 Films." *Scandinavica* 43, no. 2 (2004): 165–82.

Reeves, Hazard. "This Is Cinerama." *Film History* 11, no 1 (1999): 85–97.

Rivette, Jacques. "The Age of *metteurs en scène*." In Hillier, *Cahiers du Cinéma: The 1950s*, 275–79.

Rodowick, D. N. *The Virtual Life of Film*. Cambridge, MA: Harvard University Press, 2007.

Rohmer, Eric. "The Cardinal Virtues of CinemaScope." In Hillier, *Cahiers du Cinéma: The 1950s*, 280–83.

——. *The Taste for Beauty*. Translated by Carol Volk. Cambridge: Cambridge University Press, 1989.

Roman, Shari. *Digital Babylon: Hollywood, Indiewood and Dogme 95*. Hollywood: IFILM, 2001.

Rosen, Marjorie. *Popcorn Venus: Women, Movies and the American Dream*. New York: Coward, McCann and Geoghegan, 1973.

Rosen, Philip. *Change Mummified: Cinema, Historicity, Theory*. Minneapolis: University of Minnesota Press, 2001.

——, ed. *Narrative, Apparatus, Ideology: A Film Theory Reader*. New York: Columbia University Press, 1986.

Rosenbaum, Jonathan. "Elia Kazan, Seen from 1973." In Dombrowski, *Kazan Revisited*, 25–36.

Rosenberg, Bernard, and David Manning White, eds. *Mass Culture: The Popular Arts in America*. Glencoe, IL: Free Press and Falcon's Wing Press, 1957.

Ross, Miriam. "The 3-D Aesthetic: *Avatar* and Hyperhaptic Visuality." *Screen* 53, no. 4 (Winter 2012): 381–97.

Ross, Sara. "Invitation to the Voyage: The Flight Sequence in Contemporary 3D Cinema." *Film History* 24, no. 2 (2012): 210–20.

Rubin, Michael. *Droidmaker: George Lucas and the Digital Revolution*. Gainesville, FL: Triad, 2006.

Rutherford, Anne. "Cinema and Embodied Affect." *Senses of Cinema* 25 (March-April 2003): http://sensesofcinema.com/2003/feature-articles/embodied_affect.

Salt, Barry. *Film Style and Technology: History and Analysis*. 2nd ed. London: Starword, 1992.

Sandifer, Philip. "Out of the Screen and into the Theater: 3-D Film as Demo." *Cinema Journal* 50, no. 3 (Spring 2011): 62–78.

Sarris, Andrew. Review of *East of Eden*. *Film Culture* 3 (May-June 1955): 24.

Schatz, Thomas. *Hollywood Genres: Formulas, Filmmaking, and the Studio System*. New York: McGraw Hill, 1981.

——. "The New Hollywood." In Stringer, *Movie Blockbusters*, 15-44.

Schickel, Richard. *Elia Kazan: A Biography*. New York: HarperCollins, 2005.

Sconce, Jeffrey. *Haunted Media: Electronic Presence from Telegraphy to Television*. Durham, NC: Duke University Press, 2000.

Shaviro, Steven. *The Cinematic Body*. Minneapolis: University of Minnesota Press, 1993.

Simons, Jan. *Playing the Waves: Lars von Trier's Game Cinema*. Amsterdam: Amsterdam University Press, 2007.

——. "Von Trier's Cinematic Games." *Journal of Film and Video* 60, no. 1 (Spring 2008): 3–13.

Singer, Ben. *Melodrama and Modernity: Early Sensational Cinema and Its Contexts*. New York: Columbia University Press, 2001.

Sloman, Tony. "The Pleasures of CinemaScope." *BFFS Monthly Journal* 100 (Nov. 1981): 6–7.

Smith, Murray. *Engaging Characters: Fiction, Emotion, and the Cinema*. Oxford: Clarendon Press, 1995.

Sobchack, Vivian. *The Address of the Eye: A Phenomenology of Film Experience*. Princeton, NJ: Princeton University Press, 1991.

——. "'At the Still Point of the Turning World': Meta-morphing and Meta Stasis." In Sobchack, *Meta-morphing*, 131–58.

——. *Carnal Thoughts: Embodiment and Moving Image Culture*. Berkeley: University of California Press, 2004.

——, ed. *Meta-morphing: Visual Transformation and the Culture of Quick-Change*. Minneapolis: University of Minnesota Press, 2000.

——. *Screening Space: The American Science Fiction Film*. 2nd ed. New Brunswick, NJ: Rutgers University Press, 1987.

Solomon, Matthew. "Reflexivity and Metaperformance: Marilyn Monroe, Jayne Mansfield, and Kim Novak." In Palmer, *Larger Than Life*, 107–29.

Sontag, Susan. "Fascinating Fascism." In Nichols, *Movies and Methods*, 1:31–43.

Spadoni, Robert. "The Uncanny Body of Early Sound Film." *Velvet Light Trap* 51 (Spring 2003): 4–16.

Spellerberg, James. "CinemaScope and Ideology." *Velvet Light Trap* 21 (Summer 1985): 26–34.

Spielmann, Yvonne. "Expanding Film into Digital Media." *Screen* 40, no. 2 (Summer 1999): 131–45.

Spigel, Lynn. *Make Room for TV: Television and the Family Ideal in Postwar America*. Chicago: University of Chicago Press, 1992.

Spottiswoode, Raymond, and Nigel Spottiswoode. *The Theory of Stereoscopic Transmission and Its Application to the Motion Picture*. Berkeley: University of California Press, 1953.

Springer, Claudia. *James Dean Transfigured: The Many Faces of Rebel Iconography*. Austin: University of Texas Press, 2007.

Stevenson, Jack. *Dogme Uncut: Lars von Trier, Thomas Vinterberg, and the Gang That Took on Hollywood*. Santa Monica: Santa Monica Press, 2003.

Stewart, Susan. *On Longing: Narratives of the Miniature, the Gigantic, the Souvenir, the Collection*. Durham, NC: Duke University Press, 1993.

Strauven, Wanda, ed. *The Cinema of Attractions Reloaded*. Amsterdam: Amsterdam University Press, 2006.

Straw, Will. "Proliferating Screens." *Screen* 41, no. 1 (Spring 2000): 115–19.

Strayer, Kirsten. "Reinventing the Inhuman: Avatars, Cylons, and *Homo Sapiens* in Contemporary Science-Fiction Television Series." *Literature Film Quarterly* 38, no. 3 (July 2010): 194–204.

Stringer, Julian, ed. *Movie Blockbusters*. London: Routledge, 2003.

Studlar, Gaylyn. *In the Realm of Pleasure: Von Sternberg, Dietrich, and the Masochistic Aesthetic*. New York: Columbia University Press, 1988.

——. "The Perils of Pleasure? Fan Magazine Discourse as Women's Commodified Culture in the 1920s." In *Silent Film*, edited by Richard Abel, 263–97. New Brunswick, NJ: Rutgers University Press, 1996.

Tarratt, Margaret. "Monsters from the Id." In *Film Genre Reader II*, edited by Barry Keith Grant, 330–49. Austin: University of Texas Press, 1995.

Taussig, Michael. *Mimesis and Alterity: A Particular History of the Senses*. New York: Routledge, 1993.

Telotte, J. P. "The *Blair Witch Project* Project: Film and the Internet." *Film Quarterly* 54, no. 3 (Spring 2001): 32–39.

——. "Making Tele-contact: 3-D Film and *The Creature from the Black Lagoon*." *Extrapolation* 45, no. 3 (Fall 2004): 294–304.

Thompson, Kristin, and David Bordwell. *Film History: An Introduction*. 2nd ed. New York: McGraw-Hill, 2003.

Tromble, Meredith, ed. *The Art and Films of Lynn Hershman Leeson: Secret Agents, Private I*. Berkeley: University of California Press, 2005.

Truffaut, François. "A Full View." In Hillier, *Cahiers du Cinéma: The 1950s*, 273–74.

Tsivian, Yuri. *Early Cinema in Russia and Its Cultural Reception*. Translated by Alan Bodger. London: Routledge, 1994.

Turkle, Sherry. *Life on the Screen: Identity in the Age of the Internet*. New York: Simon and Schuster, 1995.

Turnock, Julie. "The ILM Version: Recent Digital Effects and the Aesthetics of 1970s Cinematography." *Film History* 24 (2012): 158–68.

——. "Plastic Reality: Special Effects, Art and Technology in 1970s U.S. Filmmaking." PhD diss., University of Chicago, 2008.

Utterson, Andrew, ed. *Technology and Culture: The Film Reader*. Abingdon: Routledge, 2005.

Vertov, Dziga. *Kino-Eye: The Writings of Dziga Vertov*. Edited by Annette Michelson. Translated by Kevin O'Brien. Berkeley: University of California Press, 1984.

Vincent, Tom. "Standing Tall and Wide: The Selling of VistaVision." In Belton, Hall, and Neale, *Widescreen Worldwide*, 25–39.

Virilio, Paul. *The Information Bomb*. Translated by Chris Turner. London: Verso, 2000.

——. *Polar Inertia*. Translated by Patrick Camiller. 1990. London: Sage, 2000.

Wardrip-Fruin, Noah, and Nick Montfort, eds. *The New Media Reader*. Cambridge, MA: MIT Press, 2003.

Wasson, Haidee, ed. "In Focus: Screen Technologies." *Cinema Journal* 51, no. 2 (Winter 2012): 141–72.

——. "The Networked Screen: Moving Images, Materiality, and the Aesthetics of Size." In Marchessault and Lord, *Fluid Screens, Expanded Cinema*, 74–95.

Whissel, Kristen. "The Digital Multitude." *Cinema Journal* 49, no. 4 (Summer 2010): 90–110.

——. "Tales of Upward Mobility: The New Verticality and Digital Special Effects." *Film Quarterly* 59, no. 4 (Summer 2006): 23–34.

White, Rob. "Only Connect." *Film Quarterly* 63, no. 3 (Spring 2010): 4–5.

White, Timothy R. "Hollywood's Attempt at Appropriating Television: The Case of Paramount Pictures." In Balio, *Hollywood in the Age of Television*, 145–63.

Whitney, Allison. "The Eye of Daedalus: A History and Theory of IMAX Cinema." PhD diss., University of Chicago, 2005.

Wiener, Norbert. *Cybernetics: Or Control and Communication in the Animal and Machine*. Cambridge, MA: MIT Press, 1948.

——. "Men, Machines, and the World About." 1954. In Wardrip-Fruin and Montfort, *The New Media Reader*, 67–72.

Williams, Linda. "Discipline and Fun: *Psycho* and Postmodern Cinema." In Gledhill and Williams, *Reinventing Film Studies*, 351–78.

——. "Film Bodies: Gender, Genre, and Excess." *Film Quarterly* 44, no. 4 (Summer 1991): 2–13.

——. *Hard Core: Power, Pleasure, and the "Frenzy of the Visible."* Berkeley: University of California Press, 1989.

——, ed. *Viewing Positions: Ways of Seeing Film*. New Brunswick, NJ: Rutgers University Press, 1995.

Williams, Raymond. *Television: Technology and Cultural Form*. 1974. London: Routledge, 2003.

Willis, Holly. *New Digital Cinema: Reinventing the Moving Image*. New York: Wallflower, 2005.

Wisenfeldt, Gerhard. "Dystopian Genesis: The Scientist's Role in Society, According to Jack Arnold." *Film and History* 40, no. 1 (Spring 2010): 58–74.

Wolf, Mark J. P. "A Brief History of Morphing." In Sobchack, *Meta-morphing*, 83–101.

Wollen, Peter. *Signs and Meaning in the Cinema*. Bloomington: University of Indiana Press, 1969.

Wood, Robin. *Hollywood from Vietnam to Reagan—and Beyond*. Exp. and rev. ed. New York: Columbia University Press, 2003.

——. "The Kazan Problem." *Movie* 19 (Winter 1971–72): 29–31.

Wurtzler, Steve J. *Electric Sounds: Technological Change and the Rise of Corporate Mass Media*. New York: Columbia University Press, 2007.

Young, Jeff, ed. *Kazan on Kazan*. London: Faber and Faber, 1999.

Young, Paul. *The Cinema Dreams Its Rivals: Media Fantasy Films from Radio to the Internet*. Minneapolis: University of Minnesota Press, 2006.

Youngblood, Gene. *Expanded Cinema*. New York: P. Dutton, 1970.

Zielinski, Siegfried. "Historic Modes of the Audiovisual Apparatus." *Iris* 17 (1994): 7–24.

Zone, Ray. *Stereoscopic Cinema and the Origins of 3-D Film, 1838–1952*. Lexington: University Press of Kentucky, 2007.

——. *3-D Revolution: The History of Modern Stereoscopic Cinema*. Lexington: University Press of Kentucky, 2012.

FILM AND CULTURE

A series of Columbia University Press
Edited by John Belton